University of Wales

Centre for Advanced Welsh

and Celtic Studies

THE VISUAL CULTURE OF WALES

THE VISUAL CULTURE of ❧ WALES:

Industrial Society

Peter Lord

UNIVERSITY OF WALES PRESS, CARDIFF
1998

THE VISUAL CULTURE of 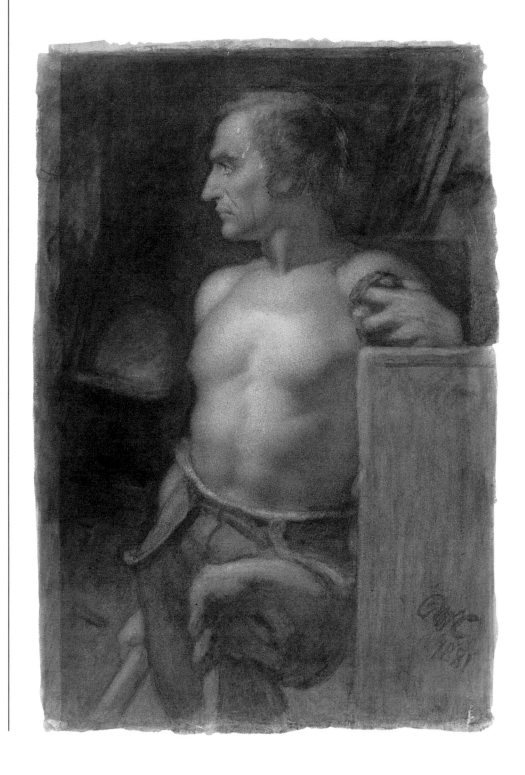 WALES

General Editor: Geraint H. Jenkins
Designer: Olwen Fowler

British Library
Cataloguing-in-Publication Data
A catalogue record for this book is
available from the British Library.

ISBN 0–7083–1496–1

Printed in Wales
by Cambrian Printers, Aberystwyth

Contents

PREFACE

Few subjects relating to Wales have suffered more cruelly from ignorance, misunderstanding and neglect than the visual culture of the nation, and the aim of this volume, and the series of which it is part, is to provide an authoritative and accessible overview of the history of the visual culture of Wales over the centuries. In recent years no one has been more influential in opening up this field of enquiry than the prolific art historian Peter Lord and it was a particular pleasure to invite him to lead a research project on 'The Visual Culture of Wales' at the University of Wales Centre for Advanced Welsh and Celtic Studies which would result in the publication of three volumes in English and three volumes in Welsh. I am confident that readers will share my conviction that this is a project well worth carrying forward and that it will bring a new dimension to the understanding and appreciation of our cultural heritage.

Peter Lord is a bold and innovative scholar, passionately committed to his subject, and there could be no better introduction to the visual culture of Wales than this lavishly illustrated volume. Although this is a single-authored text it represents the fruits of a major collaborative enterprise which has generated considerable excitement and vitality in the Centre. The sustained support of members of the research team – Lindsay Clements, Gillian Conway, Angela Gaffney, Paul Harries, Nerys Howells, Stephanie Jones and John R. Wilson – has been invaluable. We are also deeply grateful to other members of current research teams at the Centre, especially Marion Löffler, for much practical assistance. The University of Wales has handsomely supported this project and we are particularly indebted to Jeffrey D. Pritchard, Secretary General of the University, and D. Ian George, Director of Resources, for their helpful advice.

Several other major national institutions have collaborated closely and warmly. Our greatest debt is to the National Library of Wales and the National Museums and Galleries of Wales, without whose support this series would not have been possible. We count ourselves especially fortunate to be located on the doorstep of a copyright library with an enviable collection of literary and artistic treasures, and it is a pleasure to record our thanks to all the staff of the National Library of Wales for their contribution to the success of this project. A special debt of thanks is also owed to the staff of the National Museums and Galleries of Wales

for showing their confidence in this project and for being unfailingly supportive. A substantial grant from the Derek Williams Trust enabled us to employ Angela Gaffney as a research fellow based at the National Museum and Gallery Cardiff, and her meticulous researches have greatly enriched our fund of knowledge relating to the present volume. We are most grateful, too, to the staff of Cyfarthfa Castle Museum and Art Gallery, especially Derek Phillips (Assistant Curator), and the Swansea Museums Service, especially Richard Davies (Documentation Officer), for their efficient assistance at all times. The Centre is also deeply grateful to the following for financial support for the publication of this series: the Bank of Wales, the University of Wales Board of Celtic Studies, the Gwendoline and Margaret Davies Charity, the Foundation for Sport and the Arts, the Esmée Fairbairn Trust, the Hambros Trust, the Laspen Trust, the A & G Morgan Trust, and the Derek Williams Trust. Our greatest financial obligation, however, is to the Lottery Division of the Arts Council of Wales, without whose generous support and cooperation this publishing project would have remained stillborn.

Many colleagues and friends have brought fresh perspectives and insights to the project, and we are grateful to David Alston, Keeper of Art, National Museum and Gallery Cardiff, D. Huw Owen, Keeper of Pictures and Maps, National Library of Wales, and Nich Pearson, Director, Welsh Consumer Council, for reading the entire work in manuscript and for their valuable comments. Expert advice was also gratefully received from Douglas Gray, De Montfort University, Leicester, David Gwyn, Gwynedd Archaeological Trust, Christine Stevens, Museum of Welsh Life, Valmai Ward, The Arts Council of Wales, and Matthew Williams, Curator, Cardiff Castle. Peter Lord benefited enormously from the support, advice and encouragement of Miles Wynn Cato, Sylvia Crawshay and Thomas Lloyd, and the entire project team is indebted to members of the Advisory Panel to the project – David Alston, Isabel Hitchman, Sheila Hourahane, Donald Moore, Huw Owen, Nich Pearson, Richard Suggett and John Williams-Davies – for their stimulating contributions and assistance. We are grateful to Renate Koppel, Audrey Lane and Barbara Price for permitting access to personal archives, and to Charles Burton, the late John Elwyn, Arthur Giardelli, John Goddard, Winston Griffith, the late Mervyn Levy, Glyn Jones, Glyn Morgan, and Denys and Eirian Short for granting interviews which informed the text.

For permission to reproduce photographs, the Centre is indebted to private collectors, trustees and directors of galleries, libraries and museums listed in the Acknowledgements at the end of this volume.

Several other debts remain: to Olwen Fowler, who designed the volume with rare skill and enthusiasm; to Gareth Lloyd Hughes and Kevin Thomas for highly skilled photographic work; to Glenys Howells, whose editorial prowess saved us from many blunders and omissions; to Aeres Bowen Davies and Siân L. Evans for indispensable secretarial assistance; to Tegwyn Jones for preparing the index; and, finally, to the staff of the University of Wales Press for providing assistance and encouragement throughout.

Those who share my view that a nation acquires both self-awareness and self-confidence through its culture will appreciate the importance of this project, and all of us who are passionately committed to making this Centre a vibrant community of scholars hope that readers of this volume will derive the same satisfaction and pleasure which we have experienced in the course of its preparation.

Geraint H. Jenkins
March 1998

INTRODUCTION

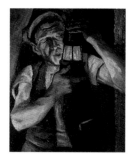

This volume and its two companions are written in the belief that an image is best understood when considered in the context of the whole world of which it is a part, rather than simply in the context of art. In this way it differs profoundly from previous attempts to survey the visual culture of Wales. If we understand a picture better as a social, rather than as an aesthetic phenomenon, we may also value it more highly. For painters, both amateur and professional, as for architects and weavers, carvers and ceramicists, knowledge of the works of other artists and craftspeople is often an element in the formation of their images. However, historical perspective diminishes the importance of such largely aesthetic relationships and strengthens the perception of an image as a part of an interaction of forces as extensive and complex as society itself. That perception applies equally to the making and the reception of an image.

For instance, the widespread identification of Wales with beautiful landscape is the cumulative effect of a mass of visual images made over a period of more than two hundred years. Aesthetic fashion and the influence of artist upon artist played a part in the evolution of those images, but at a superficial level. The need to create and sustain the landscape genre itself arose from changes of perception which affected a much wider range of people – writers and musicians, merchants and politicians – than the makers of visual images alone. The cumulative image reflects the state of society, even when its constituent elements are not intended by the image-makers as social comment.

Similarly, such cumulative images influence the evolution of society, though not always in the way intended by the image-makers. The imaging of Wales as a landscape, which continues to dominate the perceptions of many outsiders, almost to the exclusion of an idea of Wales as home to communities with particular cultural characteristics, has had a profound impact upon national life.

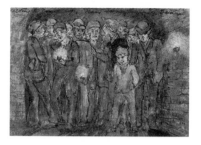

In this case, as in most others, the contribution of an individual image to the evolution of society is small and effective only as part of a general trend of images. However, by a process of crystallization, occasionally an individual image may so well articulate confused and unrefined perceptions that it affects the ideas and actions of many people, and thus can be said to influence society itself. Such images are rare but not unknown, and become icons of a section of society or even of the nation itself.

Given this primary understanding of the importance of visual culture as simultaneously a mirror to and an active force in the world beyond art, it follows that a description of images should be organized to follow that wider history. However, enlarging the starting point for analysis from the history of art to the history of society itself does not solve the problem of how best to organize the material, since the question of the most appropriate understanding of the evolution of Welsh society is as contentious as the competing methodologies of art historians. Writing from the perspective of the post-industrial world, the decision to separate the products of industrial society from other contemporary aspects of the visual culture of Wales might be considered regressive. An inclusive approach might be deemed politically more constructive in a period of reassessment of nationhood. In retrospect it is clear that the customary division of nineteenth and twentieth-century Wales between industrial and rural, often accompanied by a contiguous division between south and north, between English-speaking and Welsh-speaking, has ignored many historical continuities and shared cultural characteristics. Furthermore, describing industrial Wales as if its evolution was unrelated to that of the rest of the country has been the method employed by many of those who have sought to undermine the concept of Welsh nationhood. Since the continued viability of that nationhood is axiomatic in this volume and its companions, the implications of considering separately the visual culture of Welsh industrial society have been given much thought.

However, most of the imagery of industrial society was not made in retrospect and neither was historical perspective an important concern of most image-makers. Indeed, the immediacy of much of the work – especially the substantial

body of images concerned with political and social issues – seems to be among its most characteristic qualities. Furthermore, like the society from which it sprang, it was often manifested in new forms, especially the printed image. Academic painting and sculpture, which continued to dominate the imaging of other aspects of Wales, for long periods had relatively little to say about industrial society. Even at the beginning, when the imaging of industrial Wales was largely an extension of the landscape movement in English academic art, it seemed to most image-makers that they were observing a world apart. Beyond its material and social unfamiliarity, at the level of philosophy that world seemed to have little connection with the idea of nationhood which dominated Welsh intellectual life in the nineteenth century. Although the national context of Welsh industrial society was seldom entirely absent – striking miners were usually identified by outside image-makers as *Welsh* miners, for instance – most of the issues raised by the images were not perceived primarily as being related to questions of national identity or character. It is evident that many image-makers particularly concerned with the idea of nationhood found it extremely difficult to accommodate the industrial landscape or industrial communities within their intellectual framework. The decision to consider the visual culture of industrial society in a separate volume was thus taken because it seemed to reflect the attitudes of those involved in its production and its contemporary reception.

Because the volume takes a social phenomenon as its starting point, it considers not only the depiction of Welsh industrial landscapes and communities by artists, but also the self-imaging, through both making and patronage, of people of all classes who comprised industrial society. It is here, at certain times and among certain social groups, that a paradox emerges which seems to undermine some of the characteristics which justify considering the subject separately. Historicist imagery representing pre-industrial society, and images of the rural and the mountainous landscape periodically dominated the taste of those living in the urban and industrial world, just as they did of individuals not closely associated with industrial society. It is clear, however, that for industrialists and industrial workers alike, these genres had additional layers of meaning both because of their nouveaux riches status in society and the contrast presented by the images with the realities of their physical environment.

The aim of this volume is to present the visual culture of industrial Wales to an audience which, superficially as a result of art historical critique but ultimately for political reasons, has been deprived of the material evidence. The priority has been to exclude as little as possible in the belief that the greatest need is to lay to rest the pervasive and damaging myth that the Welsh nation is devoid of a visual culture. The organization of the imagery is broadly chronological, but sometimes thematic continuity has been given priority. For instance, a magnificent engraving of a yacht sailing under the Menai Bridge, entitled *Pride*, was intended to celebrate two wonders of the industrial world, and, furthermore, did so by means of an art process which made use of advanced technology. However, in stark contrast, the engraving was made at the same time as the publication of the first wood engraved images (the oldest method of reproducing pictures) of the dire social conditions existing in the places where such technologies were developed and artefacts made. Despite their contemporaneity, the contrast in meaning between the two types of engraving has led to their being considered in separate sections of the text.

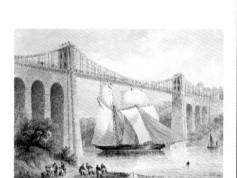

The great variety of engravings of industrial Wales and the large number of people they reached demanded that they be afforded a prominent place. However, on some occasions, quantity of images and size of audience have not been considered the most important criteria for allocating substantial space in the text. For instance, in the two decades after the Great War it seemed clear that the unique works of academically-trained painters deserved priority. At that time, academic art and the critical comment it aroused began both to reflect and to shape new attitudes to the industrial world (and in particular to the industrial worker) to an unprecedented extent. The sudden appearance of this genre, as well as the distinctness of its imagery, suggested that it represented a social change of fundamental importance.

Methodological purists, who often dominate the presentation of visual culture to the world, may find this flexible approach unsatisfactory. However, without the images, their methods have no applications, and it is the need to bring out of obscurity the raw material of which the visual culture of Wales is composed that this volume seeks to meet.

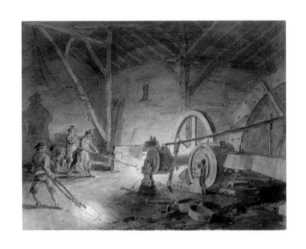

chapter

one

THE EMERGENCE

OF INDUSTRY AS

A SUBJECT

IN ART

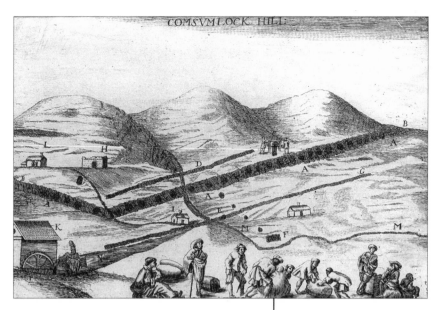

1. Anon.,

Comsumlock Hill,

1670, Line engraving,

178 × 265

Throughout the nineteenth century and the first half of the twentieth century, the dominant image of Wales created by artists bore little relation to the everyday lives of most of its people. Although aesthetic fashions changed the emphasis given to particular elements from time to time, Wales was presented by them as essentially rural or mountainous. The land was apparently unchanged in its form and the people unchanged in their behaviour since the mythic time of their creation. This image dominated not only the perceptions of outsiders but – certainly until the Great War – also the way in which most of the leaders of intellectual life in Wales chose to characterize the nation. Yet, for most of this period, the majority of the people of Wales lived in communities directly dependent on the extraction of mineral resources from the earth and their refining into the raw materials of industrial society. Their way of life became increasingly urbanized. Far from being an unchanging peasant economy, many parts of Wales stood at the forefront of technological development in the western world, and its products were of global economic importance. Nevertheless, until the Great War, artists and intellectuals interested in visual culture made no coherent attempt to image the industrial landscape and its people. Indeed, many of them perceived the physical and cultural characteristics of industrial society as inimical to their idea of the nation.

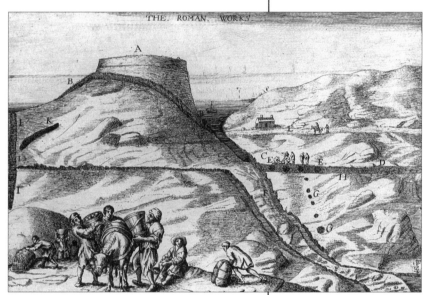

2. Anon.,

Darrein Hills or Roman works,

1670, Line engraving,

173 × 263

Given this context, it is noteworthy that among the earliest surviving Welsh landscapes are two industrial scenes. In 1670, in his *Fodinae Regales*, a study of the mining industry in the British Isles, John Pettus published two pictures of the lead mines at Cwmsymlog and Bancydarren.[1] They pre-date the appreciation of landscape for aesthetic reasons and the tours of artists in search of the picturesque, which created the familiar image of the Welsh Arcadia. Pettus lived in a period of rapidly increasing mercantile activity, and consequently of the

[1] John Pettus, *Fodinae Regales* (London, 1670).

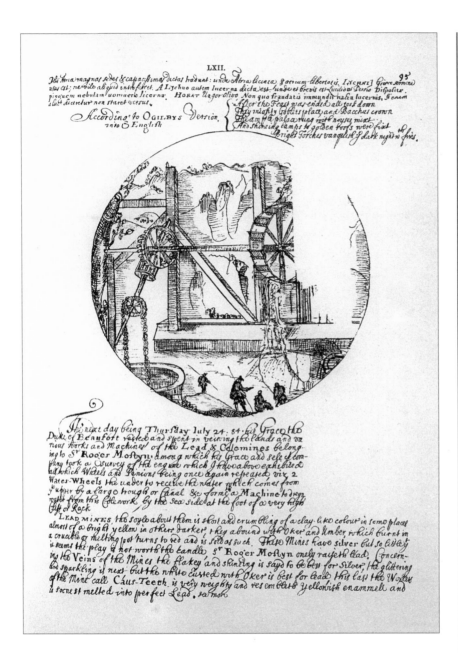

3. Thomas Dineley,
*A view of the lands
and various works and
machines of the Lead
and Coalmines belonging
to Sir Roger Mostyn*,
1684, Pen and ink,
233 × 157

documentation of resources. His two engravings were the only pictures of
mines in his book, emphasizing the importance with which the industry in
Cardiganshire was regarded at the time. Of the scale of the operations in the
area, he noted that the five 'Hearths and Furnaces, for Smelting, Stamping and
Refining' at Tal-y-bont, driven by 'four great Wheels … may well imploy 500
miners'.[2] The view of the Darren Mine extended to the sea near Aberystwyth
on which sailed ships no doubt engaged in carrying ore. Although they were
marked with letters referring to a descriptive key and were probably adapted
so as to encompass all the features necessary to a complete description of the
mining process, the views were essentially pictorial. They were far removed from
the conventions of the map and of its descendant, the bird's-eye view, which were
beginning to be used at about the same time by artists to depict a number of

[2] Ibid., p. 35. The National Museum of Wales
holds fine examples of early seventeenth-century
silverware made from ore mined in Cardiganshire.
Silver was extracted with lead at a number of
mines in the area.

4. William Williams,
*General view of the smelting
works at Gadlis and Seal for the
Corporation for Smelting Lead
with Pit-Coal and Sea-Coal*, 1720.
Pen and ink copy by J. Ingleby
from Pennant's *The History of
the Parishes of Whiteford and
Holywell* (1796), 272 × 194

5. Samuel and
Nathaniel Buck,
*The South Prospect
of Llangavellach
Copperworks*, Landore,
c.1750, Pen and ink,
90 × 145

[3] Among the estates portrayed in
this way were Margam and Dinefwr.
However, the most notable example
was Llannerch, near St Asaph, which
appears to be the earliest bird's-eye
view painted in the British Isles.

[4] Thomas Dineley, *The Account of the
Official Progress of His Grace Henry the
First Duke of Beaufort through Wales
in 1684* (London, 1888).

Welsh country estates.[3] Furthermore, the pictures of the Darren and
Cwmsymlog mines also presented working people as credible individuals
engaged in particular trades, rather than as the bucolic furniture which they
would become a hundred years later when used by artists to improve their
picturesque compositions. The mining pictures arose not as a by-product of
such pastoral aesthetics, encompassing the occasional intrusion of industry into
the rural scene, but from within the mentality which would drive the exploitation
of natural resources forward into the industrial age. Pettus's pictures stood much
closer to the tradition of the woodcuts in Georgius Agricola's treatise, *De Re
Metallica* (with which he was familiar), published in Germany a hundred years
earlier, than to the landscapes of the artists on the picturesque tour who came
in a later period. Nevertheless, they were more purely pictorial than their
German ancestors, since they did not mix the objective and the conceptual
by including sections and cutaways. Neither the draughtsman nor the engraver
of these mining landscapes is known, but Pettus himself may well have been
responsible for the original drawings since his written descriptions make it
clear that he was closely familiar with the area.

In 1684, in a spirit of inventorizing and enquiry similar to that which lay behind
the work of John Pettus, the Duke of Beaufort made a progress through Wales
in his capacity as President of the Council of Wales. His amanuensis, Thomas
Dineley, following his practice of many years, made a visual as well as a written
account of the journey.[4] Although he was a draughtsman of limited ability,
Dineley noted with objective care the appearance of castles, mansions, and
mountains. There was little to suggest to such early travellers the vast scale of
mineral wealth which lay under the surface of the earth. The country they saw

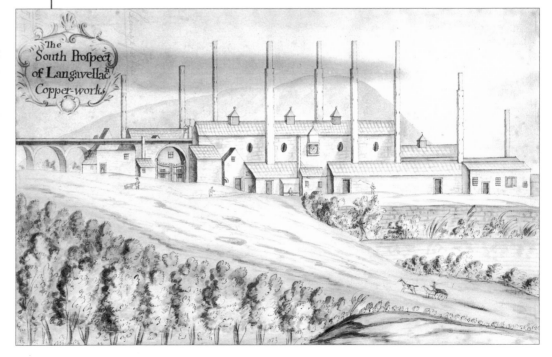

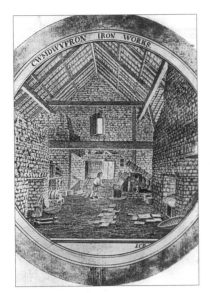

6. J.C.D.,
*Cwmdwyfron
Iron Works,*
c.1790

7. J.C.D.,
*Caermarthen
Iron Works,*
c.1790

8. J.C.D.,
*Trade Token – Kidwelly,
Whitland, Blackpool,
Cwmdwyfron forges
for I. Morgan,*
c.1790, Bronze, 30 d.

9. J.C.D.,
*Trade Token –
Caermarthen Iron Works,*
c.1790, Bronze, 30 d.

was homogeneously rural, with occasional pockets of industrial activity spread thinly over it. However, since his purpose was not aesthetic but documentary, in Flintshire he drew the waterwheel mechanisms used to drain the mines owned by Sir Roger Mostyn with the same care that he afforded the description of antiquities. The Mostyn family's enterprises in Flintshire would outlive the essentially rural Wales of the seventeenth and early eighteenth centuries. They flourished into the beginnings of the industrial age, contributing to the irrevocable change in the demography, economy and social structure of the country. They were recorded by image-makers in several stages of that process. In about 1720, for instance, William Williams engraved a view of Mostyn's Gadlys works to decorate his map of Denbighshire and Flintshire. The artist also drew the seal of the Corporation for Smelting Lead with Pit-Coal and Sea-Coal, the company established by the owner, which included depictions of two miners and their equipment.

Such imagery was produced in various forms throughout the eighteenth century. Some of it, such as the Buck brothers' drawing of the Llangyfelach copper works – the starting point of the metallurgical empire of the Morris family near Swansea – was the work of touring professional artists with their intellectual roots in the inventorizing tradition.[5] Other early views were the work of draughtsmen for whom the subject matter formed the background to their everyday lives. Their products met local demands rather than the curiosity of outsiders. Towards the end of the eighteenth century, for instance, an unknown artisan drew interior views of the Cwmdwyfran and Carmarthen ironworks at the western edge of the industry, for the purpose of engraving on trade tokens issued by the company.[6] In Merthyr Tydfil, at about the same time, William Pamplin, gardener to Richard

[5] Robert Morris, father of John, bought into the works in 1724. See Paul R. Reynolds, 'Industrial Development' in Glanmor Williams (ed.), *Swansea. An Illustrated History* (Swansea, 1990), p. 32. The Bucks drew for the production of engravings, but *The Llangyvelach Copperworks* does not seem to have been published.

[6] The drawings are signed 'JCD'. For the tokens, see Peter Mathias, *English Trade Tokens* (London, 1962), p. 51.

Crawshay, was recording the Cyfarthfa ironworks owned by his employer.[7] Taking a high viewpoint, he made two large and careful pencil drawings, noting the disposition of the buildings in meticulous detail. Minute touches of red, indicating the glow of the furnaces, were his only concession to drama in a scene which, as we shall see, excited the emotions and stimulated the intellects of many visitors from outside. Cyfarthfa, as coolly portrayed by Pamplin, was certainly very large, but it was not 'stupendous', as it would appear to the more suggestible mind of Julius Caesar Ibbetson, an academically-trained artist, visiting in 1789.

10. William Pamplin,
View of Cyfarthfa,
c.1800, Pencil, 430 × 650

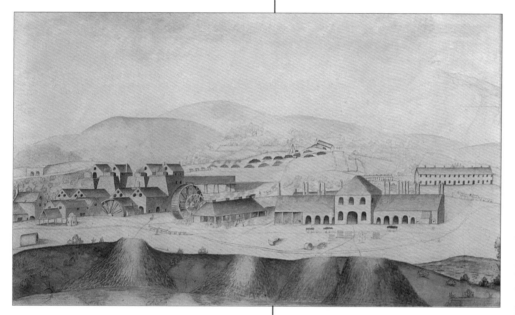

The contemporary work of Thomas Rothwell in Swansea exhibited some of the characteristics of the inventorizing attitude, emanating as it did from an industrial artisan and produced for a local market. Nevertheless, it also reflected the influence of a more artistically sophisticated community than that which surrounded Pamplin in Merthyr. Thomas Rothwell was born in Liverpool, became an engraver and porcelain painter, and found his way to Swansea via the Staffordshire potteries. He worked at the Cambrian Pottery in the period in which it was beginning to produce high quality decorated wares for the fashion-conscious urban market. Swansea itself attracted such people as summer visitors since, in addition to being an industrial centre, it was also a resort town. It was among these people, as well as local sophisticates, that Rothwell hoped to sell his topographical engravings. He drew, engraved and published his first view of the town in August 1791, choosing to depict his own place of employment, the Cambrian Pottery. The buildings were drawn in a prosaic manner, set parallel to the picture plane and separated from the observer by the river Tawe, which extended the length of the foreground. Rothwell portrayed the workers in meticulous detail, energizing a scene of modernity which was conveyed even more strongly in his second view, *The Forest Copper Works*, situated a little upstream of the Cambrian Pottery. Unlike the Buck brothers, Rothwell apparently drew the works from a boat in mid-river[8] and the consequent low viewpoint gave a dynamic perspective to the scene, the drama of which was enhanced by the dark and poisonous emissions from the chimneys. Whether this dynamic low angle of vision should be understood as conscious artistry, or simply as the consequence of seeking a viewpoint from which the whole works could be described, is difficult to determine. Rothwell did not choose to generalize and diminish the workers he portrayed in an effort further to intensify the dramatic effect. Indeed, if anything, they were portrayed oversize,

[7] For Pamplin, see M. S. Taylor, *The Crawshays of Cyfarthfa Castle* (London, 1967), pp. 22–3.

[8] Rothwell's view of *The Bathing House* at Swansea from the same series was also taken from a boat. The artist included the boat and a portrait of himself at work in the foreground. See Michael Gibbs and Bernard Morris, *Thomas Rothwell, Views of Swansea in the 1790s* (Glamorgan Archives, 1991).

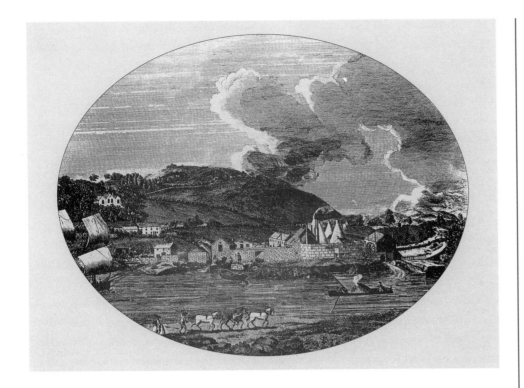

11. Thomas Rothwell,
Cambrian Pottery,
1791, Engraving,
197 x 244

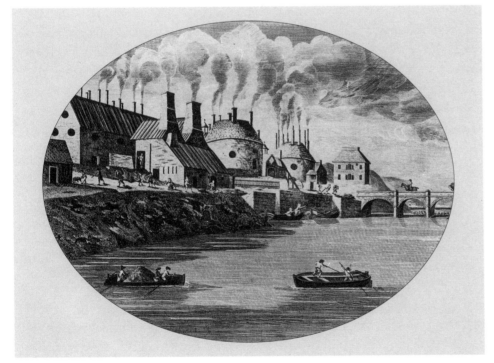

12. Thomas Rothwell,
*The Forest Copper
Works, Morriston*,
1791, Engraving,
194 x 244

with a Dutch matter-of-factness, much like Pettus's lead miners a hundred and
twenty years earlier. Nevertheless, the remainder of Rothwell's views of Swansea
(which did not portray industrial subjects), made it clear that he knew how to
construct a conventional view. Engravings after the works of academically-trained
landscape artists were by this time commonplace and influenced the objectivity
of artisan insiders in the industrialized world.

The industrial part of Cardiganshire which had interested John Pettus in 1670 also attracted the attention of Daniel Defoe for much the same reasons on a visit in 1724. Defoe reported of Aberystwyth that 'This Town is enrich'd by the Coals and Lead which is found in its Neighbourhood, and is a populous, but a very dirty, black, smoaky Place, and we fancy'd the People look'd as if they liv'd continually in the Coal or Lead mines. However, they are Rich, and the Place is very Populous.'[9] Like his predecessor on tour, Defoe was a pragmatist interested in the potential of natural resources for creating wealth, and as he travelled he took inventory of them. The rural and the old were not yet in fashion. For him, it was the modern city that represented civilization. He was unimpressed by antiquity and positively offended by ruins. Nature in its untamed and unexploited state was a wasteland: '... the Names of some of these Hills seem'd as barbarous to us, who spoke no Welch, as the Hills themselves',[10] he remarked. It was presumably Defoe's linguistic handicap and his disinclination to venture into the wasteland which gave rise to his mistaken impression that coal was to be found near Aberystwyth. However, the philosophical movement which created the image of Wales as Arcadia was stirring even as Defoe wrote. The Welsh poet and painter John Dyer foreshadowed the swing of the pendulum of fashion back towards the rural. He knew the town of Aberystwyth at about the same time as Defoe and perceived it not as smoke-blackened but as the delightful 'port / Of straw-built Aberystwyth'. On the barbarous slopes of Pumlumon, where lead was mined, he saw only 'Cambro-Britons' bracing 'their nervous limbs' as they went about their pastoral business. Emerging in the period of which Defoe was so characteristic, Dyer was not unmoved by commercial and expansionist vigour – indeed, his remarks about Aberystwyth were made in his poem 'The Fleece', a patriotic paean of praise to the woollen industry as one of the mainsprings of the economic power of England.[11] However, the celebration of commerce was simultaneously a vehicle for an exposition of his love of the countryside which led him to produce early art images of the landscape and gave him an important role as a poet in stimulating the emergent fashion for the wilds of which Wales soon became an epitome.

This fashion developed with great rapidity in the second half of the eighteenth century, fed by line engravings published by John Boydell, the critical success of the work of Richard Wilson, the aquatints of Paul Sandby and by the *Tours in Wales* of Thomas Pennant. The philosophical framework which facilitated the popularity of these works in which the landscape and antiquities of the country were praised was provided by a succession of theorists, of whom the most notable were Edmund Burke and William Gilpin. The result was an unprecedented influx of professional and amateur artists and writers touring in both north and south Wales. In the course of their explorations of the new aesthetics of the sublime and the picturesque, they encountered industrial sites which their theories sometimes caused them to invest with meanings not apparent to insiders. For instance, because of their dependence on water power, mills, furnaces and forges were often located in spectacular surroundings of particular interest to

[9] Daniel Defoe, *A Tour thro' the whole island of Great Britain* (London, 1725), p. 89. Some historians speculate, on the basis of errors in Defoe's text, that he did not, in fact, visit all those places he described, but based his work on the reports of others.

[10] Ibid.

[11] John Dyer, *The Fleece, a poem in four books* (London, 1757).

13. Paul Sandby,
*The Iron Forge between
Barmouth and Dolgellau,*
1771, Pencil,
210 × 293

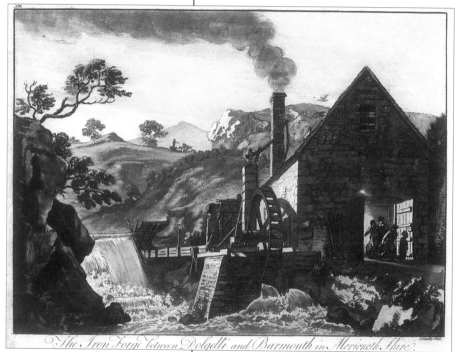

14. Paul Sandby,
*The Iron Forge between Dolgelli
and Barmouth in Merioneth Shire,*
1776, Aquatint, 215 × 298

visiting artists, who found it easy to accommodate them within the new aesthetics. Near Tintern in 1770, William Gilpin himself, theorist of the picturesque, had noted the advantages of a range of different elements – including man-made elements – in a single landscape:

> One circumstance, attending this alternacy, is pleasing. Many of the furnaces, on the banks of the river, consume charcoal, which is manufactured on the spot; and the smoke, which is frequently seen issuing from the sides of the hills; and spreading its thin veil over a part of them, beautifully breaks their lines, and unites them with the sky.[12]

The following summer, Paul Sandby and Sir Watkin Williams Wynn paused to draw an iron forge between Dolgellau and Barmouth in a similarly delightful setting. A rather prosaic pencil drawing, clearly done on the spot, showed Sir Watkin sketching while perched on a rock, his servant shading him with an umbrella. Across the gently tumbling stream before him was the forge. However, in Sandby's aquatint, *The Iron Forge between Dolgelli and Barmouth*, published in 1776, the perception was altogether different. The composition was arranged to provide maximum 'alternacy' – probably rather more than the dreary Gilpin would have approved – since Sandby's imagination had clearly been excited by the potential of the raw material for development into something more than a manufactory. Taking a low viewpoint which exaggerated the drama both of the buildings themselves and of their relationship to the mountains beyond, Sandby set the gable end in deep shadow. His viewpoint was clearly chosen for more complex reasons than those that moved Rothwell to draw his view of the Forest copper works from a low angle. By depicting the iron forge in this way he was able to create a minor version of a motif recently made famous in England by Joseph Wright of Derby's *Blacksmith's Shop*. The first version had

[12] William Gilpin, *Observations on the River Wye …* (London, 1782), p. 12.

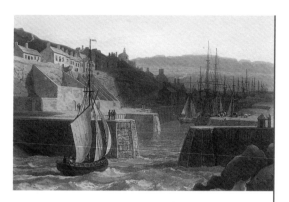

15. William Daniell,
The Entrance to Amlwch Harbour, Anglesea,
1815, Engraving and watercolour,
165 × 239

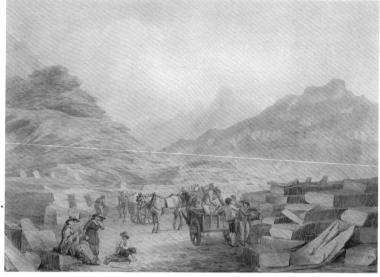

16. Nicholas Pocock,
Merioneth Slate Quarry,
1795, Watercolour,
425 × 600

been painted in 1771 and was familiar as a result of its wide distribution as a print. In Sandby's image, the door in the darkened gable of the forge was thrown open so that the light within silhouetted the smiths, thereby completing a visual homily on the power of the elemental forces of earth, air, water and fire. The last of these – fire – was released by man, and in this depiction of the forge there was an early intimation of the emergence of a new artistic perception, the industrial sublime. The idea of using light and shadow to make scholarly references to the infernal regions would probably have been foreign to Thomas Rothwell, for all his conventional facility as a draughtsman, and certainly so to William Pamplin or the unknown artisan of the Carmarthenshire ironworks. They both portrayed their familiar subjects with scarcely a hint of romantic excitement, but Sandby's books of Welsh views[13] were deliberate exercises in the avant-garde, in which he exploited both a fashionable image and the visual potential of the new medium of aquatint.

The success of copper works in Swansea, such as those depicted by Rothwell, was related to the exploitation of copper ore at the opposite end of the country, on Parys Mountain in Anglesey. Indeed, from 1782 the Upper Bank works and others at Swansea were controlled from the north, though additional ore was obtained from sources outside Wales. The Anglesey ore was exported through Amlwch, which, as a consequence, became a thriving port. In his *Voyage round Great Britain*, William Daniell would publish the hectic scene in aquatint in 1815. Like the port and the processing plants, the mines at Parys Mountain itself also moved artists to record what was, in contemporary terms, an extraction industry on a vast scale. Not even the developing slate quarries of Llanberis, depicted by the English watercolourist Nicholas Pocock

[13] Paul Sandby, *XII Views in Aquatinta From Drawings Taken on the Spot in South-Wales* (London, 1775); idem, *XII Views in North Wales ...* (London 1776–7).

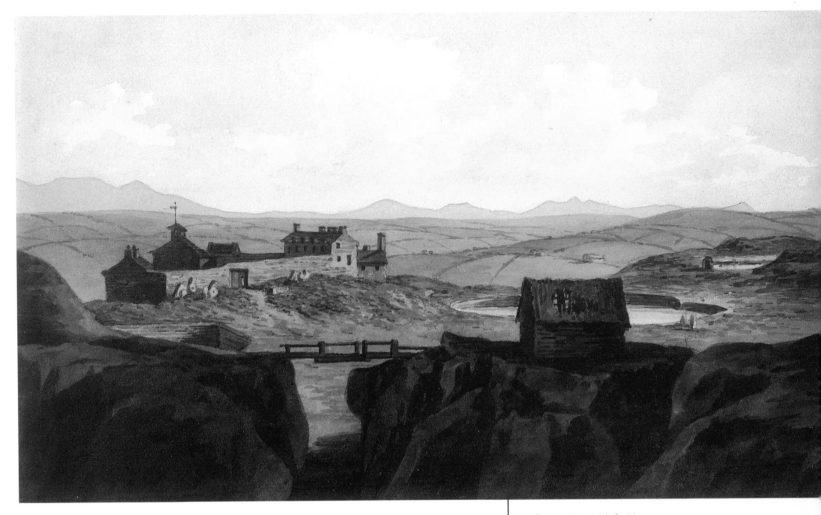

17. John Warwick Smith,
*The Copper Works on the
Parys Mountain, Anglesey,*
1792, Watercolour and gum,
125 × 214

on tour in 1795, could compare with it. The location of the copper mines
in an area which was now the resort of all the aesthetic trendsetters of the age,
resulted in the production of a substantial body of dramatic works. In 1792, as
Rothwell's prints of Swansea were published, John Warwick Smith led his friend
Julius Caesar Ibbetson and his patron Robert Fulke Greville to Parys Mountain
on their picturesque tour. Smith had an insatiable appetite for Welsh landscape
and antiquities. He visited at least a dozen times between 1784 and 1806, and
by 1785 he was familiar with the copper mines. He returned to Parys Mountain
in 1790 to produce his best work, exploiting the low eye-level view from within
the enormous pit. His visit with Ibbetson was therefore at least his third.
Ibbetson also produced a number of watercolours of the mine, one of which
had been published as a print by 1794, as well as a large oil painting. Although
Ibbetson was rather more interested in drawing people than most artists on tour,
his images of the workers at the Parys mine were dissimilar to those of Pettus and
Rothwell. He was a friend of George Moreland and his figures were redolent of
those standardized common people, part of a clean and uncomplicated rural world,

18. John Warwick Smith,
*One of the Copper Mines
belonging to the Paris Mountain
Company, Anglesea,*
1790, Watercolour,
163 × 232

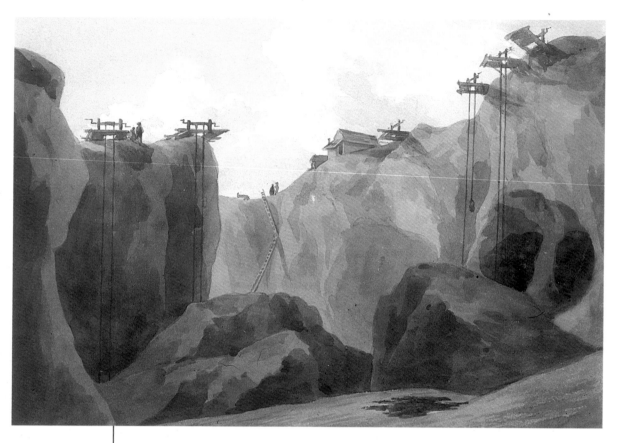

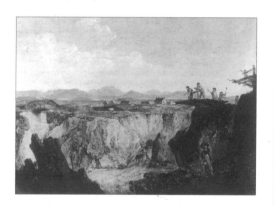

19. Julius Caesar Ibbetson,
Copper Mine in Anglesey,
1792, Oil,
314 × 441

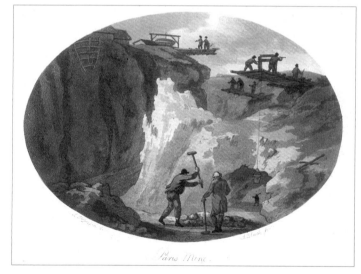

20. J. Bluck after
Julius Caesar Ibbetson,
Paris Mine, 1795,
Aquatint and watercolour,
112 × 161

which were characteristic of the more famous painter. Nevertheless, although not a particular exponent of the aesthetic, Ibbetson had, on occasions, produced landscape images in the sublime mode, and his oil painting of the Parys mine – unlike the watercolours – certainly had that connotation. Ibbetson made use of the workers to emphasize the depth and drama of the workings and in so doing suggested the experience of 'delicious terror' that he may have indulged there.

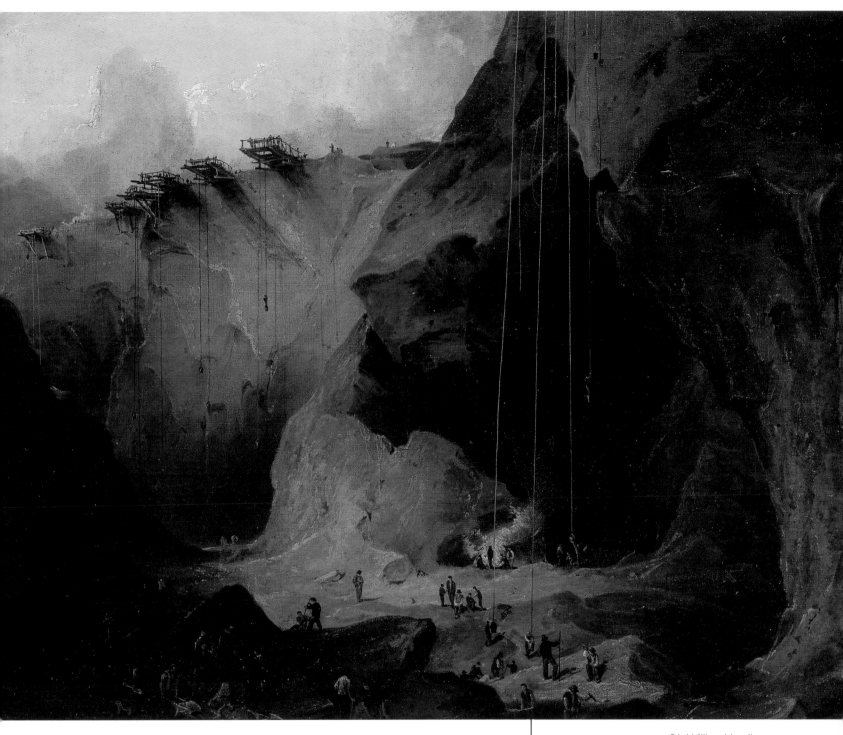

21. William Havell,
Paris Mountain Copper Mine,
c.1803/4, Oil,
845 × 1045

In this way, an aesthetic originally concerned with the human response to the overwhelming powers of nature – the handiwork of God – was extended by the painters of the late eighteenth century to include their relationship to the works of man. The large philosophical implications of man-made landscapes which evoked feelings that only the works of God had done in the past were not consistently explored by Sandby or Ibbetson, but they would become increasingly apparent in depictions of industry as its scale expanded in the early nineteenth

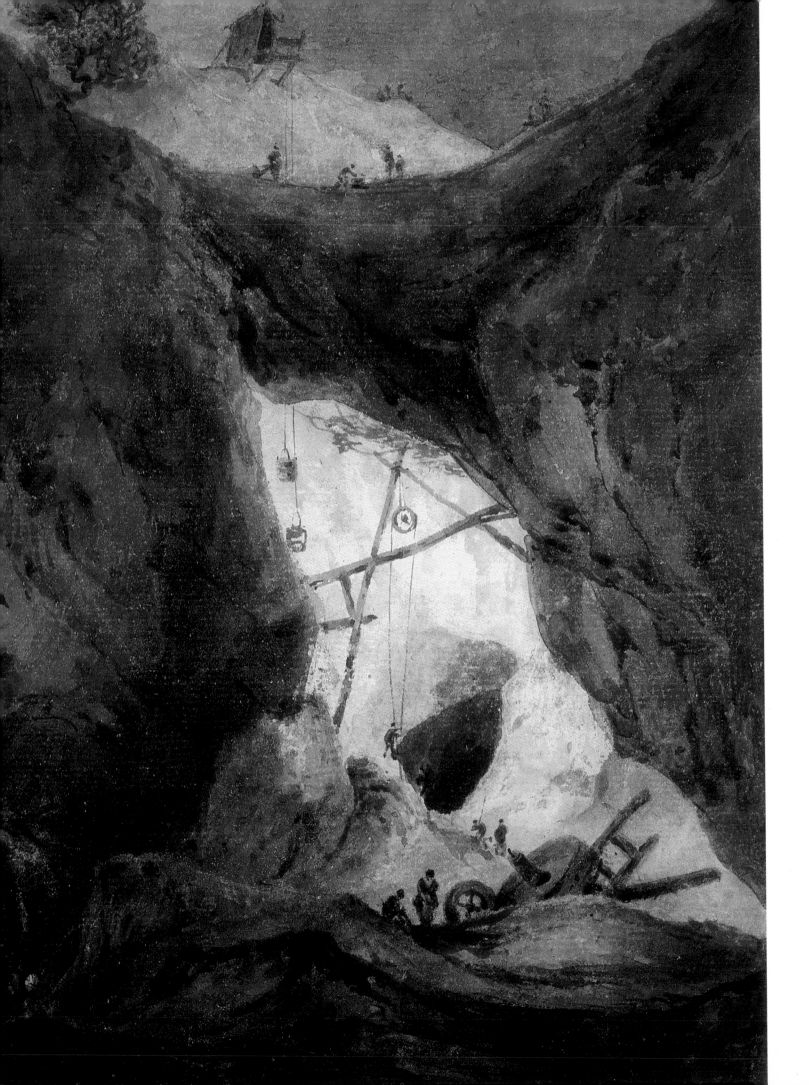

century. Only a decade or so after Ibbetson's picture, William Havell, in his version of the Parys copper mine, was distinctly more suggestive. Descending to the bottom of the pit, Havell used a low eye-level and dramatic contrasts of light and shade to produce an image quite overtly intended to be interpreted by the audience as an exercise in the sublime.[14] A French artist, François Louis Thomas Francia, responded to the scene in the same way, painting a picture even more suggestive of the entrance to the infernal regions.[15] Nevertheless, the painters of this period surprisingly failed to exploit the ultimate potential of the scene. The Parys works were largely opencast, but the neighbouring Mona mines were underground. The English scientist Michael Faraday ventured below and wrote a highly visual evocation of the scene which, for all its objectivity, also acknowledged the sublime sensitivity:

… peeping into a small chasm through which a man might by contrivance pass, we found it to be the entrance into a large cavity from 30 to 40 feet wide every way. This had been a fine bunch of ore and there were 6 or 7 men with

[14] William Havell (1782–1857) was born in Reading, and was a founder member of the Society of Painters in Water Colours.

[15] This picture and its possible international influence is discussed in detail in F. D. Klingender, *Art and the Industrial Revolution*, ed. Arthur Elton (London, 1968), p. 94.

left:

22. François Louis Thomas Francia, *The Parys Mine in Anglesey*, c.1799, Watercolour, 256 × 176

23. Paul Sandby, *Landscape with a mine*, c.1775, Watercolour and gouache, 250 × 343

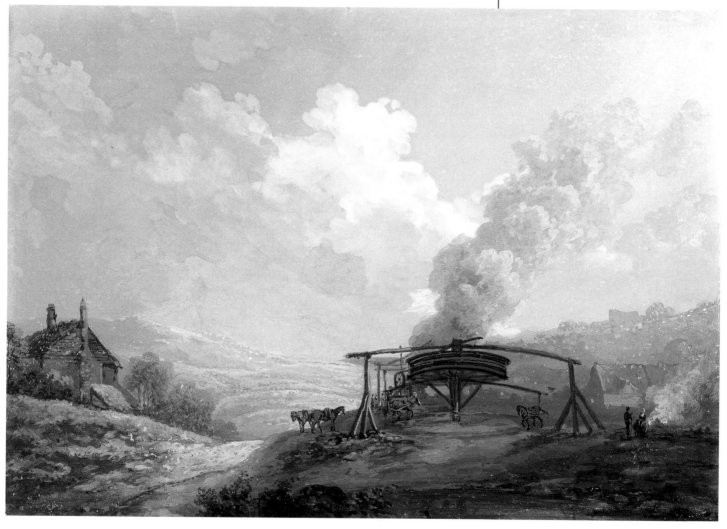

24. Julius Caesar Ibbetson,
Coal Mine, 1792,
Watercolour,
252 × 403

25. Julius Caesar Ibbetson,
Coal Staithe on the River Tawe,
1792, Watercolour,
214 × 296

[16] Dafydd Tomos, *Michael Faraday in Wales* (Denbigh, [1972]), p. 85.

[17] Quoted in R. M. Clay, *Julius Caesar Ibbetson* (London, 1948).

their candles working in it. We did not go down but putting our lights aside laid our heads to the aperture and viewed this admirable Cimmerian scene for some time with great pleasure, the continual explosion on all sides increasing the effect. This was the lowest part of those workings and was about 370 feet below the surface of the earth.[16]

Faraday's descent into the Mona mine, recorded in his diary for the benefit of his artist wife, was made in 1819, a quarter century after Ibbetson, but in the intervening period no artist on tour seems to have regarded underground workings as a potential subject for pictures.

Ibbetson toured from north to south. Arriving in the Vale of Neath, like Paul Sandby before him, he saw and drew a coal mine. It is perhaps ironic that a part of Wales celebrated for its natural beauty earlier than almost any other was also the focus of the great industry that would change its appearance beyond restoration. In 1792 Ibbetson drew a mine of a type probably little changed since medieval times. Compared to what was to come, there was, in truth, not much to see above the ground, apart from the winding gear and a decrepit building, and he did not trouble to enliven the scene with intense human activity. Only in his subsequent view of the *Coal Staithe on the River Tawe* did he present a view suggestive of the rapidly increasing scale of activity which he had recorded in Anglesey. Perched on the hill above the river was the 'tenement building with a quadrangle',[17] known as The Castle, which had been built about 1750 by Robert Morris to house some forty families of workers at his Forest copper works, located by the river below.

However, it was not in the Swansea area but at Merthyr that the explosion of industrial activity in Wales impressed itself most on image-makers. The occurrence together of iron ore and coal, within reach of the sea, made Merthyr an ideal site for the development of the iron industry once the problem of smelting with coal rather than wood had been solved. During his stay in Glamorgan under the patronage of the Earl of Bute in 1789, Ibbetson saw Merthyr in the early stages of its rapid growth, and he was still able to draw a number of essentially rural views. Nevertheless, it was immediately after his visit there that he wrote to a friend: 'I was last week w'th My Lord at Myrthyr Tydvil ab't 25 Miles off where are the Most Stupendous Ironworks.'[18] It seems likely that it was on this occasion, rather than on his return to the area with Smith and Greville in 1792, that he entered the Cyfarthfa works to draw, and where he was most clearly affected by the drama of the new world. His views took full advantage of the chiaroscuro effects and the huge shadows thrown by the workers handling red-hot iron. The impressions recorded in 1798 by J. M. W. Turner, when he too ventured northward up the Taf from Cardiff, were closely similar to those of Ibbetson. Turner had passed not far away in 1792 and again in 1795 without troubling to view the ironworks, and it was probably a commission from Anthony Bacon, co-founder with Richard Crawshay of the Cyfarthfa works, that stimulated his deviation from the conventional picturesque tour three years later.[19]

26. Julius Caesar Ibbetson,
An Iron Forge at Merthyr Tydfil,
1789, Watercolour,
220 × 290

Turner made a set of four drawings at Cyfarthfa which demonstrated the excitement that such places could stimulate in the fertile imaginations of the Romantics. Among his rivals working in a similar way in London was the Alsatian painter Philippe de Loutherbourg, who visited Wales in 1786. On an earlier scenic tour to the Lake District of England he had produced a dramatic view of *A Slate Quarry near Rydell Water, Cumberland*, and in 1801, on the border of Wales, he had painted one of the most influential of all early art images of industry, *A View of Colebroke Dale by night*. Although none of his Welsh pictures seems to have been inspired by industrial subject matter, the celebrity of this image certainly intensified the interest of aesthetes and travellers in such night-time

[18] NLW MS 5484C, f. 1v.

[19] See Andrew Wilton, *Turner in Wales* (Llandudno, 1984), p. 53.

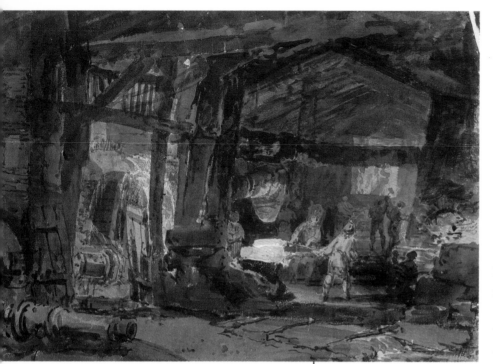

27. J. M. W. Turner,
Cyfarthfa Ironworks,
1795, Watercolour,
287 × 456

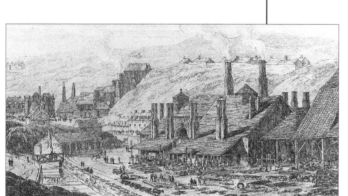

28. John George Wood,
Penydarren Iron Works,
1811, Etching,
156 × 294

scenes in Wales in the period of high Romanticism, and influenced the language of their descriptions.[20] Edward Donovan, for instance, noted in 1804 in his *Descriptive Excursions…* that near Aberafan 'Imagination can scarcely conceive a sight more truly brilliant than the appearance of this stream of fire as it issues from the furnace. But to see this to advantage the works should be attended in the night time, when the darkness must greatly favour the sublimity of the scene'.[21] The writer and draughtsman John George Wood was equally perplexed when he visited Merthyr in 1811. His journey along the rivers of Wales had no doubt been ultimately inspired by the famous example of Gilpin on the Wye, but in the subsequent forty years the scale of activities on the river banks of Wales had grown beyond what his predecessor could possibly have imagined:

… the singular effect of the fire from the numerous iron works viewed by night, where the immense columns of flame, the incessant noise of hammers, and the continued buzz of voices, impresses the mind with a sensation perfectly new, and not easy to be defined. This effect is still heightened by a near approach to the works, where, through a long range of building, innumerable human beings are seen busily employed in their various occupations; some stirring the liquid metal in a kind of oven, others drawing heated masses along the ground, and others again carrying bars of red hot iron, which, as they pass through the rollers, may be compared to the windings of so many fiery serpents: add to all this, the strong reflexion of the fire upon the figures covered with the black dirt of the works, and it will not be surprising that such a scene should recall to the recollection the fabulous descriptions of the infernal regions and their inhabitants.[22]

Wood's etching of the Penydarren works complemented the letter rather than the spirit of his description. He acknowledged the sublime connotations of the scene without fully indulging that state of mind and, like the several other industrial views he recorded on his tour, his etching was essentially objective.

[20] Notable among the painters who visited the Merthyr ironworks was John Martin, master of apocalyptic Romanticism in the period.

[21] Edward Donovan, *Descriptive Excursions through south Wales and Monmouthshire, in the year 1804* (2 vols., London, 1805), II, p. 53. Donovan seems to have been among the most widely-read guides. Gastineau later paraphrased his remarks on the condition of the labourers at Neath Abbey.

[22] John George Wood, *The Principal Rivers of Wales Illustrated* (London, 1813), pp. 57–8.

Perhaps the most remarkable art image of pre-Victorian industrial Wales was a watercolour only a few inches wide. Thomas Hornor's *Rolling Mills*, painted in about 1817, at first sight seems to follow the industrial sublime mode. The dramatic image of the intense light of the furnaces striating the sky, broken by lines of dark shadow, was a human inversion of the rays of sunlight grandly depicted descending from heaven in Sandby's aquatint of *Llangollin in the County of Denbigh*. Thomas Hornor was a late arrival from England, working in the tradition of gentry patronage of estate pictures.

29. Thomas Hornor,
Rolling Mills, c.1817,
Watercolour,
279 x 476

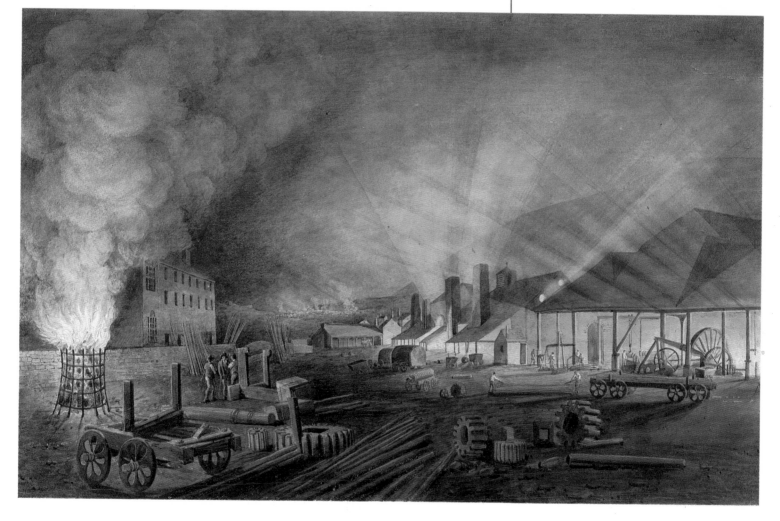

30. Thomas Hornor,
The Tinplate Manufactory at Ynysygerwn,
c.1817, Watercolour,
121 × 206

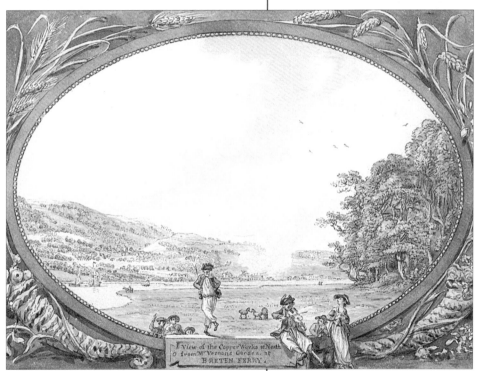

31. Paul Sandby,
View of the Copper Works at Neath,
1779, Watercolour,
157 × 210

He had perceived a market for collections of views improved by the use of an optical instrument of some kind which he had devised. Why Hornor chose the gentry of Glamorgan as potential patrons is unclear, unless it was precisely because the fortunes of many of them were currently being revived by the exploitation of mineral resources. His advertisements in *The Cambrian* and *Seren Gomer* drew a sufficient response to initiate at least five years of work which resulted in the production of about four hundred watercolour drawings. Most were bound into presentation albums with handwritten texts which, though beautiful productions in themselves, had the consequence of limiting the distribution of the images, and none seems to have been engraved. At least ten volumes were made for wealthy clients,[23] many of whom had industrial interests, resulting in pictures such as *The Tinplate Manufactory at Ynysygerwn*, above Aberdulais, which Hornor presented in an extensive landscape. His picture was strongly reminiscent of one made in 1779 by Paul Sandby, *View of the Copper Works at Neath*. Sandby was adaptable in his philosophical approach, responding to the demands of his patrons, and this picture was quite distinct from those tours de force published in his views in north and south Wales. The watercolour drawing, presumably commissioned by a Mr Vernon of Briton Ferry, from whose garden the works were viewed, was highly finished since it was subsequently to be reproduced as an engraving. An apparently innocuous mist of smoke, of which Gilpin would have approved, drifted over an extensive landscape. It was the oval border to the picture which suggested the beginnings

of a particular attitude to industrial production which the much later work of Hornor confirmed. Sandby regularly used this framing device, to which he would add a group of bucolic figures, but in *View of the Copper Works at Neath* the one-legged fiddler and his companion (who dances a jig) were accompanied by two cornucopia. These ancient symbols of pastoral plenty were adapted here to the new industrial world. His patron, Mr Vernon, clearly regarded the factories springing up in the fields neither as threats to Arcadia nor as excuses for the indulgence of sublime fantasies, but simply as beneficial to all. Although Thomas Hornor did not set off his drawing with a pastorale of yokels happily entertaining themselves with music and dance in the fields, his commentary on *The Tinplate Manufactory at Ynysygerwn* demonstrated that philosophical change in the world at large was rapidly affecting aesthetics:

> The next drawing represents a tin-plate manufactory, which occupies a situation in the vale, that might merit, in the eyes of those who look only for rural beauty and the images of pastoral life, a more appropriate and more pleasing structure. But we will not forget the doctrine of utility. This establishment by furnishing the means of employment to a number of the surrounding female cottagers diffuses among them those means of comfort which the imagination delights to associate with their condition, but which in a more agricultural district are to be sought rather in the pages of fiction than among the dwellings of the peasantry.[24]

Hornor's response to Cyfarthfa, viewed in the pragmatic light of these observations on the tinplate works, place his picture at the beginning of a new and utilitarian celebration of industry rather than at the end of high Romanticism, which celebrated it for the spiritual resonances it could generate in the learned.[25] Romantic perceptions of industrial scenery would retain their ability to transport the susceptible observer into the nether regions, conjuring up metaphors in the minds of those of a moralizing inclination, into the second half of the nineteenth century.[26] Nevertheless, Hornor's attitude presaged the emergence of a complementary new genre which would be much more characteristic of the Victorian age.

[23] They included Lord Jersey of Vernon House, John Edwards of Rheola, Watson Taylor MP, and probably John Llewelyn of Ynysygerwn. *Rolling Mills* is repeated in a number of them.

[24] NLW DV23.

[25] A perception confirmed by other aspects of his career. See Elis Jenkins, 'Thomas Hornor' in Stewart Williams (ed.), *Glamorgan Historian, Volume 7* (Cowbridge, 1971), pp. 37–50.

[26] 'John Mason Neale, the hymnologist … saw Swansea at night in 1850 and could not imagine any scene on earth more nearly resembling hell. The green flames of the copper furnaces created a "ghastly effect" and the entire scene was "awfully beautiful".' See Keith Robbins, *Nineteenth-Century Britain, Integration and Diversity* (Oxford, 1995), p. 23. The quotations are from *Letters of John Mason Neale D.D., selected and edited by his daughter* (London, 1910), p. 146. William James's guidebook, *Brecon and its Neighbourhood* (London, 1867), recommended a visit to Cyfarthfa: 'A dark night and a proper guide should be chosen, in order to enjoy this sight, which is indeed wonderful …'

27 *Pigot and Co's Directory* lists three booksellers and stationers in Merthyr in 1822, for instance, four in 1830 and three in 1835, though the range of material sold by them is difficult to assess.

28 See M. Turner and D. Vaisey, *Art for Commerce* (Bristol, 1973).

32. John Hassell,

Iron Mills – A view near Tintern Abbey,

Monmouthshire, 1798,

Aquatint and watercolour,

216 × 322

The celebration of industry would become an important aspect of Victorian identity and a focus of patriotic pride, widely shared by all classes of society. The medium of this celebration was primarily the engraving which, in its most characteristic form, came to reflect closely the rationality of the new technology it presented. Such works, like their picturesque landscape precursors, would be published in expensive editions aimed at the affluent connoisseur throughout the nineteenth century. However, the extension of the audience through the publication of cheap prints was an important development. The woodcut and subsequent wood-engraving tradition, extending back to the seventeenth century, was supplemented from the 1820s by the steel engraving which had superseded copper, reducing material costs and providing longer runs, and bringing new kinds of images into the popular market. Lithography and photogravure soon followed. The heyday of the steel engraving coincided with the development of cloth-covered books and an expansion of specialist retail outlets in Wales,[27] as well as the development of door-to-door selling techniques in the 1840s. The topical periodicals established at this time, such as *The Illustrated London News* and, later, *The Graphic*, continued to use the wood engraving, but the newer techniques brought a flood of art-derived images into the homes of the common people, printed on everything from tin boxes to paper bags and customized calendars. Many of them depicted the contemporary world of new buildings and technological wonders, including railways, ships and bridges, and were often cut out and kept. Thousands of images were produced in England by companies such as the paper bag specialists, Robinson's of Bristol, whose catalogue included numerous Welsh subjects.[28] Nevertheless, many were also drawn by Welsh artists and printed and published at home.

The emergence of a taste for engravings celebrating industry first became apparent at the end of the eighteenth century. In 1798 an aquatint by John Hassell, entitled *Coal Works. A view near Neath*, was

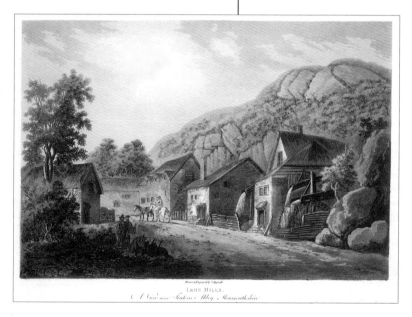

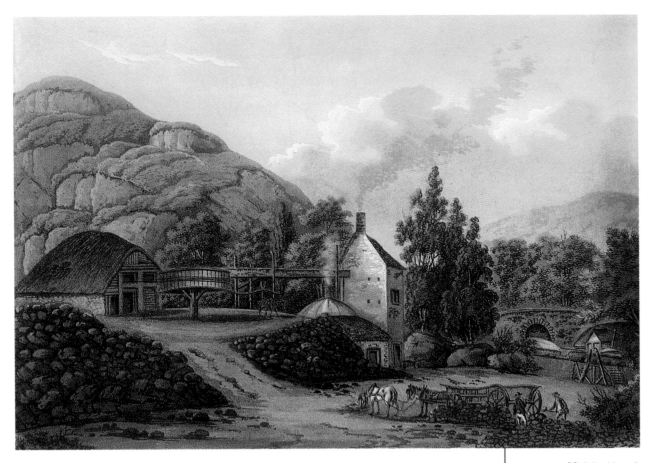

33. John Hassell,
*Coal Works. A view near
Neath in Glamorganshire,*
1798, Aquatint
and watercolour,
218 × 330

published in London. Although it was drawn only six years after Ibbetson's similar subject, it depicted a more modern enterprise in which water power had been replaced by a steam engine. Even more significant was the fact that it was published as one of a series of at least three industrial subjects by the same artist, which were followed two years later by a pair of views of a copper works near Swansea.

34. John Hassell,
*View of the Copper-Works,
Swansea, Glamorganshire,*
1800, Aquatint and watercolour,
302 × 420

PLATES III. IV. V. VI.

FOUR VIEWS ON HOLYWELL STREAM.

/ 0 GREENFIELD BRASS MILLS *on the* HOLYWELL. *Stream.*
2 0 4 COPPER WORKS, *near* HOLYWELL, *belonging to the* MONA *Company,* FLINTSHIRE.
2 1 6 COTTON WORKS, *near* HOLYWELL, *belonging to Messrs.* DOUGLAS *and Co.* FLINTSHIRE.
2 1 4 COTTON WORKS *near* HOLYWELL, FLINTSHIRE.

THESE prints represent the present state of the Holywell brook; Mr. Pennant has given an account of it's sudden eruption out of the earth, and the legendary history of it's origin. Let us revolve on it's state about three centuries ago, when the paths were worn by the numerous footsteps of misguided devotees or crowds of pilgrims, all tending to the expiatory water of it's holy spring.

In our days some application of its stream was made to the uses of this world; but it extended not to any very great degree. But in this busy period, Industry and her numerous children, rushed almost instantly on the amazed world. The whole of the stream was almost instantaneously possessed. By a happy concurrence of discovery of an immense copper work on Paris mountain in Anglesey, the value of this stream was rendered almost inestimable to the public, as well as to the individuals concerned. The ore after undergoing fusion in other places, is brought here to be beaten into the rude materials for pans, furnaces, and various utensils; or to be drawn into sheathings for ships, and for bolts to secure those sheathings, by which our vessels are secured in the most distant climates from the ravages of the destructive worm.

The other company which shares the stream, is that of the Cotton-Twist Company, which has carried the manufactory to an extent far superior to any other in Great Britain. It was within these few years originally begun by Mr. Smalley of Manchester; but by an accession of partners, is now carried on with most uncommon success. The first building is small. The two succeeding are of a vast magnitude, and a third is now erecting. These have produced improvements in mechanics unknown before. The passion of the fair sex for this species of manufacture has also whetted the genius of our artists, and produced an elegance of pattern; and a variety beyond what one would have thought the human invention could ever have produced. Here omnipotent Fashion superseded the Diva Winefreda. Let me address her in the admirable lines of the Bath Guide.

Nymph, at thy auspicious birth, Now you trip it o'er the globe
Hebe strew'd with flow'rs the earth. Clad in party-colour'd robe.
Thee to welcome all the graces, Goddess, if from hand like mine,
Deck'd in muslins, deck'd in laces, Aught be worthy of thy shrine,
With the god of love attended, Take the flow'ry twist I twine.
And the Cyprian queen descended, &c. &c. &c.

35. John Boydell,
A description of the
Four Views on Holywell Stream,
1792

[29] John Hassell (d. 1825) seems to have visited Wales regularly. Apart from his industrial views, he produced a long series of views of castles and religious ruins, published in London in 1806 and 1807.

[30] Thomas Pennant, *The History of the Parishes of Whiteford and Holywell* (London, 1796), p. 134.

[31] Pennant's awareness of industrial imagery extended yet further back. He remarked of the waterwheels at the Mostyn collieries that 'THIS engine seems to have been formed on the model of some of those used in the *German* mines in the time of *George Agricola*. See the representation of several ... in his Treatise *de Re Metallica.*' Ibid.

Although Hassell's drawings remained firmly rooted in the picturesque tradition which the later works developed almost to the point of the exotic, the engravings may be taken as a sign of an emerging market for views of industry for its own sake.[29] Further significant evidence emerged at the same period from the old-established industries of Flintshire, where the lead and coal mines (and the Mostyn family's interests) were still in a flourishing condition. Among a new group of industrialists, joining the Mostyn family in the exploitation of mineral resources, was Thomas Pennant. As an antiquarian, he not only interested himself keenly in industrial development but also in its history:

I REMEMBER a quay beneath the *Mostyn* collieries, built by the grandfather of the present *Sir Roger Mostyn*, at which small vessels used to take in their lading. And I also remember on the shore the walls which supported the wheels and other machinery of a water-engine for drawing the colliery.[30]

In 1796 Pennant published for the first time a reproduction of Dineley's seventeenth-century drawing of the Mostyn water-engine[31] in *The History of the Parishes of Whiteford and Holywell*. The fashion for picturesque and antiquarian tours in Wales was now at its height and few people had done more than Pennant himself to encourage that fashion by his writings and by the pictures he commissioned to illustrate them. His enthusiasm for industrial development might seem, therefore, to be paradoxical. However, he had been born in 1726 and, like John Dyer, had absorbed much of the rational and inventorizing spirit of the age of Defoe. Manifesting a complicated mixture of conservative and progressive values, he applied that spirit to all the phenomena of the world around him, natural and man-made, with equal enthusiasm. Although his writing encouraged the aesthete to tour, his imagination was not inclined to become overheated when confronted either with the virgin beauties of nature or with the industrial developments which caused his younger contemporaries to gush. He noted, for instance, early manifestations of environmental pollution, describing the defoliation of an area downwind

36. After John Ingleby,
*Greenfield Brass Mills
near Holywell, Flintshire,*
1792, Engraving,
131 × 181

37. After John Ingleby,
*Cotton Works near
Holywell, Flintshire,*
1792, Engraving,
122 × 180

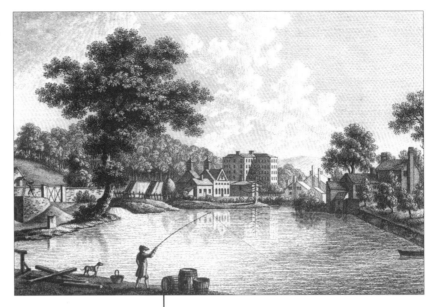

38. After Moses Griffith,
*Copper and Brass Works, and a
view of the lower Cotton Works,*
1795, Engraving,
126 × 198

of a copper works and the consequent law suit.[32]
It apparently aroused in him no sense of foreboding.
He happily combined the attitudes of the antiquarian,
the naturalist and the industrialist. Pennant was an
optimist, and noted with patriotic enthusiasm the
advance of industry almost to the door of one of
the holiest sites in Wales:

> Let me add, that within little more than one mile from the fountain of St.
> Wenefrede, at Holywell, to the gate just mentioned, Britain may be challenged
> to show, on an equal space, a similar assemblage of commercial buildings, or
> of capitals employed in erecting and in carrying on their several objects …[33]

In addition to the long-established coal and lead industries, in 1766 the first
copper and brass mills had been opened in Flintshire, to be joined ten years later
by the first cotton mill. Pennant dispassionately noted that 'By [its] successors,
and by the great copper companies, those *behemoths* of commerce, our little
Jordan was soon drunk up. By their skill and industry they succeeded, to the
benefit of the state, and to their private emolument …'[34] Since he was as great
an enthusiast for the picture as for the word, Pennant extended his celebration
of commerce into one of the earliest series of engravings of industrial sites.

[32] Ibid., p. 202: 'The smoke did such injury to the
fine woods belonging to Sir *George Mostyn*, of
Trelacre, bart. as to occasion many law-suits
between Sir *George* and the company; so that
there ensued a total cessation of the smelting-
trade in these works.'

[33] Ibid., p. 273.

[34] Ibid., p. 203.

39. After Moses Griffith,
Two Upper Cotton Works,
1795, Engraving,
126 × 199

40. After
Moses Griffith,
*River Bank
Smelting Works,*
1796, Engraving,
114 × 154

Visually, they stood in the tradition of picturesque views of great houses and castles, but the antiquities were replaced by buildings symbolic of the new industrial world. In 1792 the publisher John Boydell printed a description of the set of *Four Views on Holywell Stream.* He noted that in the present age 'Industry and her numerous children, rushed almost instantaneously on an amazed world'. The views were shared between the copper and cotton mills, where 'omnipotent Fashion superseded the Diva Winefreda'.[35] Since the original drawings for these prints were made by John Ingleby it seems certain that Thomas Pennant was involved in their publication. Ingleby was a local painter, born in 1749 at Halkyn, and had been patronized by Pennant since at least 1780. Nevertheless, the views were not included in *The History of the Parishes of Whiteford and Holywell*, where three industrial views by Moses Griffith were preferred. Until 1781 Griffith had been in the permanent service of Pennant, who was still his most important employer. The *Copper and Brass Works* and the *Two Upper Cotton Works*, which were deemed by Boydell to be 'of vast magnitude', repeated Ingleby's subjects. Signifying Pennant's thorough commitment to progress and to a world view which saw no conflict between industrialization, commerce and antiquarianism, Griffith's fine third view, *River Bank Smelting Works*, was selected as the frontispiece to the Holywell section of the volume. It stood in sharp contrast to that chosen for Volume II of the *Tours in Wales*, a pastorale of a goatherd playing the *pibgorn* (hornpipe), lying under an oak tree and surrounded by his animals, with the mountains of Snowdonia in the background. As a liberal Tory squire and an aesthete, Pennant set great store by harmony in all things, and his industrial views exemplified a polite philosophy of factories and fields, expressed by Griffith in the form of a curious gentleman who observed the factory at his leisure and a fisherman, impassively tolerant of the disturbance.

A number of original watercolours, some by Ingleby and others probably by Griffith, survive in Pennant's personal copy of his work on Whitford and Holywell.[36] The views of the Crescent Mill are probably by Griffith and are, perhaps, rejected originals from the group intended for prints. Ingleby recorded various smelting works and also a vitriol works near Holywell. Neither painter

41. John Ingleby,
Dee Bank, Smelting Mills,
c.1792, Watercolour,
141 x 193

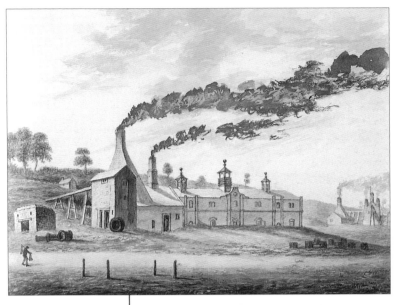

had a particular aesthetic or philosophical axe to grind, though Griffith was a more sophisticated draughtsman than Ingleby. The works of both, on the whole, exemplified the attitudes of their patron, demonstrating a moderate enthusiasm for the subject matter which was presented, however, much like the generality of rural views made by academically-trained artists on tour.

Thomas Pennant's patronage forms a link between the age of mercantile expansion into which he was born and the industrial age which, as an old man, he saw emerge. His attitudes, clearly expressed in his writings, demonstrated the existence of a continuity of rational pragmatism which the more fanciful aesthetic fashions of high art in the later eighteenth and early nineteenth centuries tended to obscure. The explosion of images of the modern world in the Victorian period was the consequence of the reassertion of that persistent cultural tendency. The printed images in which it was expressed ranged from high-quality engravings based on the work of academic artists, through the works of engineering draughtsmen, to the commercial art of the packaging manufacturer. The works of Pennant's artists presaged the development, but the later work manifested an important change in the way in which the industrial world was presented. The emphasis shifted from the place of production – the factory or the mine – to the product – the icon of high technology. The conditions under which people worked in factories and mines, and the chaotic and insanitary urban sprawl which replaced the elegant compromise of factories and fields, appealed to few patrons of visual art. Great ships, railways and bridges, however, represented the splendour of the age of iron and the might of the empire that dominated the age. Furthermore, their logic and cleanliness belied the social disturbance and the spiritual and environmental degradation which lay behind them. Such objects could be understood as the work of individual designers who achieved heroic status, like the great craftsmen who built medieval cathedrals. It is perhaps significant that in Pennant's engravings working people were nowhere to be seen. Not until the second half of the nineteenth century did theorists recognize and became preoccupied with the loss of individual craft skills which industrial production seemed to have caused.

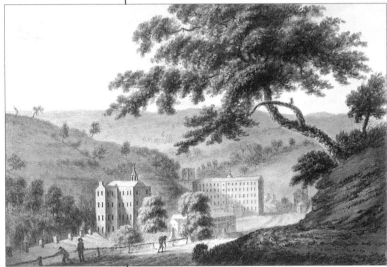

42. Moses Griffith,
The Crescent and the greater Cotton Mills,
c.1792, Watercolour,
131 x 174

[35] Preserved in Pennant's extra-illustrated copy of *The History of the Parishes of Whiteford and Holywell,* NLW PE589. The prints were subsequently reissued in a numbered series of sixteen, including originals by Moses Griffith and Thomas Sandby's *Bleachworks at Llewenni,* for which see below, p. 69.

[36] Ibid.

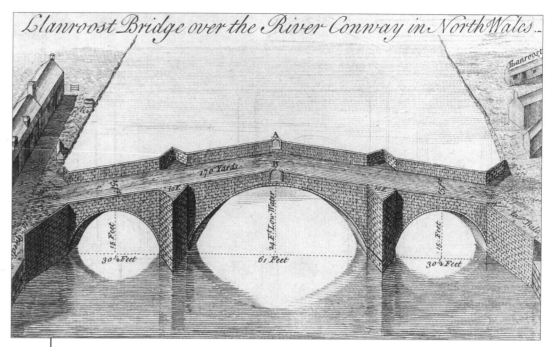

Llanroost Bridge over the River Conway in North Wales.

In Wales, of all the icons of the modern industrial world, the bridge was by far the most important. The detachment of these pristine objects from the squalor of the industrial communities in which their raw materials were produced was emphasized by the location of the most spectacular and celebrated examples in the unsullied landscapes of the mountainous north. To contemporary observers, their precision and scale seemed to complement the purity and grandeur of nature. The emergence in engravings of the bridge as an icon of the modern world and as a symbol of national genius well illustrates the evolution of aesthetics from age to age. For the eighteenth-century intellectual, the image of a bridge was both layered with spiritual metaphor and an expression of the power of the rational mind. Those familiar with the great bridges of antiquity perceived modern examples as a sign that a new civilization had arisen on the level of the Classical world. Patriotic feelings intensified this pride in the present. Inigo Jones's association with Llanrwst Bridge, although probably erroneous, became a matter of mythic significance in the mind of the Welsh public. The bridge appeared in large numbers of paintings and printed images not simply because it was perceived to be a beautiful object, but because of the fame of its alleged builder. In *The Ruins of Rome*, John Dyer set him side by side with the ancients and with Palladio and Michelangelo.[37] His fame attracted the artists, and their works, in turn, fed the myth. In the same way, the construction of a bridge over the Taf at Pontypridd, over a century later, became linked to the mythology of its builder, William Edwards, who was celebrated in an engraving in which he held a rolled drawing of his creation.[38] Nevertheless, for all that was made of it by the romantic imagination, the origins of the Pontypridd Bridge were prosaic. It was built to facilitate the development of coal mines on the estates of Lord Windsor, who, with other gentlemen, raised a subscription to ensure its completion at the fourth attempt.

[37] '... here, curious architect/If thou assay'st, ambitious, to surpass/Palladius, Angelus, or British Jones ...', John Dyer, *Poems by John Dyer* (London, 1761), p. 28. The mythology of the Llanrwst Bridge was particularly important to nineteenth-century art intellectuals in their attempts to construct a tradition of Welsh contribution to English high art. They regarded Inigo Jones as Welsh and saw him as the earliest of a succession of great artists whose nationality had not been acknowledged by the English.

[38] A copy of the engraving is to be found in a nineteenth-century album made by an unknown compiler, NLW BP109 (folio), significantly entitled 'Celebrities of Wales'. It also includes an engraving of Lord Penrhyn from the Thompson portrait alongside the usual Nonconformist ministers. For the significance of the Penrhyn portrait, see Chapter 2.

[39] T[homas] M[organ], 'Account of a remarkable Bridge in Glamorganshire', *Gentleman's Magazine*, XXXIV (1764), 564–5.

[40] This drawing was not the earliest illustration of work by Edwards. Morgan said that in 1755 'a copper plate plan, and prospect of this surprizing arch', predecessor of the successful bridge, had been published.

[41] Wilson's engraving is known in the version published in 1775 but was certainly in existence as early as 1768. See David H. Solkin, *Richard Wilson. The Landscape of Reaction* (London, 1982), p. 228.

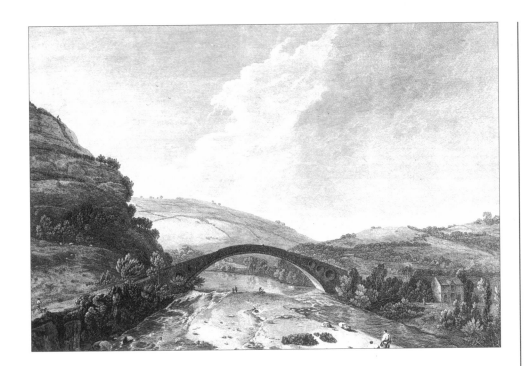

44. Peter Charles Canot after Richard Wilson,
The Great Bridge over the Taaffe,
1775, Engraving,
353 x 514

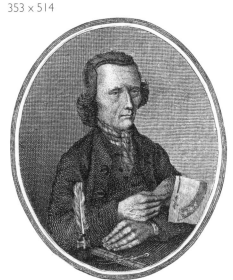

45. W. Skelton after T. Hill,
William Edwards, Architect,
c.1779, Engraving, 74 x 63

The successful completion of the bridge was brought to the attention of a public beyond Wales in the *Gentleman's Magazine* in 1764, eight years after the event.[39] In the patriotic spirit characteristic of Welshmen of his period, Edwards's friend, Thomas Morgan, pointed out the error of a previous correspondent in declaring the Rialto in Venice to be the widest arch in Europe. That honour fell to Britain, and furthermore, was the work of a Welsh person. Morgan recounted the history of three failed attempts by Edwards at spanning the Taf, but devoted the bulk of his letter to the technical and financial implications of the final project, including a technical drawing.[40] Within two years of the appearance of the article, Richard Wilson had visited the site and his painting subsequently emerged as the first of a large number of published engravings.[41] He was at the height of his career and the fact that the bridge was the only modern structure to form the focus of a Wilson print may be a measure of his own patriotic pride in the work of this native craftsman. Nevertheless, he established the image of the Pontypridd Bridge within the framework of Ancient Britain, rather than as an aspect of an emerging industrial age based on technology and commerce. Wilson's bridge, like that portrayed by almost all subsequent visitors, might have stood for ages past, deeply integrated into the unsullied landscape of Gwalia Wyllt. Its mythology turned on the Wallace-like persistence of its builder, which was presented as an admirable aspect of his national character. Even the modernist Thomas Morgan had described him, for the benefit of the English readers of the *Gentleman's Magazine*, as an Ancient Briton.

46. Thomas Pardoe,
Oval Dish with View of Pontypridd Bridge,
1821–3, Porcelain, 214 x 300

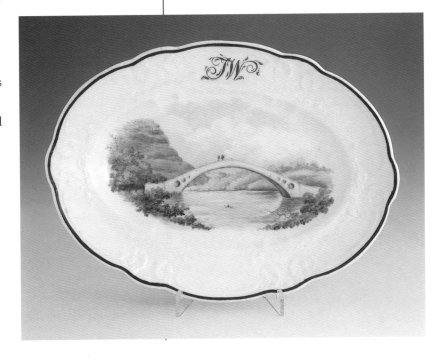

47. After Raeburn,
Thomas Telford,
1835, Engraving,
335 × 270

[42] The obituary in the *Gentleman's Magazine*, LXXIX, pt. II (1809), drew attention to the fact, but it was seldom reported in tourist descriptions of the bridge where Edwards was generally presented as a self-taught mason – the implication being that he was a simple rustic.

[43] E. Morton Nance, *The Pottery and Porcelain of Swansea and Nantgarw* (London, 1943), illustrated a Swansea earthenware jug of 1811–17, for instance, with the crest of Wales and emblems of art and music along with the bridge, plate LI, F and I. Pardoe painted a Nantgarw jug, plate CLXXXIV, C.

[44] W[illiam] S[andys] and S[ampson] S[andys], 'Walk through South-Wales in October 1819', NLW Cwrtmawr MS 393C, f. 29.

[45] Un dam yn gadarn i gyd – mewn urddas
 Mae'n harddu'r gelfyddyd;
 Adail gref a saif hefyd
 I ddydd barn neu ddiwedd byd.
Gwilim Harri, 'Chwech englyn i Bont-y-ty-pridd' in idem, *Yr Awen Resymol* (2nd ed., Aberdâr, 1910), pp. 110–11.

[46] 'y cyntav a werthai', NLW MS 13248B, II, f. 444.

The fact that Edwards was, at the time, also a Congregationalist minister was generally ignored since it was not consistent with the image that the romantic English tourist, and, indeed, many of the Welsh intelligentsia of the period, cared to indulge.[42] Wilson's print soon had many cheaper rivals, and the image also appeared on ceramics made at the Cambrian Pottery.[43] Visitors became commonplace. When William and Sampson Sandys visited in 1819, they noted that 'The country people are very proud of it; as we were approaching, a man said to us, "Going to see Pont y Pridd I suppose, sure it is a fine thing then"'.[44] It was still being celebrated in verse in 1834, at the Eisteddfod held in Cardiff. Gwilim Harri, a poet from the iron-manufacturing town of Hirwaun, composed a series of six celebratory *englynion*, concluding that the bridge was:

> A unity of strength – with dignity
> It embellishes art;
> A mighty structure which will stand
> To the day of judgement or the end of time.[45]

For all its industrial and commercial *raison d'être,* and its technical brilliance, Edwards's Pontypridd Bridge never escaped from the eighteenth-century picturesque in art images. It was presented, even at the height of the industrial age, as a pre-industrial image. Without doubt, the prime example of the bridge as an icon of the new world was Telford's Menai Bridge, opened to the public in January 1826. In numerical terms, with the exception of Caernarfon Castle, it dominated print production of Welsh imagery at both ends of the market. No modern subject approached it in popularity. Thomas Telford became the first of the heroic engineers of the nineteenth century. He was painted, striking a Byronesque pose, by Raeburn, and the image was issued as an engraving which, no doubt, sold well as his reputation grew. The visual drama of his productions (which also included the Conwy Bridge) caught the imagination of artists, intellectuals and the common people. When the painter Hugh Hughes visited the site of the bridge in 1820, making drawings for his volume of wood engravings entitled *The Beauties of Cambria,* he can have seen little but the beginnings of the towers. Nevertheless, he stayed an hour at the ferry house to 'view the new bridge, which I can conceive will be an astonishingly grand and magnificent object when finished'. William Owen Pughe noted with excitement in his diary for 14 July 1826 that he had bought, in London, an engraving of the completed bridge, 'the first to be sold'.[46] He later presented Hugh Hughes with a print of the bridge as a gift. In 1828 a sumptuous volume written by W. A. Provis, Telford's resident engineer, was published under the title *Historical and Descriptive Account of the Suspension Bridge constructed over the Menai Strait.* Printed on India paper, it cost ten guineas and included many technical engravings and two views by Arnald, but Provis himself was the artist for a number of upmarket prints published separately. The book was followed, ten years later, by the even more substantial *Atlas to the Life of Thomas Telford,* with eighty-three plates. The bulk of these were technical engravings, but there were also views which, though they inevitably

48. E. Turrell,
*View of the Suspension Bridge now
erecting over the Menai Strait near
Bangor in Carnarvonshire*,
c.1826, Engraving,
319 × 615

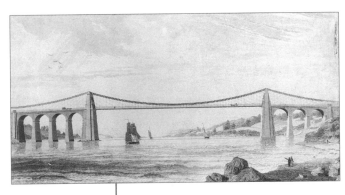

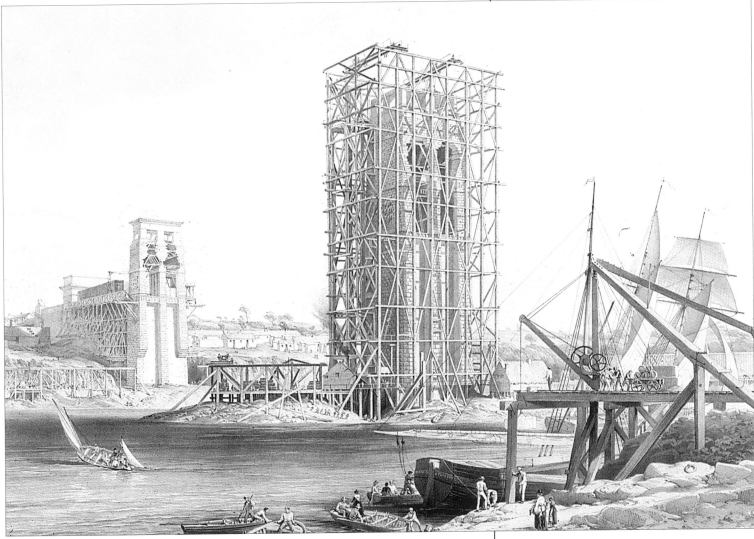

50. George Hawkins,
The Main Tower,
1849, Pencil,
234 × 427

49. George Hawkins,
*Britannia Tubular Bridge
over the Menai Straits*,
1849, Lithograph,
377 × 610

51. George Hawkins,
Britannia Tubular Bridge
over the Menai Straits,
1850, Lithograph,
380 × 613

revived elements of picturesque convention such as fishermen and other rustic foreground detail, nevertheless presented the technology dominating nature, rather than assimilated into it. The pictorial views largely retained the detail and factual accuracy of the technical drawings. They belonged to a different world from Wilson's image of the Pontypridd Bridge.

When the Menai Bridge was joined in 1850 by Robert Stephenson's Britannia Bridge, which was equally revolutionary and massive in its period, a new flood of sumptuous prints flowed forth. Many of these were lithographs produced by Day and Son in London, who seem to have turned the two bridges into something of an industry in themselves. George Hawkins[47] was the artist of the original drawings published both in Edwin Clarke's *The Britannia and Conway Tubular Bridges* of 1850 and in a bewildering number of separately-issued prints scaled up and down to suit a variety of pockets. The complex process of constructing the bridge dominated the engravings rather than the finished object. The consummation of this imagery was John Lucas's portrait of Robert Stephenson surrounded by his colleagues and set against the background of the bridge which awaits only the lifting of the final tube. The group portrait was issued as an engraving.[48]

Local painters, printers, publishers and retailers did not fail to take advantage of the potential of the bridges. A fine lithograph printed by Day and Son was issued under the imprint of William Shone's Bangor print shop in the year of the opening. The original picture was the work of Hugh Jones, the Beaumaris artisan painter, suggesting strongly that the lithograph may have been commissioned by the Bangor publisher, although it was printed in London. Shone was certainly the most active of the local publishers in this field, though Grace Humphreys and also William Pritchard in Caernarfon either printed engravings of their own or reissued the work of London companies under their imprints. As agent for Thomas Boys, the London printseller, William Shone may well have stocked the most upmarket prints, some of which, with their state of the art printing, were themselves celebrations of high technology. Among the Day and Son lithographs, that of the schooner yacht Wyvern was perhaps the most majestic. The yacht passed under the Menai Bridge in full sail and carried the simple title *Pride*.

Many of the large number of prints of the Menai Bridge issued for the middle of the market, either individually or in numerous tourist guides, were dull efforts. There were, however, lively exceptions, such as the lithograph printed and published in Caernarfon by William Pritchard, which was clearly based on the work of a non-academic artist who was named as J. C. Napper. William Crane of Chester issued a set of lithographs in different sizes which also stood out from the rest since they gave a prominent place to the human aspect of the bridge. The gateman leaned in a leisurely manner against his booth while visitors promenaded to and fro. The bridge attracted tourists of all kinds, including local people, which led to the substantial production of prints for the lower

[47] George Hawkins (1809–52) was an architectural draughtsman and lithographer.

[48] Perhaps surprisingly, the picture was not exhibited at the Royal Academy. Lucas's portrait of Robert's father, George Stephenson, was shown there after the death of the sitter.

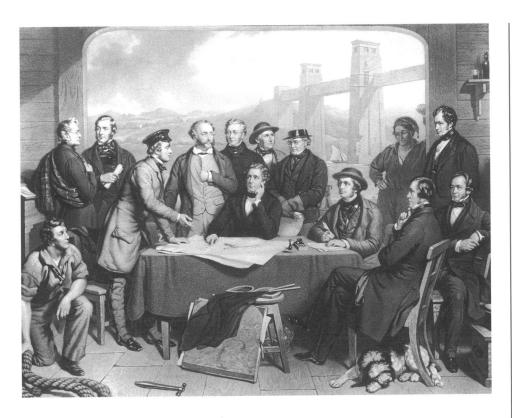

52. J. Scott after John Lucas,
Robert Stephenson and the
Committee for Britannia Bridge,
1853, Engraving,
545 x 720

53. After Hugh Jones,
West View of the Britannia
Tubular and the Menai
Suspension Bridge,
1850, Lithograph,
269 x 461

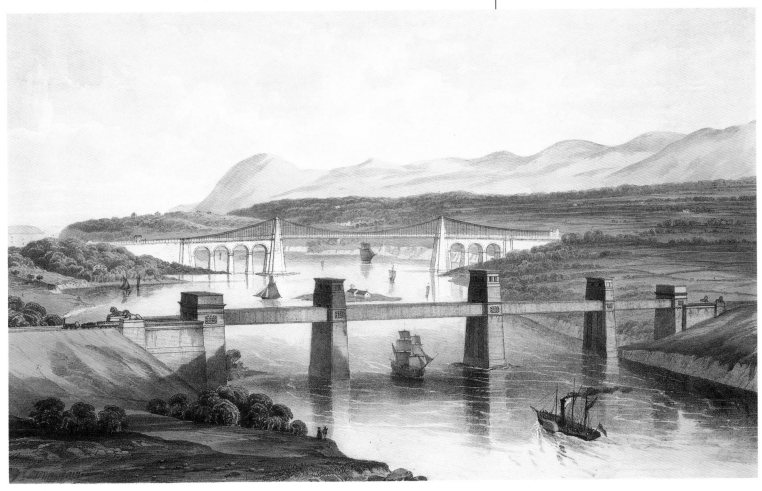

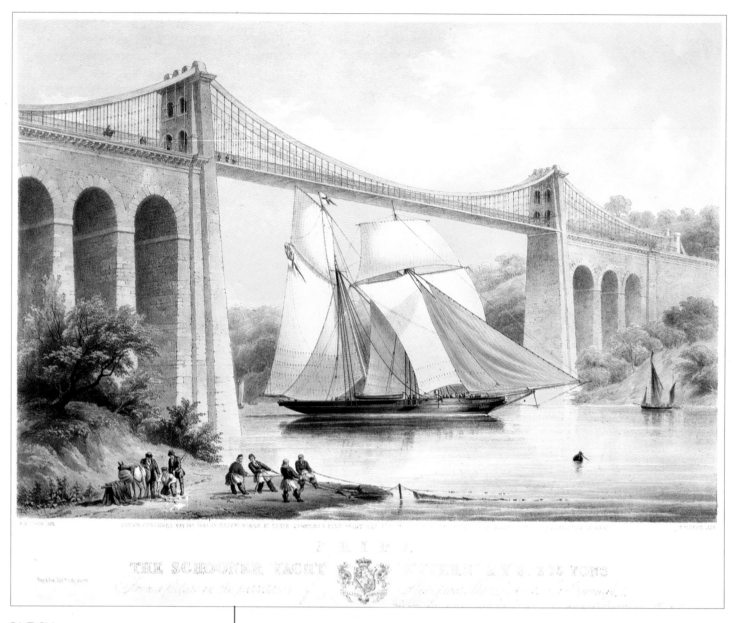

54. T. Picken
after N. M. Condy,
*Pride – The Schooner Yacht
Wyvern, R.Y.S., 205 Tons,*
1849, Lithograph,
311 x 454

55. J. C. Napper,
The Menai Bridge,
c.1845, Lithograph,
179 x 260

56. W. Crane,
*Entrance of the Menai Bridge
from the Carnarvon Shore,*
1850, Lithograph,
133 x 182

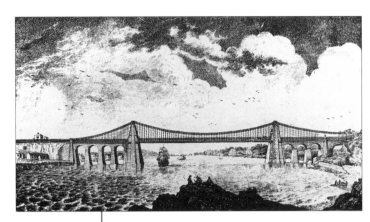

57. T. Kelly,
*A View of the Grand
Suspension Bridge
over Menai Strait,*
c.1826, Wood engraving,
151 × 282

end of the market. Among them were a number of different editions of a woodcut image and text printed in Dublin. The blocks were clearly drawn and cut in Ireland after other prints, rather than from a sight of the original, and the texts were similarly boiled down from earlier printed versions. That they were hawked to visitors on the bridge itself is in no doubt, since a version drawn by one T. Kelly and 'Printed at Allens, Dame Street, Dublin' carries the handwritten note 'Bgt at the Menai Bridge the 4 Oct 1827 – 1/-'. The price was that of a black and white print – coloured versions were 1s. 6d. Painters such as Hugh Hughes may also have sold their wares on or near the bridge. Hughes was already in his thirties when he visited the Menai Bridge in the early stages of its construction, but lived well into the Victorian age of Robert Stephenson. His last recorded work was a picture of both bridges, on which he was seen working in 1862.[49] At the very bottom of the market were prints published by John Brown of Bangor in the ballad sheet format, and here, too, we may detect the hand of Hughes, since they carried a simple but well-executed wood engraving in his manner, and they dated from a period in which he was very active in cooperation with Welsh publishers.

The Menai Bridge caught the imagination of the ordinary person as well as that of the intellectual. Rebecca Williams wrote a ballad which compared the bridge favourably, among others, to that of Llanrwst, and which noted the exploit of an Anglesey man who recklessly walked from one side to the other along the first chain to be suspended.[50] However, it was an *englyn* by Dewi Wyn which etched the bridge on the memory of generations of Welsh speakers:

> High castle above the sea, – the world drives
> Its carriages over her:
> All you ships of the ocean, too,
> Pass under her chains.[51]

[49] Hughes is known to have sold directly to the public from a tent in which he exhibited his works. His painting of the two bridges was noted by William Williams, ab Caledfryn, in Caernarfon. See Peter Lord, *Hugh Hughes, Arlunydd Gwlad* (Llandysul, 1995), p. 286. The Britannia Bridge, like the Menai Bridge, also appeared on ceramics. For instance, the Elton Collection at the Ironbridge Gorge Museum has a transfer printed mug.

[50] 'Can Newydd i Bont Menai gan Rebecca Williams, Caernarfon', printed by P. Evans, c.1826. Rebecca Williams noted only one person crossing on the chain. Other accounts mention three individuals and the mythology subsequently expanded to include the story of the shoemaker who stopped half way across to complete a pair of boots.

[51] Uchelgaer uwch y weilgi, – gyr y byd
 Ei gerbydau drosti:
 Chwithau, holl longau y lli,
 Ewch o dan ei chadwyni.

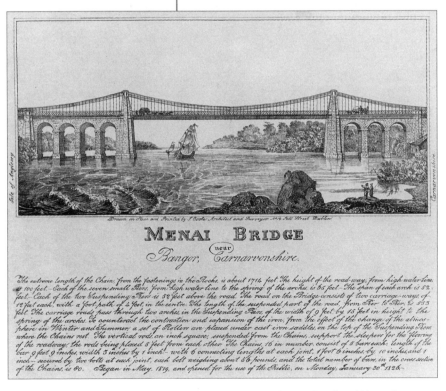

58. T. Cooke, *The Grand Menai Suspension Bridge near Bangor, Carnarvonshire,* c.1826, Wood engraving, 139 × 300

59. W. H. Lizers,
*The Britannia Tubular Bridge –
Entrance from the Bangor Side*,
c.1850, Steel engraving,
97 × 133

52 'Can Newydd, sef Proffwydoliaeth Lowri Coedbolyn, Am y dydd y cyfodir *Tube* y Britannia Bridge', NLW, J. H. Davies, Collection of Ballads (Hen Ganeuon), Vol. III, no. 37.

53 Pedwar llew tew
Heb ddim blew
Dau 'rochor yma
A dau 'rochor drew.

60. Anon.,
Bridges over the Menai Strait,
c.1860, Straw picture,
610 × 760

The Britannia Bridge would leave a similarly indelible image on the literary as well as the visual consciousness of the common people. Richard Williams (Dic Dywyll) sang a ballad about the raising of the tubes, no doubt at such popular events as the Menai Bridge fair. It had much more to say of the people's celebrations than of the technical feat of the engineers.[52] Robert Stephenson had chosen to dress his high technology in historicist clothes, designing the towers in Egyptian style in a clear invitation to compare his work with the great architectural achievements of that civilization. To complete the challenge, he added two pairs of sphinx at the ends of the bridge, transformed into English lions, and the cheap steel engravings, published in literature such as *Jackson's Guide*, made much of them. Stephenson's sculptor was John Thomas, an artist of Welsh descent but working in Gloucester. This bombastic assertion of national pride was cheerfully debunked by John Evans (Y Bardd Cocos):

Four fat lions
Without any hair
Two on this side
And two over there.[53]

Visual evidence of the penetration of such images into popular consciousness comes in the form of works made by amateur artists for domestic display, such as a pair of straw pictures worked in about 1860, showing both the Menai and Conwy bridges, and clearly based on prints. The fat lions of Britannia were prominent features and ships of all kinds sailed under the Menai Bridge. It is probable that the artist was a middle-class person with abundant leisure time, but some interpretations of the popular print imagery of the bridges can be ascribed to professional

61. Anon.,
The Menai Suspension Bridge,
c.1835, Slate carving,
327 x 1184

62. James Williams,
Bedspread,
1842–52, Patchwork,
2320 x 2010

54 Williams's tapestry achieved some celebrity, being exhibited in London and at the Eisteddfod at Bangor in 1930. See Peter Lord, *Gwenllian. Essays on Visual Culture* (Llandysul, 1994), p. 79.

55 See, for instance, NLW BP100, a scrapbook from c.1880 which has a coloured engraving of the bridges alongside prints of *Y Cymro Bach* by Robinson's of Bristol, *Llewellyn killing his dog Gelert*, and a composite page of Queen Victoria surrounded by her various residences.

craftspeople employing their skills for their own satisfaction outside their working hours. For instance the Menai Bridge had appeared in a slate carving from Dyffryn Ogwen by about 1835. The most impressive example was the tapestry produced by the Wrexham tailor, James Williams, between 1842 and 1852. Here, the bridge kept company with the railway viaduct spanning the valley of the Dee near Chirk, and a variety of biblical and exotic scenes. The border was punctuated by symbols of the United Kingdom, which made quite clear the framework of personal identity within which the Welsh imagery functioned.[54] The visual evidence strongly suggests that both the middle classes and the common people of Wales understood the bridges of Telford and Stephenson in the patriotic British terms in which they were presented to them both in the symbolism of the architecture and in loyal texts on the popular prints: 'This National & splendid specimen of British Architecture will be a lasting monument to the discernment of the present Government for having called into requisition the transcendent talents of Mr. Telford who has proved himself in this line, the first Architect of the age', declared the shilling wood engraving from Dublin. Prints were glued carefully into scrapbooks alongside other symbols of the industrial and military might of the British Empire and a few anodyne tokens of Welshness.[55]

63. Anon.,
Page from a scrapbook,
c.1880, *The Menai Bridge*,
Engraving, 230 × 288

THE MENAI BRIDGE.

THIS MASTERPIECE OF ENGINEERING SKILL, TOGETHER WITH THE TUBULAR BRIDGE WHICH CARRIES THE HOLYHEAD RAILWAY, JOINS THE ISLAND OF ANGLESEA WITH THE MAIN LAND. IT WAS COMPLETED JANUARY 1826 BY GOVERNMENT, AT A COST OF £120,000 THE ROADWAY IS 28 FEET WIDE, AND HAS A CLEAR SUSPENSION FROM PIER TO PIER OF 550 FT. THE WEIGHT OF THE SUSPENDED PORTION IS 480 TONS, & THE TOTAL LENGTH OF THE BRIDGE, ABOUT A THIRD OF A MILE.

*chapter
two*

THE VISUAL CULTURE

OF THE INDUSTRIAL

COMMUNITY

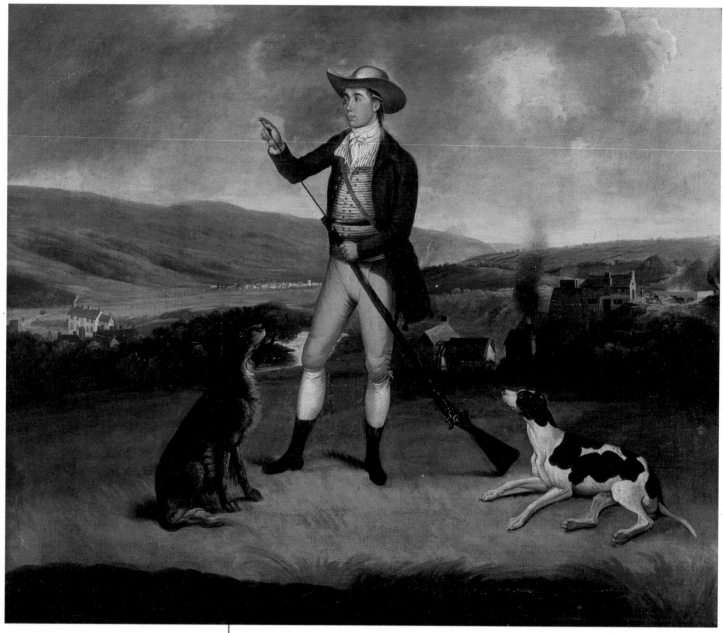

64. Anon.,
Samuel Homfray,
c.1790, Oil,
1008 × 881

The Industrialists

By his marriage in 1686 to Mary Evans, heiress of the Gnoll, near Neath, an English barrister, Humphrey Mackworth, acquired substantial interests in coal mining. Within a few years he was smelting copper and lead, and in 1698 he purchased control of the Cardiganshire lead mines of the Pryse family which had been drawn by John Pettus. Mackworth ran the whole as an integrated business and therefore may be considered the first industrial entrepreneur of Wales. He may also be considered the first industrial connoisseur and patron of the arts since, with his profits, he rebuilt the Gnoll and constructed a classical garden around it which brought him celebrity in fashionable circles. No doubt Mackworth also

65. Moses Haughton,
John Bedford,
1788, Oil,
756 × 631

bought pictures, although no records of them survive and it
seems unlikely that they would have portrayed the unusual source
of his wealth, since images of mining activity were so rare in that
period.[1] It would be another seventy years before Thomas Pennant
commissioned John Ingleby and Moses Griffith to record the industrial
sites of Denbighshire and Flintshire, in some of which the patron had
a financial interest. Pennant cannot be considered an entrepreneur
in the same way as Mackworth since he was essentially a country
gentleman and a dilettante. Nevertheless, Pennant's interest in
industrial development was a sign of the times and it is among his
contemporaries that we find the first of those entrepreneurs who
identified wholeheartedly enough with their industrial creations
to commission pictures in which this new source of wealth was
prominently celebrated.

About 1790 Samuel Homfray, one of the founding ironmasters of Merthyr Tydfil,
commissioned a portrait of himself in sporting mode, but rather than setting
himself against the conventional house and park of the country gentleman, in
the background he had his painter place an ironworks – either the Cyfarthfa
forge and boring mill which he leased from 1782 or Penydarren, begun in 1784.[2]
Similarly, his contemporary, John Bedford, built an ironworks at Cefncribwr
near Pyle, which he celebrated in 1788 in a portrait painted by Moses Haughton
in his native Birmingham. The portrait illustrated Bedford's aspirations rather
than his achievements since it showed three blast furnaces in the background,
where only one was built. From Merthyr, Richard Crawshay, founder of the
great dynasty of ironmasters, also repaired to Birmingham for his portrait,
painted by the artisan Richard Wilson.[3] He hung it in the parlour of Cyfarthfa
House, alongside the portraits he had commissioned of the Shropshire ironmaster,
William Reynolds, and the Bersham ironmaster, John Wilkinson. Although not
celebrated visually to the same extent, Bersham – like Merthyr – was described
by the painter Edward Pugh at about the time the portraits were commissioned
as 'immense, displaying such a profusion and tumultuous medley of machinery,
as to leave the mind not a little astonished at the sight of it'.[4] In what had quickly
become a convention of portraits among this generation of entrepreneurs, the

[1] Peter Hartover's panorama of the Lambton
estates in England, painted in 1680, is the earliest
surviving picture of a gentleman's estate which
shows industrial activity. It depicts Harraton Hall
and coal staithes on the River Wear. Humphrey
Mackworth's industrial achievements were,
however, celebrated in poetry by the Revd
Thomas Yalden. See Klingender, *Art and the
Industrial Revolution*, pp. 19, 202.

[2] Homfray owned a conventional country
seat, described by John George Wood in 1811:
'The splendid mansion of Mr. S. Homfray, at
Penydaran, situated upon a gentle declivity,
is sufficiently removed from the town by the
extent of the pleasure-grounds ... The hot-houses,
grape-houses, etc. furnish their respective fruits
in profusion, and walks laid out with taste and
judgment, present several points from whence
the silver Taff, winding through the long
accumulation of dingy buildings, may be seen
to great advantage.' Wood, *The Principal Rivers
of Wales Illustrated*, p. 57.

[3] For Richard Wilson (1752–1807), see *Burlington
Magazine*, XCVI (May 1954), 143.

[4] Edward Pugh, *Cambria Depicta* (London, 1816),
p. 329. Unfortunately, Pugh did not publish a
view of the works, though he did include some
industrial scenes, including Parys Mountain.

66. Richard Wilson,
Richard Crawshay,
c.1800, Oil,
1350 x 945

67. Lemuel
Francis Abbot,
John Wilkinson,
c.1800, Oil,
762 x 600

68. Richard Wilson,
William Reynolds,
c.1800, Oil,
1395 x 940

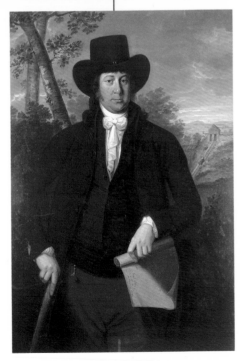

background of the Reynolds picture was formed by an industrial scene – a view of an inclined plane on a canal, one of the Shropshire man's innovations much admired by the master of Cyfarthfa.

Individuals such as Samuel Homfray and Richard Crawshay deployed personally the financial, human and technical resources which formed their world. Their relationships with their engineers in an industry dependent on the rapid development of new technologies was particularly close, and was reflected in the commissioning of a substantial group of portraits. Subsequent to building the Pontypridd Bridge, William Edwards was engaged by the Swansea industrialist John Morris to design and build the new settlement of

69. Thomas Rothwell,
South-East View of Clas Mont,
the Seat of J. Morris, Esqr.,
1792, Engraving,
220 x 269

70. Thomas Hill,
William Edwards,
c.1779, Watercolour
on ivory, 68 x 57

Morriston to house his employees. The relationship between the two men was
implicitly celebrated by Thomas Rothwell in one of his Swansea views published
in 1792, entitled *South-East View of Clas Mont, the Seat of J. Morris, Esqr.,* in
which Morris's house was seen behind the Wychtree Bridge, almost certainly
built by Edwards. Morris owned (and presumably had commissioned) the
miniature portrait of the engineer on which the published engraving was based.
The iconography of the rolled technical drawing soon became conventional for
portraits of such men, and was often supplemented by the inclusion of a pair
of dividers. In about 1810 the most famous of the Merthyr engineers, William
Williams of Cyfarthfa, was celebrated in a fine portrait by an unknown artisan
painter measuring a drawing in a substantial technical tome.[5] At the rival
Penydarren works, made famous by Trevithick's successful attempt in 1805
to build a steam locomotive, two more engineers were celebrated in portraits
at around the same time. According to Charles Wilkins, the nineteenth-century

[5] William Williams was born in 1771 and the
portrait is dated on the basis of his apparent age.

55

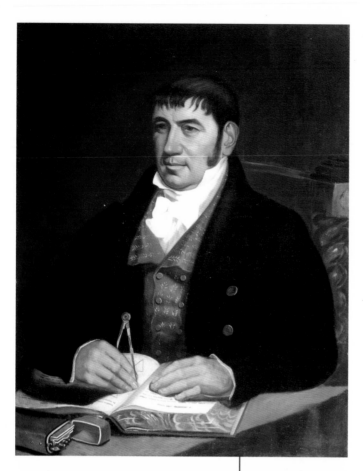

71. Anon.,
William Williams, Cyfarthfa,
c.1810, Oil,
920 × 720

72. John Petherick,
The Ironworks Manager Dozing,
c.1830, Watercolour and
gouache over pencil,
245 × 172

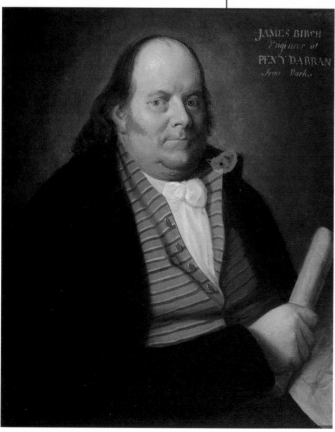

73. Anon.,
James Birch, Engineer, Penydarren Ironworks,
c.1820, Oil, 720 × 595

historian of Merthyr, 'Trevithick was materially
assisted by Rees Jones of Penydarren, an ingenious
and self taught mechanic, whose homely features are
now enshrined in the art exhibition at Kensington'.[6]
This portrait is lost but that of James Birch, also of
Penydarren, survives. The engineer sat, resplendent
in a striped waistcoat, holding a technical drawing of
a beam engine. The painter of this picture is unknown,
and neither is it clear whether it was painted in Merthyr
or elsewhere. However, by the early years of the
nineteenth century there was at least one artist resident
in the area capable of painting competent portraits,
and he was closely associated with Penydarren. Like
Trevithick, John Petherick, agent at the works, had
come to Wales from Cornwall.[7] His son, also called
John, was born in Camborne in 1788, but from at
least as early as the year of Trevithick's technological
triumph John Petherick junior painted the evolving
industrial landscape around him with an insider's
eye. Nothing is known of his training if, indeed, he
received any. Among his most attractive works is a
watercolour entitled *The Ironworks Manager Dozing,*
which may well represent his father. Petherick's
lifetime spanned the transition from factories and

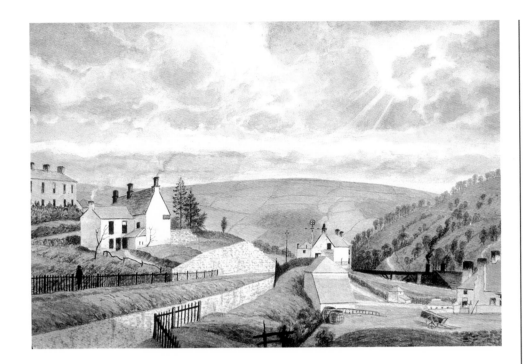

74. John Petherick,
Abertillery Tin Works,
1854, Watercolour over pencil,
125 x 184

[6] Charles Wilkins, *History of Merthyr Tydfil* (Merthyr, 1908), p. 250.

[7] John Petherick became a figure of substance in the Merthyr area. Among works listed in the catalogue to the 1880 Merthyr art exhibition was a bust of John Petherick by Joseph Edwards and a portrait by B. S. Marks. Their present whereabouts is unknown and it is not clear whether they represented the father or the son (1788–1861) of the same name.

[8] John Petherick's work survived mainly in the form of a large number of watercolours pasted into a single album, for which see Stephen Somerville and Anthony Reed, *John Petherick, Watercolours from a family scrap-album* (London, 1989). The two oil paintings of the Bute Furnaces were incorrectly attributed to Penry Williams by Christie's at the sale of 1988. Their provenance was by direct descent from Edward Williams, manager of Dowlais, and it was Williams who had lent them to the 1880 Merthyr exhibition, where they were clearly stated to be the work of Petherick. Williams would have been in a position to know. A third picture, discussed below, *Industrial Landscape*, also attributed to Williams at that sale, did not appear in the 1880 exhibition. The attribution of this picture is more difficult and I have chosen to retain it within the oeuvre of Penry Williams for the present. However, it may prove also to be the work of John Petherick.

[9] William Thomas Forman had certainly patronized at least one other Welsh artist by this time. He had been the only citizen of Merthyr, apart from Taliesin Williams, to invest in a subscription to *The Beauties of Cambria* when Hugh Hughes visited the town in 1821.

fields to urban industrial sprawl, but many of his pictures, such as *Abertillery Tin Works*, drawn as late as 1854, retained the mixed character of the views drawn by Sandby and Hassell.

Although he was an insider in the industrial world, John Petherick was not untouched by the romanticism of his time and was especially stirred by night-time scenes. Also in 1854 he painted *Terraced Houses near the Waterfront at Cardiff by Moonlight*, a watercolour in which the buildings and the masts of the ships were thrown into dark silhouette. They were further dramatized by the red glow of fire, following the convention pioneered in Wales by Sandby's *The Iron Forge between Dolgelli and Barmouth*, nearly a century earlier. His romanticism reached a remarkable peak in a pair of oil paintings, entitled *Bute Furnaces, Rhymney* and *No. 2 Furnace, Rhymney*, which were exhibited at the Drill Hall in Merthyr in 1880. The furnaces, which were designed by McCullock for the proprietors, William Thomas Forman and Thomas Johnson, based on temples recently excavated at Danhydra in Upper Egypt, caused considerable interest at the time in the engineering press. In Petherick's extraordinary pictures, the silhouetted architectural features emerged from the smoke of the furnaces in a notable exposition of the industrial sublime. They must be dated to the later 1820s, possibly to 1827, when Petherick painted his interior, *Pen-y-darren Ironworks*, in watercolour.[8] Whether these particular pictures were commissioned by the owners of the Bute Ironworks is unclear[9] but, by this time, a number of industrialists were expressing their paternalistic instincts through patronage of another local painter. Penry Williams was fourteen years younger than Petherick

and no documentary evidence has emerged to link the two, but it seems likely that they were at least acquainted with each other. In about 1825 Williams also painted a view of the Bute Ironworks, known simply as an *Industrial Landscape*. On the western bank of the river, opposite the Egyptian furnaces, he portrayed a well-heeled woman on horseback in animated conversation with a companion, while a gardener trimmed the lawn. The poisonous fumes and smoke drifted off in a southerly direction, away from the property. Conventional iconography would suggest that one or other of the mounted figures represented the patron.

75. John Petherick,
Bute Furnaces, Rhymney,
c.1830, Oil,
394 × 562

77. John Petherick,
Pen-y-darren Ironworks,
Glamorgan, 1827,
Watercolour over pencil,
101 × 76

76. John Petherick,
No. 2 Furnace, Rhymney,
c.1830, Oil,
414 × 562

78. Penry Williams,
*South Wales
Industrial Landscape*,
c.1825, Oil,
565 × 1003

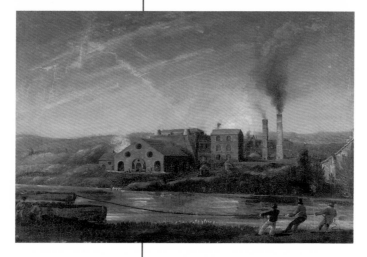

79. Penry Williams,
Ynysfach Ironworks,
c.1817, Oil,
480 × 670

[10] A group of pictures in the National Library of Wales was attributed to Taliesin Williams by their previous owner. This attribution is almost certainly incorrect, and there is no other evidence of any kind that Williams was a painter.

[11] Thomas Matthews, 'Penry Williams', translated from *Cymru* (ed. O. M. Edwards), XLII (1912), 118. Matthews also confirms that Mr Scale of Llwydcoed was an early supporter of Williams.

[12] Williams's visits to Aberpergwm are confirmed by a note in the hand of Maria Jane Williams on a drawing of a bridge near the house: 'In the year 1819', she says, 'I saw Penry Williams thereabouts, 17 years old sketching it: after which I sent him to the house where he remained a month filling albums and drawing everybody and everything.' Evidence concerning Williams's early patrons is discussed in Derrick Pritchard Webley, *Cast to the Winds. The Life and Work of Penry Williams (1802–1885)* (Aberystwyth, [1997]), Chapter 2.

Penry Williams was born in 1802 in Merthyr, the son of a house painter. According to a legend perpetuated by a number of writers, William Crawshay II was the first of the great industrialists to patronize him. Williams was alleged to have come to Crawshay's attention as the result of a picture of the arrival of the militia to quell the riots at Merthyr in 1816, painted when the artist was fourteen. The two versions of this picture were indeed owned by local citizens, though not by Crawshay, who was one of the objects of the people's resentment. The owners were Mr Scale of the Llwydcoed Ironworks, and William Williams, the Merthyr publisher, who must therefore be considered among his earliest supporters. However, by 1817, Penry Williams had painted a number of industrial views for William Crawshay II, including the *Ynysfach Ironworks*, in a naive manner similar to the *Merthyr Riots*. Crawshay is alleged to have sent Williams to the school newly-established in Merthyr by Taliesin Williams, a credible story since the ironmaster certainly interested himself from time to time in the well-being of individual employees.[10] The art critic Thomas Matthews of Llandybïe reported that Williams was making subject pictures copied from books the following year, as well as pub and shop signs for his father's painting and decorating business. Matthews declared that he received encouragement and, indeed, the instruction of Maria Jane Williams, Aberpergwm, 'and it was chiefly through the faith of Miss Jane Williams in him that Penry Williams went to London and then to Italy'.[11] Penry Williams was certainly at Aberpergwm[12] but Matthews was probably inaccurate in his promotion of Maria Jane Williams as the painter's main sponsor. The scientist Michael Faraday seems to have played a more important role in the development of his career. In 1819, on the tour which had earlier taken him to Parys Mountain, Faraday visited the Dowlais ironworks of Josiah John Guest. He was much excited by the strange world which opened up before him, with 'Men, black as gnomes … moving in all directions, taking to and bringing from the furnaces, and works; and as we came into sight of these erections, flame upon flame appeared rising

80. Penry Williams,
Waterfall Glyn Neath,
1819, Oil,
215 × 305

81. Penry Williams,
Cyfarthfa Castle, Lodgehouses and Gates,
1824, Watercolour,
134 × 189

over the country and scorching the air'.[13] Faraday's tour was designed primarily to take him to well-known picturesque sites, and so from Dowlais he proceeded to the Vale of Neath to view the waterfalls. At the Lamb and Flag he was instructed in the virtues of the various sites with the help of a number of pictures owned by Price, the innkeeper. Having viewed 'some few of the falls which were most convenient', the following day Faraday wrote to Guest at Merthyr:

> The master of the Inn where we are now has some oil paintings which though rough convey an excellent idea of the places they represent, i.e. the falls of the vale. They were painted by a person of Merthyr, a Mr Williams, who I understand will do me a set if I can get them conveyed to London ...[14]

Faraday asked Guest to pay for eight or ten of them at four shillings each and to dispatch them to London. Whether or not Penry Williams was already known to Guest when Faraday's request arrived is unclear, but the industrialist certainly acquired a further set of landscapes. The surviving pictures of this period confirm Faraday's description in that they manifest the plain vigour and openness characteristic of the talented artisan which was, however, soon to be lost in the process of artistic improvement.[15] Penry Williams was sent to London, though by whom is not entirely clear. He became known to Sir Thomas Lawrence as a promising student, and this connection seems likely to have been made through Faraday. On the other hand, the Crawshays may have financed his training at the Royal Academy Schools, which he entered in 1822. Four years later, when he left for Italy, he was under the patronage of Joseph Bailey, who was supposed to receive all his pictures for two years.[16]

Between his period of instruction at the Royal Academy and his departure for Italy, Penry Williams returned frequently to Wales to paint (in both oil and watercolour) for a number of industrialists and landowners in south Wales. Although the works included conventional rural scenes, industrial sites took a prominent place, indicating quite clearly the pride of the entrepreneurs in their achievements. The most celebrated of these commissions came from William Crawshay II in 1824–5 to paint a series of twenty-one watercolour views, some of which showed the Cyfarthfa works and his new house, Cyfarthfa Castle, then nearing completion. Williams's detailed panoramas had a crystal clarity which set them technically above any comparable works of the period, even those of Petherick. They

[13] Tomos, *Michael Faraday in Wales*, p. 24.

[14] Letter dated 20 July 1819, ibid., p. 147. Faraday did not always show the same enthusiasm that he manifested at Dowlais when confronted with antiquities. On leaving the town of Neath, he significantly remarked, for instance, that 'the ruins of an antient castle came before us but we had not natural inclination nor artificial respect enough for antiquity to trouble ourselves about them', ibid., p. 31.

[15] Eight pictures survive, four in Cyfarthfa Castle Museum and four in the National Museum of Wales.

[16] The subject matter of his work changed dramatically and permanently in Italy. Only one subsequent industrial view survives, *The Taff Vale Railway, Quaker's Yard Viaduct*. This picture was signed and dated 1845. Webley, op. cit., p. 64, followed Christie's in attributing to Penry Williams the two pictures of the Bute furnaces done by Petherick, and similarly followed Arthur Elton in attributing a second view of the viaduct at Quaker's Yard to him (Elton Collection, Ironbridge Industrial Museum). This attribution must also be considered doubtful. In 1841 George Childs exhibited *Scene on the Taff Vale Railway, Glamorgan; Viaduct erected by George Bush* at the Royal Academy. This may well be the picture in the Elton collection. For Childs, see Chapter 3.

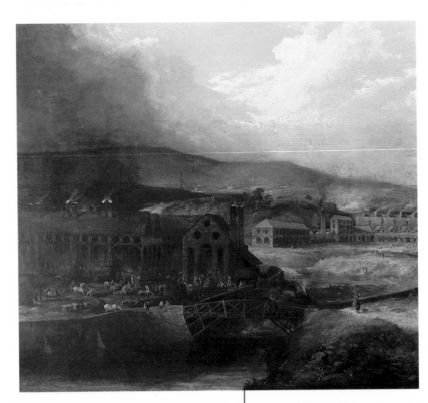

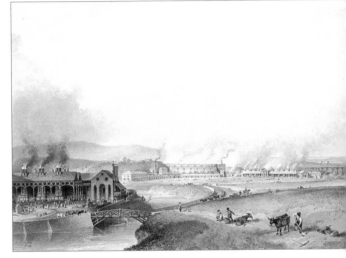

82. Penry Williams,
Cyfarthfa Iron Works,
c.1825, Oil,
1230 × 1800, detail

83. Penry Williams,
Cyfarthfa Iron Works,
1825, Watercolour,
149 × 211

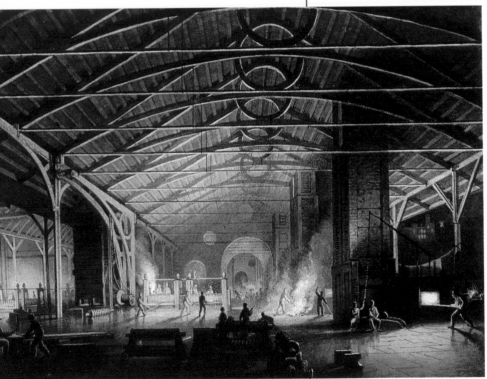

84. Penry Williams,
Cyfarthfa Ironworks Interior at Night,
1825, Watercolour,
157 × 210

[17] Charlotte Schreiber, *Lady Charlotte Guest: Extracts from her Journal, 1833–52,* ed. The Earl of Bessborough (London, 1952), p. 17.

represented a considerable change of approach from the works done for Crawshay before his training in London. A number of the watercolour series presented Cyfarthfa Castle and the industrial landscape together, either with the house in the foreground or, as in the most dramatic of the series, glimpsed at night through the open walls of the sheds which housed the furnaces and the rollers. As in the Petherick pictures of the Rhymney furnaces, in this view Penry Williams departed somewhat from his usual cool, insider observation, inspired like the Romantics by contrasts between dark and light, fire and smoke, heat and cold. The night-time scene at the works had now become such a convention that not only Romantic artists but the pragmatic owners themselves tended to see it in terms of pictures. On her first tour of her husband's nearby Dowlais works, shortly after their marriage in 1833, Charlotte Guest remarked that 'In the glare of the fires (from a little distance) the workmen formed groups which might yield fine studies for the painter'.[17] However, Penry Williams's view was rendered unusual in the genre by the inclusion of the tiny vignette of the castle, its windows glowing yellow in the night in patrician symbolism.

85. Penry Williams,
William Williams,
Cyfarthfa, c.1825,
Watercolour,
185 × 150

Among other watercolours painted by Penry Williams for William Crawshay II was one of the engineer William Williams, who was by this time bald and so obese that he had to be transported around the works on a specially constructed trolley. Nevertheless, of his celebrity there can be little doubt for, a few years later, he was painted yet again. William Williams was a member of the Cyfarthfa Hunt and in 1830 he was depicted with his colleagues in a fine group portrait.

86. W. J. Chapman,
The Cyfarthfa Hunt,
1830, Oil,
710 × 890

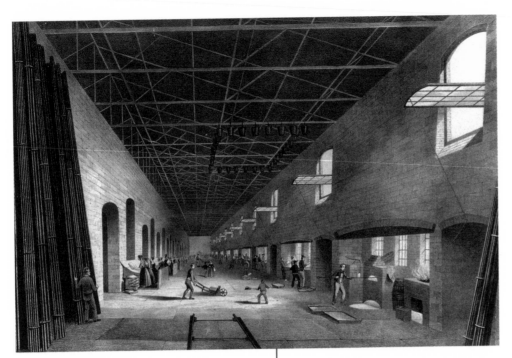

87. G. F. Bragg after unknown artist,
Trefforrest Tin Works, Glamorganshire,
c.1840, Lithograph,
310 × 462

The painter, an itinerant artisan called W. J. Chapman, based his likeness on the earlier of the portraits owned by the Crawshays. *The Cyfarthfa Hunt* provides an important insight into a part of early Merthyr society which has been obscured both by the vast wealth of the industrialists and by the appalling living conditions of the labouring classes. In stark contrast to the trials of those on the bottom of the social ladder, it was not only the industrialists who prospered but also a new middle class of tradespeople and skilled professionals, including engineers. The presence of many such talented and energetic people in Merthyr had led to the emergence of societies and institutions of various sorts at an early date. The Merthyr Philosophical Society, for instance, was founded in 1807, and although the Cyfarthfa Hunt no doubt had less elevated aspirations, it was, at the same time, a rather different phenomenon from the old established hunts patronized by the landed gentry. Among William Williams's colleagues who sat for the group portrait were merchants and shopkeepers, a solicitor, several publicans and a furnace manager.

88. J. Appleby,
Trefforrest Tin Works,
Glamorganshire,
c.1840, Lithograph,
315 × 475

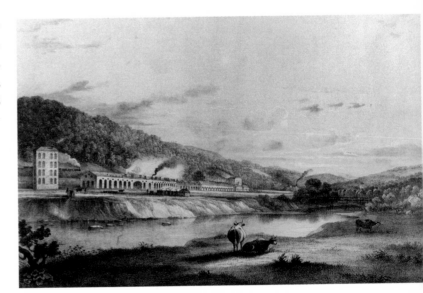

89. Anon.,

Francis Crawshay,

c.1845, Oil,

650 × 750

From among such people, and by means of their patronage, a remarkable number of artists and musicians emerged in Merthyr, including the sculptor Joseph Edwards, who became a member of the Philosophical Society.[18] Included in Chapman's picture of the hunt were a celebrated harper, Thomas Davies, and the fiddler William Richards, brother of the composer Brinley Richards.

The Cyfarthfa Hunt clearly established a reputation for W. J. Chapman in Merthyr because, sometime between 1835 and 1840, he was commissioned to paint perhaps the most remarkable series of portraits to emerge from industrial Wales. Once more, a member of the Crawshay family was the patron. In addition to Cyfarthfa, in 1819 William Crawshay II acquired an ironworks at Hirwaun which he set about modernizing. To work in tandem with it, Crawshay subsequently began the construction of a tinplate works at Treforest, between Merthyr and Cardiff, which was in production by 1835. The Treforest works was celebrated in about 1840 by the publication of a pair of lithographs, one of which was an unusual interior view by G. F. Bragg, which clearly showed men, women and children at work.[19] The prints were dedicated to William Crawshay but both the Hirwaun and the Treforest works were managed by his second son, Francis. It was Francis who commissioned W. J. Chapman to paint portraits of at least seventeen of his employees at the two works.[20]

Francis Crawshay was an unusual and somewhat reluctant industrialist. He spoke Welsh and maintained a close relationship with his employees which extended beyond the general paternalism of his father. He also befriended Dr William Price of Llantrisant and as a consequence became much interested in druidic affairs. The exploits of Frank Crawshay, as he was known, entered the folklore of the area,[21] although his father took a dim view of his original behaviour and his inability to make money. His portrait series was not entirely without precedent for there existed among the landed gentry a tradition of commissioning artisan painters to portray employees, and W. J. Chapman would benefit from such commissions on several occasions. The most celebrated pictures of this type were the series painted by John Walters of Denbigh for Philip Yorke of Erddig, near Wrexham, in the 1790s. However, no precedent seems to exist for paintings of industrial workers, and the Francis Crawshay pictures must be attributed

[18] Joseph Edwards was born in 1814, the son of a monumental mason. Details of his early life were given by another Merthyr sculptor and musician, William Davies (Mynorydd), in *Wales* (ed. O. M. Edwards), II (1895), 134–7.

[19] Bragg is unrecorded in the standard reference works, unless he is the Gerard Bragg, born in Liverpool, given by Benezit.

[20] The commission and the career of the painter are described in detail in Peter Lord, *The Francis Crawshay Worker Portraits* (Aberystwyth, 1996). Sixteen of the portraits survive in one group, but an additional portrait, which was in different ownership, has been lost.

[21] In 1929 Frank Crawshay was depicted by Lewis Davies in his novel *Y Geilwad Bach* as a kindly and paternalistic figure, much respected by his employees.

90. W. J .Chapman, *John Davies,*
Tin Mills Manager, Hirwaun,
c.1835, Oil, 355 × 265

primarily to the unusual character of the
patron himself. The portraits encompassed all
grades of employee, although no women were
depicted. Given the numbers employed and their
importance both as skilled and unskilled workers,
this is a difficult omission to interpret. It seems
unlikely to reflect sensitivity on the part of the
employer to liberal opinion concerning the
morality of using women and children in heavy
industry, since most employers supported the
practice. Neither can it be accounted for by
supposing that the portraits emphasized
managerial employees, for although the likes
of John Davies, manager of the tin mills at
Hirwaun, were well represented, so too were
craftsmen and labourers. All their faces were
finely painted by Chapman, although their
bodies and the backgrounds were more sketchily
done. All the men were shown in landscape
settings (which were more characteristic of

from left to right:
91. W. J. Chapman,
David Davies, Cinder Filler, Hirwaun,
c.1835, Oil, 355 × 265

92. W. J. Chapman,
Thomas Francis, Quarryman,
c.1835, Oil, 355 × 265

93. W. J. Chapman,
Rees Davies, Mechanic, Hirwaun,
c.1835, Oil, 355 × 265

94. W. J. Chapman,
David Lewis, Storekeeper, Hirwaun, .
c.1835, Oil, 355 × 265

Hirwaun than Treforest), and as a result, only those whose employment was
undertaken in the open air were depicted at work. For instance, David Davies,
a cinder filler, was shown enveloped in the smoke of the burning cinders which
he shovelled into a heap. The quarryman, Thomas Francis, was portrayed by
Chapman coming from his work with sticks of dynamite over his shoulder, the
pink stone of the quarry behind him drawn more clearly than the background of
any other of the pictures. Many of the men were shown with tokens of their trade.
Rees Davies of Hirwaun carried the dividers emblematic of the engineer, while
David Lewis drew back his coat to reveal the keys of the storekeeper.

On his visits to the Hirwaun works, Francis Crawshay frequented the Cardiff
Arms Inn in the town which, over the years, acquired a group of portraits of
local industrialists, including his own. According to tradition, the collection
became substantial enough to cause the mantelpiece to bend under the weight
of them, a situation which was resolved by propping the sagging woodwork with
two fine steel pillars, cast at Cyfarthfa for the purpose. According to John Lloyd:

> The portraits of Clark of Dowlais, Frank Crawshay, Robert Crawshay,
> Fothergill, Wayne and Lord Bute, hanging on the walls, add an interest
> to what we may call 'the steel pillar room'.[22]

[22] John Lloyd, *Old South Wales Iron Works*
(London, 1906), p. 17. The pictures are untraced.

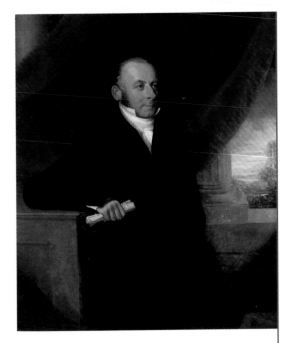

95. Anon.,
William Crawshay II,
c.1830, Oil,
1250 × 1000

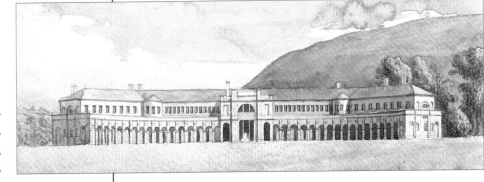

96. William Pamplin,
*Cyfarthfa House and the
Glamorganshire Canal*,
c.1800, Pencil,
430 × 650

97. Moses Griffith,
Lleweni Bleach Works,
c.1775, Watercolour,
69 × 185

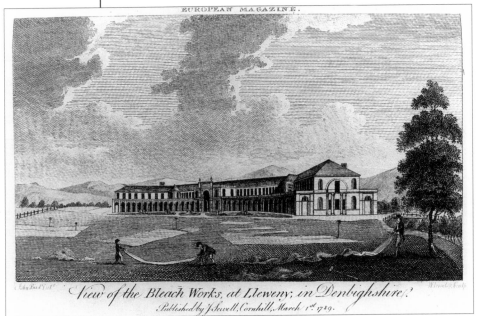

98. W. Bromley after John Bird,
. *View of the Bleach Works at
Lleweny in Denbighshire*,
1789, Engraving,
115 × 170

Francis Crawshay's father, William II, possessed all the conventional aggrandizing instincts which seemed to be absent in his son, and he expressed them fully in his building of Cyfarthfa Castle. His grandfather, Richard, had had no scruples about living over the shop, and he occupied Cyfarthfa House, built by his erstwhile partner, Anthony Bacon, until his death in 1810. William Pamplin had drawn it, four-square by the Glamorgan Canal, in the middle of the works. The design of the house reflected the famous portrait of its second owner which, solid and forthright, hung inside. However, the entrepreneurial excitement of the founders often waned in the sons and grandsons, and at least some of their creativity was diverted away from making money and into spending it.[23] Cyfarthfa Castle not only exemplified such a generational change in attitudes, but also a personal aspiration on the part of William Crawshay II to assert his independence of his father, who did not approve of extravagance. 'A great House and expensive establishment will not fight our Battle in Trade', he curtly remarked to his son in 1820.[24] However, such exercises in architectural self-assertiveness as Cyfarthfa Castle were ultimately directed to the world beyond the family. The imagery was addressed primarily to the owner's peer group and was made widely known by invitations to visit in person, by published written descriptions and through engravings. In the second half of the eighteenth century, although Thomas Pennant had not indulged in image-building of this sort on his own account, he too had been much involved in the use of pictures to advertise the displays of others. In addition to the mills and foundries of Flint, he had Moses Griffith draw the remarkable bleachworks constructed by his friend, Thomas Fitzmaurice, at Lleweni, subsequently published by Boydell.[25] It would be reported in *Black's Guide* in 1869, with the hindsight of a more pragmatic age, that Fitzmaurice (like Francis Crawshay) was 'distinguished by eccentric philanthropy'.[26] Nevertheless, he constructed, to the design of Thomas Sandby,[27] one of the most remarkable industrial buildings of the period.

At least four engravings of the bleachworks were published, the first of which, by John Bird, appeared in the widely-read *European Magazine* in 1789. The works was 350 feet long with a crescent-fronted arcade of 30 arches forming a backdrop to a statue of the River God Thames, disgorging into a pool and cascades descending to the river Clwyd over a mile away. The description, published with the picture, in the *European Magazine* must have gratified the proprietor greatly:

> The buildings – with the cloth on the Green, and the natural romantic country in the back-ground – form a most delightful view from the house – and it is highly worthy of the attention of those gentlemen who may chance to pass near it. – Perhaps it may be hard to say, whether they will be more delighted with the beauty of the place – or charmed with the politeness of its hospitable Master.[28]

[23] For the development of the Crawshays' industrial interests, see J. P. Addis, *The Crawshay Dynasty* (Cardiff, 1957). The relationship between William II and his son Francis was especially difficult. Addis remarks of Francis: 'Both he and his son were extremely odd characters, and William Crawshay was convinced that they were mad', ibid., p. 142.

[24] NLW, Cyfarthfa Papers, William I to William II, 22 September 1820.

[25] For Fitzmaurice's relationship with Pennant and a resultant series of political cartoons, see Peter Lord, *Words with Pictures* (Aberystwyth, 1995), pp. 76–8.

[26] Quoted by Peter Howell, 'Country Houses in the Vale of Clwyd – II', *Country Life*, vol. 162, no. 4199 (1977), 1966. Fitzmaurice would 'drive over to Chester in a coach-and-six and stand behind a counter to sell his produce', behaviour which was regarded as unusual in a gentleman.

[27] Thomas Sandby (1723–98) was brother to Paul. See Johnson Ball, *Paul and Thomas Sandby, Royal Academicians* (Cheddar, 1985).

[28] *European Magazine*, I (1789), 168. Within the bleachworks, flax produced on the Irish estates of the owner was processed.

99. Unknown architect,
Middle Row, Butetown, near Rhymni,
c.1825–30, photograph by Kevin Thomas

100. Paul F. Bourgeois,
Clasemont, Morriston,
c.1820, Oil

Sandby's design reflected the scholarly classical tastes of the eighteenth-century gentry, and the optimistic view that factories and fields might coexist suggested in the other engravings of industrial subjects initiated by Pennant. Housing for labourers and craftspeople was sometimes designed for employers in a similar rational spirit to display a paternalistic interest in the welfare of the workforce. The Butetown houses at Rhymni, with their deep Palladian eaves, represented a tradition of liberal concern for the housing conditions of the lower classes dating back well into the eighteenth century, which had resulted in the design in England of improved dwellings by a number of distinguished architects.[29] Enlightened attitudes to workers' housing were sometimes encouraged by the need to attract labour in periods of boom, and cultured architectural images were intended as much to create a good impression in polite society as to improve the lot of the labourer. Consequently, they sometimes masked houses which were scarcely better in quality than the rest. Nevertheless, there is no reason to view with absolute cynicism efforts such as those made by the Morris family at Morriston. William Edwards's new town, developed after 1768 around Robert Morris's 'castle' tenement, was conceived for his son John in essentially humane terms.

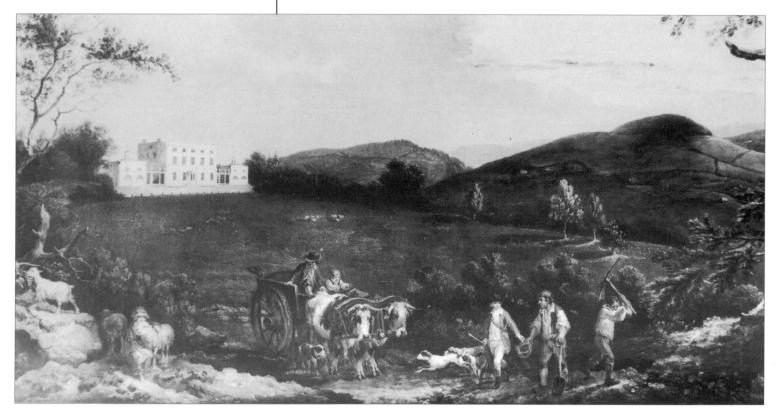

Like Morriston itself, John Morris's own new house, Clasemont, reflected classical tastes. It was built in 1775 by John Johnson, but soon became the victim of its owner's entrepreneurial skills. By 1806 the stench emanating from the works was affecting the whole of the lower Swansea valley from Hafod to Tŷ'r Canol. Clasemont was demolished and Sketty Park House was rather unsatisfactorily assembled by the Swansea architect William Jernegan, using, in part, salvaged material from the old building. Lesser beneficiaries of the industrial boom also removed to pastures green, from the Vale of Neath in the north to Gower in the south, where 'retired sea-captains and industrialists jostled for the best sea-side views for their houses and painstakingly cultivated gardens'.[30] Among them was a London-born solicitor, John Edwards, whose father had been a successful engineer. He commissioned his cousin, John Nash, to rebuild the family house of Rheola in the Vale of Neath in the Picturesque manner. Masquerading as a cottage, Rheola was, in fact, a substantial country house, but its avant-garde style with its reference to the habitations of the common people, however spurious, signalled to the gentry all around the arrival of new wealth and, in Edwards's case, radical politics.[31]

[29] Butetown may have been based on a planned village at Lowther, Cumbria, designed by James Adam in 1765.

[30] Thomas Lloyd, *The Lost Houses of Wales* (London, 1986), p. 74.

[31] For Edwards and Rheola, see Richard Suggett, *John Nash: Architect in Wales* (Aberystwyth, 1995), pp. 92–101.

101. Thomas Hornor, *Rheola, Vale of Neath*, 1816, Watercolour, 89 × 140

The different social and educational backgrounds of self-made men like John Edwards and William Thomas Forman were often reflected in more eclectic tastes than those of their long-established neighbours. Forman was inspired by the contemporary discoveries of English and French archaeologists working in the wake of imperial expansion outside Europe. Nevertheless, despite the Egyptian style of his furnaces, the massive stone ball which he set before them on a squat pillar seems likely to have been a symbol of man's new understanding and consequent harnessing of the great forces of nature through Newtonian science, rather than a reference to ancient or exotic mythology. William Crawshay II was of the same generation as Forman, and he also chose to present to the world a very different image of himself from that of John Morris. Cyfarthfa Castle was a medieval fantasy designed by Robert Lugar and completed in the boom year of 1825. That Crawshay, a leader in the most technically advanced industry in the world, should choose to present himself in the guise of a feudal lord of the middle ages might seem eccentric were it not characteristic of a number of his peers. Two years later Thomas Hopper began building Penrhyn Castle for George Hay Dawkins Pennant, who had inherited the slate quarries of the Bethesda area. Penrhyn Castle was built on a vast scale, much bigger than Cyfarthfa, and comparable with some of the greatest expressions of medieval revivalism all over Europe. Hopper was an English architect but was particularly popular with Welsh patrons. In addition to Penrhyn Castle, he built Llanover in Elizabethan style for Benjamin Hall (a relative of the Crawshays) and Margam in Tudor Gothic for the Talbot family. These historicist houses added a symbolic distance to the physical distance which their owners were placing between themselves and the source of their wealth. It is tempting to interpret this

102. S. Lacey after H. Gastineau,
Cyfarthfa Castle, Merthyr Tydfil,
c.1830–5, Engraving,
90 × 146

103. Thomas Hopper,
Penrhyn Castle,
1827

development as a reflection of an emerging mood of industrial gloom. The houses certainly coincided with increasing concern among intellectuals about the working conditions of the ordinary people. That concern would lead to enquiries such as the 1842 Report of the Children's Employment Commission, which shocked polite society with its comments on ironworks and mines, including those owned by the Crawshays. The complementary idea that industrial production methods resulted in the moral and spiritual degradation of workers, as well as their material exploitation, was also taking root. At a more immediate level, the paternalistic relationship between employer and employee established briefly by the Crawshays and the Guests, was rapidly being undermined by the stress of dealing with financial crises and difficult labour relations in the 1830s and 1840s. However, historicism had too long a pedigree in architecture for this early nineteenth-century outbreak to be interpreted exclusively in terms of a flight from the less agreeable aspects of modern industrial life.

William Crawshay II viewed the battle of trade not only in a pecuniary sense, but also in terms of prestige and politics. For all its size, Cyfarthfa was smaller than the Dowlais works of the Guests. Furthermore, although industrial wealth was often overlaid on the considerable resources of a long-established gentry class, those, like the Crawshays, who were truly nouveaux riches certainly felt social pressure and their vast houses 'implied a pedigree, even if none existed'.[32] Notwithstanding her liberal opinions, Lady Charlotte Guest came from a gentry family. Years earlier, on her first arrival at Dowlais, she had remarked of Crawshay that he was 'beyond all rule and description and is quite one of those meteoric beings whom it is quite impossible to account for'. His cousin, Joseph Bailey, had 'a low born purse proud cunning'.[33] Nevertheless, she had chosen to marry an industrialist, born in Dowlais and Welsh-speaking. Following the opening of the Great Exhibition in 1851 and subsequent hobnobbing with the Queen and Prince Albert, Charlotte Guest could

[32] J. B. Hilling, *The Historic Architecture of Wales* (Cardiff, 1976), p. 177.

[33] Schreiber, *Lady Charlotte Guest*, p. 41, 19 October 1836.

104. Anon.,
Dowlais House,
c.1840, Engraving

105. Penry Williams,
*The Procession to the
Christening in L'Ariccia*,
1831, Oil,
9140 × 12190

write in her diary, with some justification, that she was 'the wife of the largest manufacturer in the world'.[34] Shortly before his marriage Guest had rebuilt Dowlais House, which, like Cyfarthfa Castle, looked down on the works from an elevated position. Among his wedding presents to his wife in 1833 had been a painting, *The Procession to the Christening in L'Ariccia*, early fruit of the improved, Italianate Penry Williams. John Guest liked to buy pictures, and over the years added a number of others by Williams, including a portrait of Charlotte. They had commissioned a pair of portraits of themselves by A. E. Chalon shortly after their marriage and,

[34] Ibid., p. 271, 1 May 1851.

106. William Walker
after Richard Buckner,
Lady Charlotte Guest,
1852, Engraving,
420 × 320

107. William Walker
after Richard Buckner,
Sir Josiah John Guest,
1852, Engraving,
420 × 320

in 1846, Sir John had been sufficiently impressed by the work of Richard Buckner at the Royal Academy to commission a further pair. An annual visit to the Academy was now a regular part of the social round in which the new industrial rich rubbed shoulders with the old gentry. Richard Crawshay, it will be remembered, had gone to a Birmingham artisan for his portraits. Lady Charlotte's portrait was exhibited at the Academy in 1848 and both pictures were engraved for public edification. Similarly, later generations of the Crawshay family would also turn to establishment artists in London for family portraits, including Watts and Sargent.[35]

35 Charlotte Guest became an important collector of ceramics, but this interest does not appear to have developed until after the death of her first husband and her departure from Wales. See Ann Eatwell, 'Private pleasure, public beneficence: Lady Charlotte Schreiber and ceramic collecting' in Clarissa Campbell Orr (ed.), *Women in the Victorian Art World* (Manchester, 1995), pp. 125–45.

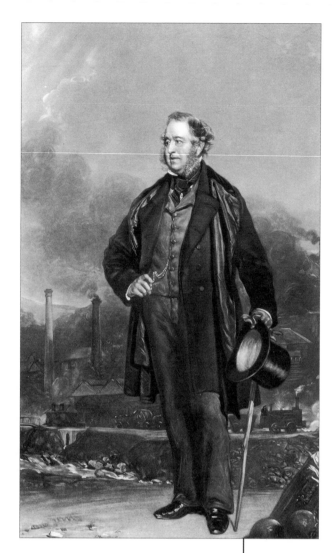

108. G. R. Ward after John Prescott Knight,
Thomas Brown, General Manager
of the Ebbw Vale Ironworks,
1861, Mezzotint,
618 × 377

Notwithstanding the patronage of Penry Williams by William Crawshay II and Francis Crawshay's remarkable worker portraits, commissions from the second and third generations of industrialists which directly celebrated the source of their wealth were generally unusual.[36] It is notable that the finest picture from the second half of the nineteenth century which repeated the iconography developed to celebrate the early entrepreneurs was neither of, nor commissioned by, an owner. The splendid portrait of *Thomas Brown, General Manager of the Ebbw Vale Ironworks*, painted in 1861, was commissioned by a public body with which Brown was associated, The Ebbw Vale Literary and Scientific Institution. Moreover, it was not the work of an artisan but of J. P. Knight, one of the most prolific academic portrait painters of the mid-Victorian period.[37] In this respect, the patronage of the greatest industrial dynasty of the north followed a similar pattern to the dynasties of the south. Richard Pennant, founder of the great Bethesda slate quarries, had himself portrayed in entrepreneurial splendour by Henry Thomas, towards the end of the eighteenth century. He stood pointing to a map of his new route over the mountains from Capel Curig, eventually incorporated in Telford's Chester to Holyhead road. In the background was the Royal Hotel, built by him at the same time to designs by Wyatt, in order to develop the tourist trade. On Pennant's death, the family commissioned Richard Westmacott, one of the most famous sculptors of the day in England, to make a tomb which was a remarkable attempt to integrate the high art conventions of the late eighteenth-century aristocracy with images appropriate to a new kind of person. A quarryman and a peasant woman, in unlikely classical *déshabillé*, mourned the departure of the great capitalist, while one of a series of vignettes around the tomb itself illustrated the quarrying process in naturalistic terms. However, the portrait and the memorial would have no descendants with a comparable iconography among the works commissioned by the two succeeding generations who inherited and developed the family fortunes.

[36] No painting of Treforest or of Cyfarthfa seems to have been commissioned subsequent to the Penry Williams pictures, for instance, although the Crawshay family owned just such a picture of a French steelworks. In 1818 George Crawshay, brother of Robert Thompson Crawshay, had married into a French steel manufacturer's family. In about 1840 the painter Ignace François Bonhomme was commissioned to paint their works and the picture was brought to Wales. Bonhomme was a leading figure in a revival of realist painting in France and his picture has a frame cut to resemble the shape of the front of the building. The attribution is traditional in the family. The painting has been incorrectly identified as Cyfarthfa in a number of publications. There are a number of portraits of this branch of the family also by Bonhomme.

[37] John Prescott Knight RA (1803–81). Among Knight's other Welsh sitters was Richard Hussey Vivian of Swansea, painted in 1839.

109. Henry Thomson,
Richard Pennant,
c.1800, Oil,
5940 × 2995

110. Richard Westmacott,
Memorial to
Richard Pennant,
1820, Marble

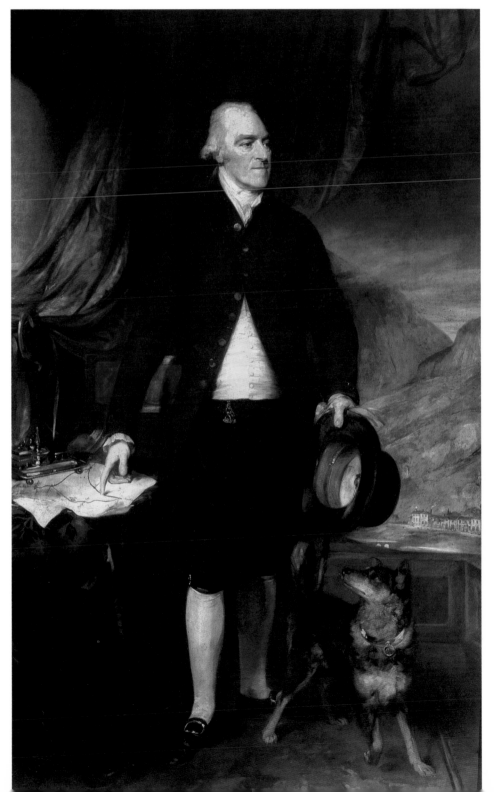

111. Unknown photographer,
The Dining Room,
Penrhyn Castle,
c.1900

Both George Hay Dawkins Pennant, builder of the castle, and Edward Gordon Douglas Pennant expressed their immense wealth in imagery which made no reference to its source. Although they were notable collectors of painting and sculpture, their collections included little of an industrial nature, or of Welsh national or even local iconographic interest. George Pennant, however, did develop local resources of both skilled labour and material on his vast building project, causing the patriotic Angharad Llwyd to remark that 'Mr. Pennant deserves the thanks and admiration of every friend of Wales for the almost exclusive encouragement he has given to the native artificers of every kind'.[38] Nevertheless, he and his son-in-law lined the walls of the extraordinary edifice mainly with old masters, including Cuyp, Ruysdael

112. F. R. Lee,
The River Ogwen at
Cochwillan Mill,
1849, Oil,
1140 x 1510

113. Hubert Herkomer,
*Edward Gordon, 1st Baron
Penrhyn of Llandegai*,
1881, Oil,
1260 × 890

and Rembrandt, several Canaletto landscapes, a Gainsborough portrait and an Italianate Wilson. Adding to his predecessor's acquisitions, Edward Pennant formed one of the finest galleries of European high art in Wales. However, at a time when some of his peers were interesting themselves in the development of Welsh art culture, he contributed nothing by way of patronage. The very small number of Welsh landscapes in his collection is particularly striking, given its location. He had no David Cox, then at the height of his prestige,[39] nor a single work by any of the younger Welsh landscapists such as Clarence Whaite or Benjamin Williams Leader, who were, by the 1850s, exhibiting at the Royal Academy and attracting critical attention. Edward Pennant bought *The River Ogwen at Cochwillan Mill* by F. R. Lee since it contained a portrait of his keeper and of his friend, General Cartwright, and a single Creswick, *Rain on the Hills*, which probably represents Dolbadarn Lake, but these were the only examples of the genre. Lord Penrhyn lived much of his life in England, generally returning to the castle for two periods only each year. He was heavily dependent in his collecting on the advice of a Belgian dealer and he seems to have experienced no patriotic excitement as a result of the Welsh revival which was stirring in his time. Along with Sir Watkin Williams Wynn, he was among the patrons of the Bangor fine art exhibition of 1869, in which contemporary Welsh works were shown with a loan collection of European high art. The family contributed a number of pictures and artefacts, but the opening was attended by his wife and daughters alone,[40] and it is clear that he did not take the leading role which might have been expected of both the richest man in the area and an art buyer on a large scale. His main contribution may have been indirect and more the consequence of his frequent absences than of his presence, since Penrhyn Castle was opened to the public from an early date – the only art collection of substance on view in the area. Only Lord Penrhyn's commission to Hubert Herkomer to paint his portrait at the castle in 1881 may indicate some awareness of the mood of artistic mission among his peers. The German painter involved himself with art in Wales as a result of his friendships with Cornwallis West of Ruthin Castle and Mansel Lewis of Stradey, both gentleman artists of a patriotic turn of mind.[41] The Penrhyn commission came in 1881, a year before Herkomer adjudicated for the first time at the National Eisteddfod.[42] The painter took the opportunity while at Penrhyn to engrave the Greuze painting, *La Petite Boudeuse*, but his relationship with the family did not flourish. Penrhyn's daughter, Alice, sourly remarked of the portrait: 'This picture is much disliked by the family, as a most unpleasing likeness.'[43]

[38] Angharad Llwyd, 'A History of the Island of Mona', *Prize Essay, Beaumaris Eisteddfod* (1832), p. 12.

[39] Cox was extensively patronized at Powis Castle, for instance. George Hay Dawkins-Pennant may have commissioned a set of eight estate views by the painter George Fennel Robson (1790–1833). See Alastair Laing, *In Trust for the Nation. Paintings from National Trust Houses* (London, 1995), p. 95.

[40] *Carnarvon and Denbigh Herald*, 14 and 21 August 1869.

[41] Mansel Lewis in particular was known as a painter and etcher. He exhibited at the Royal Academy between 1878 and 1882. See Chapter 3.

[42] See Peter Lord, *Y Chwaer-Dduwies – Celf, Crefft a'r Eisteddfod* (Llandysul, 1992), p. 49.

[43] The pictures, with the author's comments upon them, are listed in Alice Douglas Pennant, *Catalogue of the Pictures at Penrhyn Castle and Mortimer House in 1901* (Bangor, 1902).

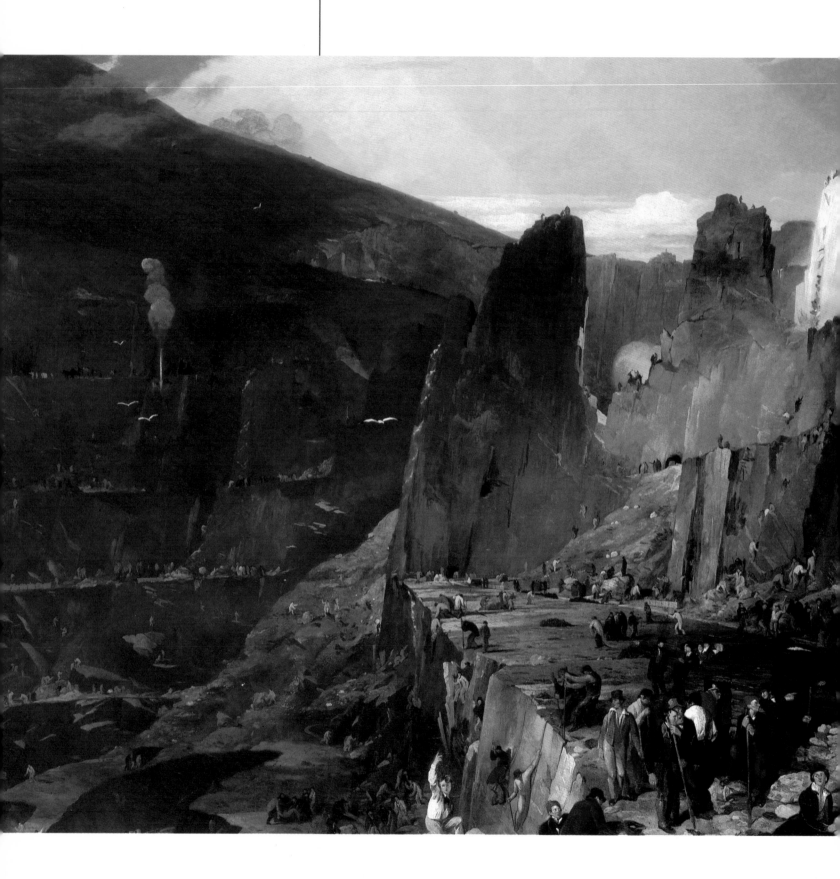

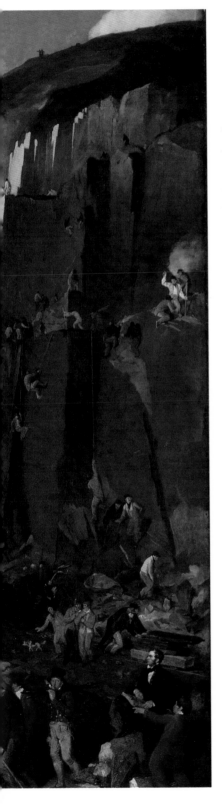

114. Henry Hawkins,
*The Penrhyn Quarry
in 1832*, Oil,
1320 × 1880

The single, and remarkable, exception to
the Penrhyn family's indifference to Welsh
iconography and industrial subject matter was
their purchase of *The Penrhyn Quarry in 1832*,
by Henry Hawkins, an English painter not
otherwise noted for his Welsh subjects.[44]
Princess Victoria visited the quarry in 1832
and although the picture is not a depiction of
this coup for Lord Penrhyn, its purchase may
be related to the event. However, although
the large canvas may have been painted and
acquired by George Pennant at around this
time (or, indeed, commissioned by him), it
is equally possible that it is the same as the
picture entitled *The Great Bangor Slate Quarries,
North Wales*, which was exhibited at the Royal
Academy in 1848. In this case, it would have
been bought by his son Edward. The stylistic
evidence certainly suggests that the picture
was painted in mid-century on the basis of
drawings made earlier. Despite the drama
of the landscape, the picture did not attempt
a sublime and threatening otherworldliness,
concentrating instead on the accurate detailing
of the workers in the manner coming into
vogue with the Pre-Raphaelite Brotherhood.
It displays a distinct tendency to portray the
men striking noble poses,[45] in contrast to
the artisan depiction of Francis Crawshay's
employees in the series of 1835–40. In the
foreground, a gentleman views the scene of
frenetic human activity with an apparently
detached and technical interest. This may
be the artist himself.

[44] He exhibited only a portrait of *John Wynne of
Garthmeilo* and *A Welch Peasant Girl* at the Royal
Academy in 1831 and 1832.

[45] In the centre foreground is a gesticulating boy
who adopts the pose of Reynolds's *Infant John the
Baptist*. Laing, *In Trust for the Nation*, p. 95.

115. George Hayter,
C. R. M. Talbot,
1834, Oil,
385 × 335

116. Anthony Keck,
The Orangery at Margam,
1787

[46] Rollo Charles, 'Some Penrice Pictures' in Stewart Williams (ed.), *Glamorgan Historian, Volume 5* (Cowbridge, 1968), p. 218.

[47] For the Swansea potteries, see Morton Nance, *The Pottery and Porcelain of Swansea and Nantgarw*. For William Weston Young, see Elis Jenkins, 'William Weston Young' in Williams (ed.), *Glamorgan Historian, Volume 5*, pp. 61–101. The view of Pontypridd bridge is reproduced on p. 41.

[48] 'The diary of Lewis Weston Dillwyn', 5 March 1824, *South Wales and Monmouth Record Society, Publications*, no. 5 (1963).

[49] 'The diary of Lewis Weston Dillwyn', ibid., 13 July 1829. Dillwyn also notes the painting of his own portrait and that of his wife Mary by Leslie, and a number of other commissions and purchases, as well as visits to exhibitions and his voting in the House of Commons in favour of the purchase of two Correggios by the National Gallery. He refers to the new Margam as 'Talbot's Palace'.

In the south, the case of the Mansel Talbot family at Margam offers close parallels to that of the Penrhyn family in the north. Immediately prior to the industrial period, the ancient Welsh line failed and Margam and Penrice passed to an English branch of the family in the person of Thomas Mansel Talbot. Like their northern contemporaries, the Mansel Talbots built a new home, and bought old master paintings and sculpture to fill it. Thomas Mansel Talbot exploited the industrial potential of the south not, in the main, as an entrepreneur, but as a landowner, granting leases for copper processing and coal extraction. He had gone on the grand tour, and in 1775 despatched no fewer than twenty-three cases of pictures and sculptures from Leghorn to Mumbles. Many of these were acquired through the famous dealer in Rome, Gavin Hamilton, and included a number of forgeries as well as genuine works by notable Italian masters. The other great art entrepreneur of Rome, Thomas Jenkins, is believed to have sold him works by Poussin and Rembrandt.[46] Thomas Mansel Talbot had less respect for his native tradition than for that of Italy and he demolished the medieval house at Margam. He commissioned the architect Anthony Keck to build him a villa at Penrice, in which he installed himself. Subsequently, in 1787, Keck built the Orangery at Margam, one of the most notable buildings of the eighteenth century in Wales. Thomas Mansel Talbot also commissioned some pictures, notably a set of sporting scenes by Sartorius, which included his own portrait, at full gallop.

Thomas's son, Christopher Rice Mansel Talbot, was of a more entrepreneurial turn of mind, and developed the estates considerably, investing also in railways and in the new port which carried his name. He became immensely rich and, no doubt inspired by the architect's work for Lord Penrhyn at Bangor, commissioned Thomas Hopper to build a new Margam for him in Tudor Gothic. It was a similarly vast undertaking, not finished until 1844. Christopher Rice Mansel Talbot was a more confident connoisseur than Lord Penrhyn, and relied largely on his own judgement in his patronage, which included a commission to William Morris for windows in the rebuilt Margam Abbey church. In 1834 he was painted by Sir George Hayter in preparation for his vast composite picture of the reformed House of Commons. The artist sketched him as a romantic young aesthete, an unlikely image given the context of the finished painting. He spent considerable sums of money in the sale rooms, and also advised others, including his rich

117. Anon.,
perhaps Penry Williams,
William Weston Young,
c.1818, Ink,
159 × 152

118. J. Simpkins after
William Weston Young,
Conferva fucoides from Dillwyn's
British Confervae,
1806, Engraving,
175 × 248

neighbour and friend Lewis Weston Dillwyn, proprietor of the Cambrian Pottery. In his diary for 4 July 1835 Dillwyn noted blandly: 'I went to meet Talbot at a picture Sale, where by his advice I bought a Titian and 5 other pictures.' On other occasions, he bought works by Van Huysum and de Capelle, which also clearly reflected Talbot's taste.

Dillwyn employed artists as a part of his business at the Cambrian Pottery. The factory had been established in the 1760s by the Quaker ironmaster William Cole. In the late 1780s George Haynes joined the company which, under his direction, began to produce high-quality work. It was Haynes who had employed Thomas Rothwell at Swansea and also Thomas Pardoe, who became the Cambrian Pottery's most distinguished decorator. Lewis Weston Dillwyn took over the company, with Haynes as manager, and introduced his friend and fellow Quaker, William Weston Young, to work alongside Pardoe. Young's work reflected the owner's deep interest in botany and zoology. As well as decorating ceramics, he provided nearly half the illustrations for Dillwyn's botanical work *British Confervae*. Dillwyn and Young became involved in the celebrated attempts of the ceramicist William Billingsley to produce high-quality porcelain at Nantgarw, north of Cardiff, and lost considerable sums of money as a consequence. However remarkable its technical and artistic achievements, Nantgarw was an economic disaster. Pardoe decorated much of the remaining stock following the final collapse of the venture in 1820, some of it with Welsh imagery, including a view of the Pontypridd bridge.[47]

Dillwyn was also a member of the circle of industrialists exploited by the young Penry Williams. In 1824 they were together in London, where Williams was introduced by him to the painter C. R. Leslie.[48] It may be that Williams's panoramic *Swansea Town and Bay* was associated with Dillwyn, since it clearly showed the pottery. However, Dillwyn's patronage of contemporary painters was dominated by portrait commissions to Leslie, who, like his patron, had family origins in the United States. The most notable of these works was the family group clustered around the deathbed of Dillwyn's daughter in 1828. Dillwyn noted in his diary: 'In the morning early I had sat for my Portrait in the affecting picture which Mr Leslie is now making.'[49]

119. Penry Williams,
Swansea Town and Bay,
c.1830, Oil,
803 × 1408

120. Unknown photographer,
Interior of Margam Castle,
c.1850

[50] John Henry Vivian MP and his son, the first Lord Swansea, formed a notable connoisseur collection which was dispersed in 1919. See *Western Mail*, 14 October 1919.

[51] Harris painted a number of industrial scenes, notably *View of the Hafod Copper Works*, c.1850, Glynn Vivian Art Gallery.

[52] *Ceninen Gwyl Dewi* (1898), 45. The description of the bust is quoted in John Vivian Hughes, *The Wealthiest Commoner, C. R. M. Talbot, 1803–1890* (Port Talbot, 1978), p. 19. How Talbot and Griffith became acquainted is not known.

[53] The Menelaus pictures were bequeathed to the Cardiff Museum and subsequently became part of the National Museum collection. They were catalogued by Edwin Seward and T. H. Thomas, also important contributors to the 1880 Merthyr exhibition.

[54] The surviving evidence suggests that fewer engineer portraits were commissioned in the middle of the nineteenth century than at the beginning. Cyfarthfa Castle and Museum has only one, an unidentified individual painted by W. E. Jones. Parker Hagarty was born in Australia but made his career in Cardiff. He was best known as a landscape painter and exhibited regularly in the National Eisteddfod and with the South Wales Art Society. The South Wales Institute of Engineers commissioned at least six portraits, including one by Margaret Lindsay Williams.

The parallel between the taste of C. R. M. Talbot and that of Lord Penrhyn is striking. Talbot bought works attributed to Dutch masters, notably Cuyp, Italian masters including Titian and Rubens, as well as Canaletto, Van Dyck and Claude. Together with his father's collection of classical sculpture, most of it pillaged from Hadrian's Villa by Gavin Hamilton, it formed the finest collection in south Wales. C. R. M. Talbot showed marginally more interest in local iconography and indigenous productions than Lord Penrhyn. He was patron of the splendid 1880 art exhibition, held at the Drill Hall in Merthyr, which brought together many works by artists associated with the area and some industrial subject matter. Nevertheless, Talbot's own tastes do not seem to have encompassed industrial imagery. Ibbetson's work found its way into his collection, as it did into many others in the area. He also commissioned the Swansea marine painter James Harris, senior, to paint pictures for him on a trip around Cape Horn. Harris was patronized by a number of prominent families in the Talbot circle, notably the Llewellyns and Vivians,[50] perhaps mainly because he was a local artist, but his work for Talbot probably arose from his patron's particular interest in sailing.[51] Most intriguing of Talbot's Welsh works were sculptures by Milo ap Griffith. According to John Lewis, writing in 1898, Talbot was 'a great admirer and one of his warmest supporters'. In 1879 he commissioned a bust (in which he was depicted in the guise of a Roman senator), and in 1882 he bought *Summer Flowers*.[52]

A copy of Milo ap Griffith's bust of Talbot was displayed at the 1880 Merthyr exhibition, along with works from Cyfarthfa and from the collections of many lesser figures associated with industrial enterprise in the area. Occupying a unique and important place among these was the collection of William Menelaus who had begun his working life as a carpenter but who had risen to be a managing partner at Dowlais. His collection would eventually include works by Tissot and Alma-Tadema. In Merthyr he showed oils by Millais and Constable and watercolours by Cox and Cotman.[53] In 1857 Menelaus was among the founders of the South Wales Institute of Engineers, and was its first president. In the early twentieth century this body would continue the nineteenth-century tradition of engineer portraits. The first picture to be commissioned was of Menelaus himself, painted by Parker Hagarty in 1907.[54]

121. Parker Hagarty,
William Menelaus,
1907, Oil,
1250 × 900

122. Unknown
photographer,
William Menelaus,
c.1907

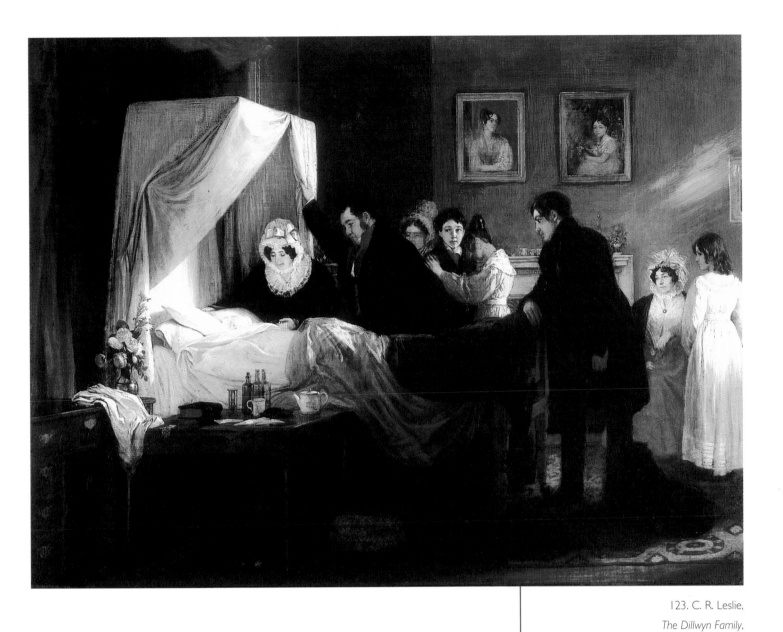

123. C. R. Leslie,
The Dillwyn Family,
1829, Oil,
580 × 790

124. James Harris,
*View of the Hafod
Copper Works from
the East Side of
the River Tawe*,
c.1850, Oil,
887 × 1396

125. Milo ap Griffith,
C. R. M. Talbot,
1879, Bronze, 650 h.

55 Calvert Richard Jones's father owned much of the centre of Swansea and he had extensive mineral and coal interests. Daguerreotype photographs were available to the public at a very early date in Swansea. On 7 May 1842 *The Cambrian* newspaper carried the first of a number of notices, extending to 1 October of the same year, inserted by Mr Langlois who was taking portraits at the Royal Institution.

126. Calvert Richard Jones,
Margam Castle,
1841, Daguerreotype,
150 × 240

Perhaps the most remarkable aspect of the art interests of the circle of family and friends around the Dillwyns and Talbots in Glamorgan was their pioneering work in photography. The earliest surviving Welsh photograph is a Daguerreotype of C. R. M. Talbot's new house at Margam, taken in 1841. The photographer was Calvert Richard Jones, a friend of Talbot's since their student days at Oxford. Calvert Richard Jones had learned about photography because Talbot was a first cousin to Henry Fox Talbot, who developed a photographic process in England in 1839 around the same time that Daguerre developed his rival process in France. Fox Talbot was in close touch with his Welsh cousins and C. R. M. Talbot's daughter, Emma, and her husband, John Dillwyn Llewelyn, were made aware of his invention immediately. With Calvert Richard Jones and also Llewelyn's younger sister Mary, they began their own experiments. John Dillwyn Llewelyn was the son of Lewis Weston Dillwyn of the Cambrian Pottery, and the wealth contained within this labyrinthine set of relationships among the industrial elite of Swansea enabled the young people to combine their scientific and artistic interests in pursuit of the new medium.[55]

127. Calvert Richard Jones,
Self-portrait of the photographer,
c.1845, Calotype,
218 × 160

128. Unknown photographer, *John Dillwyn Llewelyn with his wet collodian outfit*, c.1853, Collodian

The photographers made use both of Daguerre's process and the negative/positive process of Fox Talbot which had been refined by 1841 and was known as the Talbotype or Calotype process. John Dillwyn Llewelyn's most memorable pictures were, perhaps, his studies of people in the landscape. The sitters were very often members of his own family, but he also recorded working people such as a *Hay Girl at Penllergare*, probably taken in about 1853. He took many photographs by the sea, in which he shared a particular interest with Calvert Richard Jones. In 1854 he showed a substantial number of prints at the exhibition of the Photographic Society of London and the following year his sequence of four prints called *Motion* won a silver medal at the Exposition Universelle in Paris.[56] Calvert Richard Jones has received less attention than his friend, partly as the result of the mistaken attribution of many of his pictures to Fox Talbot. The confusion arose because Jones sent some of his negatives to be printed at Fox Talbot's laboratory in Reading. Calvert Richard Jones took his early pictures in Wales, notably in and around the docks in

[56] For John Dillwyn Llewelyn, see Richard Morris, *John Dillwyn Llewelyn, 1810–1882, the first photographer in Wales* (Cardiff, 1980).

130. John Dillwyn Llewelyn, *Hay Girl at Penllergare*, c.1853, Collodian

129. John Dillwyn Llewelyn, *Thereza and Emma at Caswell Bay*, 1853, Collodian

Swansea, but his most remarkable achievement was the series of Calotypes he produced on a Mediterranean tour in 1845, in the company of C. R. M. Talbot and his family. He was the first person to photograph many of the antiquities of the area, such as the Coliseum in Rome.[57]

The creative interest of these men and women in photography seems to have waned in the 1850s and 1860s as techniques advanced and the medium became accessible to many more people. Nevertheless, it was at this time that Robert Thompson Crawshay of Cyfarthfa began to take photographs.[58] Early in his career he had exhibited some of the familiarity with the working people for which his half-brother Francis was noted. He was deeply interested in music and established the famous brass band for the workers at Cyfarthfa. The degree of his early paternalism can be measured by the acute sense of betrayal he felt at the unionization of the workers in mid-century, and his subsequent embittered estrangement from them. Robert Thompson Crawshay's sense of isolation was intensified by his becoming deaf, and it was as a result of this misfortune that he diverted his artistic interests into photography. He had a mobile darkroom constructed to enable him to photograph landscapes and although these compositions sometimes contained portraits of himself or his associates, more often they seem oppressively desolate. The empty shells of the closed Cyfarthfa and Penydarren works provided him with magnificent still life subjects which

131. Calvert Richard Jones,
Coliseum, Rome,
1845, Calotype

132. Robert Thompson Crawshay,
The Penydarren Works in Ruin,
c.1870, Albumen print

133. Robert Thompson Crawshay,
Penry Williams, c.1866/7,
Albumen print

134. Robert Thompson Crawshay,
Rose Harriette Crawshay,
c.1870, Albumen print

echoed his mood of intense isolation. Crawshay also took large numbers of studio portraits of his family, especially his daughter Rose Harriette (known as Trotty), posed in exotic costumes. These sittings and also the work of developing plates which she was required to do by her father became a serious trial to Trotty as Robert Thompson Crawshay declined into a tyrannical figure, filled with resentment against the world. In his will, he asked that his gravestone be carved with the words 'God forgive me.'[59]

[57] For Calvert Richard Jones, see Penny Cotter, *Calvert in Camera* (Cardiff, 1990).

[58] Augusta Hall, Lady Llanover, also took photographs in this period. Robert Thompson was the eldest son of William Crawshay II's second marriage.

[59] The development of Robert Thompson Crawshay's interest in photography can be traced in detail in his correspondence, NLW, Cyfarthfa Papers, Vol. 6, Letter Book, 1865–70.

135. Julius Caesar Ibbetson,
Portrait Group, Cardiff Castle,
1789, Oil,
643 × 895

Despite his great wealth, Robert Thompson Crawshay was not notable as a connoisseur of painting by comparison with the Talbot and Penrhyn families. However, even their substantial investments were cast into deep shadow by the patronage of the third marquess of Bute. Like the others, the foundation of Bute's vast wealth was ownership of land on which extraction industries and refining were developed. Bute was the landlord of the Guests at Dowlais, for instance, though that particular relationship was a source of tribulation to both parties. The lease provided Bute with meagre returns, and the landlord's attempts to revise it would have resulted in the closure of the great works had not the second marquess conveniently perished a few weeks prior to its termination in 1848. When his infant son came of age, twenty years later, he was reckoned by most observers to be the richest man in Britain.

The founder of this fortune, John, fourth earl and first marquess of Bute, son of a former Prime Minister who was a considerable patron of the arts, had been a somewhat distant figure in Wales. Nevertheless, he had taken advantage of Ibbetson's presence on his tour of 1789 to commission a group portrait which marked the early stages of the family's involvement with the town of Cardiff. The earl and his heirs were depicted among a bevy of local dignitaries in the picturesque ruin of Cardiff Castle, which he owned.[60] Through the window opening on the left, Ibbetson symbolized the town by a glimpse of St John's church, and through that on the right, the family by a view of the castle house. The second marquess consolidated this relationship and built the docks through which the town would flourish. Its population in 1821 was 3,521 but by the time the third marquess came of age it had risen by a factor of more than ten. In 1901 the population reached 164,333 and was still rising rapidly.

As was the pattern in the other great industrial families, the entrepreneurial zeal of the father waned in the son. On his majority in 1868, *The Times* gave voice to the curiosity of all about the third marquess's money by asking peremptorily:

[60] There is some doubt as to whether the figure at the centre of the group is the fourth earl. It may represent his father.

'What will he do with it?'[61] The answer was that he would spend it.
Among a number of building projects, he created two of the most
extraordinary architectural fantasies in Europe at Cardiff Castle
and at Castell Coch, just outside the town. In 1874, reviewing an
exhibition of his plans for Cardiff Castle, *The Architect* observed:

> The thoughts and occupations of the owner are translated in the
> things surrounding him; there is style in them – not the style of the
> multitude, but of a grand seignior who, from circumstances, has
> more sympathy with the past than the present; who is poet enough
> to choose poetical illustrations for the decoration of his favourite
> rooms; and who, blest with vast hereditary possessions, chooses
> to make a little world of them and live in it.[62]

The Architect was not entirely accurate in this assessment. The third
marquess did not neglect the development of the resources in this world
which financed his fantasy of another. Nevertheless, his spiritual retreat
into the middle ages was certainly wholehearted. On his majority he had
converted to Roman Catholicism. Among a substantial group of scholarly
writings on a variety of historical topics, his translation of the Roman
Breviary was his magnum opus. He employed the architect William
Burges to give expression to his passion for the Catholic middle ages.
The two men had met in 1865 and until his death in 1881, with his work
incomplete, Burges was an intimate family friend as well as an employee.
The Architect's critic was correct in observing that Bute's taste was not
that of the multitude, but incorrect in the implication that his ideas bore no
relation to the needs of the contemporary world. Bute and Burges shared a
passion for the ancient material they studied, but the marquess also sought to
present himself to the world as a man in pursuit of a moral mission. He believed
that his scholarly passion would be translated into art works which would 'make
people better'.[63] It was a mission shared by contemporary Welsh art intellectuals.
In very much the same terms as those used by Cornwallis West at the opening of
his massive Fine Arts exhibition at the Ruthin National Eisteddfod,[64] in 1868
Bute addressed successful students at the Cardiff School of Art:

136. George Berwick Rodger,
The third marquess of Bute,
c.1890

[61] *The Times,* 4 January 1869.

[62] *The Architect,* XI (1874), 147.

[63] *Cardiff and Merthyr Guardian,* 12 December 1868.

[64] See Lord, *Y Chwaer-Dduwies,* pp. 41–4.

137. William Burges,
Summer Smoking Room, Cardiff Castle;
paintings by F. Weekes and H. W. Lonsdale;
carvings by Thomas Nicholls;
tiles by Simpson,
photograph by Francis Bedford,
1878

138. William Burges,
The Clock Tower, Cardiff Castle,
photograph by Francis Bedford,
1879

139. Axel Herman Haig,
Winter Smoking Room, Cardiff Castle,
1870, Watercolour,
403 x 352

I would remark upon the state of art in Cardiff. The immense and sudden increase of this town in material prosperity has been but slightly accompanied by a development of taste for, and encouragement of art ... It is a state of things which all of us who love art and Cardiff must much regret and try and rectify. I am, personally, painfully alive to the fact that the castle is very far indeed from setting anything like an example of art. All I can say is, that that is a defect which I hope to see remedied in time.[65]

The fourth earl of Bute had been pleased to be represented to the world by Ibbetson in the context of the castle as a picturesque ruin. In a more morally pro-active age, his grandson did not find passive reverie a sufficient response to the past, and set to work to improve the present. In his report on the potential for development of Cardiff Castle, commissioned by Bute in 1865, Burges had presented three options: '1. The Strictly Conservative, 2. The Antiquarian, 3. The Modern.' Bute opted emphatically for the modern, as he would, again, at Castell Coch following Burges's report in 1872. Together, patron and architect were able to construct the most ambitious embodiment of aesthetics which were broadly shared by a generation of artists and writers – the generation of Ruskin, of the Pre-Raphaelite Brotherhood and of the Art and Craft Movement. As we have seen, the historicism expressed at an earlier date in the patronage of Penrhyn, Crawshay and Talbot was only marginally attributable to a rejection of the world which their own activities had helped to create. That of Bute was deeply affected by a widespread revulsion among contemporary intellectuals towards the dark side of industrialization.

Burges proposed to transform the old house by the castle keep (on which Henry Holland and 'Capability' Brown had worked) by adding five dramatic towers, housing a series of rooms decorated with painting, sculpture, glass, ceramics and furniture of complex iconography. The Clock Tower rooms, appropriately, developed the theme of time. In the winter smoking room, one source was Norse mythology. The bedroom above was decorated with themes from geology and legend. The summer smoking room was a microcosm. In the Bute Tower, the themes were more various. The sitting room had allegories of the seasons, while at the top, the roof garden was adorned with scholarly borrowings from medieval Christianity, Roman domestic architecture, and the Hebrew *Book of Kings*. The finest specialist manufacturers in metals, glass and ceramic tiles were employed on a lavish scale, and workshops were established in Cardiff to produce the woodwork. The effort was soon doubled by the reconstruction of Castell Coch from the medieval foundations upwards. Even the death of Burges did not inhibit the work greatly; it was pursued to completion in the early 1890s, following to the letter the architect's intentions where known, or otherwise, their spirit. For those unable to visit the sites themselves, detailed perspective views, exhibited at the Royal Academy and published widely, were commissioned by Bute from Axel Herman Haig, a Swedish émigré artist, 'the perfect expositor of Burges's special genius'.[66]

[65] *Cardiff and Merthyr Guardian*, 12 December 1868.

[66] J. Mordaunt Crook, *William Burges and the High Victorian Dream* (London, 1981), p. 85.

right: 140. William Burges, *Castell Coch*, photograph by Kevin Thomas, 1998

below right:
141. H. W. Lonsdale, *Robert the Consul*, Mural in the Banqueting Hall, Cardiff Castle, c.1875, Oil.

Neither industrial pride nor the patriotic expression of Welsh identity were to be counted among the many otherwise characteristic visions of the age made manifest at Cardiff Castle and Castell Coch. For all the importance of Wales to Bute and of Bute to Wales, the third marquess remained stubbornly an Anglicized Scot. As an antiquarian, he was well aware of Welsh literary tradition and, indeed, was a supporter of the Eisteddfod in a modest way. His architect studied the castles of Conwy, Caernarfon and Caerphilly, and borrowed from them. Their work was eclectic to a degree perhaps unsurpassed by any patron and architect before or since, and left contemporary critics, even in an age of prodigious aesthetic borrowing, thoroughly bemused. Yet Welsh material was confined to some carvings of animals from the Mabinogi and the ambiguous subject of the life of Robert the Consul, a twelfth-century Norman Lord of Glamorgan, depicted in the murals in the banqueting hall of Cardiff Castle. Consequently, these extraordinary works of art, which attracted such detailed attention in the English press, passed almost without comment in Wales outside Cardiff. Commentators of the period of the national revival had almost nothing to say of them. Notwithstanding the admiration of Tom Ellis and O. M. Edwards for Ruskin and Morris, the implementation of their ideas in Bute's aristocratic and Catholic tradition made the castles seem like foreign bodies. Despite the abilities of a number of contemporary sculptors such as Milo ap Griffith, no Welsh artists were commissioned, so deep was the commitment of Burges to his own circle of workers. To nationalists, it must have seemed a huge opportunity missed. Yet, ironically, it was Bute's vast investment which indirectly facilitated the production of many important expressions in art of the national revival. Among the local artisans who found employment at the Bute workshops was Thomas John, a joiner and carver from Cowbridge. John carved figureheads for ships, among other things. At the Bute workshops he prospered and became foreman, producing carving and inlay work. His son Thomas worked with him,

142. William Goscombe John,
Portrait of Thomas John (Senior),
1888, Pencil,
151 × 119

above and opposite:
143. Thomas John (Senior),
Drawings for inlay panels,
c.1870, Watercolour,
564 × 87

in particular on the inlay work in the Chaucer room.[67] His other son, christened plain William John, later adopted a name from his mother's side of the family to become William Goscombe John. He, too, worked under his father in the workshops, and later recalled his contribution:

The inlay work in the Clock Tower was done before 1874 ... My father did it all and during the years that the work was in hand was on most intimate terms of friendship with Burges and the various London artists and art workmen who carried out Burges' designs. Thomas Nicholls, sculptor of London, made the models for all the sculpture and his men were sent down to carve them. He did all the stone sculpture ... It was through my father's friendship with Burges and Nicholls that I went up to Nicholls' studio as a pupil assistant.[68]

144. Thomas Nicholls,
Cardiff Castle Library Chimney-piece, 1874

[67] Thomas John, senior, was born at Llantrithyd, near Cowbridge in 1834. He was apprenticed there to a cabinetmaker. 'During these formative years he came under the influence of cultivated people in the district and was much interested in music and literature ... Early in the sixties he took up wood carving and, later on, inlaying when engaged in the Bute workshops ... He died June 27th, 1893 at Cardiff ...' NMW, Artists' Files, William Goscombe John, letter dated 25 February 1931.

[68] Ibid., letter to Isaac Williams, dated 7 November 1929.

145. *Ceiling at Tal-y-garn,*
Pont-y-clun, c.1879

146. *Tal-y-garn, Pont-y-clun,*
photograph by
Kevin Thomas,
1998

Goscombe John stayed in Nicholls' workshop for five years, before entering the Royal Academy schools in 1884. At the suggestion of Bute, who made a substantial donation towards the fund raised to help him, he went to Greece, Egypt and Turkey in 1889. He returned to work in his London studio on the kind of national imagery so conspicuously absent from the greatest single act of art patronage ever made in Wales itself.

The marquess of Bute's lack of interest in particularly Welsh subject matter and forms was echoed in the more limited but nonetheless substantial patronage of other industrialists in the Vale of Glamorgan in the high Victorian period. Some of them, including the Cory family at Dyffryn, built on a grand scale but most filled their houses with the products of foreign artists and workshops. Notable among them was George Thomas Clark, a Londoner by birth, who made his way upward by means of both private enterprise and public office. From 1852 he was closely involved with the management of Dowlais, where William Menelaus, later also to become a buyer of art, figured among his protégés. Between 1865 and 1898 Clark completely remodelled Tal-y-garn, an ancient farmhouse near Pont-y-clun, as a mock-Tudor mansion, reflecting his antiquarian interests. He fitted it out with fireplaces, painted ceilings, carved and inlaid woodwork, almost all of which was of Italian origin. 'The tiles in the entrance lobby and conservatory and the two battle-pieces are from Biustinaini of Naples', he remarked, 'bought when I was there with Talbot', emphasizing the social interaction which directed the taste of this network of industrial art patrons. Clark was responsible for the general design of some of the commissioned work at Tal-y-garn.[69]

69 A typescript copy of Clark's own account of the work at Tal-y-garn is held in NMW, People and Places Files. Clark's 'Biustinaini' is probably an error for Giustiniani.

148. John Evan Thomas,
The second marquess of Bute,
1852, Bronze

147. Milo ap Griffith,
John Batchelor,
1886, Bronze,
by an unknown
photographer,
c.1890

Most of the industrialists were recorded for posterity by painters, either for their own purposes or for the institutions with which they were associated, but few were celebrated in sculpture. In the case of the marquess of Bute, given both his association with the town of Cardiff and with Goscombe John, this is somewhat surprising. Had Cardiff been inclined to commission such a piece, John would have been the obvious choice of artist, but the relationship between the Liberal-dominated council and the Bute estate was a troubled one.[70] Bute's father, the second marquess, had been celebrated by the erection of a statue by John Evan Thomas in 1852. It was paid for by public subscription and stood in front of the old town hall.[71] However, the year of the unveiling of the statue was also that of the Liberal victory over the Conservative candidate supported by the Bute estate in the parliamentary election, and the battle lines which marked the relationship of the town and the estate for the rest of the century were drawn. The Liberal cause in the town was led by the shipbuilder, John Batchelor, whose attempts to improve civic amenities were frustrated by the estate. The struggle

[70] John produced a bust of the agent to the Bute estate, John Stuart Corbett, in 1889. Herkomer painted a portrait of Bute which was presented to the city by the marquess in his mayoral year, but there is no sculpture.

[71] It was subsequently moved to its present location at the head of St Mary's Street.

149. Alfred Gilbert,
David Davies, Llandinam,
1893, Bronze,
photograph by Kevin Thomas

was symbolized by the campaign to build the Free Library, for which the estate refused to provide land. The library was eventually built and when Batchelor died in 1883 it was proposed to erect a statue in his memory at the side of the building. The commission was given to Milo ap Griffith and the work was set in place in 1886 with the words 'The Friend of Freedom' cut on the plinth. The Tory *Western Mail* celebrated the unveiling by publishing its own satirical epitaph impugning Batchelor's reputation. Despite the presence of a policeman day and night, the sculpture was defaced three times in three weeks. Lascelles Carr, the editor of the *Western Mail*, was assaulted by Batchelor's sons who, having received only a very moderate fine from the local magistrates, sued him for libel. A fourth defacement of the statue was accompanied by a threat to blow it up with dynamite and a dock foreman was charged under the Damages of Works of Art Act.[72]

In the context of this furore it was perhaps not surprising that very few industrialists were celebrated by public sculpture in south Wales in the second half of the nineteenth century. A more practical reason for this failure, at a time when the New Sculpture movement was in its prime and such celebrations were a prominent feature of public life in industrial towns in England, was the limited development of the civic authorities themselves in the coalfield. Such commissions as were given were mainly confined to the three major ports. In addition to the statue of the second marquess of Bute in Cardiff, Newport and Swansea both celebrated figures associated with the development of their docks, namely Lord Tredegar and Hussey Vivian. The Vivian statue in Swansea again resulted in a dispute involving Milo ap Griffith, who was passed over for the commission in 1883 – a circumstance which may be related to the award of the Batchelor commission soon afterwards. In response to a letter published in the *Western Mail* complaining that a native sculptor had not been given the work, Lord Aberdare raised his substantial voice in sympathy:

> That a Welsh sculptor should fail to secure the patronage of a Welsh committee for a statue to be erected in Wales, is not at all a strange thing; but is it not really surprising that, in the face of such incidents as that of the Vivian statue, any Welshman should be so short-sighted as to clamour for 'Wales for the Welsh!' If Welsh talent depended on Welsh support it would garner more kicks than halfpence. The gentleman who championed Mr. Milo Griffith in your columns omitted to mention a very striking fact, redounding more to the young sculptor's credit even than his eisteddfodic successes, viz., that at this year's exhibition of the Royal Academy space was accorded to no fewer than four works from his studio. 'A prophet is not without honour, save in his own country'.[73]

Nevertheless, Lord Aberdare was on hand to unveil the Vivian statue in March 1886. Seven years later, a statue of David Davies, builder of Barry docks, was added to this powerful triumvirate of entrepreneurs. The sculptor was again an Englishman, Alfred Gilbert, and casts of his work were erected both in Barry

[72] The wider context of this commission is discussed in John R. Wilson, *Memorializing History: Public Sculpture in Industrial South Wales* (Aberystwyth, 1996).

[73] *Western Mail*, 21 September 1883. Milo ap Griffith had won the first prize at the 1883 National Eisteddfod in Cardiff.

[74] Only one other statue on this scale of an owner is to be found in the coalfield. *The Late Lord Buckland* by Goscombe John was unveiled outside the town hall in Merthyr in 1933. Buckland, proprietor of the *Western Mail*, had campaigned hard to save the ailing coal industry. He was granted the freedom of the borough by the Labour council at Merthyr in 1923.

150. Unknown photographer,
The unveiling of the statue of Hussey Vivian,
Swansea, 1886

151. John Evan Thomas,
Lord Tredegar,
1848, Bronze

152. W. Merritt,
Archibald Hood,
1906, Bronze,
photograph by
Kevin Thomas

(where funds had been raised by public subscription) and in Davies's home village of Llandinam. The iconography of the statue reflected that of the engineer paintings of the early part of the nineteenth century, for Davies was shown studying a plan of the docks.

In the coalfield itself, only one industrialist was celebrated in this way before the outbreak of the Great War. In 1906 the leader of the Rhondda mine workers, William Abraham (Mabon), unveiled a statue of the coalowner Archibald Hood outside the Llwynypia Workmen's Institute, of which he was a benefactor. This connivance by Mabon in the paternalism of the owners did not truly reflect the spirit of the times. Four years later the pretence of such relationships would be violently thrown aside by working people at Tonypandy, just a few miles away.[74]

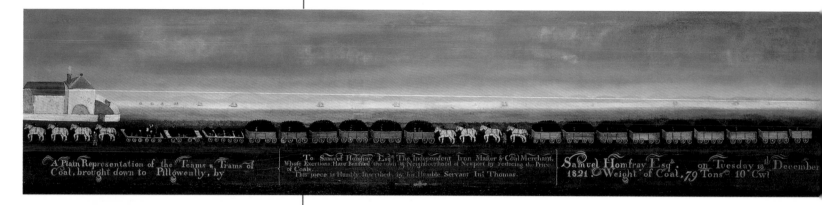

Inside the painting:
A Plain Representation of the Teams & Trams of Coal, brought down to Pillgwenlly, by | To. Samuel Homfray Esq. The Independent Iron Master & Coal Merchant, Whose Exertions Have Benifited the town & Neighbourhood of Newport by reducing the Price of Coals. This piece is Humbly Inscribed by his Humble Servant Ini Thomas. | Samuel Homfray Esq. on Tuesday 18th December 1821 Weight of Coal, 79 Tons 10 Cwt

153. Inigo Thomas,
*A Plain Representation of the Teams
& Trams of Coal, brought down to
Pillgwenlly, by Samuel Homfray Esq.
on Tuesday 18th December 1821,*
c.1821, Oil, 850 × 3600

75 The degree of this dependence was variable.
Ieuan Gwynedd Jones points out that in areas
such as the Vale of Neath, many industrial
workers continued also to work on the land into
the middle of the nineteenth century, and the
same is true of some of those employed in the
slate industry in the north. See Ieuan Gwynedd
Jones, 'Margam, Pen-hydd and Brombil' in idem,
*Mid-Victorian Wales. The Observers and the
Observed* (Cardiff, 1992), pp. 80–102.

76 'It is a practice with Mr. Guest to induce men to
save from their wages, what will enable them to
build a house. A bit of land is given them to clear
for a garden if they choose, and for the trouble of
clearing it they are to have it rent free for two or
three years. Long low leases are granted them of
other spots and then, when a workman has saved
a few pounds, he builds himself a little house and
settles.' Tomos, op. cit., p. 25.

The People

In 1821 Inigo Thomas painted one of the most remarkable pictures of
industrial Wales. *A Plain Representation of the Teams & Trams of Coal, brought
down to Pillgwenlly, by Samuel Homfray Esq. on Tuesday 18th December 1821* was
twelve feet long and was set up in a public house in Newport (pre-dating the
'Steel Room' of the Cardiff Arms at Hirwaun with its collection of industrialist
portraits). This location, the artisan tradition to which the painter clearly
belonged, and the remainder of the extensive inscription, all seemed to suggest
that it was a simple expression of gratitude on the part of the populace to 'The
Independent Iron Master & Coal Merchant Whose Exertions Have Benefited
the town & Neighbourhood of Newport by reducing the Price of Coals'. The
relationship of the people to the industrialist was one of considerable dependence,
not only on the part of the labourers and craftspeople, but also the middle class
of trading and professional people who indirectly benefited from the success of
the new industries. In areas such as Merthyr, the only economic foundation for
the community was that provided by the industrialist and when wages were cut or
people put out of work there was serious distress.[75] In this respect, the relationship
was not much dissimilar to that existing in rural areas between the landless peasant
and the gentry in the eighteenth century. On his visit to Dowlais in the company
of the owner in 1819, Michael Faraday observed the age-old workings of such
relationships, being 'much amused … with the various applications made to Mr.
Guest by the men and inhabitants. Some wanted redress; some craved assistance;
some begged for employment'.[76] Nevertheless, for all the paternalism of families
such as the Guests and the Crawshays, sections of the populace had already

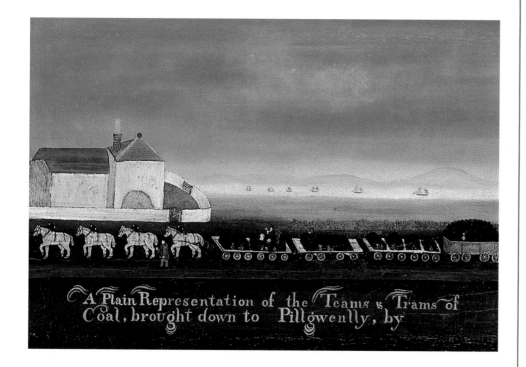

154. Inigo Thomas,
*A Plain Representation of the Teams
& Trams of Coal, brought down to
Pillgwenlly, by Samuel Homfray Esq.
on Tuesday 18th December 1821*,
c.1821, Oil, detail

signalled their unwillingness to accept conditions dictated by their employer.
Three years before Faraday's visit, there had been riots in Merthyr, and it may
be that the dedication of Inigo Thomas's painting of the coal train to Samuel
Homfray in 1821 reflects a more complex attitude than paying an ingratiating
compliment to the master on the public benefits of his entrepreneurial activities.
Despite the dependence of the people on their employers, the relationship was
increasingly perceived by them as one of exchange, and the painting may
represent a perception that they could congratulate the industrialist of their
own volition. The picture may be understood as an expression of pride in
participating in new technology and emerging confidence among working
people, rather than of ingratiation based on dependence.

Direct expressions of the people's attitude to the industrialists, such as *The
Homfray Coal Train*, are unusual in visual culture before the emergence of a
fully-fledged union movement with its banners and posters. Popular patronage
through the purchase of engraved images of industrialists and their works might
be a guide to attitudes, but evidence from within the working community is hard
to find. From the other side, the diary of Charlotte Guest suggests a degree of
adulation for the family expressed by the public celebration of significant events
such as marriages and births. The interest of common people in the family at the
big house is not necessarily inconsistent at an everyday level with the emergence
of radical politics. The fascination of the have-nots for the displays of the wealthy,
often expressed without resentment, is a mysterious but persistent phenomenon.

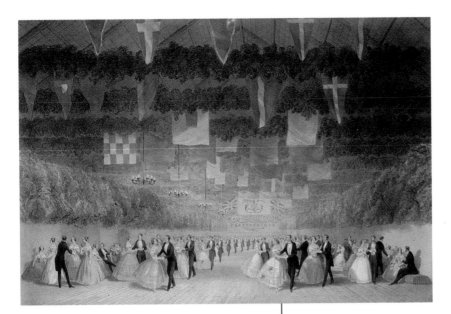

155. J. Appleby,
Ball in the Wagon Shed,
1846/7, Engraving,
315 × 425

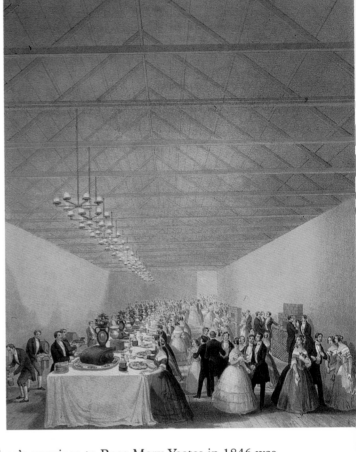

156. J. Appleby,
Banquet in the Wagon Shed,
1846/7, Engraving,
346 × 260

Robert Thompson Crawshay's marriage to Rose Mary Yeates in 1846 was recorded by the production of a pair of prints depicting the ball and feast organized in the huge wagon shed at Cyfarthfa for 'the Ladies of Merthyr'. They may have found their way onto the walls of the houses of the loyal middle class or into picture albums, the compilation of which was a common pastime among the shopocracy, professional people, and their children.

Portrait engravings of leading industrialists were indeed published, based either on paintings or, later, on photographs, and sold to the general public. However, it must be said that surviving examples of scrapbooks do not generally suggest a high status for such images when compared with engravings of Nonconformist ministers and poets, certainly at a national level. Locally, portrait engravings may have found a market. A series of letters from Robert Thompson Crawshay to Francis Schenck, an Edinburgh lithographer, throws some light on the obscure area of the production of such prints. In 1866, apparently on the initiative of the publisher, Crawshay gave consent for the printing of a portrait of himself based on a photograph. The print was published by March 1867 and reviewed in *The Mining Journal*. Crawshay was delighted with the result and purchased several hundred copies, presumably to be given away to his peers as mementoes of visits and as general tokens of esteem. This was a common practice among the gentry and intellectuals.[77] A more unusual aspect of the commission came to light as the

[77] W. J. Rees, Casgob, for instance, had his portrait by Hugh Hughes engraved for this purpose in 1828. The notice of Crawshay's portrait appeared in *The Mining Journal*, 9 March 1867, 160. Reference was again made to it on 23 March 1867.

157. Cartlidge,
Robert Thompson Crawshay,
1866, Albumen print

158. Francis Schenck after Cartlidge,
Robert Thompson Crawshay,
1867, Lithograph,
443 x 319

result of a dispute with the photographer, John Mackay of Merthyr, who had intended bringing out his own lithograph 'at a cheap rate for the Working Class'.[78] In Crawshay's opinion, Mackay's effort was a 'disgrace to everyone concerned', but the matter was resolved by paying off the photographer and printing a cheap version of the Schenck lithograph. Crawshay bought '200 prints at 2/6 for the men'. These were presumably distributed free, though no evidence on this point or of the men's opinion of the gift survives.

Similar problems of deficient evidence arise in the detailed interpretation of the market for prints of engineering subjects. As we have seen, such prints were produced in large quantities, but it is difficult to determine to what extent they were purchased and displayed, in particular by those involved in the production of the raw materials from which bridges and railways were made, as an expression of pride in participation. On the whole it seems unlikely that there was any particular market for printed images of engineering wonders in places such as Merthyr or among manual workers and their families. Views of a local bridge, dock or works may have appealed, such as the lithograph produced by J. F. Mullock to celebrate the opening of the new dock in Newport in 1842, but

[78] NLW, Cyfarthfa Papers, Vol. 6, Letter Book, 1865–70, f. 37 and below, ff. 77, 75. Mackay had taken over the Merthyr business of Cartlidge, the photographer of the portrait of Crawshay, when it failed in 1866.

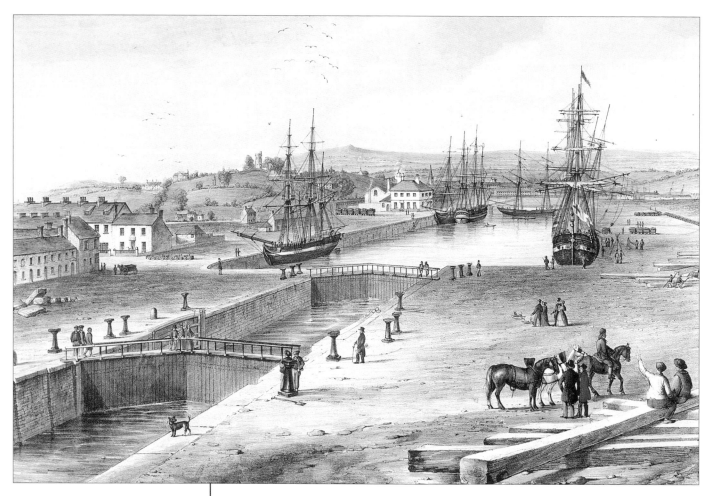

159. J. F. Mullock,
View of the Dock,
Newport, Monmouthshire,
1842, Lithograph,
420 × 545

their market would have been limited by price. The two views of the Treforest tinplate works, for example, were certainly not downmarket affairs, and even lithographs clearly aimed at a wider audience were not always cheap. In 1878 Harris, Son and Co. of Merthyr, whose populist credentials in the fields of inexpensive portraiture and photography were good, advertised a 'splendid lithographed view of Merthyr'. It was based on a photograph, the sales of which had encouraged the 'larger enterprise', but it retailed at 21s., a price which set it in the middle-class parlour rather than the working-class kitchen.[79]

The surviving evidence suggests that prints of rural landscape and subject pictures, culled from various sources, and portraits of religious and political leaders, were more popular than industrial subject matter. Photographs and engravings of the interiors of the houses of the middle class and of industrial workers which show framed prints *in situ*, however, are rare. Herbert Johnson's drawing, *A Collier's Home in the Rhondda Valley*, taken for *The Graphic* in 1875, shows decent furniture, including a long-case clock, decorated with vases and figurines – an image of simple sufficiency which confirmed the observations of a reporter for the magazine *Good Words*, made seven years earlier:

[79] *Merthyr Express,* 21 December 1878.

160. Herbert Johnson,
*A Collier's Home in the Rhondda
Valley*, from *The Graphic*,
1875, Wood engraving,
100 × 111

161. Advertisement from
the *Merthyr Express*,
21 December 1878

VIEW OF MERTHYR,
1878.

NOW BEING PUBLISHED A

SPLENDID LITHOGRAPHED

VIEW OF MERTHYR.

PRICE 21s.

IN making the above announcement MESSRS.

HARRIS, SON & CO.

hope the patronage accorded to them for the large

PHOTO VIEW will be extended to them in this

larger enterprise of getting up a LITHO VIEW,

which has taken the Artists some months to copy

from the Photo.

SPECIMENS to be seen at the STUDIO,

But a respectable percentage of the cottages, nevertheless, have tidy living-rooms, and almost all, whether tidy or untidy, have a warm, fully-furnished look that is very different from the pinched, bare, hungry aspect of the rooms to be seen in many parts of the East-end of London, for instance ... Every cottage-door stands open in Dowlais, and therefore the stranger can observe its domesticities without the least intrusion. He sees good fires ... and tea-trays brought out at abnormal hours in English estimation. He sniffs the fumes of oleaginous cookery. In cottage after cottage, too, he sees a handsome, old-fashioned eight-day clock, sometimes a good sofa, and almost universally either a dresser or a chest of drawers, and a table, set out with glass and crockery.[80]

[80] *Good Words* (1869), 40.

105

162. Anon.,
Edward Matthews, Ewenny,
c.1892, Ceramic,
200 × 137

81 Wirt Sikes, *Rambles and Studies in old South Wales* (London, 1881), p. 56, but originally published as a series of articles in the United States. The 'peasants going to wedding' were almost certainly images on plates and cups based on the prints of John Cambrian Rowland. They were produced for the Welsh market as far away as Germany. Wirt Sikes was the American consul in Cardiff. The book was illustrated by his friend, T. H. Thomas.

Another social observer, the American Wirt Sikes, visited Merthyr in the 1870s and described the artefacts in more detail. He noted that:

> Most of the cots are decorated with cheap pictures and images in plaster or crockery. On one wall we see a portrait of Abraham Lincoln side by side with one of Richard Cobden. A favourite *objet* in these interiors is Britannia, seated, helmet on and shield at side, in blue or green glass. Others are crockery knights on horseback, with curling black locks and gold-tinted waving plumes; groups of peasants going to wedding in white gowns and red kerchiefs; and a stalwart hero, who we hope is Owen Glendower, but who on inquiry proves to be Wallace.[81]

163. Anon.,
Y Cymro Bach (The Little Welshman)
published by Robinson's, Bristol,
c.1900, Lithograph,
232 × 305

164. Anon.,
Llewellyn killing his dog, Gelert,
c.1900, Lithograph,
237 × 310

Sikes's discovery of a print of Lincoln may have been exceptional and elevated to the typical because he was writing for an American audience, but the democratic sentiments expressed by the display of such prints were surely widespread. His disappointment (for he was one who moved in the patriotic Welsh circle of T. H. Thomas in Cardiff) on discovering that the figurine represented Wallace rather than Glyndŵr presents another problem of interpretation. Images of heroic Welsh figures were not widely available, though whether this represented a failure of supply or of demand in the new and populous urban areas is problematic. The only figurines produced in Staffordshire for the Welsh market seem to have been those of Nonconformist preachers such as Christmas Evans and John Elias. Welsh ceramic factories occasionally produced mementoes of this kind, such as a plaque of the famous Glamorgan preacher, Edward Matthews, probably made shortly after his death in 1892 at Ewenni, the village with which he was closely associated. Much of the national imagery which was available in the second half of the nineteenth century was the by-product of packaging and advertising, rather than a response to a demand among those with even a small disposable income for self-imaging either as Welsh people or as industrial workers. The packaging manufacturer Robinson's of Bristol produced *Y Cymro Bach*, a Welsh child seated on a goat in a popular English tradition nearly as old as printing itself, and the very few images of the Princes of Gwynedd were confined to the myth of *Llewellyn killing his dog, Gelert*, which appeared, late in the nineteenth century, in various versions as a postcard and a decoration for almanacks. Similarly, T. H. Thomas's *John Elias Preaching at the Association in Bala*, printed on customized almanacks in the 1890s, may have been displayed on the walls of more pious Methodist families in the industrial

165. T. H. Thomas,
John Elias Preaching at the Association in Bala,
1892, Colour lithograph,
480 × 385

left:

166. S. Curnow Vosper,
Salem,
1908, Watercolour,
700 × 725

south, and Curnow Vosper's *Salem* certainly achieved wide popularity as a result of its distribution as a free gift with Sunlight soap. The popularity of *Salem* may reflect not simply the appeal of the timeless image of rural life among industrial workers with their roots in an older Wales, but also a more widespread and unsatisfied demand for national imagery of any kind. *Salem* is unambiguously an image of national character.[82] What is clear from the surviving evidence is that images of industrial communities and their products cannot have been particularly obvious on the walls of houses in industrial communities.

Things made at home either in the form of amateur art objects such as paintings, or craft objects such as quilts made for domestic use but having a strong visual content, only infrequently made specific reference to the industrial nature of the community. Quilting, transferred from its original rural context, became an important part of creative as well as of practical life in industrial communities. It was mainly undertaken by women, though not exclusively so, and, as we have seen, the most notable example of the form to celebrate the wonders of contemporary engineering was made by the tailor James Williams at Wrexham. However, this was very much a display piece. More modest and practical quilts were made in large quantities both for home use and for sale. In addition to individual professionals, quilt clubs brought women together to work and a system of payments by instalment evolved to ease financial burdens. Both these developments seem to have been particular to industrial areas in the south. Mavis Fitzrandolph, the pioneering historian in the field, noted that Mrs Lace of Aberdare 'began to make quilts for orders during a long coal strike in 1907, to help feed her three small children'. Clearly, her customers were not colliers. 'She was paid five shillings for the

82 See Peter Lord, 'Salem: A National Icon' in idem, *Gwenllian. Essays on Visual Culture*, pp. 37–42.

167. Unknown photographer,
*Mrs Lace and Mrs Olivia Evans
demonstrating quilting at the
Welsh Folk Museum,*
1951

168. *Slipware plate from Buckley pottery, 19th century, 255 × 355*

169. Sarah Jane Roberts, *Cockerel Plate, Llanelli Pottery, c.1900–15, 276 d.*

first order and from five to twelve shillings for others, according to pattern; during the year she earned ten guineas by making twenty-six quilts.'[83] The patterns used on such work showed little variation from rural quilts as they evolved. External influences, such as work sent back by Welsh immigrants to industrial areas in the United States, are evident especially in patchwork from both rural and industrial communities. Use was occasionally made of representational imagery, such as the bedcover done to celebrate the centenary of Carmel Baptist Chapel in Pontypridd in 1910, which illustrated local landmarks.[84]

As Wirt Sikes had observed, cheap ceramics, bought at fairs and markets as well as in local shops, were another important expression of working-class taste and well-being in the home. Their display developed particular Welsh associations in the context of the dresser. Again, women were mainly responsible and the tradition within which they worked had been transferred from rural areas to industrial communities.[85] Many ceramics associated especially with Welsh taste, including copper lustre ware, were produced mainly in England for the Welsh market. Nevertheless, at Buckley in the north-east, and at Ewenni, Swansea and Llanelli in the south, well-established ceramic factories found themselves close to the burgeoning markets of industrial Wales. Ewenni and Buckley produced slipware, not extensively used in display except in the case of personalized items such as celebrations of births or marriages.[86] However, although renowned for their high quality porcelain, both the Swansea and Llanelli factories also made popular transfer printed ware at various stages in their development. After 1877 Llanelli also produced cheap hand-painted ceramics, including the cockerel designs of Sarah Jane Roberts, which became particularly popular as display items.[87]

[83] Mavis Fitzrandolph, *Traditional Quilting: Its Story and its Practice* (London, 1954), p. 48.

[84] Christine Stevens, *Quilts* (Llandysul, 1993), p. 26.

[85] See Moira Vincentelli, 'Welsh Dressers and Ceramic Display', *Planet*, 100 (1993), 34.

[86] In the Buckley area, brickworks were also of great importance. A thriving offshoot of the production of plain bricks was decorative terra cotta work. Highly skilled artisans were employed in modelling ornate decorations for public buildings. See John E. Thomas, 'The Red Marl Industry', *Wales* (ed. O. M. Edwards), II (1895), 262–3. The article includes a photograph of artisans at work.

[87] For the work of Sarah Jane Roberts (1859–1935), see Gareth Hughes and Robert Pugh, *Llanelly Pottery* (Llanelli, 1990).

170. Jenny Jones,
Crazy patchwork cover,
1884, 1710 x 1710

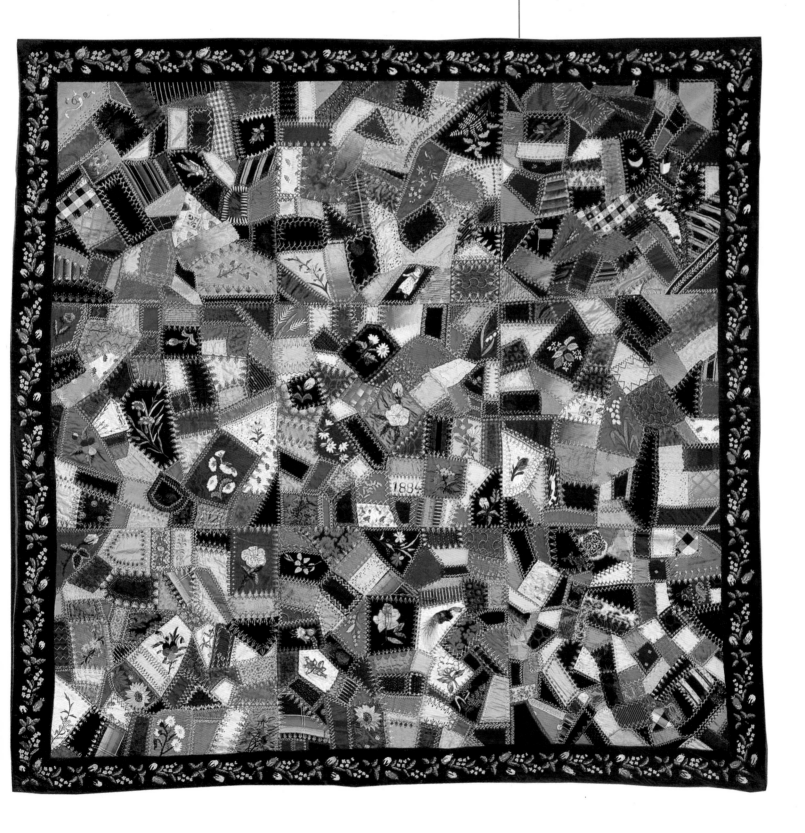

171. William Edward Jones,
Lord Aberdare,
c.1877, Oil,
2400 × 1600

Personal and family pride within industrial communities, expressed in the acquisition and display of fine things, also manifested itself in the commissioning of paintings. In the *Merthyr Express* of 15 August 1874, the aspiration and ability of Cleopas Harris to make portraits available well down the social order was made clear:

> PORTRAIT PAINTING. – The firm of C. Harris and Co., photographic artists and portrait painters, of High-street, Merthyr, must by this time have become, if not a household word, at least a well-known name in hundreds of places throughout this district by the repute won for them by their oil painted portraits, which, while being executed at a price within reach of the working classes, are also of a high standard of excellence as works of art.

Travelling artisans, notably Hugh Hughes and William Roos, made portraits available if not to the working classes, then certainly to the middle classes, in rural Wales. However, not a single portrait by either artist painted in an industrial community is known and we must conclude that both painters avoided Merthyr, Cardiff, Newport and even Swansea.[88] This was not their world, despite the fact that Roos had some connection with it through his grandfather who had been closely involved with mining at Parys Mountain and with shipping in Amlwch. The new urban areas certainly contained as many potential patrons as Caernarfon and Carmarthen among middle-class people with their disposable incomes and an eye on the mores of their social superiors. Gaining commissions in places such as Merthyr, however, required a different approach from that of the itinerants in the small towns of the west and the north, and artisan practice developed primarily in the hands of resident painters. James Flewitt Mullock in Newport and William Watkeys in Swansea were both active from the 1830s.[89] However, by far the most productive and entrepreneurial in their attitudes of all the painters was the Harris family in Merthyr.

[88] Hugh Hughes visited Swansea in 1821, taking drawings for *The Beauties of Cambria*, and he may have painted portraits there. It was an older-established place than the other industrial towns, fashionable for sea-bathing, and had attracted substantial numbers of visiting painters and art teachers in the second half of the eighteenth century. Hughes also briefly visited Merthyr on the same tour, but neither he nor Roos seems subsequently to have ventured beyond Carmarthen. The aversion of Hugh Hughes for industrial Wales is discussed on pp. 131–3. Clearly, the itinerant W. J. Chapman was not intimidated by the demands of working in an industrial community. However, in the absence of any personal information about his life, it is fruitless to speculate on the contrast between his clientele and that of the indigenous itinerants.

[89] For Mullock, see John Wilson, *Art and Society in Newport: James Flewitt Mullock and the Victorian Achievement* (Newport, 1993). For Watkeys and artisan practice in general, see Peter Lord, *Artisan Painters* (Aberystwyth, 1993). There may have been many other artisans, as yet unrecognized, working in industrial communities. For instance, the 1891 census for the parish of Ystradyfodwg gives one David J. Ryan, aged 27, Portrait Artist, as living at 89 Bute Street, Treorchy. He is recorded as being a Welsh monoglot. I am grateful to Mari Williams for this reference.

172. Unknown photographer, *Cleopas Harris and his three sons, Albert, George and Charles,* c.1890.

Cleopas Harris arrived in Merthyr about 1866 from Canada, where he had been a soldier. In that year he seems to have worked as a photographer in a business established by J. Emrys Jones, a monumental mason whose brothers, William Lorando and Watkin D. Jones, had gone to London as art sculptors. Cleopas Harris, however, was not the first resident portrait painter in Merthyr. William Edward Jones had already been in the town since 1853, presumably attracted from London by the potential market among industrialists, engineers and other professional people. He succeeded in gaining their patronage and also found customers among the local gentry. In 1855 he painted a presentation portrait, paid for by subscription, of Dr William Thomas, master of the Court Hounds. The following year he painted Thomas Evans, brother of the manager at Dowlais and an important figure in the marketing of the company's products. Towards the end of his career he painted Robert Thompson Crawshay and Lord Aberdare. W. E. Jones seems to have sustained himself with portrait work in Merthyr, though he also painted historical subjects and landscapes. On his death in 1877 'there were 105 examples of his work ..., including original designs in landscapes, and head studies and copies of eminent masters of the art' in his studio, but remarkably few have survived. Coincidentally, the notice of the sale of Jones's studio contents appeared in a local newspaper on the same day as a report of the coming of age of George Frederick Harris, son of Cleopas Harris, who would expand the social base of portrait patronage in Merthyr far beyond that achieved by Jones.[90]

G. F. Harris may well have received some instruction from W. E. Jones, since he described him as his 'late departed friend',[91] and he was almost certainly taught by the two painters employed by his father by 1871 to work for him while he developed the photographic side of the business. By 1877 patronage had expanded sufficiently for the family to employ three additional painters, including, very briefly, the Royal Academy-trained William Gillies Gair.[92]

[90] *Merthyr Telegraph*, 2 November 1877. A brief biography and list of works by W. E. Jones is given in T. F. Holley, 'William Edward Jones, Painter of Portraits', *Merthyr Historian*, 6 (1992), 97–107. The list is not exhaustive and some confusion arises as a result of the activities of a second William E. Jones in Bristol. William Edward Jones of Merthyr was not the maker of the landscape prints attributed to him.

[91] *Merthyr Express*, 3 November 1877.

[92] The painters employed in 1871 were John Scott Kinear and Arabella Neale. They were replaced by a Mr Lancaster and a Mr Gunn, and by William Gillies Gair.

[93] Albert subsequently moved away and by 1886 had a studio in Chelsea, according to the *Merthyr Express*, 4 August 1886.

[94] *Merthyr Express*, 26 January 1878. I am grateful to Rosemary Scaddon and Eira Smith for the newspaper references given here.

[95] Ibid., 13 November 1886.

[96] Ibid., 30 December 1882.

[97] *Carnarvon and Denbigh Herald*, 8 October 1868. For the Eisteddfod exhibitions as a whole, see Lord, *Y Chwaer-Dduwies*.

173. George Frederick Harris,

Rosina Davies,

1896, Oil,

620 x 510

Subsequently, they were replaced by Jemima Reade Ashley, who married G. F. Harris, and by Cleopas Harris's second son, Albert.[93] Such a flourishing business was sustained by maintaining a high profile through participation in public affairs and aggressive advertising. In 1878 the company announced that 'Nothing succeeds like success. Within the last ten years thousands of oil painted portraits ... and thousands of gold frames made for them, and during that time thousands of pounds have been paid in wages and spent in the town of Merthyr by Harris, Son, & Co.'.[94] This advertisement appeared in the same issue of a local newspaper as a report of a libel action brought by Gillies Gair on the grounds that Cleopas and G. F. Harris had 'unlawfully, wickedly and maliciously' made and exhibited a painting 'intended to represent the said William Gillies Gair as ridiculous and contemptible, by reason of their having painted the said William Gillies Gair as with a pipe in his mouth and a glass purporting to contain liquor placed in front of him ...'. The rather ludicrous proceedings were dismissed, but the resultant public amusement no doubt added to Harris's reputation.

Harris, Son & Co. produced portraits painted from life, sometimes of a high standard, as in the case of the evangelist *Rosina Davies*, done in 1896 by George Frederick. They also painted portraits from supplied photographs, and they coloured photographs taken in their own studios. They established a portrait club, to which members paid a regular subscription and were painted according to their luck in the drawing of lots. In this way 'a £10.10s. portrait in oil can be obtained for £7', noted the *Merthyr Express*.[95] Even at the ten guinea full price, portraits of a good technical quality were available to a wide public in Merthyr and also in Cardiff and beyond, since the company almost certainly exhibited and advertised in the west of England. At the same time, the photographic studio flourished, and the company ventured into printmaking with their view of Merthyr and also an illuminated Lord's Prayer. In 1882 they claimed to have sold 15,000 copies, though only 500 in Wales, a failure which was attributed to the 'prevalence of the Welsh language'.[96]

Like James Flewitt Mullock in Newport, the Harris family taught art and involved themselves in a variety of other ways with the development of a taste for painting and sculpture in Merthyr. In Wales, a perception of a particular historical deficiency in art culture, coupled with the visual quality of the industrial landscape and the degrading living conditions of many of the people, ensured that it was a theme to which Victorian intellectuals would return time and again in the Eisteddfod pavilion and other public platforms. Over a period of fifteen years of intense activity, a series of exhibitions of art and industry, several of them on a very large scale, simultaneously sought to celebrate modern technology and the prevailing ultra-conservative mode of art and decoration. Like the historicist houses of the industrialists, taste stood in such stark contrast to technology that in retrospect it is difficult to understand how the two emerged from the same culture. At Ruthin in 1868, Cardiff in 1870, Wrexham in 1876, Merthyr in 1880, Cardiff in 1881 and again in 1883, patriotic artists and intellectuals, including Cornwallis West, Edwin Seward (the Cardiff architect) and T. H. Thomas, sought to encourage the practice of art among working people and to 'improve' their taste. At the first of these large exhibitions, organized by Cornwallis West, the working classes were kept apart from the affluent by increased prices on certain days. The *Carnarvon and Denbigh Herald* was clear about 'the beneficent effect of pictures and works of art upon the population of a country':

174. John Thomas,
Fine Art Exhibition, Ruthin,
1868

> We trust, therefore, that the people of Wales, the intelligent and ingenious artisans, the large portion of the population employed as colliers, miners and slate quarrymen, in this, the sister and neighbouring counties of North Wales, will be enabled to visit the exhibition before it closes. We hope it will not be necessary to complain of a neglect of duty of employers of labour to send men to this exhibition ...[97]

175. John Thomas,
*The Organizers of the National
Eisteddfod at Ruthin,*
1868

The Ruthin exhibition had been organized to coincide with the National Eisteddfod, which had pioneered the field from 1862 when the Social Sciences Section was inaugurated at Caernarfon. This section, developed by the educationalist Hugh Owen and his associates, was intended to extend the scope of the Eisteddfod to include every aspect of contemporary life – science, technology and social matters. Among the instigators was the sculptor William Davies (Mynorydd) a native of Merthyr. He gave a lecture on 'The employment of leisure hours by working men in Wales' and exhibited 'upon an elevated balcony, six graceful statuary models' for the edification of the people. Nevertheless, the initial stimulus which had given rise to these exhibitions was the Great Exhibition at the Crystal Palace in

176. Unknown photographer,
Fine Art and Industries Exhibition,
Cardiff, 1881

London in 1851.[98] Charlotte Guest had helped to organize an excursion to the exhibition for about a hundred workers from Dowlais, 'good honest-hearted Welshmen' who, apparently, 'would not silence their enthusiasm at seeing me' when she met them at Paddington station. Their education was furthered while in London by conducted tours of the British Museum and the Houses of Parliament.[99] Workers were exhorted to attend the Welsh exhibitions and were aided by cheap tickets on the railways and low entrance fees on particular days. They flocked to the Cardiff Exhibition of 1881 in considerable numbers, and were reviewed with as much curiosity as the pictures themselves by some of the more patronizing members of the intelligentsia:

A tide of excursionists swept me the other day into the exhibition! I had been in before, when there was a classic calm prevailing, and old cognoscenti, spectacled, studied the masters of the past and the renowned of the present; when you could hear a quiet rustle of silk here and there, and above the measured hum the tinkling of a piano touched by some fair hand. This is the time when one can thoroughly appreciate the beauties which art has placed before us, as well as the wonders accomplished by man. It is then that you can revel in the diamonds and rubies, in the cunning silver and gold work, in the relics from distant lands, and the memorials of distant times. Not so on an excursion day. The decorated walls become of secondary interest; you are wedged between stout humanities, hustled, pushed, have your corns trodden upon, until, getting into a little haven, you can console yourself by sketching the living sea that throngs by. No demure utterances, no amateurish comments, no looking-through one's hands, or inclining the head to an horizontal position, just as it is conventional to do in the Royal Academy; but the hearty, unconventional expression of the collier and his sweetheart, of the tin-plate worker, of the farmer, of the dock labourer, and the class generally whose avocations are 'the drawing of water and the hewing of wood'.[100]

[98] The influence of 'working classes exhibitions' in England on Welsh art intellectuals should also be noted. Lord, *Y Chwaer-Dduwies*, p. 36.

[99] For the excursion and Charlotte Guest's experiences at the Great Exhibition, see Revel Guest and Angela V. John, *Lady Charlotte. A Biography of the Nineteenth Century* (London, 1989), pp. 160–1.

[100] *Western Mail*, 16 September 1881.

177. Anon.,
New Free Library,
designed by Edwin Seward,
1882, Engraving,
79 × 123

NEW FREE LIBRARY.

By the turn of the nineteenth century, the provision of permanent museums
and art galleries in the larger towns was well advanced, giving working people
the opportunity to look at pictures and artefacts when, and if, they could find the
time. Indeed, the Cardiff Exhibition of 1881 had been organized by the architect
Edwin Seward in order to raise funds to decorate the shell of the new Free Library
and Art Gallery, which had been such a bone of contention with the Bute estate.
By 1888 Newport had established a museum with the purchase of collections
belonging to Samuel Homfray and by 1895 it was housed in a new building.[101]
In Merthyr, the development of working-class taste was furthered, with some
irony, by the corporation's purchase of Cyfarthfa Castle in 1909, where, the
following winter, an art exhibition of distinction was opened. It drew many
of its exhibits from small private collections in the area, of which there were a
considerable number, such as that of the Mayor, F. T. James, who showed several
works by David Cox. The 1880 exhibition at Merthyr had likewise involved many
well-known figures from the rapidly emerging art world, notably Edwin Seward
and T. H. Thomas. C. R. M. Talbot headed the list of patrons and many exhibits
were drawn from the collection of William Menelaus of Dowlais. This source of
support, in particular, must have seemed most relevant to the prevailing ethos,
given Menelaus's humble origins. He was a model of the improved working man.

The earlier exhibition at Merthyr had drawn criticism from Cleopas Harris
on the grounds of discrimination against local artists. 'Perhaps they fondly
imagine in this conceit', he remarked, 'that they can stifle or keep back talent
from coming to the front. They may as well imagine they can keep back the
tide …'[102] The 1910 exhibition endorsed Harris's prediction, and also displayed
a very strong desire on the part of the organizers to celebrate local achievements
by a heavy emphasis on the work of Penry Williams and with the dedication of
considerable space to the works of Thomas Prytherch, Curnow Vosper, Milo ap
Griffith and Goscombe John. In a sense, Cleopas Harris's criticism of the 1880

[101] See Wilson, *Art and Society in Newport*, p. 33.

[102] *Merthyr Express*, 29 May 1880.

178. George McCulloch,
A Welsh Puddler,
1881, Watercolour,
516 × 327

exhibition was unfair, since it was certainly among the intentions of exhibition organizers in that period to develop art culture by exploiting the potential of individuals from among the working class. Nevertheless, Harris's personal irritation was understandable since his company, despite its great contribution to the visual culture of Merthyr, was represented by only one work. Businesses like that of Harris, Son & Co. were not quite what the organizers had in mind. They sought to find a hidden genius among the common people, who might go on to make his or her mark in the English and continental art worlds, and the examples of Wilson, Gibson and, of course, Penry Williams were repeatedly invoked to make the point. A number of young artists did indeed emerge from middle-class backgrounds in the towns of the south, including Christopher Williams and Margaret Lindsay Williams. However, with the exception of Edgar H. Thomas, who had worked in a weaving factory in Pontypridd, not until immediately before the Great War did a steady trickle of young people from working-class backgrounds begin to make professional careers as artists.

The effect of the more general aim of the exhibitions – to 'improve' working class taste – is difficult to quantify. The art to which the people were exposed must have seemed remote to many of them. At T. H. Thomas's Cardiff exhibition of 1883 only two of two hundred and sixteen entries took industrial Wales as their subject. George McCulloch's *A Welsh Puddler* clearly attempted to associate an image of the common man with that of a classical god, but whether or not the association impressed the average puddler on a day trip to

179. T. H. Thomas,
'Sackcloth and Ashes', Tip Girls Leaving Work, South Wales Coal District,
c.1879, Oil,
895 × 685

the exhibition from Dowlais or Cyfarthfa is impossible to say. Three years earlier, the Merthyr exhibition catalogue had strikingly – and no doubt intentionally – listed as exhibit No. 1, T. H. Thomas's *'Sackcloth and Ashes', Tip Girls Leaving Work, South Wales Coal District.* Yet despite the presence of this painting, along with John Petherick's views of Forman's Egyptian furnaces and Penry Williams's *Merthyr Riots*, industrial subjects were overwhelmed by a surfeit of waterfalls, mountains and moralities. As we have seen, through the medium of prints,

180. James Baleman,
St Paul, c.1890,
Coloured print on glass,
350 × 250

103 D. Cunllo Davies, 'Art in Welsh Homes', *Wales* (ed. O. M. Edwards), II (1895), 223.

104 Alfred T. Davies, *The Cult of the Beautiful in the School* (Oxford, 1912), p. 18.

such images found their way into middle-class homes, but whether their appeal encouraged those with a small disposable income to invest in original works is difficult to determine. In Merthyr, perhaps uniquely in Wales, pictures of this kind were readily available without resort to an art gallery or special exhibitions, and at a reasonable price, thanks to the entrepreneurial attitude of the Harris family. George Frederick painted landscapes for the parlour and allegories such as *The Black Sheep*, which he exhibited in the shop window of J. S. Jones, Outfitter. It was heavily interpreted by the critic of the *Merthyr Express*, perhaps Harris himself: 'In the foreground stands a ragged black sheep, with the backs of the remainder of the flock turned towards him. His wool is in tatters and he is quite deserted by his companions, two of which stand in the middle distance, and regard him with seeming curiosity as an object to be avoided rather than courted ...'. However, 'The sunlight is made to fall on the black sheep, thus showing that although deserted by his companions ... he is not deserted by One above, who continues to light and guide his footsteps'. Despite Harris's efforts to promote his landscape and subject pictures, later continued through his association with the South Wales Art Society, the sales of such works were certainly appreciably smaller than those of the portraits which remained the backbone of the business. These were also the form most likely to attract the less affluent. However, the vast majority of working people, even if they did frequent the large exhibitions on excursion day, remained outside the world of art patronage, whether by choice or financial necessity. They occasionally drew the scorn of commentators such as D. Cunllo Davies of Blaina, who noted in 1895: 'The Welsh working man has but a darkened eye to see and enjoy the beautiful in art. Indeed, in the mining towns of South Wales, he seems to have no eye whatever. He very rarely rises higher in the decorating of his home than the highly-coloured caricatures of Biblical characters, sold by hawkers at his door. The grocer's almanac, framed in gilt, appears to be the highest step to which he has ever advanced in the appreciation of art.'[103] D. Cunllo Davies was a Nonconformist minister of rabid anti-Catholic views which caused him to concentrate his criticism on popular religious prints, 'the most sordid specimens of art'. Nevertheless, in general his views were shared by others. Alfred T. Davies, writing about art in schools in 1912, asked:

Is there not especial need to-day why we in Wales should strive to cultivate the Beautiful? Life with us is surely growing uglier every day. Forgetful of Ruskin's warning words that 'Life without industry is guilt, but industry without art is brutality', men are so busy digging underground that they are actually forgetting how to live decently above ground.[104]

The religious prints to which D. Cunllo Davies took particular
exception were extremely popular in both rural and industrial areas.
They were a familiar part of domestic display alongside the equally
highly coloured ceramics on the dresser and the patchwork bedcovers.
The painter Carey Morris remembered that 'the vendors were invariably
sons of Israel and the pictures were obviously Roman Catholic in
sentiment; the subjects were the Madonna and Child and the
Crucifixion, very gaudily coloured and the general effect considerably
heightened and made most attractive to the people by a liberal supply
of gold and silver tinsel decoration'.[105] In retrospect, the idea of Jewish
vendors selling Roman Catholic pictures to Nonconformists in rural
areas struck Carey Morris as remarkable, but would have been less
so in those valleys where Irish and Italian immigration had produced
more cosmopolitan communities.

181. Herbert Johnson,
*The Audience at a performance of
Macbeth in the Merthyr Theatre,*
1875, Wood engraving,
163 × 136

D. Cunllo Davies sought to damn by faint praise even the popularity
of portraits of religious and political leaders, of which, in general, he approved.
'Here and there', he opined, 'one finds a picture of Gladstone, John Bright, or
Spurgeon. These hang on the wall because the Welshman has a very decided
view in matters political, a one-sided hero worship, and a deep place in his heart
for religion and its leaders.'[106] His kind would continue to be frustrated by the
resistance of the common people to improvement and the development of visual
culture among them along its own lines. Within a year of Davies's criticism, the
first films were made and shown in Wales. An American, Birt Acres, set up his
apparatus in Cardiff for the benefit of the photographic society only a few months
after the first screenings in the world of projected cinema by the Lumière brothers
in Paris. Soon afterwards, Acres shot the first film in Wales, showing the visit of
the Prince of Wales and Queen Alexandra to the latest Fine Art and Industrial
Exhibition in Cardiff. The consequent furore in the press regarding the propriety
of such an intrusion on royal privacy ensured large audiences at public screenings
and established early on that film would be 'definitely low brow, an entertainment
for the great unwashed commonality'.[107] The music hall and the theatre had, of
course, been long established in the new industrial towns as an important part
of the culture of the common people. In 1875 *The Graphic* published a drawing
of an audience of working people watching *Macbeth* at the primitive Merthyr
Theatre. Film would quickly infiltrate such venues, as well as become a part
of the world of travelling shows at the fairs which, though inherited from the
pre-industrial world, remained an important part of life in the valleys of south
Wales before the Great War.

[105] Carey Morris, 'Art and Religion in Wales',
quoted in Eirwen Jones, 'An Artist in Peace and
War', *Carmarthenshire Historian*, XV (1978), 40–1.

[106] D. Cunllo Davies, op. cit., 223.

[107] Terry Ramsaye, quoted in David Berry, *Wales
and Cinema. The First Hundred Years* (Cardiff,
1994), p. 29. The following account of the early
development of cinema in Wales draws heavily
on Berry's research.

182. Unknown photographer,
William Haggar (Senior), c.1905

Before the end of 1896, a second film-maker, R. W. Paul, was competing with Birt Acres for audiences by making and showing films in Cardiff and also in Swansea. Both technology and subject matter developed with great rapidity, and two genres emerged as particularly popular once the impact of the early 'actuality' films of street scenes, railways and crashing waves had declined. Sporting events became crowd-pullers following the showing at the Philharmonic Hall in Cardiff of the world heavyweight title fight between Gentleman Jim Corbett and Bob Fitzsimmons in 1897:

> Prizefights were soon recognized as failsafe attractions ... sometimes re-staged for the screen with film-makers demanding that knock-outs take place precisely at the ideal spot in the ring for the cameras. It must also be remembered that staged but illegal prizefights were still in the 1890s a feature of Valleys life. Boxing, in both fairgrounds and halls, was a huge spectator attraction when Wales boasted a clutch of World or British champions including flyweight Jimmy Wilde ..., Freddie Welsh and Peerless Jim Driscoll ... In June 1907, the audience at Cardiff's Andrews Hall cheered as Driscoll unwrapped a Sunday punch on screen to floor former bantamweight World Champion Joe Bowker in London days before – and Peerless Jim was present at each Cardiff performance.[108]

Prizefighting had attracted the attention of artisan painters in the past,[109] but film recreated it and other events of immediate concern and interest to working people in a new form which was available collectively to the masses. The medium rapidly developed its own grammar and style.

The second genre to find public favour also evolved from an existing tradition. Since the 1880s William Haggar had travelled in Wales with his drama company which performed in its own theatre, hauled by horse and subsequently by traction engine. He showed his first films at Aberafan in 1898. These were bought in from other makers, and the venture received an early setback: 'The family motto became "follow the coal" after his bioscope activities were almost wiped out in the great six-month stoppage of 1898 as pitmen tightened their belts.'[110] Nevertheless, early in the new century, Haggar began to make his own films, developing the melodramatic plays presented by the stage company which was increasingly dominated by members of his own extensive family. Among his most popular stage productions was *The Maid of Cefn Ydfa*, of which Haggar made a film version in 1908. It was superseded by a new version directed by his son in 1913–14. Many Haggar films had a strong anti-authoritarian animus, expressed by slapstick comedy in which the police were usually the butt of the joke. The company's most important films in terms of the development of cinema, *A Desperate Poaching Affray* (1903) and *The Life of Charles Peace* (1905), were of this type. The earlier production included one of the first chase sequences to be filmed and it was shown widely in the United States. It seems to have been influential in the development of that genre in American films which

[108] Ibid., p. 29.

[109] The Erddig portrait series by John Walters, for instance, painted in the 1790s, included a view of a fist-fight involving William Williams, a blacksmith.

[110] Berry, op. cit., p. 47.

from left to right:

183. Frame enlargement
from William Haggar's
A Desperate Poaching Affray,
1903

184. Unknown photographer,
Haggar's Royal Electric Bioscope,
c.1900

subsequently crossed the Atlantic in the other direction in large numbers, dominating the programmes of Welsh cinemas as they did in many other parts of Europe. Films on Welsh subjects, of which some twenty-six were made between 1912 and 1927, no doubt had their following, but it was the American exotica which exerted the most far-reaching influence on working-class culture.

The travelling cinemas of Haggar and other pioneers were highly visual in themselves. They were brightly painted, heavily ornamented and often featured a fairground organ. However, safety regulations incorporated in the Cinematograph Act of 1909 precipitated a rapid decline and a consequent scramble to upgrade existing halls and build permanent cinemas. By the time the King's Hall in Pentre opened in 1913, for instance, there were seven cinemas in the Rhondda. Working-men's institutes also became venues at an early date, reflecting closely the main audience for the new medium. By 1900 the Blaengarw Working Men's Hall was showing films and 'In 1913, miners of Nine Mile Point Colliery, Cwmfelinfach, devoted the whole top floor at their new institute to a "cinematograph theatre" hoping it would raise more than half of the institute's total cost of £11,000 – and workers also owned and managed a "successful" cinema venture at Ogmore Vale. Miners from Mardy and Eastern collieries ran the workmen's hall at Pentre and, by the early years of the century, the 1,900-seat hall at Ferndale, Rhondda, boasted "a new operating box of solid concrete to take two machines".'[111]

Opposition to the cinema was frequently voiced by those of a similar turn of mind to the Revd D. Cunllo Davies, but the tide of popularity was irresistible. The anti-authoritarian subject matter of early Haggar films, along with sporting subjects and public events filmed in a way that signalled the beginning of current affairs reporting, clearly appealed more widely than the moralities and landscapes of the painters displayed at art exhibitions. Despite the best attempts of the improvers, the continuity in working-class visual culture from popular prints and drama into cinema proved much stronger than attempts to inculcate a taste for elevating art.

[111] Ibid., p. 85.

123

185. Anon.,
*Advertisement for the Art Department
of the Western Mail*, 1913

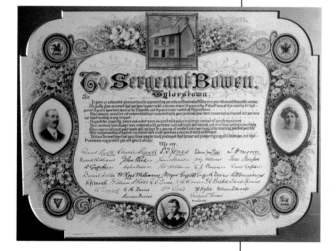

186. Anon., *Illuminated address
presented to Sergeant Bowen of Tylorstown,
Glamorgan, on his retirement*, 1910

[112] Gwyn A. Williams in his introduction to John
Gorman, *Banner Bright* (London, 1973), p. 1. John
Petherick was the father of the painter. See
above, pp. 56–9.

Both the communal nature of cinema and the anti-authoritarian
themes of some of Haggar's films matched the mood of
working people in the first years of the new century. That mood
was expressed also in the posters, banners, illuminated addresses
and a host of more ephemeral items which were commissioned
by the wide range of societies and associations in which working
people came together to pursue a common purpose. These
included chapel Sunday schools, temperance societies, friendly
societies and trade unions. The market for illuminated addresses
reached such proportions that the *Western Mail* established an art department
in Cardiff dedicated to their production. The most powerful imagery was to be
found on trade union banners. The visual symbolism of association had a tradition
extending back into the middle ages, but the conservatism of the medieval trade
guilds turned into the radical collectivism of the union movement under the stress
of industrialization. When the workers of Merthyr rose in insurrection in the
summer of 1831, they marched, as Gwyn A. Williams pointed out, under banners:

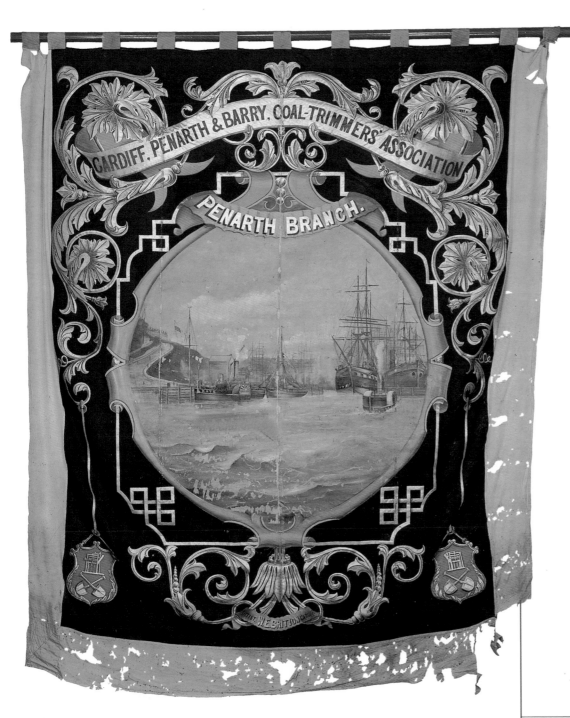

187. William Edward Frank Britten,
*Banner of the Cardiff, Penarth
& Barry Coal-trimmers Association,
Penarth Branch,*
c.1888, Oil on silk,
3048 x 2515

188. Unknown photographer,
*'Clwb Llangwm' – the Llangwm
Friendly Society,* c.1900, with
banner painted by William
Hughes, Bryn Blodau

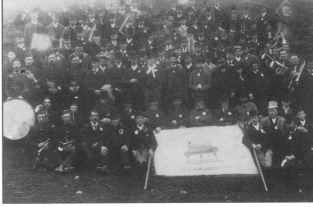

Makeshift banners they were for the most part, white ones inscribed 'Reform'; one young boy, Abednego Jones, carried a flag as big as himself, shouting 'Death to kings and tyrants! The reign of Justice for ever!' To house after house, over a hundred of them, the banners went, witness to a ritual of expiation and retribution. Into the great ironworks they went, to summon forth the laggard. John Petherick, a works agent, met a party carrying one out through the gates. 'Here!' said the banner-bearer, 'lay your hand on the flagstaff.' Petherick did so. 'Right,' said the bearer, 'you're sworn in.'[112]

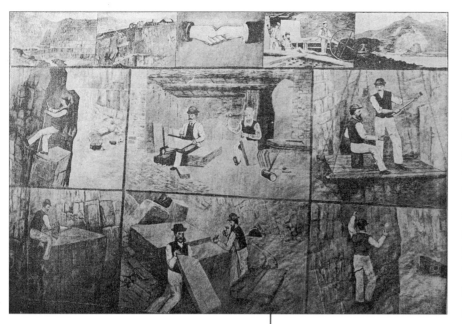

189. Anon.,
*Banner of the North
Wales Quarrymen's Union,*
c.1900

In the troubled 1830s the 'makeshift banners' of spontaneous protest began to give way to the professionally-made banners of organized labour unions. The most famous producer, George Tutill, founded his business in London in 1837 and supplied banners to hundreds of Welsh unions and other societies, but the business established by Henry Whaite in Manchester also flourished. Whaite's son, Clarence, began his career making banners in the 1840s and ended it in the following century as the most important Welsh landscape painter of his day and life president of the Royal Cambrian Academy. At the high point of production in the late 1880s, professionally-made banners ranged in style from the purely heraldic and symbolic, through allegory to realism. The Cardiff, Penarth and Barry Coal Trimmers Association opted for realism, with a scene of the docks done by William Edward Frank Britten, a painter who initially worked in London but later moved to Cardiff. He earned a living not only by painting decorative banners, but also by producing ship pictures for owners and captains. On the other hand, the North Wales Quarrymen's Union seems to have turned to an untrained artist, probably one of their own number, for their banner. It may be related to the dispute of 1874 with Lord Penrhyn but more likely belongs to the period of the great strike of 1900–3. Its ten realistic scenes were probably derived from the work of the increasing number of photographers who recorded the quarries, both above and below ground, in the 1890s. Like the union banners themselves, some of their pictures, notably the dignified image of workers at a cooperative quarry set up by the union in response to the strike, formed part of a rising tide of images of a new sort. They reflected the increasing polarization of labour and capital and the associated social trauma of industrial Wales from the 1870s onwards.

190. Unknown photographer,
Splitting and measuring slates,
c.1900

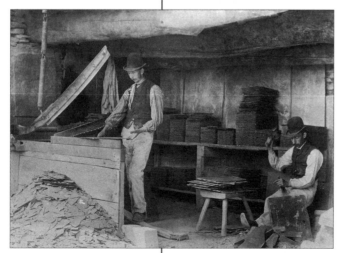

191. Unknown photographer,
*Quarrymen at the Moel Faban
Quarry in Bethesda,*
1904

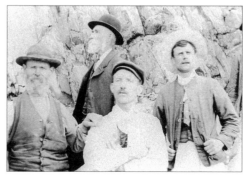

126

chapter
three

THE IMAGING

OF SOCIAL

TRAUMA

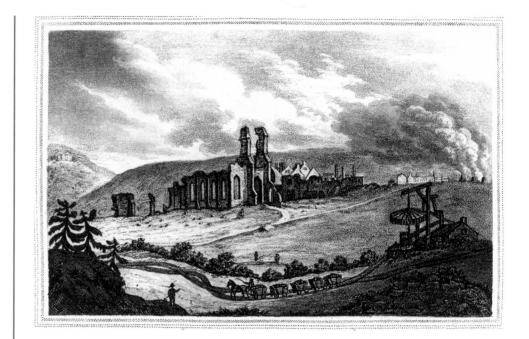

192. Edward Donovan,
Neath Abbey,
1805, Engraving,
90 × 120

In the early years of the nineteenth century, it became apparent that a new kind of world was emerging. The nature of society was changing, not simply the scale of commercial activity and the old technologies. Three years before Thomas Hornor's visit to Merthyr, where he painted his dramatic and affirmative picture of the Cyfarthfa furnaces at night, the riots of 1816 gave notice that the urban industrial world, with all its attendant stresses, had arrived. Those at the heart of the matter, who laboured and returned from their work to some of the most squalid living conditions in Europe were, unsurprisingly, slow to begin imaging themselves, but occasionally the realities of their existence could be glimpsed in the words and pictures of the more sentient travellers. Although Julius Caesar Ibbetson documented the hard physical labour of the 'cobbers' on the surface at Parys mountain in 1792 and the dangers of the working methods employed in the mine itself, he left no impression of having questioned the rights and wrongs of the matter. J. M. W. Turner, however, was quite pointed in his written observations:

> Tuesday View'd the Paris & Mona Mountains – Smelting houses &c a wonderful production of Nature & of equal advantage – Men poorly paid – not more than 14d p. day – ab. 1500 persons employed. Black bread & water principal diet. The most wretched & ignorant poor wretches that can be Conceived in human forms ...[1]

Turner further emphasized the poverty of the workforce in contrast to God's bounty in providing such wealth by pointing out that the owner, Lord Uxbridge, was benefiting to the tune of £40,000 a year. Similarly, in the south, although Ibbetson and most of his contemporaries kept their moral distance, the first intimations of the less agreeable human realities of the new world began to

[1] John Gage (ed.), *Collected Correspondence of J. M. W. Turner* (Oxford, 1980), p. 16. There is, however, some doubt as to whether the diary from which this extract is taken is, indeed, the work of Turner. For the mines, see J. R. Harris, *The Copper King* (Liverpool, 1964).

emerge in the observations of a few travellers. In his image of the coal mine near Neath, Ibbetson had presented some workers in archaic peasant mode. However, in the same area, five years later, Henry Wigstead, friend and companion of Thomas Rowlandson, hinted at the existence of an altogether more dynamic community, albeit in conventional terms. He remarked: 'The appearance of the miners on the road to this place, (especially at their dinner hour, when they are seen in great numbers, carrying their implements) led us to conceive them inhabitants of the infernal regions; which was not a little heightened by a back ground of fire and smoke.'[2] In 1805 Edward Donovan went much further by choosing to show in an engraving a scene to which most others would, at best, allude – the dramatic juxtaposition of two worlds. The famous ruins of Neath Abbey were, by this time, encroached upon by a copper smelting works and a coal mine. He both drew the scene and speculated upon its significance:

> We contemplate the remains of such religious structures ... with infinitely greater veneration when the surrounding objects are in unison with the peaceful melancholy of the time-worn ruin we are pausing over; and the heart is allowed to enjoy, in undisturbed tranquility [sic], the emotions they inspire. – The favourite haunts of contemplation are silent, solemn, remote from intrusion; but neither silence, nor solemnity, have a local habitation here: – the spot in which it stands is contiguous to the copper works and collieries, and the ruin is itself become the abode of wretchedness: a receptacle for the miserable families of the poorer workmen employed in those concerns.[3]

Donovan had been preceded recently to the place by an exiled Breton traveller and amateur artist, Comte Maudet de Penhouet, who described the subterranean living conditions of the families of the miners at Neath Abbey in some detail:

> ... the cells of it serve as a retreat to an innumerable gang of mendicants, whose figures are hideous beyond all that can be imagined: the air which they respire in these subterranean caverns is, without doubt, the cause of that livid complexion and lean aspect which so particularizes them. As soon as I entered into one of the vaulted outer parts, several women came out of holes that communicated with it; they surrounded me, and the farther I advanced, the more the troop augmented: they carried almost all of them infants upon their backs, and the tone of voice in which they begged of us could be compared only to that of those women who headed the rebels at Paris ... Night coming on, we could not begin to draw any thing.[4]

[2] Henry Wigstead, *Remarks on a tour to North and South Wales in the year 1797* (London, 1799), p. 57.

[3] Donovan, *Descriptive Excursions*, II, pp. 75–6.

[4] Comte Maudet de Penhouet, *Letters describing a Tour through part of South Wales* (London, 1797), p. 38.

193. Comte Maudet de Penhouet,
Inhabitant of Ruins near Neath,
1797, Etching,
125 × 70

The following morning, Penhouet returned to draw a pit woman with her child in front of the Abbey ruins without a trace of the picturesque which obscured the realities of late eighteenth-century industrial life in the work of the professional artist on tour. For all his gentlemanly background, his pencil was naive and so he drew the woman with forthright honesty.

Although de Penhouet's response to the appalling living conditions of workers at the mines and copper refineries of Neath Abbey was unusual in that he troubled to document what he saw at all, his written comments showed little sign of compassion. He remarked: 'In fixing on those places as their habitations, they save themselves the payment of rent – but idleness is the great cause of their continuing in this state of misery.' These were not the things he had expected to see on his tour, and he quickly moved on to scenes of a more agreeable nature.[5] His image did not set a precedent, and, indeed, was probably seen by few people since his book was circulated mainly among his friends. Artists on the picturesque tour passed by on the other side, even when presented with the two worlds in close proximity. In places such as Neath, it required considerable visual gymnastics to exclude the undesirable pollutants but, nevertheless, artists succeeded in doing so and the Abbey continued to appear in publications such as Henry Gastineau's *South Wales Illustrated* as a noble and undefiled ruin, even when the distress of the people was noted in the text.[6] Furthermore, there were many other attractive places to visit, especially in the north, where artists were not confronted with such contradictory scenes. As the nineteenth century progressed, fewer and fewer artistic travellers came to industrialized Monmouthshire and Glamorgan, giving Wirt Sikes reason to describe south Wales by 1881 as *terra incognita*.[7] On the whole, artists went elsewhere – and particularly to Snowdonia – since the industrial landscape and its people offended them.

Urban industrial society proved more problematic to Welsh artists than to tourists from outside. In a physical sense, they could also stay away. We have noted the striking absence of portrait patronage from industrial areas in the careers of the artisan painters Hugh Hughes and William Roos. It was less easy for the more thoughtful of them to escape intellectually, given the scale of the change that was plainly under way in the economic and social structure of their country. Nonconformists like Hughes were emerging from the wings of intellectual life and approaching the centre of a stage which they would occupy for the rest of the century. As they moved, they absorbed from the antiquarians, poets and painters of the eighteenth century – like early Christians absorbing elements of the Pagan culture of their predecessors – an image of the land of Wales as unsullied as the morals of the people reborn in the faith. The nation was represented in art by salmon fishing on the Teifi, the beauty and antiquity of Betws-y-coed and Harlech Castle, and the devout, clean and loyal common people who were supposed to inhabit those regions. In 1816 Hugh Hughes drew a picture of them gathered together at a *Sasiwn* in Bala, far from the industrialized world. Four years later, in his diary for 14 June 1820, he observed that the preaching at such events 'does not only effectually render more strictly moral those who value and believe it; but that it has changed the whole face of our country, by raising, humanizing, taming, enlightening, and moralizing the mass of the population'.[8] Merthyr presented huge and powerful evidence to the contrary. As we have seen, it was in the same year of 1816 that the first major civil disorder broke out in what was rapidly becoming another Wales. The riots in Merthyr resulted in the calling out of the militia. Penry Williams painted the scene as several groups of soldiers, with bayonets fixed, dispersed the crowd. More orderly and no doubt better-off citizens looked on from the high ground and from the windows of their houses. William Crawshay, soon to become Penry Williams's patron, took to the hills, hiding in a farmhouse during the disturbances.

In 1821 Hugh Hughes made his only recorded visit to Merthyr, drawing for his book of engravings, *The Beauties of Cambria*. He met Iolo Morganwg there, in the company of his son, the teacher Taliesin Williams, but in his diary he made no mention of the extraordinary landscape through which he had moved. Hughes confined himself to noting his experience of the people:

[5] A few travellers noted the scene at Neath Abbey with compassion. J. T. Barber, in *A Tour throughout South Wales and Monmouthshire …* (London, 1803), p. 147, noted that 'Unceasing drudgery ... was unable to obtain them the necessaries of life much less a taste of those comforts, to which the exertion of useful labour might seem to have a just claim'.

[6] Gastineau noted that 'much of the effect as a religious ruin, is lost by the appearance of population: numbers of poor families, belonging to the adjoining copper works, take up their abode within its walls; and the emotions of veneration which would otherwise naturally arise in the mind, are absorbed in attention to the looks of distress, and the cries of misery'. H. Gastineau, *South Wales Illustrated* (London, n.d., c.1830–5), no pagination.

[7] 'North Wales is pretty well known; but South Wales is *terra incognita* to most Englishmen.' Sikes, *Rambles and Studies*, p. ix.

[8] *Wales* (ed. O. M. Edwards), III (1896), 354.

194. Penry Williams,
Merthyr Riots,
1816, Oil,
383 × 830

Today I travel twenty four miles on my journey homeward, that is, to Merthyr Tydfil. At Merthyr, in an Inn called the Crown. I will not forget the name of the place until it is impossible for me ever to come close to it again. The company was four or five men of a sort that my heart would not tolerate, my whole heart would do nothing but despise them; I sat in the same room as these for two or three hours without once opening my mouth. It was a blessing to me that nothing I loved was praised by them. To me, they were so vile that their disapproval excited me to love the objects of their abuse as if they necessarily deserved it, and to permanently detest whatever their kind found praiseworthy.[9]

The landscape and the common people of Merthyr seemed untouched by the new morality. However, since Hughes and many patriots like him were engaged in nation-building on the basis of the idea of the moral and docile *gwerin Gymreig* (Welsh peasantry), the workers he observed in Merthyr were not only an offence to him personally but also to his concept of Wales. Such Nonconformist intellectuals were manufacturing an idea of the nation which was outmoded even before it was fully formed, and inappropriate to depict Wales in the increasing complexity of its sociology. Their failure to create an inclusive concept, manifested in the visual culture by a dearth of imagery – even moralizing or critical imagery – which could bring industrial Wales within the national frame would have important implications.[10]

After 1816 Penry Williams would never again portray civil disorder, despite the fact that in Italy he witnessed the culmination of the *Risorgimento* in the fighting for Rome in 1848–9. His Welsh colleague John Gibson, who was often described as the greatest sculptor of the age,[11] fled that scene, remarking that 'The Muses are said to be silent amidst the clash of arms', and never attempted to image modern life.[12] The other-worldly Gibson was a model for Joseph Edwards, the first of the remarkable group of sculptors who emerged from Merthyr in mid-century. Yet although Edwards often waxed lyrical about his homeland from his studio in London, he saw Wales only as the domain of bards and Christian mystics. The brothers William Lorando and Watkin D. Jones, who followed Edwards from Merthyr to London, nurtured similar fantasies.[13] The Jones brothers were, in turn, followed to London by the Davies brothers. William Davies (Mynorydd), was a notable Nonconformist progressive and a leader among those who sought to raise what they perceived to be the low profile of art in Wales. Yet he, like the others, produced no imagery relating to the extraordinary industrial community from which he had emerged. The potential of industry and the industrial community as a symbol of Wales and of Welshness was almost completely ignored in indigenous art before the Great War.

This reaction did not, however, mean that industrial society went entirely visually unrecorded. In the 1830s a few artists from outside Wales portrayed the new world in works which seem filled with foreboding appropriate to that troubled decade. Through the medium of engravings based on his conventional drawings of castles and bridges, Henry Gastineau became one of the most familiar of all the image-makers of the nineteenth century. As we have seen, he sanitized the abbey ruins at Neath. However, his original paintings were sometimes of a different character, flamboyant and Turneresque. In his remarkable view of the *Hafod Copper Works at Swansea*, the yellow light of a low sun, complemented by

[9] Translated from the Welsh, *Cymru* (ed. O. M. Edwards), VIII (1895), 266.

[10] As far as is known, Hughes only once included industrial elements in an image. *Y Cymro Newydd* was designed, probably in collaboration with others, for the radical magazine *Y Cymro* (1830), and although it showed factories and symbols of technology, it did so in idealized and sanitized form, like those of Thomas Pennant.

[11] See Joseph Mayer, for instance, NLW MS 4915D, f. 96, f. 123.

[12] T. Matthews, *The Biography of John Gibson, R.A., Sculptor, Rome* (London, 1911), p. 113. Penry Williams wrote a detailed account of the siege of Rome in a letter dated 20 May 1849, which was sent to Mrs Berrington, Woodland, near Swansea: NLW MS 16704E, ff. 217–18. His early imagined portrait of Field Marshall General Suwarrow, 1817 (Cyfarthfa Castle Museum) has a battle scene in the background.

[13] William Lorando's pioneering contribution to the Abergavenny Eisteddfod of 1845, intended to signify the national psyche, was *Taliesin Pen Bardd*. There was a third Jones brother, John Emrys, who stayed in Merthyr as a monumental mason. It was he who provided Cleopas Harris with his first employment as a photographer.

195. Henry Gastineau,
*Hafod Copper Works
at Swansea*, c.1830,
Watercolour,
202 × 296

196. John Sell Cotman,
Copper Works at Swansea,
c.1800, Watercolour,
252 × 352

the orange of the man-made fires within, threw the human beings into melancholic shadow. A similar mood, if somewhat less intense, coloured John Sell Cotman's view of the Swansea copper works. The association of these scenes with pictures of hell was commonplace by this time, and no doubt Gastineau had such pictures in mind. If so, his workers corresponded to the devilish employees of the underworld rather than to the condemned souls, since they clearly belonged to this place, integrated into it by their labour, though dwarfed by its product. Gastineau did not place them in the foreground so that they might become individuals, but observed them in the distance as part of an unnatural panorama at which he stared for a moment before passing on to the green fields and hills of Breconshire or Carmarthenshire. It is, perhaps, indicative of the unusual nature of the image that it was not engraved.

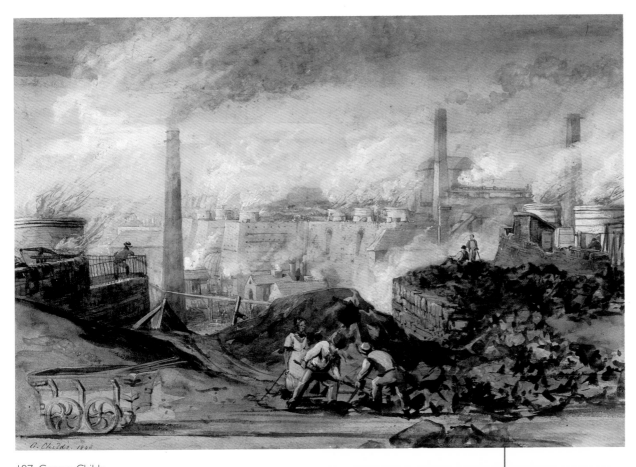

197. George Childs,
Dowlais Ironworks, 1840,
Watercolour, 239 × 349

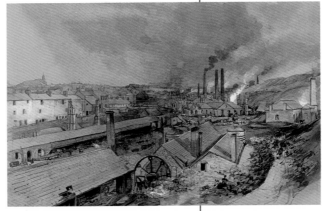

198. George Childs,
Dowlais Ironworks,
1840, Watercolour,
255 × 360

Like Gastineau, George Childs's normal subject
matter was typified by his view of *St Donat's
Castle*, shown at the Royal Academy in 1839.
However, the following year he visited Merthyr,
and the most remarkable of three surviving
drawings made there echoed Gastineau in
presenting human labour proceeding, self-
absorbed, against a landscape which seemed
too huge to be its consequence. In retrospect, it
is easy to read into such images the implications
for individuals and communities that this new
world would have. How much of this artists
such as Gastineau and Childs sensed at the
time is a matter of speculation. With so few
images to examine, it is not easy to say to
what extent they were informed by the civil
disturbances of the period and by the
emerging political and social literature.

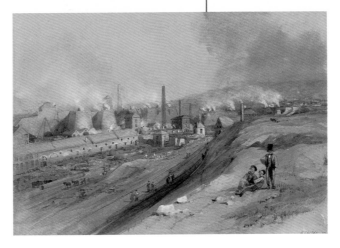

199. George Childs,
Dowlais Ironworks,
1840, Watercolour,
240 × 349

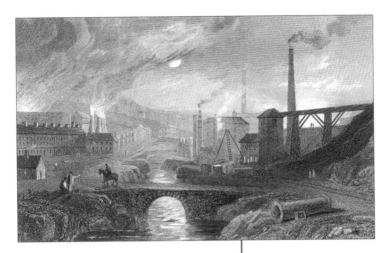

200. S. Lacey after unknown artist,
Nant-y-glo, c.1830,
Engraving, 83 × 146

Nevertheless, it is difficult to escape the conclusion that since these artists chose, against the prevailing aesthetic, to portray the scene, they felt some deep sense of foreboding. Here, industrial gloom emerged from the industrial sublime. The observers stood alienated from what they saw. In a view of the Nant-y-glo ironworks, drawn by an unidentified artist in about 1830, a single figure stood isolated on a bridge as if in contemplation of the other-world. It predicted by more than a century the kind of picture which would become commonplace when industrial Wales finally took its place at the centre of the art-imaging of the nation.[14]

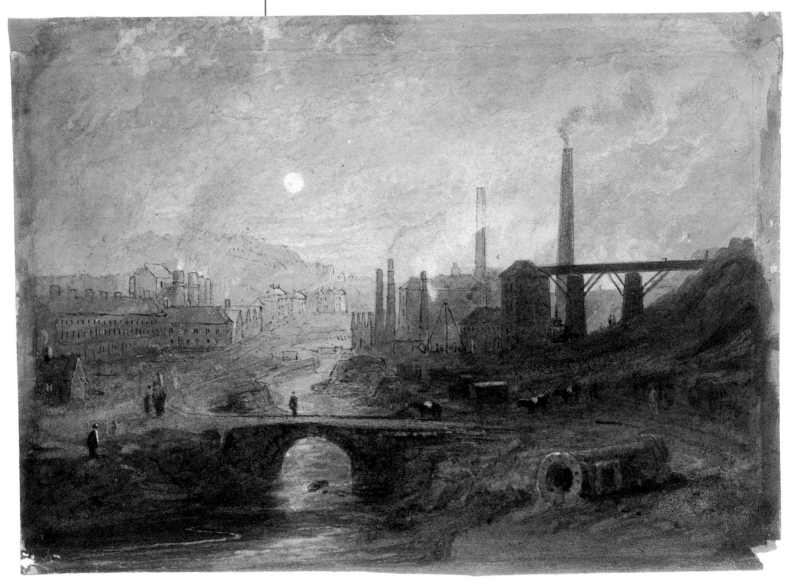

201. Anon.,
Nant-y-glo Ironworks, c.1830,
Watercolour, 141 × 199

202. Anon.,
The Protesters at Hirwaun,
c.1831, Engraving

With the exception of these remarkable images, academic painting and sculpture had little to show. Art engravings, as we have seen, presented to the world only pristine icons of technological achievement. It was image-makers working in a different context who were responsible for the rapidly increasing number of depictions of industrial trauma which emerged through the Victorian age as a visual counterpoint to the celebrations of the engineering prints. Penry Williams's picture of the 1816 riots cannot be seen as the product of an art culture, with which the painter was largely unfamiliar at fourteen years of age. It stood much closer to the reportage of the ballad singer, translated into visual form, and it was within an evolving tradition of popular prints, both documentary and campaigning, that the dark side of the industrial world emerged. Nevertheless, pictures of protest from the disturbed 1830s were rare. Indigenous ballad publishers had little to say and less to show. The main producers were in rural rather than in industrial areas, but the comparable absence of pictures of the Rebecca riots, which affected rural communities, suggests that the reasons for the dearth of images of social unrest went deeper than geography, and echoed the alienation clearly felt by some of the travelling artisan painters for the industrial world. Coupled with the endemic fear of accusations of disloyalty to England, Nonconformist intellectuals who might have drawn and published such politically sensitive imagery, felt constrained both on the conservative and liberal wings. Conservatives took the view that the established order was the consequence of God's providence and that to try to overturn it other than by petition to those in power was sinful, and many liberals were of the opinion that God's intention was that mankind should behave according to rational principles. Violence was regarded as irrational and therefore, however great the abuse, ungodly.[15]

The 1831 rising in Merthyr, in which many protesters died at the hands of the militia, led to the production of only one, probably contemporary, printed image. Nevertheless, it was a notable and stirring example in the French revolutionary tradition. In the words of Gwyn A. Williams: 'At Hirwaun, up on Aberdare Mountain, the rebels ritually sacrificed a calf, washed a flag in its blood and

[14] The picture is often attributed to George Robertson, but this cannot be so since he died in 1788, many years earlier than the scene depicted. The picture may be by Gastineau, since a similar line engraving by Lacey, who engraved many of his works, dating from about 1830, survives in the National Museum of Wales.

[15] Hugh Hughes, for instance, was a radical but he described the Chartist Rising of 1839 as an 'outrage'. He maintained that it was chiefly the work of Englishmen. See Lord, *Words with Pictures*, p. 136.

The attack of the Chartists on the Westgate Hotel, Newport, Nov. 4th 1839

203. James Flewitt Mullock,
*The attack of the Chartists
on the Westgate Hotel,
Newport, Nov. 4th, 1839,*
c.1840, Lithograph,
172 × 260

impaled a loaf of bread on the staff. His arms drenched to the elbows, the bearer set off with his bloody talisman of the people's martial law to summon the "Sons of Vulcan" to insurrection.'[16] The source of the dramatic image of this event is unknown, but it seems to have been imaginative rather than documentary, and not to have come from within Wales. It was the 1839 Chartist uprising in Newport that spawned the first indigenous print of a civil disturbance with its roots among the urban industrial proletariat. Since it is possible that the artisan painter James Flewitt Mullock was an eyewitness to the events he depicted (or if not, he certainly could have spoken to many who had been there), his image of *The attack of the Chartists on the Westgate Hotel* had a degree of authority as reportage which gave it a shared quality to Penry Williams's earlier painting, but which distinguished it from the romantic print of the protesters at Hirwaun.[17] This does not mean that Mullock intended his picture to propagandize the Chartist cause. He probably judged that the potential market for such a print would be substantial, given the intense interest in the events depicted which extended over the considerable period of the trial of the leaders and the subsequent debate about their death sentences. It is not clear at what stage in the proceedings the print went on the market, but it seems likely to have pre-dated two other engravings of the scene in which the numbers involved in the uprising were increased dramatically. The trial of the three leaders was documented visually and published in book form,[18] but a single print of John Frost, Zephaniah Williams and William Jones was also issued, their portraits set above the death sentence (subsequently commuted), which was handed down by the judge.

[16] Introduction to Gorman, *Banner Bright*, p. 1.

[17] A drawing of the events was prepared by a military officer for use in the trial, and this may also have been a source used by Mullock.

[18] Anon., *The Rise and Fall of Chartism in Monmouth* (London, 1840).

204. W. Taylor,
*A View of the Westgate
Hotel & Mayor's House
Newport, as they appeared
after the Dispersion of the
Chartist Rioters*, c.1840,
Engraving, 260 × 454

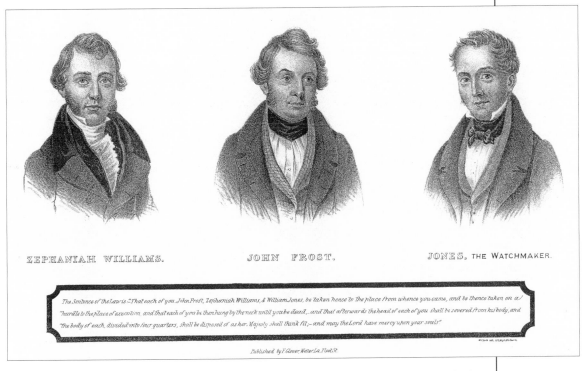

205. W. Clerk,
The Welch Chartist Martyrs!,
c.1840, Lithograph,
212 × 300

206. Lucy Bentley Smith,
Joseph Kenny Meadows,
c.1860, Oil,
259 × 201

The shock of the violent disturbances of the 1830s led to a new decade in which unease about the living and working conditions of the industrial proletariat became widespread in liberal circles. In 1842 the documentary engravings in the report of the Children's Employment Commission shocked polite society. Soon afterwards, a profusely illustrated periodical press emerged in England. The engineering achievements of the industrial age were lavishly celebrated in the new press, but the other side of the urban industrial coin was not ignored. From the beginning, civil disturbances and industrial disputes were reported in pictures. *The Illustrated London News*, published weekly from 1842, was widely disseminated all over the empire. It sold initially for 6d. and immediately achieved a circulation of 24,000, which rose to 200,000 in the 1850s. It was followed by a host of other periodicals competing for the middle market. Although *The Illustrated London News* was not a working-class newspaper, photographic evidence from the end of the century reveals that pictures from such magazines were cut out and pasted on the walls of the humblest dwellings in Wales. The pictures were produced by teams of wood engravers, who worked quickly but to high standards, creating a new vocabulary

207. Anon.,
The Riot at Mold, Flintshire,
1869, Wood engraving,
160 × 235

[19] Joseph Kenny Meadows (1790–1874), son of a retired naval officer. He also worked for *Punch* and illustrated a large number of books. No evidence of a continuing relationship with Wales, subsequent to his removal to London, has come to light. T. Mardy Rees, *Welsh Painters, Engravers, Sculptors (1527–1911)* (Carnarvon, [1912]), p.105.

[20] *The Illustrated London News*, 12 June 1869, 602.

[21] Including Dic Aberdaron in a style and format closely similar to the John Evans portrait. See Lord, *Words with Pictures*, p. 115.

[22] The disaster was also photographed and painted.

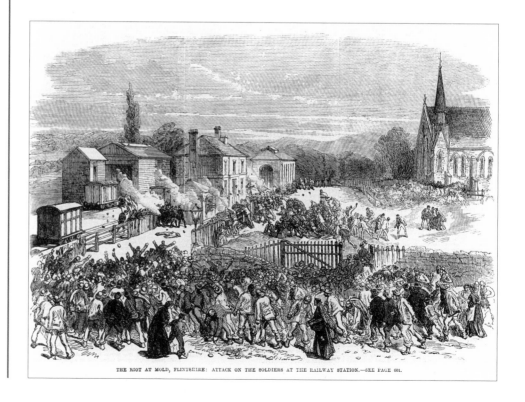

THE RIOT AT MOLD, FLINTSHIRE: ATTACK ON THE SOLDIERS AT THE RAILWAY STATION.—SEE PAGE 601.

of documentary imagery. They were based on sketches done by or on behalf of their own reporters, who were sent out to cover events. Among the original artists for *The Illustrated London News* was Joseph Kenny Meadows, born in Cardiganshire in 1790.[19] Daguerreotypes were also used from an early date as a basis for engraving, and after 1851 it became possible to print a photographic image directly onto a woodblock.

In Wales, the north-east coalfield did not attract the attention of image-makers to anything like the same extent as the south, but events at Mold in June 1869 became sufficiently serious for *The Illustrated London News* to publish a picture, typical of the reportage of the new press. Two colliers were sentenced to gaol for assaulting a colliery manager, and a riot ensued. Fifty soldiers had already been called out in support of the police who 'had to use their Sniders in terrible earnest, and four or five of the rioters were killed, two of them being women'.[20] With such pictures and comment, the illustrated press was influential in developing an ambiguous attitude towards mining communities which became characteristic of the English middle class into the second half of the twentieth century. The account of the behaviour of the colliers, which accompanied the picture of the disturbance at Mold, was highly critical, and the soldiers, who had suffered only cuts and bruises, were elevated to the level of heroes. On the other hand, the sympathetic treatment of mining disasters became almost a genre in itself. The projection of the image of the collier in adversity in popular prints had begun as early as 1819. Albin Robert Burt, a painter who produced a number of Welsh subjects in engraved form,[21] drew a full length portrait of 'John Evans who was buried without food or light, during the space of 12 days and nights, in a Coal-pit at Minera, near Wrexham, 120 yards below the surface of the earth'. Evans was plainly drawn in his working clothes, as an object of curiosity. To the outsider, miners were, and would remain, a distinct and exotic breed but since forbearance in the face of adversity was a virtue much celebrated in Victorian society, disasters, often luridly described, became a focus for waves of sentiment, leading to the creation of the image of the stoic miner and his grieving but dignified woman. *The Illustrated London News* had included a number of topographical descriptions of the sites of accidents but it was the disaster in 1852 at the Hartley Colliery at Newcastle-upon-Tyne in England which released the full potential of the illustrated press for the first time. The rescue attempts occupied several days, enabling the illustrators to reach the scene and do their work in a spirit of reportage, rather than analysis after the event.[22] In 1867, 178 miners died at Ferndale, but the deaths were instantaneous and the press coverage was confined to a panoramic

208. Roffe after A. R. Burt, *John Evans who was buried ... in a Coal-pit at Minera, near Wrexham ... Sept. 27th 1819*, c.1819, Engraving, 245 × 163

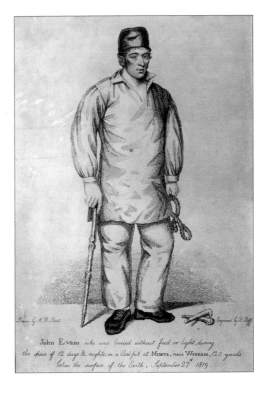

209. Anon.,
*The Flooded Colliery at Troedyrhiw
– Rescue of the miners,*
1877, Wood engraving,
298 × 425

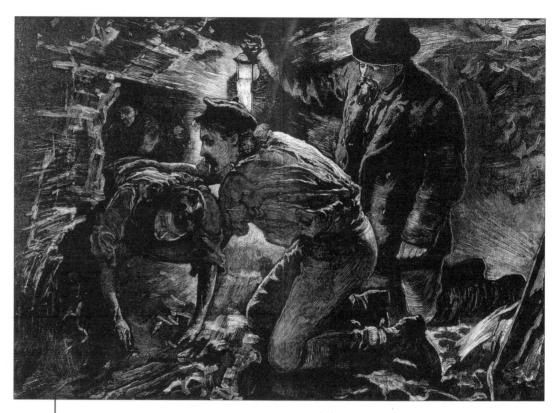

[23] For other examples of Welsh funereal imagery, see Peter Lord, *Clarence Whaite and the Welsh Art World. The Betws-y-coed Artists' Colony, 1844–1914* (Aberystwyth, 1998), Chapter 5.

[24] Translated from Hywel Teifi Edwards, *Arwr Glew Erwau'r Glo: Delwedd y Glöwr yn Llenyddiaeth y Gymraeg 1850–1950* (Llandysul, 1994), p. 114. The events are described in detail in Ken Llewellyn, *Disaster at Tynewydd* (Cardiff, 1975).

[25] See Lord, *Words with Pictures*, for examples in popular prints. The Dillwyn family group by C. R. Leslie, reproduced on p. 85, is a noteworthy example from an academic painter.

[26] The use of artists living in the area of an incident was not unusual. In 1853 Teale of Brecon contributed six drawings of floods in the town to *The Illustrated London News* of 30 July.

[27] *The Graphic*, 28 April 1877, 386.

view of the removal of the bodies. Victorian artists in general were much preoccupied with death, but Welsh funereal imagery seems to have had a particular resonance and, in April 1877, the opportunity arose to do it full justice.[23] Fourteen miners were trapped near Porth by an inundation of water from a pit which had been the scene of 114 deaths a decade earlier. The attempts to reach the men brought many illustrators and reporters to the Rhondda. According to Hywel Teifi Edwards, 'The Tynewydd pit ... was turned into a theatre which nailed the attention of Britain and America to a heroic drama which took ten days to perform',[24] as the rescuers cut a tunnel towards the last five survivors. Coverage in *The Illustrated London News* and *The Graphic* was not only extensive but developed a new aspect as compared to the description of the Hartley Colliery disaster. Direct observation was mixed indiscriminately with imaginative reconstruction of the highlights of the rescue. *The Illustrated London News* filled its cover with *Rescued – Scene at the Pit's Mouth* and *The Graphic*, over a double-page spread, presented an even more intimate underground view of the moment when Isaac Pride, one of those who had tunnelled seventy yards, passed the youngest of the survivors from the mouth of the rescue tunnel to his colleagues. Here, reportage became indistinguishable from the imagery of popular fiction, itself related to the melodramatic art images presented regularly at the Royal Academy. *The Graphic*'s bedside scene, *In the Hospital – Meeting of George Jenkins and his Family*, repeated the visual conventions of the deathbed genre which transcended the Victorian visual world from academic art to popular print.[25]

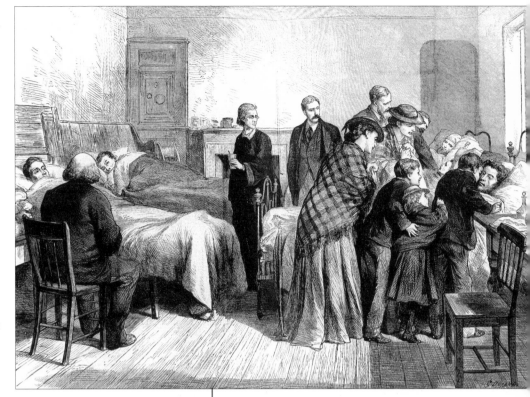

210. G. Durand,
In the Hospital – Meeting of
George Jenkins and his Family,
1877, Wood engraving,
296 × 415

Both magazines despatched their own artists
to the Rhondda, but *The Illustrated London News*
also made use of the drawing abilities of one of
the doctors in attendance, Edward W. S. Davis,
who was able to venture underground.[26] His
pictures of clusters of exhausted rescuers with
little to do other than await the outcome had the quality of
genuine reportage. *The Graphic* extended its written account
to a history of mining and its technology, emphasizing the
unfamiliarity of the industry to a middle-class public whose
prosperity depended upon it. Like the visual imagery, the text
lurched suddenly from analysis to romance and from objectivity
to stereotyping, including particular Welsh stereotyping:

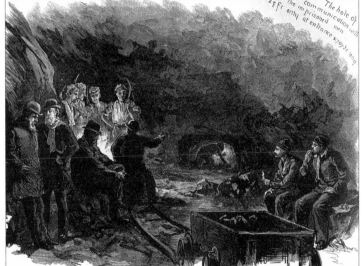

> The colliers are a hardy race of simple, brave-hearted
> men, who daily carry their lives in their hands, for ... their
> occupation is one of continual danger. When the swarthy
> workman leaves his humble cottage after kissing his wife
> and children, and shoulders his pick and shovel for his
> spell of labour in the gloomy bowels of the earth, he knows
> not whether he shall ever again see their loved faces and
> the glorious golden sunlight, or whether his mangled and
> blackened corpse may not in a few hours be drawn up the shaft, and borne
> home to his bereaved widow and weeping babes. It is perhaps this awful sense
> of standing as it were in the immediate presence of Death that makes the collier,
> especially the Welsh collier, so susceptible to the influence of religion, and so
> unswerving in his faith respecting the protective care of that Providence which
> is as powerful to save in the deep dark caverns of the earth as on the lonely
> waters of the ocean, the trackless sands of the desert, or amid the rugged
> fastnesses of the mountains.[27]

211. Edward W. S. Davis,
The Troedyrhiw Colliery Accident: The hole of
communication with the imprisoned men,
1877, Wood engraving,
174 × 236

This account and others like it emanating from England carried a distant but clear echo of the eighteenth-century portrait of the noble savage who dwelt in the mountains. Nevertheless, it would have been widely read in Wales and the national sentiments it expressed were echoed by many Welsh writers. However, waves of sympathy for the bereaved and praise for the bravery of the rescuers in 1877 did not totally obscure the alter ego of the miner. The Tynewydd disaster occurred in the wake of two serious disputes resulting in a stoppage of the South Wales Coalfield and its dependent industries for six weeks in 1873 and twenty-one weeks in 1875. In its coverage of the disaster, the liberal-minded *Graphic* made reference to earlier events:

> A great deal has been written about the ignorance and barbarism of the British miner, how in his obstinacy he refuses to work except for a very high wage, and how he spends his increased earnings upon legs of mutton for his ugly dog and champagne for himself, while his wife and children have hardly the necessaries of life. The picture, however, is grossly exaggerated, and we may take it that the collier is very much like any other British working-man, somewhat rough-mannered and plain-spoken, perhaps, and a trifle overbearing when, under the direction of the Union leaders, he strikes, and finds that the masters are obliged to give way. Still for all this he is by no means destitute of the nobler instincts of humanity, and we can readily forgive much to men who, when their fellows' lives are imperilled, are so eager to strain nerve and muscle, and to brave the greatest dangers to rescue them.[28]

In fact, the extensive visual coverage of the two disputes in *The Graphic* and *The Illustrated London News* made little resort to the image of the miner as a dangerous barbarian, in contrast to the undertone of 'noble savage' present in the depictions of disasters. Indeed, the first picture of the 1873 dispute showed the scene at the conference between the two sides held at the Royal Hotel in Cardiff, with William Menelaus, general manager at Dowlais, in the chair. The men were in their Sunday best and listened intently and respectfully to a harangue delivered from the owners' side of the table. The following day they rejected the proposed 10 per cent cut at an open-air meeting and struck. A similar open-air meeting in the 1875 dispute was depicted with equal restraint. Indeed, *The Graphic*, while regretting the social and economic consequences of the dispute, went out of its way to point out that 'the conduct of the men on strike has been most exemplary'.[29] Both illustrated papers concentrated their coverage on hardship within the mining community caused by the dispute and resorted only occasionally to an emphasis on the suffering of those described as 'innocent' in an implied criticism of the strikers. Herbert Johnson was despatched by *The Graphic* to Merthyr, where he drew extensively. His picture of the tidy home of a collier on strike who, according to the writer of the accompanying article, had cynically prepared himself for the struggle, was compared to the squalid home of an iron miner in Dowlais, laid off as a consequence of the strike. The miner suffered through no fault of his own as a consequence of his fellow-worker's selfishness. Whether this interpretation

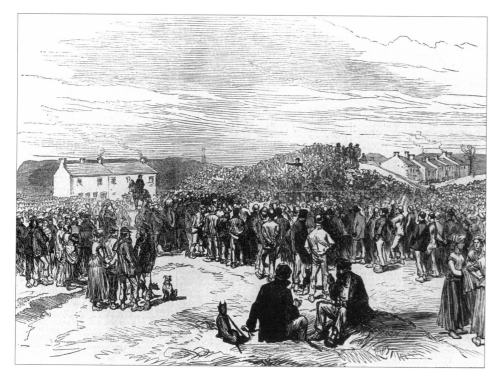

212. Anon.,
The Lock-out in South Wales:
Mass Meeting of the locked-out
at Mountain Hare, Merthyr-Tydvil,
1875, Wood engraving,
163 x 235

reflected the artist's intention must be considered doubtful in view of the content of the remainder of his images. Johnson ventured underground at Vochrin Pit, apparently the first artist to do so in Wales, to draw in a dramatic sequence the deteriorating conditions. He saw timbers, a foot in diameter, which 'in consequence of neglect, had snapped and bent like twigs, and the sides and

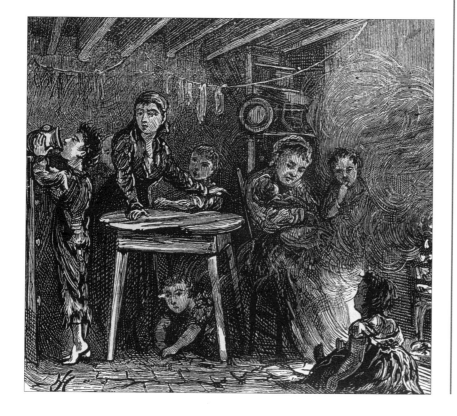

213. Herbert Johnson,
A Miner's home in Gas Row, Dowlais,
1875, Wood engraving,
99 x 111

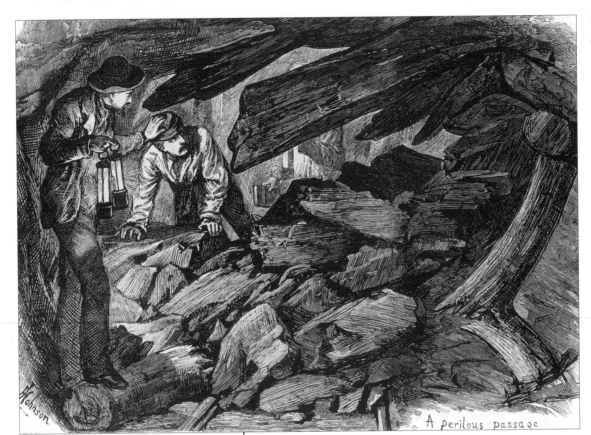

214. Herbert Johnson,
A perilous passage,
1875, Wood engraving,
161 × 226

roof forced in till the width was less than five feet ... "Such is the strange power", remarks our artist, "which the earth seems to have of healing itself, as it were, that not only does the roof descend and the sides close in, but even the floor rises and cockles in an endeavour to reach the roof ...""[30]

Notwithstanding the inevitable compositional interventions of the artist in transposing reality, scenes such as *Exodus of Miners from Merthyr Tydvil* had a remarkable presence and sense of truth. Although the scenes were often organized on a stage running parallel to the picture plane, once on the stage they owed as much to the verité of the camera as to the conventions of academic art. *Waiting for Relief outside the Workhouse at Merthyr* portrayed 'the scene at midnight in front of the Union Workhouse, where men and women crowd in such numbers that the relieving officers cannot attend to them all by the close of evening'. It succeeded brilliantly as reportage not only in its objectivity but in its ability to move by conveying the psychological mood in the isolation and introspection of the figures against the snowy night sky. In order to qualify for relief, men were set to stone-breaking. Johnson's depiction of stone-breakers was given particular resonance by the decision of the Poor Law guardians, dominated by the ironmasters and coalowners, to reduce pay rates and debar unmarried men entirely. This attempt to undermine the strike scandalized liberal opinion and was described in *The Illustrated London News* as 'manifestly wrong'.

30 Ibid., 27 February 1875, 195.

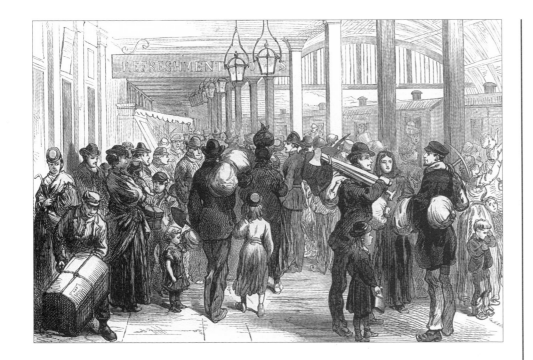

215. Anon.,
*The Strike in South Wales: Exodus
of Miners from Merthyr Tydvil*,
1873, Wood engraving,
160 x 237

216. Anon.,
*Waiting for Relief outside the
Workhouse at Merthyr*,
1875, Wood engraving,
161 x 237

217. J.N. after Charles W. Campion,
*A Street Scene at Merthyr –
Before the 'Lord Raglan',*
1873, Wood engraving,
112 × 150

Both Johnson and C.R.,[31] the unidentified artist of *The Illustrated London News* in the earlier dispute, sought to portray the social life of the mining communities in the contemporary spirit of improving general knowledge. In 1873 *The Graphic* had engraved *A Street Scene at Merthyr – Before the 'Lord Raglan'*, based on a drawing by Charles W. Campion of Neath,[32] and *The Illustrated London News* ventured inside a public house, showing dancing to the harp in a room decorated with a poster against low pay. C.R. penetrated yet deeper into the private life of the community on a Sunday morning by attending a dogfight. The powerful drawing evoked an irritated response from some readers of the paper:

> One of the engravings published last week, representing a party of colliers amusing themselves with a dog-fight on a Sunday morning, has given some offence to respectable inhabitants, who protest against it as a picture of the morals and manners of that class, or one characteristic of social life in that part of the country. We had certainly no intention of placing it before our readers in such a light, for everybody knows that the Welsh people, for the most part, are religious observers of the Sabbath ... and the colliers, as a class, are probably as good as their neighbours; but there are black sheep in every flock. Our Special Artist is prepared to testify that he actually saw the dog-fight and the crowd of spectators on a Sunday morning, in a particular place ...[33]

[31] A number of artists with these initials worked for the paper in the period. See Rodney K. Engen, *Dictionary of Victorian Wood Engravers* (Cambridge, 1985).

[32] Campion had earlier drawn a panoramic view of the opening of the new docks at Swansea, *The Illustrated London News*, 8 October 1859, 343. He does not appear in the street directories of the period as an artist or as a photographer.

[33] *The Illustrated London News*, 8 February 1873, 130.

218. C.R.,
*The Strike in South Wales:
A Sunday's Amusement*,
1873, Wood engraving,
160 × 237

219. Herbert Johnson,
Back o' Plough, Dowlais,
1875, Wood engraving,
88 × 118

This response to an image is of interest in demonstrating attitudes both within and beyond the community, and also for the confirmation it offers that visual reportage in London papers found its way back to Wales and was considered important. Such scenes and such people had been described before, but seldom portrayed. It is clear that Johnson, two years later, was also able to come close to the people both in communal situations by his portrayal of a working-class theatre audience watching Shakespeare, and at the level of individuals in their homes. The dire poverty depicted in images such as *Back o' Plough, Dowlais*, and supported in text, must have affected liberal consciousness in the area:

In 'Back o' Plough', one of the most wretched districts in Dowlais, our artist sketched a room in which a family lived as well as slept. On a truckle bedstead, upon which was spread some loose dirty rags, lay a sick man, covered only by his tattered old coat; while his wife, a pale, pinched-face creature, stood by his side, nursing a half-starved baby ... The walls were reeking and the floor saturated, and in the filthy ceiling was a large hole. Such are the places in which some of the poor wretches live and die.[34]

[34] *The Graphic*, 6 March 1875, 222.

The ethics of reportage were only beginning to develop and the pictures which led such texts were in a transitional state. They were clearly informed by photography but, at the same time, remained under the influence of academic art in the form of both contemporary realist tendencies in France and England and older classical conventions. The pictures operated in the context of a similarly fluid interaction in literature between realist fiction, reportage and political polemic. In England the impact of reportage on writing was famously exemplified by Dickens, whose work certainly exerted an influence on the vision of the artists of the illustrated press. In Wales the realist novels of Daniel Owen were written from within an industrial community which experienced serious poverty and civil disturbances, such as those at Mold in 1869. In 1874 *The Athenaeum*, reviewing realist pictures of industrial workers by the English painter Eyre Crowe, including *The Spoil Bank* which depicted women and children collecting coal on Lancashire slag heaps, reported that:

> We admire Mr Crowe's conscientiousness in painting such uninviting subjects as these but we submit that he might often have used his time more wisely, and that photography was made for such work as recording all that these pictures tell us.[35]

In this unresolved aesthetic situation, even within the work of a single artist, such as Herbert Johnson, images often lurched from reportage to moralizing, from attempted objectivity to blatant distortion. The representation of women industrial workers in particular brought out these various tendencies and is particularly difficult to interpret. Academic artists were steeped in conventions for the portrayal of women which, in the second half of the nineteenth century, emphasized physical fragility, spiritual purity and chastity. In their portrayals of tip girls, patch girls, and women picking coal on the slag heaps, the new artist reporters found it difficult to resist constructing sentimental images contrasting these conventions with what seemed to them to be circumstances which ran counter to the essence of femininity. Furthermore, the 1873 dispute brought artists into mining communities in the immediate aftermath of a protracted debate about women's work, resulting, in 1872, in legislation which further restricted their hours of employment. The liberal view of the morality of the situation was in the ascendant against not only the views of the coalowners but also many of the women who worked in the industry. Consequently, the artist's images often discovered young beauty transcendent in a hostile environment. The cover illustration of *The Illustrated London News* of 15 February 1873 indicated the paper's liberal, reforming line, by means of an image of *Gathering Shindles for Fuel* in which the face and breasts of a poised, Botticelli-like maiden were highlighted in simple metaphor against the darkened tip.[36] Nevertheless, it would be untrue to suggest that the objective instincts of this new kind of artist-reporter were entirely suppressed under the weight of a particular moral stance and the European academic art tradition. *Coal Famine at Merthyr* (1873) presented women with little attempt to moralize or sentimentalize, and the 1875 lock-out

[35] *The Athenaeum*, 9 May 1874.

[36] A fortnight earlier *The Graphic* had led with a similar, though less obvious image, drawn by Valentine Walter Bromley, one of a number of distinguished engravers who tackled the subject. In 1868 a member of the Dalziel family, probably Edward (1849–89), had included a female worker among his illustrations for a long and picturesque essay entitled 'The Merthyr Iron Worker' in the magazine *Good Words*. Bromley drew for *The Graphic* (1872–3) and for *The Illustrated London News* (1873–9). For these and other engravers mentioned, see Engen, op. cit.

[37] The stark use of silhouette in this engraving foreshadowed by seventy years an image which became famous in Ralph Bond's film, *Today We Live*, reproduced on p, 221.

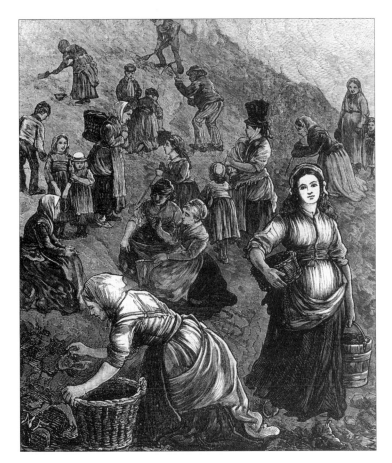

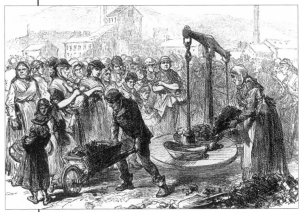

220. Anon.,
The Strike in South Wales:
Gathering Shindles for Fuel,
1873, Wood engraving,
249 x 210

221. Anon.,
The Strike in South Wales: Coal Famine
at Merthyr – 'A Penn'orth of Coals',
1873, Wood engraving,
162 x 236

was the subject of a number of images clearly reproduced without artifice from notes taken on the spot. Neither did more carefully constructed pictures such as *On a Tip, Collecting Fuel*, sentimentalize, though it might be considered to be hostile to the hardship endured by those it portrayed.[37]

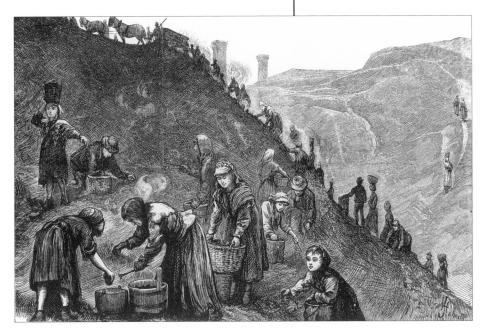

222. Herbert Johnson,
The Lock-out in South Wales –
On a Tip, Collecting Fuel, 1875,
Wood engraving,
148 x 226

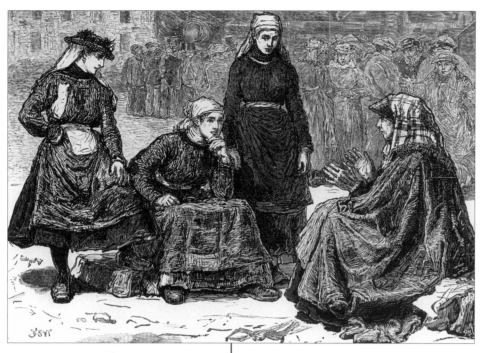

223. J.S.W.,
Group of 'Tip' Girls,
1875, Wood engraving,
163 × 238

[38] William Clayton is recorded at Iron Street, Tredegar, in street directories between 1868 and 1895. The mineworker series is, however, probably earlier than 1868.

[39] Angela V. John, *By the Sweat of their Brow. Women Workers at Victorian Coal Mines* (London, 1983), p. 184.

[40] Similar posed portraits were taken in large quantities of native peoples all over the world, feeding a curiosity about ethnic and social difference which it would be uncharitable to describe simply as voyeurism.

[41] Quoted in D. Hudson, *Munby, Man of Two Worlds* (London, 1972), p. 291.

Engravings such as the *Group of 'Tip' Girls* in *The Illustrated London News* of 1875 provide a rare opportunity to consider directly the relationship between the work of artist-reporters and photographers. The fascination of the Victorian intelligentsia with images of otherness was fed by photographic studies made by anthropologists of indigenous peoples in the southern hemisphere brought into contact with the west by colonial expansion. In the 1860s High Street photographers all over Europe and in the United States discovered a parallel popular market for images of working-class exotica to be found in their own countries. In Wales the most notable examples were the photographs of mineworkers taken in the studio of William Clayton in Tredegar.[38] It has been suggested that Clayton's photographs of women workers 'consciously and deliberately extended a particular image ... Photographic techniques would be used to great effect – especially controlled lighting and the use of a long lens. High skirting boards, large shovels and riddles accentuated the strength and squat appearances. Thus the physical image of the pit women was exploited through photography, enabling the women to be presented as objects of curiosity'.[39] This view overstates the sophistication and sexist intent of the photographer, whose 'high skirting boards' were merely the standard dado background of the portrait studio. Clayton photographed male mine workers in exactly the same studio, and comparison with Francis Crawshay's paintings of about twenty years earlier reveals that unless both painter and photographer, despite being commissioned for different reasons, were similarly motivated to distort, the photographs were remarkably objective, reflecting the scientific detachment of the work of the anthropologists. They certainly did not approach the artificiality of images of rural women in national costume which were beginning to emerge from photographers' studios at the same time. Women mineworkers were, indeed, objects of curiosity, but so were the men, and that curiosity owed much more to otherness of class than to gender. It was in some of the engraved images that attitudes to gender were brought to the fore by artifice.[40]

224. William Clayton,
Mine Worker,
c.1860

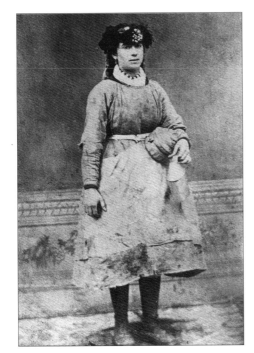

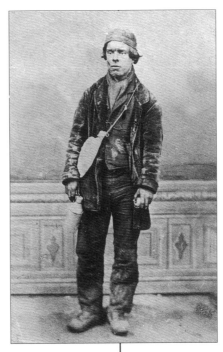

225. William Clayton,
Mine Worker,
c.1860

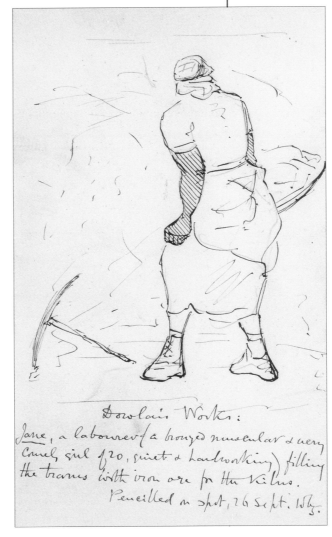

226. A. J. Munby,
*Jane, a Labourer
at Dowlais Works,*
1865, Pencil,
150 × 90

The main limitation of most of the
photographs of the early 1860s as
reportage was that they were studio
products. The contemporary drawings
of A. J. Munby activated the static
studio scenes but did not contradict
their essential honesty. Munby, who
visited Wales on several occasions
between 1861 and 1876, was
unusual for a man of his class in
that he approved of working women.
In his diary, he quoted numerous
instances of complaints from women
about the restriction of their working
hours: 'It's a great loss to us girls,
Sir, yes indeed ... We used to earn
8 to 11 shillings a week, and now
we do earn only six', complained
a woman at Bryn-mawr, having
lost her night work.[41]

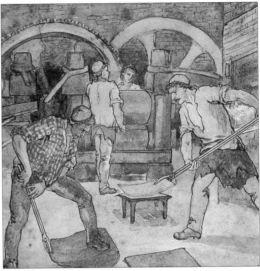

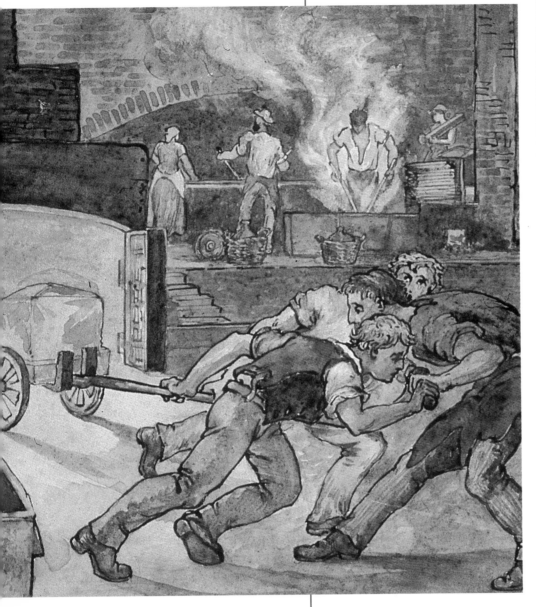

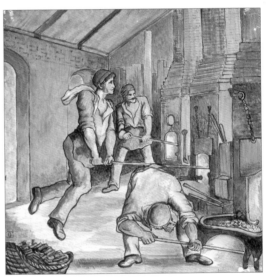

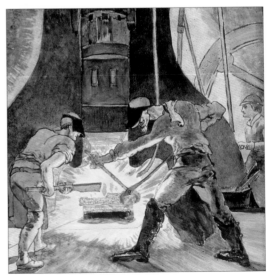

227. T. H. Thomas,
Trefforest Tin-plate Works:
Pickling and Annealing,
1874, Pen and watercolour,
147 × 147

right, from top to bottom:
228. T. H. Thomas,
Trefforest Tin-plate Works: Furnace
Man, Doubler and Tin Roller,
1874, Pen and watercolour, 147 × 147
229. *Trefforest Tin-plate Works: Finers,*
c.1874, Ceramic, 152 × 152
230. *Trefforest Tin-plate Works:*
Shingler and Cutter,
c.1874, Ceramic, 154 × 154

below:

231. T. H. Thomas, *'Sackcloth and Ashes', Tip Girls Leaving Work, South Wales Coal District,* c.1879, Engraving, 274 × 200

In 1874 T. H. Thomas made a remarkable series of twelve watercolour drawings, entitled *Process of Tin-plate Making*, which also illustrated female and child labour in heavy industry without apparent negative comment. Indeed, the drawings conveyed the energy and concentration of the workers, both male and female, with a distinctly affirmative tone. They were intended to be reproduced as ceramic tiles and a single set was manufactured with the images hand painted, rather than reproduced as transfers.[42] However, sometime before 1880, Thomas painted his *'Sackcloth and Ashes', Tip Girls Leaving Work, South Wales Coal District*, the title of which clearly suggested that society was shamed by the persistence of this particular practice. Although Thomas was born in the coalfield, the painting reflected a liberal and reforming view consistent with his middle-class Nonconformist upbringing in the Baptist College at Pontypool where his father was Principal. The engraved version of the painting clearly revealed the influence of both the visual conventions and the mixture of reportage and moralizing apparent in the imagery of the illustrated papers, to which he contributed drawings from at least the beginning of the 1870s. In 1883 he published a drawing of an underground prayer meeting which also reflects a moralizing strain in his character. This may be the earliest example of an image which would become increasingly important in the efforts of liberal-minded patriots to counteract the growing reputation of Welsh miners outside Wales as dangerous subversives. Thomas's image was probably based on first-hand experience since, by this time, he had returned to Wales to continue his career as an illustrator, in particular for *The Graphic*. He ventured underground to draw in at least two pits, one in the Forest of Dean and the other at Cwmbrân, being probably the first professional Welsh painter to do so. His coloured drawings, perhaps developed from monochrome originals done on the spot, had the same Daumier-like quality of outline and chiaroscuro as those made in the tinplate works.[43] They also seem to reflect Daumier in their attempt to convey more than a simple documentary record of working life. They succeeded in evoking a sense of respect both for the dignity of individuals in the isolation and introspection of their labour, and for the peculiar collective spirit of the pits.

[42] It is significant that the information that the drawings were intended for reproduction on ceramic tiles was given in a review of art works shown at the Cardiff Fine Art and Industrial Exhibition of 1881, *South Wales Daily News*, 5 September 1881. Thomas's intention may well have been that they be used in the decoration of the Free Library in Cardiff (designed by his close friend, Edwin Seward), for which the exhibition was intended to raise money.

[43] A single monochrome drawing, clearly preparatory to the tinplate series, survives in the National Museum collection.

232. T. H. Thomas,
*Cutter, Fitter and
Haulier Underground,*
c.1875, Watercolour,
88 × 163

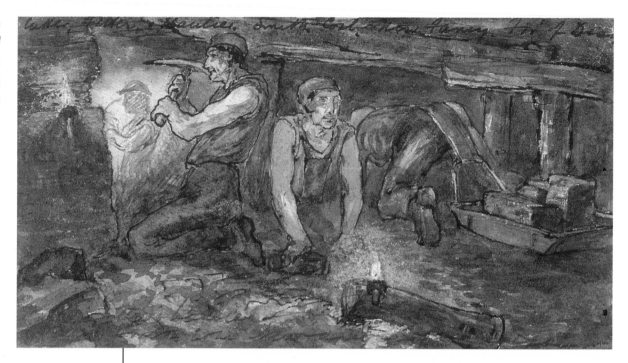

right: 233. T. H. Thomas,
Waiting to come up,
c.1875, Watercolour,
ink and pencil,
88 × 128

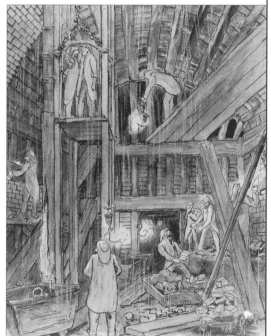

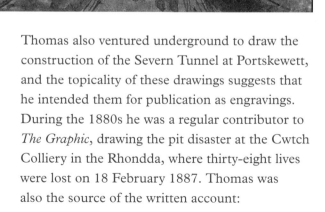

234. T. H. Thomas,
Engineering Works at Port Skewett,
c.1879, Ink, wash and gouache, 279 × 225

235. T. H. Thomas,
A Memorial of Tynewydd,
1887, Pencil,
137 × 123

Thomas also ventured underground to draw the
construction of the Severn Tunnel at Portskewett,
and the topicality of these drawings suggests that
he intended them for publication as engravings.
During the 1880s he was a regular contributor to
The Graphic, drawing the pit disaster at the Cwtch
Colliery in the Rhondda, where thirty-eight lives
were lost on 18 February 1887. Thomas was
also the source of the written account:

236. T. H. Thomas,
Effect of Explosion at 'Cwtch' Colliery,
Ynyshir, 1887, Pen and wash,
117 × 349

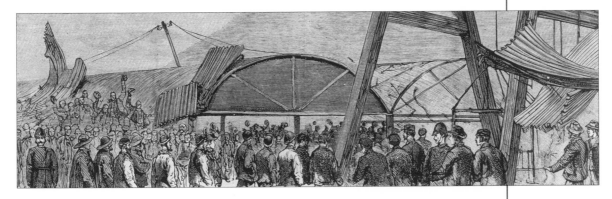

237. After T. H. Thomas,
After the Explosion,
1887, Wood engraving,
70 × 225

239. After T. H. Thomas,
A Last Look at his
Old Comrade, 1887,
Wood engraving,
79 × 73

238. T. H. Thomas,
A last look at his old 'Butty',
1887, Pencil,
103 × 118

Our sketches need only a brief explanation. At Pontypridd, where passengers change carriages, a trolly [*sic*] laden with coffins afforded ghastly evidence of the disaster which had occurred. Opposite to our artist in the railway carriage sat a powerful man, carrying a walking stick carved from end to end with inscriptions in Welsh and English. This stick had been given him with an address by workmen of the Tynewydd Colliery, when he was one of the party endeavouring to rescue miners entombed there. He was now going to see if he could be of any use at Cwtch. Sad burdens were carried past the houses on the Ynyshir Road, and most of the blinds were drawn down, yet the children, who had just had new skipping-ropes, continued to play … An elderly workman arrived by train, having heard that an old comrade was among the killed. He went into the clean cottage room, with its brightly polished chest of drawers, 'Little Red Riding Hood' and the portrait of the minister framed on the wall, and took a last look at his old fellow-labourer.[44]

[44] *The Graphic*, 26 February 1887, 210. T. H. Thomas was not named as the artist or as the reporter, but this was not an uncommon practice. Thomas had also drawn the disaster at Pen-y-graig Naval Colliery in 1885, but his pictures were not published, probably because of the intensive reporting of the Balkan war.

As we have seen, T. H. Thomas sent his '*Sackcloth and Ashes*' to the 1880 art exhibition at Merthyr, and the importance which he attached to it may be judged from the fact that he subsequently sent it to the exhibition of the Royal Cambrian Academy at Rhyl in 1883, where it must have stood out as an alien presence among the views of Betws-y-coed and the river Llugwy. Even in Cardiff, in the painting competitions at the National Eisteddfod organized by Thomas himself in the same year, McCulloch's heroic *A Welsh 'Puddler'* and a lost picture entitled *A Cefn Soup Boy* were lonely ships sailing on a sea of views in Snowdonia at a time when the leadership of the visual revival in Wales was substantially in the hands of individuals who, like T. H. Thomas, came from urban and industrialized communities.[45] Of his generation, only B. S. Marks, born in Cardiff in 1827, turned social issues in urban communities into subject matter. Immediately after moving his portrait practice to London, Marks gained a considerable reputation with his pictures of destitute street children. *Saved from the Streets* (1870) and *100,000 Neglected and Destitute Children in London* (1872) were shown at the Royal Academy at the height of public debate about such issues. *Board School Children* was exhibited in the Cardiff Fine Art and Industrial Exhibition of 1881 and subsequently became part of the city collection. Yet despite the fact that he spent the first forty years of his life in his home town, no equivalent material by Marks set in Wales has come to light. The subsequent generation, coming to maturity in the decade before the Great War, displayed similar characteristics. Christopher Williams moved in Fabian circles and was much concerned with the condition of poor people in industrial cities. *Why?*, his massive picture of the homeless, which he painted in 1911, showed people sleeping out on the Embankment in London.[46] A year later, in his adjudication of the arts and crafts exhibition of Eisteddfod Tir Iarll in his home town of Maesteg, he maintained that 'a criticism which was generally levelled against ... Welshmen was that they were full of enthusiasm one moment, and then full of despair':

> They were the produce of their country, but he doubted very much whether their valleys were valleys of despair ... He should say they were full of hope, and their mountains inspired them with faith ... 'Man does not live by bread alone'. It was with the full knowledge of the meaning of this phrase that they had attempted to bring art into their colliery districts to help those who toiled hard for their living in the bowels of the earth to realise and partake of the beauties and glories of this world ...[47]

Despite his concern for the well-being of the industrial community from which he sprang, Williams's patriotic enthusiasm for Welsh subject matter manifested itself only in historicist and allegorical subjects taken from the Mabinogi and the age of the princes. There was to be no Welsh equivalent of *Why?*. Like his contemporary, Goscombe John, his concept of Welsh revival failed either to present industrial society positively in a modernist spirit or to encompass social distress and industrial strife.

[45] *Catalogue of the Art and Craft Exhibition of the Royal National Eisteddfod, Cardiff, 1883.*

[46] The picture was destroyed in London during the Second World War, when it was in the possession of the Salvation Army.

[47] *The Glamorgan Gazette*, 9 August 1912. I am grateful to Geraint H. Jenkins for this reference.

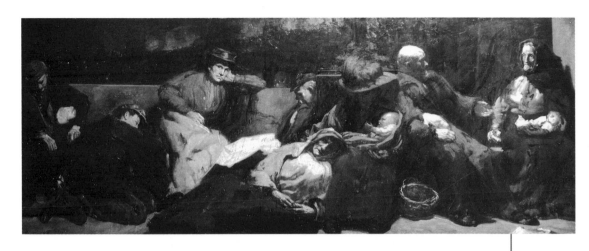

240. Christopher Williams,
Why?,
1913, Oil,
1211 x 3227

241. B. S. Marks,
Board School Children,
1881, Oil,
474 x 748

Any suggestion that the absence of art imaging of urban or industrial Wales by indigenous painters and sculptors might be due to a lack of critical framework or potential patronage for such subjects towards the end of the century is difficult to sustain in the light of English and American examples. As B. S. Marks showed, from the 1870s it was possible to paint pictures of social disturbance in a way which brought them within the acceptable framework of liberal-minded opinion, pioneered by the illustrated press. In the United States, Robert Koehler's *The Strike* had achieved critical acclaim and also popular success through the engraving published in *Harper's Magazine* in 1886. The success was repeated in continental Europe, where the scene depicted was variously identified as Belgium and France.[48] Hubert von Herkomer, one of the most prestigious

242. Robert Koehler,
The Strike,
1886, Oil,
1820 × 2760

painters in England at the time, also ventured such subjects, notably *On Strike*, painted in 1891. The picture was well-received by critics and bolstered his reputation since 'The people he represents do not pose as martyrs, and protest with dramatic violence against a social system that grinds them down. They suffer, and have suffered; but they have accepted their lot with unconscious courage, and have fought their fight with no questioning of its rights or wrongs. They neither rave against nature, nor whine about the injustice of the world in which they find themselves ...'[49] *On Strike* does not seem to have been intended as a Welsh subject, although von Herkomer had very strong connections in Wales. The first person outside Germany to buy one of his large subject pictures had been Charles Mansel Lewis of Stradey Castle, Llanelli, who paid the considerable sum of £500 for *After the Trial of the Day* in 1873. As a result, the two men became close friends. Mansel Lewis was himself a painter and etcher, and von Herkomer's realist influence probably lies behind subjects with titles such as *A Vagrant and The Soup Kitchen* done by him in the seventies and eighties.[50] Nevertheless, he is not known to have painted a subject relating to any particular industrial dispute or social trauma. The single, but remarkable, exception to the lack of images of this kind came not from the coalfield in the south but from the slate industry of the north.

The painting of *Lord Penrhyn and the 1874 Strike Committee* may, however, owe much by way of inspiration to the sudden flood of visual reportage arising from the 1873 dispute in the south, and in particular to the depiction in *The Graphic* of the meeting between the colliers and the owners at the Royal Hotel in Cardiff. In 1874 a chain of disputes at several quarries led to a seven-week strike at Bethesda. The arrangements made to bring the dispute to an end collapsed and a second strike followed which was resolved by Lord Penrhyn, the owner, who redressed some of the men's grievances. The negotiation leading to what was regarded,

[48] In fact, the raw material for the picture was garnered by Koehler in Germany and in England. See Philip S. Foner and Reinhard Schultz, *Das Andere Amerika* (Berlin, 1983).

[49] A. L. Baldry, *Hubert von Herkomer R.A.: A Study and a Biography* (London, 1901), pp. 54–5.

[50] Charles William Mansel Lewis (1845–1931) was trained by William Riviere (1806–76) whose son, Briton Riviere (1840–1920), painted family portraits at Stradey Castle. Mansel Lewis exhibited at the Royal Academy between 1878 and 1882, and involved himself in the promotion of visual culture in Wales, especially through the National Eisteddfod. See Lord, *Y Chwaer-Dduwies*, Chapter 5. His organization of the Art Treasures exhibition at Llanelli led to the establishment of the Llanelli School of Art.

[51] It was destroyed there by fire.

243. After Charles Mercier,
*Lord Penrhyn and the 1874
Strike Committee,*
c.1875, Lithograph,
297 × 421

from the workers' point of view, as the successful resolution of the dispute formed the subject of the painting. It appears that the leader of the union, W. J. Parry, was responsible for commissioning the picture and that the quarry-workers themselves paid for it, although there does not seem to have been a public subscription. The painting was done by a little-known English artist, Charles Mercier and, surprising as it may seem, given the enmity aroused by the dispute, circumstantial evidence suggests that Lord Penrhyn himself may have been party to the commission. Mercier had painted a group portrait of members of the Carlton Club in London, to which Lord Penrhyn belonged. The images of the strike committee were based on photographs and that of Penrhyn himself on the portrait by Henry Tanworth Wells at the castle, though whether Mercier had a sight of the original or worked from a photograph of the picture is unclear.

Parry was a complex self-publicist, who developed an ambiguous relationship with Lord Penrhyn, and he was regarded by many as having ultimately betrayed the workers. Whatever the precise details of its financing, the picture, measuring 8ft. x 5ft., hung in Parry's house.[51] However, like Koehler's *The Strike*, its main significance lay in its distribution in the form of a print. The subsequent status of Parry himself in the eyes of his colleagues may have been in some doubt, but

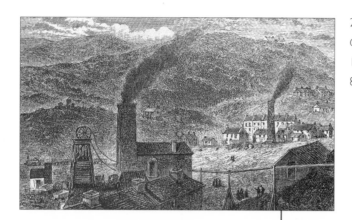

244. Anon.,

Gwlad y Glo,

1906, Engraving,

80 × 131

AT THE FURNACE.

245. D. J. Davies,

At the Furnace,

1894

246. D. J. Davies,

Ready to descend,

1895

the distinctly unsympathetic representation of Lord Penrhyn no doubt ensured its popularity among working people. It became a celebrated token of the community and of trade unionism over a long period. In 1892, on the occasion of the Quarrymen's Festival of Labour in Caernarfon, the newspaper *Y Genedl Gymreig* reissued it in the form of a poster, flanked by portraits of contemporary leaders, including Mabon, a unique link between north and south in the industrial imagery of the period. The paper offered versions at threepence and a shilling, advertising it as 'A BEAUTIFUL PICTURE, appropriate to be hung in the palace or in the cottage alike, as a memorial to TWO HISTORIC EVENTS in the development of CAPITAL AND LABOUR IN NORTH WALES'.[52]

The year before *Y Genedl Gymreig* published the print, *Cymru*, the first Welsh magazine to attempt to reach the popular market with a fully illustrated format, was launched by O. M. Edwards. The magazine was monthly and therefore not the most appropriate medium for reportage, but even so the absence of industrial images was remarkable. *Cymru* was, in essence, the organ of romantic nationalism. Indeed, its content might be said to have defined the movement's concerns. The same was true of the children's magazine, *Cymru'r Plant*, which sprang from it the following year. As late as 1906, when a rare image of a pit was published, it was presented as an alien and disagreeable phenomenon. Entitled *Gwlad y Glo* (the Land of Coal), the picture was to be interpreted as representing 'The country of barren hills, the country of high chimneys, the country of tiny houses, the country of smoke and dust and soot'.[53] Only with the launching in 1894 of the sister magazine, *Wales*, intended to promulgate national sentiment among English speakers, was an effort made to include the industrial community by occasionally presenting it in a positive spirit. O. M. Edwards asked D. J. Davies, a young artist living in Llanelli whom he assisted with financial loans as well as commissions, to illustrate an article on the manufacture of tin plate. The following year, Davies contributed illustrations of coal mining to *Wales*. *The South Wales Daily News* was well pleased by the results:

Wales has all too few artists, so that the excellent work of Mr D. J. Davies, a Llandeilo boy, who lives at Llanelly, is worthy of special notice. He has been doing some very good work for the *English Illustrated Magazine* and in this month's *Wales* he has some capital illustrations in the vicar of St. Paul's sketch of the rise and growth of the tin-plate industry in Llanelly in that magazine.[54]

Both text and pictures were documentary and conceived in the tradition of improving the general knowledge of the common people. Edwards's magazines scrupulously avoided any kind of political comment on the issues which dominated the life of industrial Wales, north and south, in the period. When a pit disaster and the angry reaction to it made a fleeting appearance in a serial published in 1894, it was allegedly 'illustrative of Welsh thought 50 years ago'.[55] Nevertheless, the strike of 1893 was clearly on the author's mind. Both callous owner and hot-headed and politicized young workers were condemned, and contrasted with the docile hero of the piece who displayed Christian forbearance in the face of injustice. Right ultimately triumphed as he became a preacher in Van Diemen's Land. The artificial rhetoric and stereotypes of the text were accompanied by the visual equivalent, *After the Explosion*, an image clearly bought in by the editor from a picture agency.

Wales appeared contemporaneously with the first attempts at visual reportage in Welsh newspapers. The 1893 'South Wales Coal War' was the occasion, although the *Western Mail* had published line engraved portraits and scenes for some years before the dispute. In fact, according to David Davies, subsequently editor of the *South Wales Daily Post*, the *Western Mail* had played a leading part in developing visual imagery in the daily press:

> ... the Western Mail was the foremost pioneer on this side of the Atlantic in experimenting with processes that have since become common place ... I was associated with J. M. S[taniforth] in the earliest efforts to supplement the written word with the picture or portrait. For a time we 'ploughed a lonely furrow' together.[56]

[52] 'DARLUN PRYDFERTH, teilwng i'w osod i fyny yn y palas fel yn y bwthyn, fel coffadwriaeth am DDAU AMGYLCHIAD HANESYDDOL yn nadblygiad cysylltiadau CYFALAF A LLAFUR YN NGOGLEDD CYMRU'). *Y Genedl Gymreig*, 18 May 1892. Subsequent disputes in the north, and especially the Great Strike at the Penrhyn slate quarries of 1900–3, seem to have produced relatively little imagery. Gwynedd Archives, Caernarfon, holds a drawing of police and mounted soldiers escorting strike-breakers through the streets of Bethesda.

[53] Translated from the Welsh, *Cymru'r Plant*, XV (1906), 176.

[54] *South Wales Daily News*, 1 December 1894. The author may have been Llew Williams, a reporter known to Davies. See NLW, O. M. Edwards Papers, class A, general, a letter from D. J. Davies to O. M. Edwards: 'I know the Editors intimately.' However, no illustration by Davies has been identified in the *English Illustrated Magazine* between October 1893 and February 1895. Davies had earlier solicited the help of Tom Ellis, but without success. See Peter Lord, 'Cofeb Daniel Owen – Artistiaid a Noddwyr y Deffroad Cenedlaethol', *Barn*, 395/6 (1995), 36–41.

[55] E. Cynffig Davies, 'Gabriel Yoreth. A story illustrative of Welsh thought fifty years ago', *Wales* (ed. O. M. Edwards), II (1895), 94–6.

[56] *South Wales Daily Post*, 19 December 1921.

247. J. M. Staniforth,
Self-portrait, c.1900, Pen and ink,
180 × 153

[57] The *Western Mail* was a publishing house as well as a newspaper, and it was in the broader business that Staniforth was initially employed. It was from there that his earliest published cartoon, of Ebenezer Beavan, was published in a skit on the 1882 municipal election in Cardiff.

[58] *South Wales Daily Post*, 19 December 1921.

[59] The cartoon was of Thomas Gee. Cartoons also appeared that year in the *Evening Express*.

[60] Welsh Folk Museum, T. H. Thomas Papers, 2591/23, letter from Staniforth to Seward, 6 April 1909.

Joseph Morewood Staniforth was born in Cardiff in 1863 and apprenticed at the age of fifteen in the lithography department of the *Western Mail*. By 1882 he was drawing political caricature and was transferred to the editorial staff of the newspaper by its editor, Lascelles Carr.[57] The earliest drawings to appear in the newspaper were published in 1885:

> The processes of re-production were crude and unsatisfactory, and there were many disappointments – some of them embarrassing – especially during the period that an appliance was used by which drawings were transferred to plaster of Paris plates. Eyes and ears and other essential features were apt to disappear in re-production, and the results were not happy.[58]

Staniforth's first cartoon to be published in the newspaper appeared on 29 August 1889,[59] but the simple line images of the 1893 dispute, a mixture of cartoons and the paper's earliest attempts at visual reportage, such as *Mass Meeting at Aberdare*, were unsigned and may not be exclusively his work. During the last two weeks of August, when matters came to a head with the arrival of mounted troops in Merthyr and Pontypridd, a daily stream of pictures suggested that the miners were dangerous agitators, armed with cudgels and, on one occasion, a gun. In the face of the soldiers, they were, moreover, cowards. The malice of the imagery often outstripped the texts.

For three decades, J. M. Staniforth occupied a position as the most important visual commentator on Welsh affairs ever to work in the country. His cartoons reflected, perhaps more accurately than any other visual source, the diversity of Welsh life in the period. He was active in the art world of Cardiff, lecturing and writing, associating with Edwin Seward and his 'dear old friend' T. H. Thomas,[60] and he became chairperson of the South Wales Art Society in 1910. He was, therefore, in close touch with matters of importance to romantic nationalists within the art world and was well aware of the cultural life of Welsh-speaking

right:
248. J. M. Staniforth,
Mass Meeting at Aberdare, 1893

far right:
249. J. M. Staniforth,
Dowlais Colliers Marching Home from Work Armed, 1893

250. J. M. Staniforth,
Baby Graves,
1907

Wales in the north as well as in the south. Matters such as
T. H. Thomas's campaign to have the dragon of Wales placed on
the Royal Standard, which received extensive newspaper coverage
over a long period, were reflected in his imagery. Nevertheless,
most of his visual comment reflected the less esoteric concerns
of the bulk of the people (though not necessarily their opinions),
and industrial and commercial affairs loomed large. Although
he worked for a Conservative newspaper, Staniforth attacked
the social evils perceived as resulting from unregulated capitalism,
notably the appalling housing conditions of parts of Merthyr. In
1907, under a drawing entitled *Baby Graves*, he quoted a remark
made by the writer George Robert Sims that 'hundreds of human
lives are being sacrificed year after year in Dowlais and the other
bad districts by the failure of the capitalists employing labour to
rescue that labour from foul and filthy dwellings which are death-
traps and murder-holes'.[61] Although inclined to use allegory,
Staniforth's images developed the attitudes of the earlier reportage
of the illustrated papers. Perhaps as a result of the emergence of
illustration in the daily press, the content of papers such as *The
Illustrated London News* and *The Graphic* had, by the turn of the
century, substantially changed to an emphasis on metropolitan
and Imperial social life, fashion, and sports.

Staniforth developed the character of Dame Wales as a spokesperson for middle-
of-the-road Welsh opinion, sometimes supporting, sometimes contending with
John Bull. Dame Wales advised caricatured leaders of the real worlds of commerce,
religion and politics. Staniforth's satire was usually gentle, prompting Lloyd
George to remark that:

251. J. M. Staniforth,
What He May Expect,
c.1900, Pen and ink,
203 × 259

> I always consider him to be one of the best political caricaturists of the day;
> and although he invariably hits the party to which I belong, and the ideas in
> which I believe – and hits them hard – yet he does it with such wit and such
> skill, and what is still more important, I think, in a caricature, with such
> unfailing good humour, that he always affords as much genuine amusement
> to political foes as he possibly can do to his political friends.[62]

[61] Staniforth was quoting from one of a series of
articles written by Sims for the *Western Mail* and
Evening Express on social issues in various parts of
the south, subsequently published in a collection
entitled *Human Wales*.

[62] J. M. Staniforth, *Cartoons of the Welsh Revolt*
(Cardiff, 1905), p. 3.

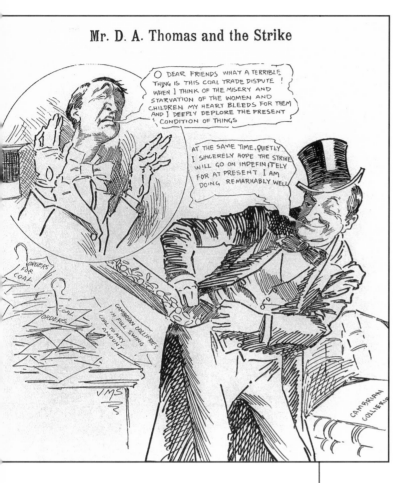

252. J. M. Staniforth,
*Mr D. A. Thomas
and the Strike,*
1898

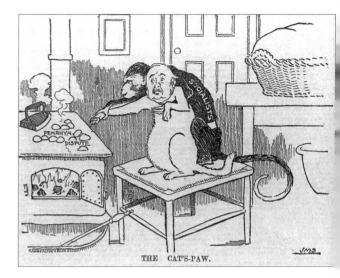

253. J. M. Staniforth,
The Cat's-Paw,
1903

In the opinion of his contemporaries, he did much of his best work during the 1898 coalfield dispute over the sliding scale of payments to miners, which, like its notorious predecessor of 1875, lasted twenty-one weeks.[63] During that time, Staniforth drew over fifty cartoons on the subject. He followed the conservative line of the paper, but reflected a wider spectrum of middle-class opinion which was critical of both sides because of the damage being done to the general economic position. The Coalowners Federation were seen to be obdurate and the workers vacillating as the position of Mabon, their leader, began to be challenged from below. In an unusual exception to the moderate rule for which he was renowned, Staniforth aggressively accused D. A. Thomas of hypocrisy. The MP's Cambrian Collieries were not affected by the strike, presenting him with the opportunity to express pious sentiments of regret at the evil consequences of the dispute, while at the same time lining his pockets. Keir Hardie might also perhaps have been less than convinced by suggestions of Staniforth's consistently good nature and moderate tone, as perceived by middle-of-the-road Liberals and by Conservative opinion. In his comment on the Tonypandy disturbances of 1910, Staniforth's pencil was deployed unequivocally to condemn the Labour Party and the strikers. Staniforth's anti-Socialist views were also expressed in his less numerous comments on the strike at the Penrhyn slate quarries which lasted from 1900 to 1903. He pictured the Liberal leader, Campbell-Bannerman, as the 'cat's-paw' of the Socialists in his attempts to bring the dispute to an end.

The *Western Mail* was particularly active in promoting a religious, orderly and hard-working image of the coalfield. During the Revival of 1904–5 the newspaper published an extensive and widely distributed series of portrait postcards. The 'Revival Series' implied that the people had not only rediscovered their faith but

[63] The Earl of Plymouth remarked, for instance, 'That Mr. Staniforth had strong political convictions I do not doubt; but he never let these obscure the fairness of his attitude in touching controversial matters. He was naturally much concerned with the industrial troubles which not infrequently originated in South Wales, as in the coal strike of 1898; but he never inflamed the passions of the disputants – rather did he continuously work for peace and conciliation, as is seen in many cartoons published between April and September of that year.' *Western Mail*, 19 December 1921.

[64] Although strongly associated with the 1904–5 revival, the image is, in fact, much older. Among his illustrations for David Davies's *Echoes from the Welsh Hills*, a volume designed in 1883 overtly to project the image of the pious Welsh folk to the English, T. H. Thomas had included an underground prayer meeting.

[65] A seventh card, printed in blue and entitled *A South Wales Colliery*, was a romantic moonlight view of the scene above ground. It was unsigned and may not be by Staniforth.

[66] See Peter Lord, 'Delwedd y Werin Gymraeg' in Ivor Davies and Ceridwen Lloyd-Morgan (eds.), *Darganfod Celf Cymru* (Cardiff, 1998).

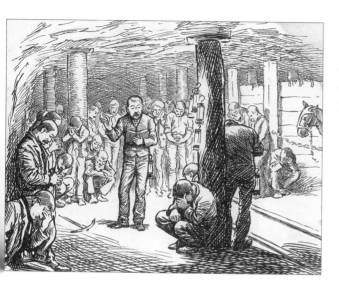

254. J. M. Staniforth,
Revival Service
in a Coal Mine,
c.1904, Pen and ink,
211 × 256

255. J. M. Staniforth,
The Colliery Series of
Postcards: Working
in a Stall, c.1903–5

256. J. M. Staniforth,
His Own Reputation, 1910

also those virtues of piety and docility associated with it by
conservatives. The image of the underground prayer meeting
became an icon of the Revival and Staniforth contributed a picture
to the genre, based on a description from a staff reporter of a meeting
at the Nantmelyn colliery, Cwmdâr.[64] At about the same time, the
Western Mail published the 'Colliery Series' of postcards, printed in
dramatic red and black. Staniforth drew at least six underground
scenes illustrating various aspects of the collier's work.[65]

In one of the most revealing of Staniforth's cartoons, drawn at
the height of the disturbances at Tonypandy, the ego and alter ego of
the collier, as perceived from the outside, were brought together with
perhaps even more significance than Staniforth intended. In *His Own*
Reputation, the militant collier was portrayed leaping on a defenceless
baby, symbolic of bravery, religion and orderliness. The association
of these virtues with the child-like innocence of the common people
carried a resonance extending back more than a hundred and fifty
years into the imaging of the Welsh folk. The point of view in
Staniforth's *The Pied Piper of South Wales* was as essentially anti-
democratic and patrician as the imagery of the mid-eighteenth
century. The colliers' leaders, emerging from among the people
themselves, bewitched the innocent into following them as surely
as Methodist preachers had bewitched the rural folk.[66]

HIS OWN REPUTATION.

257. J. M. Staniforth,
The Pied Piper of South Wales,
1910

THE PIED PIPER OF SOUTH WALES.

258. *World's Graphic* photographer,
An exciting incident at Dinas, 1910

By the time of the 1910 dispute, photographs were regularly printed in the newspapers by the half-tone process.[67] Visual reportage, therefore, seemed more clearly differentiated from comment in the contrast between photographs and drawings. In the middle of the November disturbances, Staniforth's cartoons appeared in close proximity to photographs taken by *Western Mail* staff, which included not only portraits of negotiators but also street images of police restraining strikers, the aftermath of looting, the funeral of a collier killed in a disturbance, and an image allegedly showing the wife of a non-striking miner intimidated by pickets. The paper's use of photography was far from disinterested. For instance, using dramatic pictures, the *Western Mail* attempted to elevate Leonard L. Llewelyn, general manager of the Cambrian, into 'one of the heroes of Wales'.[68] With the assistance of other management staff and volunteers, Llewelyn had stoked the boilers of the power house at Llwynypia, from which the strikers had been ejected, in order to keep the pumps working. He was presented on 11 November both in a formal portrait and with his sleeves rolled up at the stoke-hole, under the headline 'How the Glamorgan Colliery was saved from ruin'.

DANGEROUS DISEASES NEED DRASTIC REMEDIES.

259. J. M. Staniforth,
*Dangerous Diseases Need
Drastic Remedies*, 1910

260. Unknown photographer,
*How the Glamorgan Colliery
was saved from ruin*, 1910

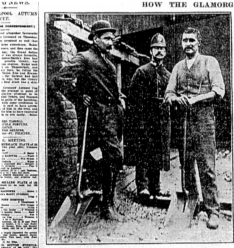

HOW THE GLAMORGAN COLLIERY WAS SAVED FROM RUIN.

His helpers, at rest in the power house, were skilfully photographed from a low angle, 'exhausted after almost superhuman toil'. Two days previously, Staniforth had drawn *Dangerous Diseases Need Drastic Remedies*, against the report that Churchill had ordered soldiers, despatched to put down the strikers, to be detained at Cardiff. On 17 November Keir Hardie was savagely attacked in

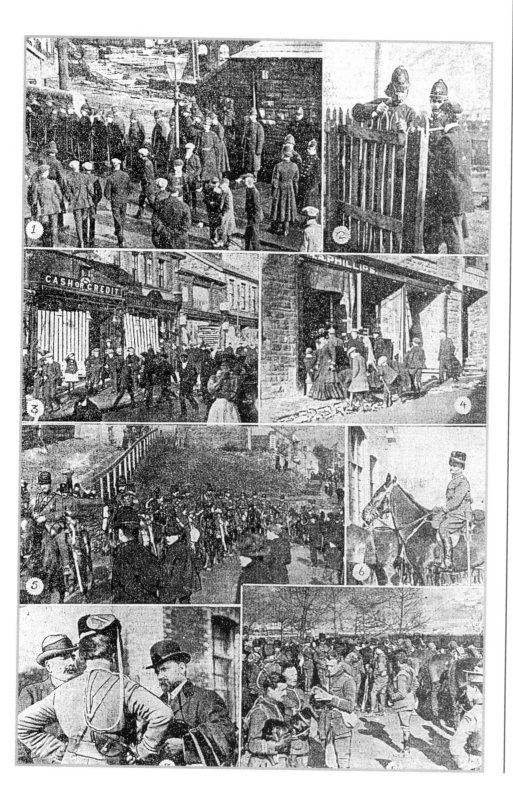

261. *Western Mail* photographers, *More snapshots at the scenes of the riots in the Rhondda Valley*, 1910

[67] The first newspaper half-tone was published in the *New York Daily Graphic* in 1880, but the technique was slow to spread. The *Western Mail* was using half-tones by 1897. The first newspaper to be illustrated exclusively with half-tone photographs was the London *Daily Mirror* in 1904.

[68] *Western Mail*, 11 November 1910.

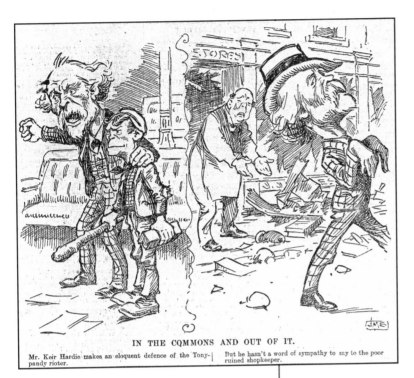

IN THE COMMONS AND OUT OF IT.

Mr. Keir Hardie makes an eloquent defence of the Tony-| But he hasn't a word of sympathy to say to the poor
pandy rioter. | ruined shopkeeper.

THE WELSH HERO.
"PEACE HATH HER VICTORIES NO LESS RENOWNED THAN WAR."

263. J. M. Staniforth,
The Welsh Hero,
1913

top left:
262. J. M. Staniforth,
In the Commons and Out of It,
1910

left:
264. Unknown photographer,
The Face of Grief,
1913

In the Commons and Out of It for his support of the strikers, who were characterized in this, as in other images, by an ape-like neanderthal.

In the time-honoured tradition, however, the ape-like neanderthal could be instantly transformed into the noble savage. The appalling explosion at the Senghennydd pit in 1913 moved Staniforth to produce a series of sympathetic drawings, notably *The Welsh Hero*, which was adorned with the motto 'Peace hath her victories no less renowned than war'. The *Western Mail* was filled for days with pictures of rescuers going down and the dead being brought up from the pit. The Senghennydd explosion produced perhaps the most powerful photographic image of disaster in the pre-war period, taken by an unknown *Daily Mirror* photographer.

265. Unknown photographer,
W. E. Jones,
1970

The traditions of visual reportage and political comment, led by the conservative *Western Mail*, dominated the imaging of the industrial community until the Great War. Nevertheless, around 1910, the first examples of a new kind of imagery emerged from within the industrial community itself. William Edmund Jones was born at Pontypool in 1890 and by the age of fifteen he was taking photographs of the everyday life of the people around him. Although he was constrained by the technology of the open magnesium flash in a coalfield notorious for gas, by about 1910

266. W. E. Jones,
Clog and Legging Level,
c.1910

he was taking photographs underground in a small gas-free pit called the Clog and Legging Level.[69] W. E. Jones was motivated in part, no doubt, by a simple interest in the technical and aesthetic possibilities of the medium, but he also perceived his photographs as social documents and used them for political purposes. He came from a radical background. His father, Jabez Jones, was an active member of the South Wales Miners Federation and the Independent Labour Party. In the absence of a newspaper or magazine with both the interest and the means to make use of such images, Jones's photographs found their audience in the form of lantern slides used by his father in lectures given all over the coalfield in which he presented his political platform.

W. E. Jones's photographs emerged at the same time as the first works of a group of young painters who, after the war, would transform the image of industrial Wales presented by artists. The famine of industrial imagery in Welsh art was about to end. Those responsible were, like W. E. Jones, born into working-class communities in the coalfield. They would reject the aversion of their predecessors to the presentation of this world as an image of Wales and take both the industrial landscape and the working life of the community as central motifs in their work.

267. W. E. Jones,
*The photographer's
mother and neighbours,*
c.1905

chapter
four

INSIDER

ARTISTS AND

INDUSTRIAL

SOCIETY

In the years immediately before and after the Great War, three professional painters emerged from working-class backgrounds in south Wales. To what extent their emergence is attributable to the attempts of the intellectuals of the 1880s and 1890s to reveal such 'hidden talent' is difficult to determine, but Evan Walters, born in 1893, Vincent Evans, born in 1895, and Archie Rhys Griffiths, born in 1902, all seemed to fit the proposed model. They benefited from the development of public funding in the period both in terms of scholarships to attend art schools and also from the improved provision in some of those schools. Evan Walters arrived at Swansea School of Art in 1910, the year after the appointment of the new principal, William Grant Murray, who would develop it into the most successful and prestigious art school in Wales.[1] Eight years later he was followed by Vincent Evans, a collier, who gained a scholarship from the Glamorgan Education Committee which was adjudicated by Goscombe John, a direct link with the pre-war generation of patriotic progressives. By this time Evans was twenty-three and had already published a number of drawings in local newspapers, which referred to him as the 'young Ystalyfera collier artist'.[2] Strongly reflecting nineteenth-century paternalistic attitudes to working-class talent, Vincent Evans was presented by the press as a paragon of Imperial virtue in his commitment to the Boy Scout movement. He was one of a family of seven children who had bettered himself despite starting in the pit at the age of thirteen.[3] In 1919 Vincent Evans was joined at Swansea School of Art by Archie Griffiths, who had begun his working life in a tin plate works, subsequently spending four years at the coal face in the Mountain Colliery.[4]

The young painters also benefited from a gradual change of attitude towards industrial subject matter among some of their teachers. The pioneers of the 1880s had campaigned for Welsh art in the context of a tradition which largely excluded industrial imagery, but the three painters of the new generation would all use the industrial communities from which they sprang as an important source of imagery throughout their careers. This change reflected a general atmosphere of assertiveness on the part of working-class people in the coalfield in the period. The events at Tonypandy in 1910 marked a high point in political activism and both the photographer J. E. Jones and the oldest of the painters, Evan Walters, emerged at precisely that moment. The early development of the painters was

[1] The 1935 exhibition of works by past students of Swansea School of Art showed the work of twenty-eight living professional artists trained at Swansea. They were nearly all natives of south and west Wales, though from a wide variety of social backgrounds. Nevertheless, Swansea was an exception and there were frequent calls for improved standards in the period. Fred Richards (1878–1932), the painter, illustrator and educationalist from Newport, was particularly active in seeking to raise standards of art education in Wales in this period. He wrote the *Report on the Teaching of Art in Welsh Intermediate Schools* (London, 1918) for the Central Welsh Board, and campaigned among influential Welsh people and in the press. See, for instance, his address to the Cambrian Society at Oxford University, reported in the *Western Mail*, 24 January 1921.

[2] *Cambria Daily Leader*, 21 February 1916.

[3] See, for instance, 'The Collier Artist', *Western Mail*, 28 April 1920. An eighth child was subsequently born. Vincent Evans's father, John Evans, was a monumental mason, and his younger brother, Jenkyn, became a sculptor of considerable ability in his spare time. Throughout his life Vincent Evans regarded the Scout movement as an important liberating experience, enabling him to travel abroad, for instance.

[4] See Griffiths's own account in the *Western Mail*, 17 June 1927.

268. Unknown photographer,
Evan Walters,
1926

269. H. A. Chapman,
Vincent Evans,
c.1918

270. Vincent Evans,
A Collier's Sketches,
1916

271. Unknown photographer,
Archie Rhys Griffiths,
1928

272. William Goscombe John,
*The Engine Room Heroes
Memorial, Liverpool,*
1916

273. William Goscombe John,
*Fountain to the Pioneers of the
South Wales Steam Coal Trade,* 1906,
photographs by Kevin Thomas, 1998

facilitated by changing attitudes among established artists, both outside and within Wales. During the Great War, Evan Walters had gone as far as New York to work, but even at the Royal College of Art in London, attended by the other two painters after the war, doors were opening to new ideas. William Rothenstein, the principal from 1920, had a strong sense of social responsibility and the acceptance of the two former miners at the college suggests his direct influence. Writing of Archie Griffiths in 1928, he remarked that in mining life he had 'a great subject matter at his finger ends',[5] a sentiment alien to most of the dominant figures in the English art world before the war. Nevertheless, both Archie Griffiths and Vincent Evans, like Evan Walters, had been using industrial imagery in their art from the time of their first training at Swansea. It is indicative of an early change in attitudes in Wales itself that Goscombe John had felt able to say of Evans in 1915: 'It is very refreshing to find an earnest and capable student turning his attention to scenes that are near him and of which he has experience, rather than to conventional compositions.'[6] At the time, Goscombe John was working on *The Engine Room Heroes Memorial* in Liverpool with its heroic figures of stokers and engineers. This was not Goscombe John's first use of such imagery. In 1906 he had designed the *Fountain to the Pioneers of the South Wales Steam Coal Trade* at Merthyr to celebrate the entrepreneurial efforts of Robert and Lucy Thomas of Waun-wyllt. Among the relief carvings decorating the arches which supported the domed memorial were miners at work and symbols of industrial power, including a steamship and a railway engine. However, it was only in the Liverpool memorial that the workers were elevated from illustrative details to iconic status. They made a dramatic contrast with the contemporary Pantheon of National Heroes in the City Hall in Cardiff, the culmination of the historicist art aspirations of the romantic nationalists. Goscombe John exercised an influence on that scheme both as adviser and as the sculptor of *Dewi Sant*, which was set

above and left:

275. Leonard Merrifield,

Merthyr War Memorial, 1931, Bronze

274. T. J. Clapperton,

'Mining', maquette for

Carving on the National

Museum building, Plaster

up in the most prominent position in the Marble Hall. T. J. Clapperton, another of the sculptors commissioned to work on the Pantheon, demonstrated similarly contradictory inclinations. His rather timid *Bishop William Morgan* for the Pantheon contrasted strongly with his energetic maquettes for the figure groups, *Mining and Shipping*, which were to be carved on the new National Museum building.[7] However, Clapperton's work was more obviously transitional than that of Goscombe John. His dynamic modern workers strained at their labour under the gaze of allegorical goddesses. It was the idea of labour which was celebrated, rather than the experience and aspirations of working people. Leonard Merrifield's *Merthyr War Memorial*, not completed until 1931, would continue in the same tradition by mixing the portraits of a working miner and a mother and child emblematic of sacrifice with the mythological figure of St Tydfil.[8]

[5] William Rothenstein, *Catalogue of Paintings, Drawings and Etchings by Archie Griffiths, A.R.C.A.* (Glynn Vivian Art Gallery, Swansea, 1928).

[6] *South Wales Daily News*, 7 December 1915. Goscombe John took the trouble to write to him, 'complimenting him on his work', *Western Mail*, 18 April 1920.

[7] Thomas John Clapperton was born in 1879 in Scotland. He trained at the Glasgow School of Art and at the Royal Academy Schools in London.

[8] Leonard Merrifield (1880–1943) was a pupil of Goscombe John. In addition to the war memorial at Merthyr, he was also commissioned to carry out the *Trevithick Memorial* in the town, which was left incomplete. Among his other important Welsh commissions were the *Hedd Wyn* memorial at Trawsfynydd and the seal of Coleg Harlech. For a detailed discussion of Welsh war memorials, see Angela Gaffney, 'Commemoration of the Great War in Wales' (unpublished University of Wales PhD thesis, 1996).

276. Vincent Evans,
War, 1915

277. Unknown designer,
The Welsh Outlook,
1914, 251 × 202

9 Thomas Jones's association with David Davies
had begun in 1910 when he was appointed to
lead the national campaign against TB. He became
Secretary to the National Health Insurance
Commission (Wales) in 1912 and was Secretary
to the Cabinet from 1916 to 1930. On leaving this
post he became Secretary to the Pilgrim Trust.
For the career of Thomas Jones (1870–1955),
see E. L. Ellis, *T. J., A Life of Dr Thomas Jones, CH*
(Cardiff, 1992).

This belated and limited celebration of labour in Welsh sculpture during
the Great War was reinforced at a critical level in a new monthly magazine,
The Welsh Outlook, first published in 1914. *The Welsh Outlook* was financed by
the coalowner David Davies of Llandinam and edited by Thomas Jones, soon
to become secretary to the cabinet in Lloyd George's wartime administration.
Jones was to exercise an important influence on the development of visual
culture in Wales for forty years.[9] In its discussion of industrial and political
issues, as well as in its stylish format, *The Welsh Outlook* was a breakthrough
in Welsh intellectual life. It was anti-Socialist but not rabidly so, despite its
funding by a liberal capitalist, and in many ways it was progressive, combining

278. Vincent Evans,
The Parting,
1916

279. Auguste Rodin,
The Genius of War, reproduced
in *The Welsh Outlook,* 1914

280. William Goscombe John,
The Departure: 'Hope', reproduced
in *The Welsh Outlook,* 1915

the promotion of Welsh autonomy with an internationalist attitude which related Wales to contemporary movements of various kinds in other countries. Under the initial direction of Thomas Jones, the magazine gave visual culture a far higher profile than it had ever enjoyed before in a Welsh periodical. The tone was set in the first issue with an illustration of Millet's *Going to Work*.

Two of Vincent Evans's earliest published drawings, *War* and *The Parting,* reflected photographs of art works reproduced in *The Welsh Outlook* in 1914 and 1915. The closeness of Evans's allegorical ideas to Rodin's *The Genius of War* and to Goscombe John's *The Departure: 'Hope',* strongly suggest that the young painter was among

[10] Trevor L. Williams, 'Thomas Jones and the "Welsh Outlook"', *Anglo-Welsh Review*, 64 (1979), 39.

[11] George Minne (1866–1941) was the most important figure to stay in Wales during the war. 'After the powerful sculpture of Rodin and the grandiose decors of official artists, it was as if Minne reduced his artistry to the humble modelling of poor, slender figures. And it is exactly that poverty which suddenly made him fascinating in the eyes of the progressive press and the Viennese *avant-garde*. Minne is not a grandmaster; his work is not a homogenous series of masterworks, his art is not always pure, but his early work is an innovating answer, both to the social realism of the nineteenth century and the idealism which existed e.g. at art academies.' (Introduction to the essay on Minne's work published with the retrospective exhibition at Ghent in 1982.) When Minne and his family and friends arrived in London they were met at the Gwalia Hotel by the Davies sisters and accompanied on the train to Aberystwyth by Professor H. J. Fleure. They were welcomed at the station by a large crowd. The family was given a house at Llanidloes where they remained until the end of the war. The story is recounted in the unpublished memoirs of Marie Gevaert-Minne (1978), private archive. The landscape painter Valerius de Saedeleer also settled in mid-Wales, at Rhydyfelin near Aberystwyth. See *Western Mail*, 8 April 1921.

[12] From the panels intended by Meunier as a monument to labour at Louvain. Meunier was also the subject of a photographic feature in *The Graphic*, 2 May 1914: 'The glory of Meunier is that he revealed to poverty its conscience and its moral beauty. Sympathetic, powerful and concentrated, his art was stamped with nobility ...'

[13] Quoted in Eirene White, *The Ladies of Gregynog* (Cardiff, 1985), p.18.

[14] *The Welsh Outlook*, III (1916), 134, review of Thomas Matthews, *Perthynas y Cain a'r Ysgol* (Undeb y Cymdeithasau Cymraeg, 1916).

[15] Lionel Walden (1861–1933) was born in Norwich, Connecticut, and studied in Paris under Carolus-Duran. He died in Honolulu.

[16] *Western Mail*, 3 December 1914.

[17] P. Mansell Jones, 'Welsh industrial landscapes', *The Welsh Outlook*, XVIII (1931), 156.

the three thousand subscribers who read the magazine every month in its first year.[10] It may have been of seminal importance, enabling him to relate academic art to his own experience of the world. The content of the magazine reflected the predilection of Thomas Jones for Belgian artists and writers, a number of whom came to Wales as refugees under the patronage of Gwendoline and Margaret Davies, daughters of the sponsor of the magazine. In a series of articles and illustrations, *The Welsh Outlook* set up the worker paintings of Laermans, including *The Strike*, and the sculpture of Minne[11] and Meunier, notably *The Miners*,[12] as appropriate models for Welsh artists. 'The study of painting and sculpture is in a deplorably backward condition in Wales', remarked the magazine in November 1914. 'Shall we take advantage of the unexpected presence in our midst of this brilliant group? ... The opportunity is unique, but we may be too parochial to seize it.'[13] In a comment on the conservatism and limited range of proposals for art in Welsh schools recently published by Thomas Matthews, the magazine observed that 'studies of various aspects of labour, already reproduced in early numbers of this journal, appear so suitable for South Wales schools'.[14]

Thomas Jones's frustration at the failure of Matthews's generation of romantic nationalists to perceive the relevance and potential of the industrial world as a source of imagery might have been taken beyond the comparison with Belgian work made in *The Welsh Outlook*. Although Jones was probably unaware of it, an American painter, Lionel Walden, had visited Wales before the turn of the century.[15] His *Steel Works, Cardiff, at Night*, which was exhibited at the Paris Salon of 1897, clearly illustrated the potential of industrial subject matter to enhance the national revival by presenting to the world a modernist image of Wales to set side by side with the unsullied mountain landscape and the Nonconformist folk. That outsiders were willing to see Wales in these terms was demonstrated by the purchase by the Musée d'Orsay of the same artist's *Les Docks de Cardiff* in the previous year.

The Welsh Outlook challenged the prevailing image of Wales not only in visual culture but also in its affirmation of the Belgian modernist poet Verhaeren. His visit to Wales had also attracted the attention of the daily press. 'Verhaeren is the poet of industrial urban Europe, with its marvellous organization of human and mechanical energy', reported the *Western Mail*. 'He has wandered in Berlin and Vienna, Antwerp and Glasgow, and caught the rhythm of their "pell mell multiplicity", the music of their crashing hammers and speeding trams and clamouring crowds ... During his stay in our own neighbourhood it is the coal tips and ships and docks at Barry which have fascinated him.'[16] P. Mansell Jones, who conducted Verhaeren on his tour, later remembered his reaction to the view from a train passing Landore:

From window to window he rushed, like one possessed by a kind of sacred terror, his arms held up in amazement, absorbing the scene with his eyes, and reiterating one irrepressible phrase – unpardonable perversity and significant paradox? – *Que c'est beau! que c'est beau!*[17]

281. Constantin Meunier,
The Miners, reproduced in
The Welsh Outlook, 1914

282. Lionel Walden,
Steel Works, Cardiff, at Night,
1897, Oil,
1450 × 2010

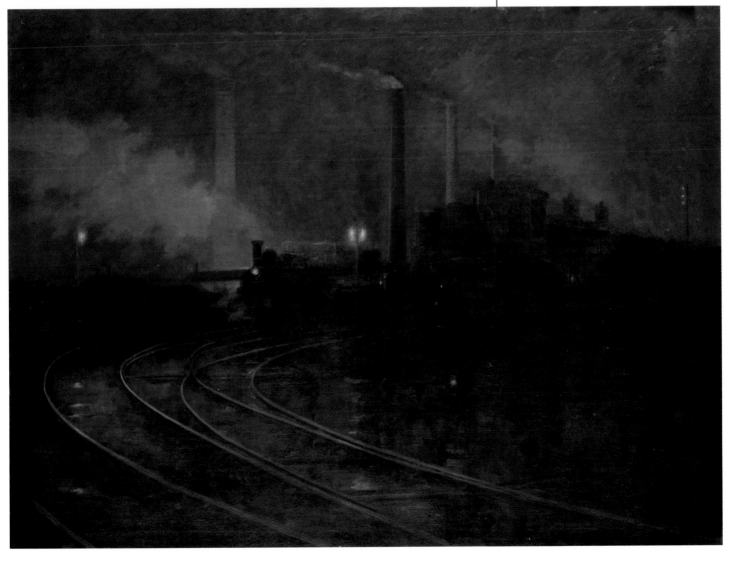

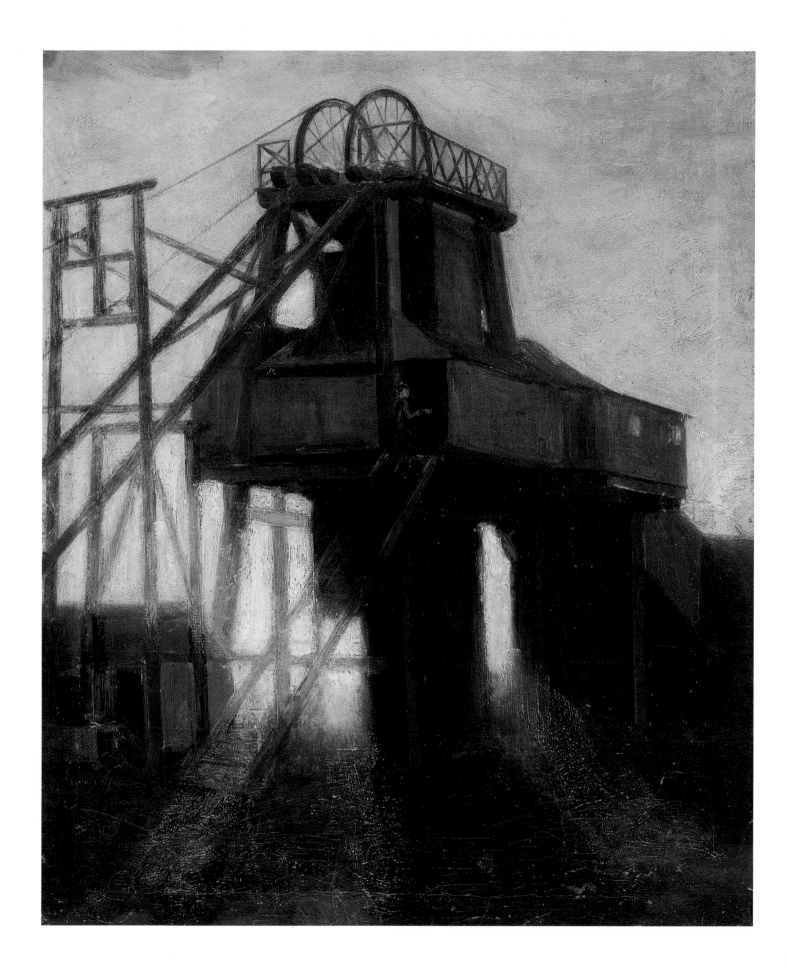

283. H. A. Chapman,
Evan Walters, 1920

The career of Evan Walters, the oldest of the new group of Welsh painters, had begun before the war when the novelty of his cultural background attracted much attention in the local press. As Walters's career flourished, the mythology of his arrival at the school of art was embellished, but there is no reason to doubt the essential verity of the account given by his teacher, Harry Hall, who described him as 'dressed in shabby clothes, with a colourful handkerchief round his neck and on his head a cap which he did not remove, pulled down on one side. The first impression was that he was a gipsy lad. His speech seemed to be a mixture of Welsh and English, and we had great difficulty in understanding him'.[18] While these picturesque observations revealed as much of the English background of Harry Hall as they did of Walters, nevertheless they correctly suggested the mixed culture experienced by the painter in his home community of Llangyfelach which would have a lasting effect on his work. All the new painters came from the western edge of the coalfield, where the rural and the industrial continued to interact as they had done throughout the nineteenth century. The Nonconformist tradition mediated through the Welsh language remained strong and all three were Welsh speakers. The imagery of Evan Walters and Archie Griffiths, in particular, reflected this mixed culture. They would exhibit rural landscape and religious pictures as well as industrial images. Nevertheless, it was the imaging of the coalfield and the mining community which distinguished Evan Walters for early observers of his career. In 1911, as Thomas Matthews celebrated the painters of mountain landscape in the magazine *Cymru*, John Davies Williams of the *Cambria Daily Leader* reported the emergence of 'A Brilliant Artist' in a mixed exhibition of the South Wales Art Society. Williams would prove to be a perceptive and informed critic:

left:
284. Evan Walters,
Cefn Cyfelach Colliery,
c.1920, Oil,
611 × 508

> A new artistic idea! Not that all these water colours and oils that picture the [Gower] peninsula are not interesting; only that we are getting very used to them, and just a little tired of them.

> Right among them is a painting of a pit head – the familiar lines of Cefn Cyfelach! And not far away is another of Tirdonkin Colliery, and another of The Night Shift at the Boilers ... Evan J. Walters is going to make a name for himself ...[19]

In 1920 Evan Walters was given an exhibition at the Glynn Vivian Gallery by Grant Murray. Although industrial paintings were considerably outnumbered by rural scenes, subject pictures and the portraits by which the painter earned his living, *Cefn Cyfelach Colliery* was shown again and it was this, together with other

[18] *Evan Walters – Memorial Exhibition* (Swansea, 1952), p. 4. The sculptor and jeweller Harry Hall had begun teaching at the Swansea School of Art at about the same time as Grant Murray.

[19] John Davies Williams, *Cambria Daily Leader*, 6 December 1911. Williams also praised the industrial scenes of Percy Gleaves: 'May they point the way of the Society – from Gower to Landore', he remarked, presaging Verhaeren's celebration of the great steelworks.

285. Evan Walters,
Mother and Babe,
1919, Oil,
380 x 290

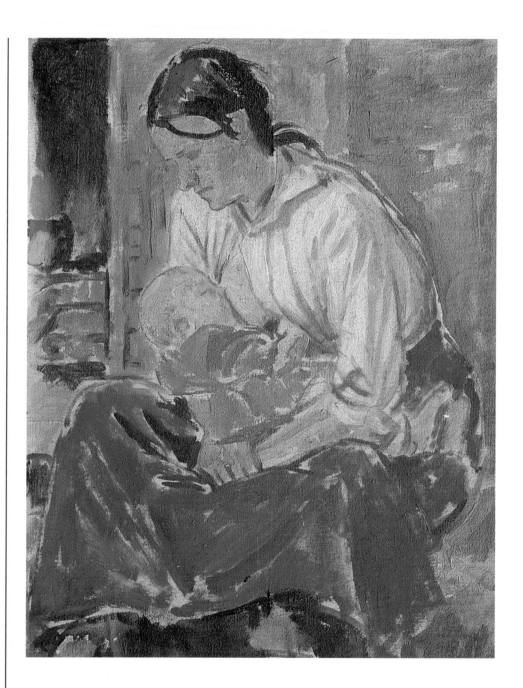

[20] Winifred Coombe Tennant, 'Leader notice and its consequences', *Cambria Daily Leader*, 25 November 1927. The quotation is given in fuller form, along with a number of letters from Winifred Coombe Tennant concerning Evan Walters, by Iorwerth Hughes Jones in 'Evan John Walters (1893–1951)', *Gower*, 17 (1966), 23–8.

portrayals of the mining community, which caused the greatest excitement. In particular, they attracted the attention of Winifred Coombe Tennant, who would become Walters's most important patron:

The first picture which my eyes fell on as I stood looking into the room took me by surprise and storm, and has been one of the jewels of this house for the last seven years. It was a small oil painting entitled 'Mother and Babe', showing a dark-haired, rather weary-looking collier's wife, sitting beside her kitchen fire suckling her baby, the typical Madonna and Child of Industrial Wales.[20]

287. Evan Walters,
The Haulier,
c.1920

286. Evan Walters,
Portrait of Mrs Coombe Tennant,
1920, Oil, 600 × 500

288. Vincent Evans,
Boring a Bottom
Hole Underground,
1919, Pencil,
243 × 296

The surprise with which Walters's work was greeted by observers in Swansea was a measure of the conservatism of what had preceded it and the isolation of artists from modernist work in other parts of Europe, despite the best efforts of *The Welsh Outlook*. Nevertheless, drawings such as *The Haulier* were praised by insiders excited at seeing their industrial community portrayed in an art gallery for the first time. Both Vincent Evans and Archie Griffiths were still students at the Swansea School of Art at the time of Walters's exhibition, and were travelling in the same direction as their older contemporary. Immediately prior to the exhibition, Evans had a mining drawing, *Boring a Bottom Hole Underground*, accepted by the Royal Academy.

289. Evan Walters,
The Welsh Collier (Portrait of William Hopkin),
1926, Oil, 597 x 299

290. Unknown photographer,
*William Goscombe John (left) and
William Grant Murray in Swansea*, 1926

291. Archie Rhys Griffiths,
The 'Dartmoor' Crop,
1926

Evan Walters's next important exposure to public attention came at a moment of particular pertinence, given his social origins and the nature of his imagery. By the mid-1920s, the industrial economy was beginning to crumble as a consequence of the decline of artificially high levels of wartime demand and intense competition, resulting in social distress and industrial unrest on a far larger scale than that seen during periods of disruption in the second half of the nineteenth century. Its most dramatic manifestation was the labour dispute in the coalfield which led to the general strike of 1926. It was against this background that the National Eisteddfod was held in Swansea. The art and craft section was organized on a vast scale by Grant Murray, who nurtured ambitions of expanding the market for the work of contemporary painters and sculptors. From the economic point of view, the timing could hardly have been worse, but Grant Murray's attempts to excite public interest were aided by the local success of Evan Walters, who dominated the painting competitions. Among Walters's prizewinning paintings was *The Welsh Collier*. A local newspaper, choosing its words carefully, described the work as depicting 'a striking (or locked-out) collier, for whose temperament the artist had considerable regard, and into whose eyes the circumstances of the time brought occasionally a certain fierceness'. Clearly, the political context gave such pictures a particular impact. They were exploited by Grant Murray, who orchestrated the press reports to give the exhibition and the larger question of the place of art in contemporary life a high public profile. Nevertheless, Grant Murray drew attention to their modernism rather than to their politics, and presented the exhibition to reporters, always eager for controversy, as a battle between the old and the new in art. The opposing camps were represented by the two judges, George Clausen and Augustus John, who had failed to agree on their adjudication, resulting in the award of shared first prizes.[21]

Vincent Evans had left the Royal College of Art in 1924 to take up a teaching post in New Zealand and was not represented in the Eisteddfod exhibition.[22] Shortly before his departure, Archie Griffiths, with the aid of a scholarship recommended by Goscombe John, had begun his career at the College. The *Cambria Daily Leader* published twelve of his drawings during the year and the inclusion of only one of his works, the wash drawing *Pressure*, in the Eisteddfod exhibition of 1926, is difficult to understand.[23] Immediately after the Eisteddfod, and as if in silent criticism of this deficiency, John Davies Williams reproduced two further drawings of miners, *Looking for Coal in an Old Tip* and *The 'Dartmoor' Crop*, in the *Cambria Daily Leader*, without comment.

[21] Clausen had contacts with Wales extending back into the nineteenth century. He had been an adjudicator in the National Eisteddfod for many years and had drawn the industrial landscape, for instance, the watercolour *Landore*, published in *Studio*, 66 (1915–16), 228. He had taught Margaret Lindsay Williams.

[22] According to his daughter, 'His early years had been full of insecurity', and 'he decided that he would commit himself to the secure work of teaching at first.' NLW, Vincent Evans archive. Vincent Evans's departure for New Zealand was not necessarily the reason for his failure to exhibit at the Swansea Eisteddfod since Grant Murray was proud of the fact that he was able to show contemporary works of art from Australia, India and the United States. For the exhibition, see Lord, *Y Chwaer-Dduwies*, pp. 85–92.

[23] Furthermore, Griffiths was one of a very small number of exhibitors to show under a pseudonym – 'Miner'.

292. Evan Walters,
The Convalescent Collier Tom Rees,
1927, Oil,
592 × 292

293. Unknown photographer,
Evan Walters with his picture
'The Convalescent Collier',
1927

²⁴ *Cambria Daily Leader*, 16 November 1927. It
was John's withdrawal from his planned exhibition
at the Warren Gallery that had given Walters his
opportunity. It seems likely that John suggested
Walters as his replacement. The paper quotes
Walters as saying: 'It was during the National
Eisteddfod at Swansea that Mr Augustus John
became much impressed with my work, and
the result of that is this exhibition in London.'

²⁵ *The Times*, 19 November 1927.

In 1927 Evan Walters was given an exhibition at the gallery of Dorothy Warren
in London. It included a substantial number of pictures of the mining community,
including *The Miner's Bath* and *The Convalescent Collier*. Augustus John announced
that 'a new genius' had arisen.[24] Critical reaction was good but reviews such as
that in *The Times*, in the tradition of the nineteenth-century perception of the
miner as an ethnic curiosity, were at pains to play down the reading of the
pictures as social or political comment: 'As a matter of fact, they do give a
good deal of information about the domestic habits of colliers in South Wales,
but the information is all by the way, and there is no indication that the subjects
were painted other than for purely pictorial reasons.'[25]

Walters's paintings, and the story of his background in a mining community –
assiduously embroidered by the gallery owner – appealed to liberal-minded
intellectuals within the London art world at the time. Every picture was sold, but
his subsequent failure to impress this London audience suggests that the success
of the show was in large part a sympathetic gesture made in the aftermath of the
general strike and the deepening depression. The pictures were timely without

being threatening, enabling middle-of-the-road patrons to express their social concern without venturing into radical politics. Their perceptions of the situation of the mining community were expressed in the vocabulary of pathos and many of Walters's pictures appealed directly to that sensibility. Of *The Convalescent Collier*, he remarked: 'That man worked underground for thirty years, and he has paid the penalty of ill-health. He is a life-long invalid.'[26] The picture featured prominently in the press coverage, including a photograph of the artist holding the painting which was syndicated to a number of papers.[27]

No direct evidence exists to show that Archie Griffiths saw Evan Walters's London exhibition in 1927, but it seems highly likely that he did so, given the extensive publicity surrounding it and the fact that he was studying in London at the time and moving in Welsh circles.[28] A few months prior to Walters's exhibition, Griffiths had submitted his entry for the Prix de Rome competition. *The Expulsion from Eden* was described by his friend, the writer Geraint Goodwin, as a 'mining village, a little cross with its poor jar of daffodils, a shrunken tree, the outworks of a pit, and behind a strange, glowering sky'. Goodwin remembered Griffiths at this time, 'standing before a picture, "Preaching in the Mines", with the haggard, luminous head of an old miner looking upward, his mates gathered round – a student's picture one might say, but a picture so strangely moving that I felt there and then that a new voice had come to proclaim the agony and sublimity of the Celtic soul. If we were not

294. Evan Walters,
Geraint Goodwin, c.1935

[26] *Cambria Daily Leader*, 16 November 1927.

[27] Including, for instance, the *Cambria Daily Leader*, 16 November 1927.

[28] The two men were certainly close friends by 1932, when Walters helped to hang Griffiths's London exhibition.

295. Archie Rhys Griffiths,
The Expulsion from Eden,
1927

296. Archie Rhys Griffiths,
Testing a Collier's Lamp,
c.1933, Oil, 611 × 511

reared upon the self-same hill, from then onwards we contrived to present a united front to the world, sharing our thoughts and aspirations, talking interminably about Art as we understood it; those long preparatory years... when for the hundredth time we would leave a Lyons tea-shop with the awful presumption of having judged the world and found it wanting.'[29]

On his departure from the Royal College in 1928, Grant Murray showed a collection of Griffiths's paintings at the Glynn Vivian Gallery. William Rothenstein, who wrote the introduction to the Swansea exhibition catalogue, believed that 'The subjects showed an intimate knowledge of the miner's life; but objective though they were in treatment, one was always aware of an inner mystical spirit, which raised his designs far above mere illustration, however informative and interesting'. In *Testing a Collier's Lamp*, painted in about 1933, Griffiths used dramatic lighting to suggest an association with Holman Hunt's *Light of the World*. Rothenstein believed Griffiths had 'a moving sympathy with toiling and sweating workers underground',[30] an opinion borne out in *Miners Returning from Work*, painted in 1931. The tired introspection of the men and the overall mood of solemnity was again created by the sophisticated use of lighting, on this occasion throwing the faces of the workers into dark shadow. Griffiths's own remarks confirm the mixture of objectivity and mystical idealization of the miner perceived in the work by Rothenstein:

> I was until a short time ago a miner myself, and, let me say that, so far from the iron having entered my soul, as it were, I am genuinely glad of the time I have spent underground. There, in spite of all mental and physical disadvantages, I was caught up in that idealistic spirit which permeates all our little communities down there. For – and it is hard to explain to some of the sophisticated people here [London], who think only of some definite reward – music and literature, even art, is carried on for the love of the thing; the joy of creation, apart altogether from professional gain.[31]

Griffiths's most important public commission, gained for him by Rothenstein, was to paint a mural at the Working Men's College in Camden Town. He produced a large allegorical piece in which Christian iconography and Social Realism met. The classical gods and goddesses resorted to in the allegorical sculpture of the Civic Centre buildings in Cardiff were replaced by ordinary men and women representing age and youth, the arts and labour. Nevertheless, at the centre of a landscape of factories and fields, where agriculture and fertility were represented

[29] Geraint Goodwin, 'An Artist of Vision: The Work of Rhys Griffiths', *The Welsh Outlook*, XIX (1932), 79. Archie Rhys Griffiths abandoned his first Christian name while living in London. Geraint Goodwin did not mention Griffiths in his autobiographical *Call Back Yesterday* (1935), but described a meeting with a thinly-disguised Augustus John. Griffiths had painted a portrait of Goodwin by 1928, but the writer also knew Evan Walters, and it was his portrait that was used on the cover of the book. *Preaching in the Mines* was Griffiths's diploma work at the Royal College of Art, originally named *All that hath life and breath* and painted on the set subject of the 150th Psalm. The painting was later known by a third title, *Entombed*.

[30] Rothenstein, *Catalogue of Paintings, Drawings and Etchings by Archie Griffiths, A.R.C.A.*

[31] *Western Mail*, 17 June 1927.

[32] At the same time as he was painting the Camden Town mural, Griffiths was painting portraits for the Astor family. See *Sunday Despatch*, 18 October 1931. The Astors were wealthy liberal philanthropists and these commissions were gained for Griffiths by the intervention of Thomas Jones. The Astor family were patrons of Jones's Coleg Harlech, established in 1927 to provide working people with an opportunity to develop their education. The Camden Town mural has been destroyed.

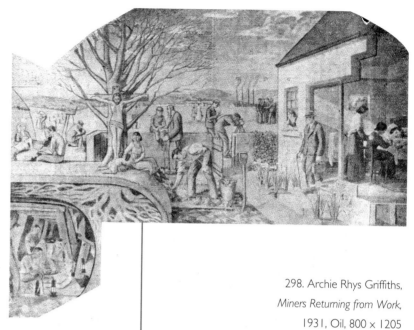

297. Archie Rhys Griffiths,
*Mural at the Working Men's
College in Camden Town,*
1932

by a man tending his allotment in the company
of a mother and child, Griffiths set a crucifixion.
Christ's suffering, however, was accompanied
by symbols of the suffering of working people.
Below the ground a miner was seriously injured
in an accident, and at the other end of the mural,
a woman lay on her sickbed, surrounded by her
family as the doctor left the house.[32]

298. Archie Rhys Griffiths,
Miners Returning from Work,
1931, Oil, 800 × 1205

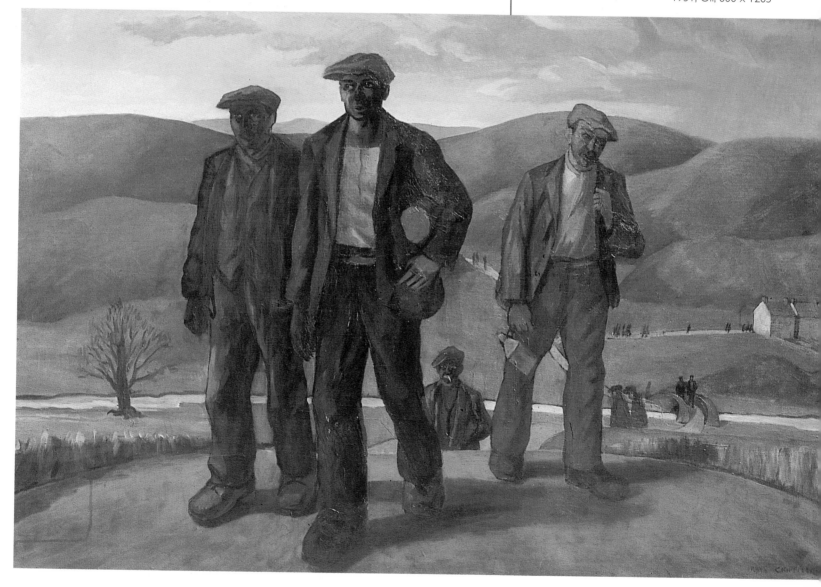

299. Vincent Evans,
The Pit Disaster,
c.1918, Pencil,
228 × 177

300. Vincent Evans,
Nobel Calendar,
1918, Pastel, 197 × 127

33 *Toilers Underground* was bought for £60 and hung 'in the most prominent place in our Council Chamber'. Letter to the artist, dated 24 September 1919, private archive.

34 The picture has been lost.

35 The exhibition may have been, wholly or in part, the same as that shown at the Cooling Gallery in London in 1933. Rothenstein saw the show and commented favourably on the drawings in a letter to the artist. He was less impressed by the paintings but concluded: 'I wish some of the people interested in Welsh art could go and see your things.' NLW, Vincent Evans archive. Tom Richards had been secretary of the South Wales Miners' Federation and in 1920, under his direction, it had bought *The Haulier* for £150.

While Griffiths was working on the mural in 1932, Vincent Evans returned from New Zealand and again took up mining imagery. Of the three painters, Evans was closest to the formal labour movement. Early in his career he made some political cartoons, at least one of which was published in *Llais Llafur (Labour Voice)*. In a more general sense, early documentary drawings such as *The Pit Disaster* demonstrated the immediacy of his visual response to the community. In 1918 he was commissioned by the explosives manufacturer Nobel to illustrate a calendar, and within a year the Miners' Federation of Great Britain had bought his work.[33] Evans became a friend of Jim Griffiths, president of the Federation, and subsequently presented them with a portrait of Tom Richards MP as a gesture of thanks for their support. Among his many subject pictures in the 1930s was *A Miners' Federation Meeting Underground*.[34] In 1933 he organized an exhibition of his own works at Gwauncaegurwen, the proceeds of which were donated to the relief of poverty in the area.[35] Nevertheless, Vincent Evans did not

301. Vincent Evans,
*A Miners' Federation
Meeting Underground*,
c.1933

venture into the production of overtly political work or join those artists who came together in 1933–4 to found the Artists International. Many of them were Communist Party members and some had been to the Soviet Union to witness Socialism at first hand. They were anxious to encourage the development of a working-class art but, despite his obvious sympathies with the labour movement and the fact that he was a contemporary at the Royal College of a number of prominent figures in the Artists International, there is no evidence that Evans associated himself with them or their ideas. Despite the support of the Miners' Federation, Evans found few patrons and lists of his mining paintings exhibited at the National Eisteddfod at Neath in 1934 and at the exhibition of the work of former students of the Swansea School of Art in 1935 show that most of his pictures remained in his own possession.

Like Archie Griffiths, in this period Vincent Evans made a large-scale painting allegorical of a working people's Utopia.[36] He located *A Welsh Family Idyll* at the western edge of the coalfield where he had grown up. The mood was contemplative and the main themes were continuity and harmony within the family, and the bond between people and the earth. A young father turns the soil and the eye is drawn up through his body and his angled head to the baby, returning to the bare earth through his wife. The group is shaded by an oak tree, symbolic of wisdom. The figures, representing the generations of the family, are absorbed in their own thoughts. Vincent Evans eschewed the clichés of Welsh life – the chapel, the choir, the national costume – and painted a picture which was timeless yet thoroughly modern. His artistic reference point was not *Salem* but, clearly, Puvis de Chavannes. Evans regarded the picture as his most important and worked on it over a long period, perhaps having conceived it before going to New Zealand. It had much in common with Archie Griffiths's Camden Town mural, but the nature of the relationship between the two men is unclear. No correspondence survives but both were involved in an abortive attempt to establish a centre for Welsh painters in London.[37] Ceri Richards, who went from the Swansea School of Art to the Royal College with Griffiths in 1924, may also have been associated with this idea. Around 1928 Richards painted a remarkable portrait of his colleague, 'A grave figure of some dignity: black haired but red bearded, the artist of dreams.'[38]

[36] Evans exhibited a picture entitled *Father Forgive Them* at the Neath National Eisteddfod in 1934, offered for sale at a price of £500. Both title and price suggest that this, too, was a large allegorical piece.

[37] 'A number of Welsh folk who are domiciled in London, or who spend most of their time in the Metropolis, are considering the possibilities of establishing a centre for Welsh artists in London. Plans at the moment are still in the melting pot, but an announcement is likely to be made very soon in regard to the matter.' *South Wales Evening Post*, 2 April 1932.

[38] *South Wales Daily Post*, 8 December 1930.

302. Ceri Richards,
Archie Griffiths,
c.1928

303. Vincent Evans,
A Welsh Family Idyll,
c.1935, Oil,
1415 × 3212

304. Vincent Evans,
Drawing for
A Welsh Family Idyll,
c.1935, Pencil,
561 x 383

305. Vincent Evans,
Drawing for
A Welsh Family Idyll,
c.1935

Evan Walters also seems to have been developing ideas for a large allegorical painting in this period, but with a different purpose. Only a drawing for *The Hogs, the Pedagogues and the Demagogues* was completed, though a painting entitled *The Communist*, made around 1932, was clearly related to it. The iconography of Walters's images in the twenties and early thirties was ambiguous. Nor did his written comments on the images throw much additional light on his attitude to the politics of the coalfield and his perception of the role of painting in that situation. Walters interpreted one of his potentially most provocative pictures, *Bydd Myrdd o Ryfeddodau*, painted in 1926, in terms which left open the question of whether it was specifically a comment on the condition of communities in the coalfield or on humanity in general. It is unclear whether its Valleys' funeral subject was intended as an allegory for a wider truth:

> Here you see the dark group on the hills; below, the grave, with its young white bodies. There is no sign of happiness or resurrection in the singing. All is hopeless, dreary, dark, and it rends the hearts of the spirits as they hear it, so melancholy and mournful are the sounds.[39]

Walters was of the opinion that not 'many Welsh people will approve of this'. Presumably he felt that Christian believers would be offended by the denial of resurrection implicit in the gloom. The question remains as to whether that resurrection was of individual souls in paradise or of industrial communities on

306. Evan Walters,
*The Hogs, the Pedagogues
and the Demagogues*,
c.1930, Pen and wash,
266 x 519

[39] *Cambria Daily Leader*, 16 November 1927.
The picture was shown at the 1926 Eisteddfod exhibition and, at the time, Augustus John was reported as describing it as 'damn good'.

earth. If *Bydd Myrdd o Ryfeddodau* seemed to deny the hope offered by Jesus, *The Hogs, the Pedagogues and the Demagogues* denied the hope offered by politicians. Walters clearly suggested by the cruciform posture of the central figure in *The Communist* that the two were related, implying a denial both of Christianity and Marxism. Archie Griffiths's diploma painting of 1927, entitled *Entombed*, was similarly preoccupied with contrasting visions of salvation: 'I represented

307. Evan Walters, *The Communist*, c.1932, Oil, 760 × 921

308. Evan Walters,
Drawing for *The Communist*,
c.1932, Pencil,
554 × 378

a bearded man in the centre as the true follower, flanked by one who was trying to reason things out for himself, and a youth, as representative of a generation that adapts itself to anything, regardless of consequences. In the background I placed an atheist, who sneers at everything, and this, with a horse and a rat – creatures who feel but cannot reason – completed the picture.'[40] Nevertheless, both Griffiths and Walters more often presented their audience with suffering and death in the pits as the central theme, rather than with political philosophy. Among Griffiths's subjects were *The Fatal Accident*, painted in about 1922, and *Tro yn yr Yrfa*, done some six years later, which 'shows a procession of colliers

309. Evan Walters,
The Dead Miner,
c.1935, Oil,
605 × 510

taking home by night the body of a fellow workman killed in a colliery, seen at one corner of the picture, to a house seen in the distance with cosily lit windows which a black spot with his collier's lamp swinging has nearly reached on the errand that will cast despair over the only happy corner of the scene. The tramping men with their burden, the lowering hills and the black pit workings have the very menace of death painted into them ...'[41] Similarly, some of the later pictures of Evan Walters, such as *The Dead Miner*, expressed the trauma of injury and death in the pits. In these later works, Evans continued to echo Christian iconography, perhaps with ironic or questioning intent, but their intensity was increased by the use of a more open and expressionist style.

Such pictures asked many questions and lamented loudly, but their politics remained obscure and may indeed have reflected more accurately than the mythologizing of both political left and right the dominant state of mind of communities in the coalfield in the inter-war years. For their different reasons, activists on both sides cultivated the image of the coalfield as a hotbed of revolutionary struggle. Nevertheless, the General Strike of 1926 ran like a fault line through the history of the labour movement. The Strike proved a comprehensive defeat and, in so far as a complex situation can be described in simple terms, the dominant mood afterwards was indeed one of depression. The morale of mining communities collapsed, and it is significant that it was in those places less drastically affected by unemployment, notably the anthracite-producing areas, that the Communist Party was most successful. It is not clear whether Walters had in mind a particular model for the central figure in *The Communist*, though Lewis Jones, author of *Cwmardy* and *We Live*, was an obvious candidate since he was famous for his passionate oratory. If so, the muted politics of the paintings of Walters and of Griffiths were the more clearly emphasized by contrast, since *We Live* was the greatest art expression of Communist beliefs and mass action made in the period. *The Communist* presented the passion of the orator as the focal point but, in a manner reminiscent of Daumier's *Ecce Homo*, the audience appeared distanced from the messianic figure, observing intently but bemused rather than stirred to revolt.

[40] *Western Mail*, 17 June 1927. This was the same picture described by Geraint Goodwin under another title; see note 29.

[41] *Cambria Daily Leader*, 29 November 1928.

310. Unknown photographer, *The Soviet Level: locked out miners working at a level near Glyn Neath*, 1926

Despite the failure of liberal-minded intellectuals in England to support Evan Walters after his 1927 exhibition, their troubled social conscience would have important long-term consequences for visual culture and for the arts in general in Wales. Between 1927 and 1931, educational settlements were established at Maes-yr-haf in the Rhondda, at Merthyr, and at Risca. Others followed at Bargoed and the Rhymney Valley in 1932, at Pontypool in 1934 and Dowlais in 1935. A settlement was an institution established by a philanthropic group to occupy and develop the education of unemployed people. The movement was labyrinthine in its organization and philosophically diverse. The Society of Friends was particularly active, establishing the first Valleys' settlement at Maes-yr-haf and also the most ambitious of all the schemes at Bryn-mawr in Monmouthshire. The Quakers believed that industrial collapse provided an opportunity for social experiment in which the spiritual and economic condition of the people could be shown to be intimately linked. Their schemes for creating work organized on a cooperative basis implied a criticism both of unregulated capitalism and the socialist alternative. In her analysis of the symptoms of collapse in the Bryn-mawr community, Hilda Jennings identified the failings of both mainstream responses: '...the conception of leadership as autocracy, on the one hand, and the reaction by which democracy is conceived of as mass control over mandated delegates, on the other'.[42]

The 'Bryn-mawr Experiment' began in 1928, following the exhaustion of the resources of the town's Distress Committee. Members of the Society of Friends moved into the area from England and, although their intervention was in the paternalistic tradition of the nineteenth century, they attempted to develop a thorough understanding of the particular nature of the community at Bryn-mawr by organizing a community survey carried out by local people. On the basis of the survey, Bryn-mawr and Clydach Valley Industries Ltd. was established in 1930 as a parent organization giving loans to enable small groups of individuals to establish cooperative enterprises. Bootmaking and weaving businesses were begun, but the manufacture of furniture was by far the most successful venture. The furniture 'was all of individual design and followed the trend of modern architecture in its use of flat, unbroken surfaces, relying for its effect on the natural material, proportion and line'.[43] The distinctive designs of Paul Matt, coupled with the publicity surrounding the production of the furniture by previously unemployed workers, appealed to a particular section of the market, resulting in financial success but also criticism of working-class people perceived to be producing 'luxuries for the well-to-do in Oxford and London'.[44] The work of the Bryn-mawr settlement was shown regularly in the Art and Craft exhibitions

[42] Hilda Jennings, *Brynmawr. A Study of a Distressed Area* (London, 1934), p. 220.

[43] Ibid., pp. 213–14.

[44] *Industrial Survey of South Wales made for the Board of Trade by the University College of South Wales and Monmouthshire*, quoted by Jennings, op. cit., p. 217.

[45] Ibid., p. 213.

[46] Published posthumously in *Young Wales*, July 1899, 145–52. Ellis had attended Ruskin's lectures while a student at Oxford.

of the National Eisteddfod, ensuring a high profile in Wales for the experiment, if not high sales.

The idea of the spiritual elevation of the people through craftsmanship and the appreciation of beauty was central to the Quaker philosophy applied at Bryn-mawr:

> Among the main objects kept in view in the development of new industries have been the re-awakening of the spirit of craftsmanship, which was once so strong in rural Wales, and the release of personality in work which is not derogatory to human dignity in the sense that it aims at production of shoddy goods.[45]

The ideas of John Ruskin and William Morris were clearly important antecedents for the experiment. Indeed, the rhetoric of liberal-minded activists in the twenties and thirties was closely similar to that used in the reporting of social distress in the English illustrated newspapers in the 1870s. Such attitudes found practical expression during the Depression not only through outside interventions such as those of the Quakers but also from within. Welsh nationalist intellectuals at the end of the nineteenth century had been directly inspired by Ruskin and Morris and their teaching was passed on to the next generation through the new university, and in books and periodicals. For instance, Tom Ellis had espoused the virtues of Ruskin and Morris in his lecture 'Domestic and Decorative Arts in Wales', delivered to the Cymmrodorion in 1897.[46] Inspired by Ellis's patriotic liberalism, as well as by the nationalism of Mazzini in Italy and by their reading of contemporary social theory in England, in 1890 a group of students at Aberystwyth formed the idea of establishing a

311. Paul Matt,
Talygarth Sideboard, Tretower Table and Mount Chair, photograph from catalogue c.1930–40

312. Paul Matt,
Chest of drawers and armchair,
c.1930–40

313. Leonard Merrifield,
Thomas Jones,
1928, Bronze, 430 h.

[47] The settlement was established in 1901, though not directly by those who had conceived the idea at Aberystwyth.

[48] Thomas Jones described the aspirations of students at Aberystwyth in 'College Memories', see idem, *Leeks and Daffodils* (Newtown, 1942), pp. 78–86.

[49] In January 1929, for instance, Margaret Davies wrote to Jones about the government's policy of moving unemployed workers out of the Valleys to new industries in Slough and Dagenham: 'The enemy Despair is gaining ground daily. I can't help feeling that we are back in the war days and that extraordinary measures will have to be taken. This policy of "transference" cannot cope with the situation. Do try to take some of your Cabinet Ministers down to see for themselves.' Quoted in White, *The Ladies of Gregynog*, p. 41.

[50] See Percy Watkins, *A Welshman Remembers* (Cardiff, 1944), p. 147.

[51] Percy Watkins, 'Adult Education and the New Leisure in Wales', *Welsh School of Social Service, 1934. School Addresses delivered at the Friends Meeting House* (1934), p. 46.

settlement in Cardiff and took the first practical steps towards that end.[47] Among them was Thomas Jones, who acknowledged the strong influence of Tom Ellis.[48] As we have seen, through *The Welsh Outlook*, Jones subsequently sought to expand the awareness of visual culture in Wales and, in particular, the importance of imaging industrial labour. Jones rose rapidly to a position of great influence both as a civil servant and in his direction of the Pilgrim Trust, among the richest private charities at work in the period. The Trust, and eventually the government itself through the National Council of Social Service, assisted the work of the settlements and, wherever Jones's influence was felt, his interest in visual culture was apparent. He developed his association with the Davies family of Llandinam, sponsors of *The Welsh Outlook*, and in the 1930s Margaret and Gwendoline Davies diverted substantial sums of money away from art collecting and into the relief of distress in the Valleys. Their new house, Gregynog, was used as a base for meetings and conferences by movements active in the social field, and the sisters themselves sought to influence policy through Thomas Jones at the highest levels.[49]

In 1933 another Welsh civil servant, Percy Watkins, was appointed Director of the National Council of Social Service. He identified two main objectives of the Council's work – firstly, to provide unemployed people with clubs in which they themselves could organize activities and, secondly, to expand the number of educational settlements.[50] However, Percy Watkins saw the movement in a different light from the Quakers and felt that it was not appropriate for it to deal with the underlying problem of the lack of paid work, but that it should concentrate on what he referred to as 'other aspects of the problem'.[51] These other aspects concerned what was euphemistically referred to in the period as 'spare time'. So-called 'cultural activities', including the practice and appreciation of art, would play a part in attempts to ameliorate the symptoms of distress. The Bryn-mawr Arts and Crafts Club seems to have been created at an early stage, and certainly by 1935 classes were being held in the Merthyr settlement. Art clubs were also established independently of the settlements.

From a different political standpoint, Thomas Jones's interventions, whether at governmental level or through the trusts, were perceived as no more than palliatives intended to stabilize a situation which threatened the position of the ruling class. Wal Hannington's analysis from the Communist point of view was that the government had been frightened into belated intervention by the activities of the National Unemployed Workers' Movement and especially the National Hunger March of 1932 against the Means Test. There was also a fundamental conflict of opinion between Marxists and Quakers, which led to the boycotting

of the Friends' projects (in particular those involving the use of voluntary labour) by unions and some left-wing local authorities. On the narrower question of 'spare time' and the arts, Hannington was equally unimpressed by interventions from outside the working class:

> I believe that the organising of social life for the unemployed is a job for the working class movement itself. It need not be confined to darts, cards, and billiards, but should be extended into cultural pursuits embracing working-class music, drama, art, films and literature. Much talent has already been discovered amongst the unemployed, and more would reveal itself if real scope for its development were provided, free from the patronising influences of people unconnected with the working class movement.[52]

In 1928 the painter Cedric Morris had taken his first steps towards becoming involved in this complex interaction of responses to economic distress. For people like Wal Hannington, his interventions no doubt seemed characteristic examples of 'patronising influences'. Cedric Morris was in a unique position. Like Evan Walters (who was four years his junior), Vincent Evans and Archie Griffiths, Morris was an insider, born into the industrial community of the Swansea area. However, his family circumstances were very different from those of the other three. He was the direct descendant of John Morris, owner of the copper works who had commissioned William Edwards to design the settlement of Morriston to house his workers. His mother came from the Cory family, also important industrialists. Cedric Morris spent a privileged childhood mostly in Gower and subsequently attended Charterhouse School. By 1914 he had decided to become a painter and went to Paris. After the war, he re-established himself in that city, using his studio as a base from which to travel extensively on the Continent.

In 1927 Cedric Morris moved to London and in the following year returned to Wales to paint. He was overwhelmed by his emotional reaction to his own country. In July he expressed his feelings in a letter to his lover, Arthur Lett-Haines, from Llangennith:

> I always said this was the most lovely country in the world and it is – it's so beautiful that I hardly dare look at it – and I realise now that all my painting is the result of pure nostalgia and nothing else – I thought I was homesick for England but not at all – dirty grimy little market garden – it was this I wanted ...[53]

[52] Wal Hannington, *The Problem of the Distressed Areas* (London, 1937), p. 214.

[53] Tate Gallery, Cedric Morris Papers, 8317.1.4, item 52.

314. Unknown photographer, *Cedric Morris with his painting 'The Entry of Moral Turpitude into New York Harbour'*, 1926

315. Cedric Morris,
Llanmadoc Hill, Gower,
1928, Oil,
662 × 810

Over the next few years, Morris travelled from London to paint landscape at such celebrated beauty spots as Solfach, and not until 1934 did his letters reveal an awareness of the human distress in the Valleys which formed a counterpoint to the physical beauty that initially excited him. In September of that year, Morris called on Charles Mansel Lewis at Stradey Castle, with whom he got on well as he 'was dragged all round the county to meet nobby persons'.[54] No record survives of what passed between Mansel Lewis and Morris on this return to the social milieu of his youth, but it is reasonable to suppose that both visual art and the

condition of the unemployed people of the area were discussed. As we have seen, Mansel Lewis's father, who had died in 1931, had been a painter of considerable ability and an important promoter of visual art in Wales, in particular by means of his support for exhibitions, such as those organized for the National Eisteddfod. His last effort in this direction had been made at the Llanelli Eisteddfod of 1930, the climax of a series of impressive exhibitions held throughout the previous decade. Since 1930 the Eisteddfod exhibitions had gone into decline, leaving professional artists without a satisfactory platform on which to show their work on a regular basis in their own country. It is probably more than coincidence that, within a few months of his visit to Stradey Castle, Cedric Morris was deeply involved in the promotion of a large exhibition of Welsh painting and sculpture.

The precise genesis of the Contemporary Welsh Art Exhibition of 1935 remains uncertain, but the letters of Cedric Morris make it clear that he was the prime mover and organizer. In February 1935 he informed Lett-Haines that he would 'be up and down to town while the Welsh business is being worked [out] – I shall have to do practically all the work to do with it – that is all the arranging, selecting and putting together and meeting the people – I have done it all so far and I think it will be worth while ...'[55] He had been at work since at least January and although others became involved, notably Frances Byng-Stamper of Manorbier Castle as secretary and Augustus John as selector, it was Morris who provided the continuity which enabled the exhibition to open at the National Library of Wales in Aberystwyth in July 1935. As artists and connoisseurs, the motivation of the organizers was uncomplicated. According to Clough Williams-Ellis, speaking at the opening in Aberystwyth, 'The exhibition had been hatched in London and its purpose was to initiate Welshmen into their countrymen's work. It was felt that the Welsh were not conscious of what Welshmen had done and could do. The exhibition was literally an eye opener ...'[56] In the case of Cedric Morris himself, however, the exhibition became entwined with a deeper sense of personal responsibility, if not guilt, for the condition of unemployed people in the years of the Depression. Industrialism was in a state of collapse, ruining those men and women whose labour had created the wealth of his own family. Morris believed that art had the power to enrich and to heal, and that through making paintings and sculptures available to ordinary people he could contribute to alleviating their distress. Immediately after the opening in Aberystwyth, he went to stay with Frances Byng-Stamper at Manorbier Castle. He wrote to Lett-Haines about his experience and his plans for the exhibition when it moved to Swansea:

Am leaving here tomorrow and they are dropping me at Pembrey, nr. Carmarthen – I may stay there or wander on to the Swansea Valley – I want to try and do some work among these people if I can find anywhere to stay – also to try and make some contacts there – am not looking forward to it much, pretty dreary, but feel I ought to be here ... I am not enjoying myself much – all sorts of things are happening to me and this place tears me to bits, but I am working and I suppose that is the main thing ...[57]

[54] Ibid., item 78.

[55] Ibid., item 85. The letters make it quite clear that the version of events reported by W. B. Cleaver in the introduction to *The Contemporary Art Society for Wales. 50th Anniversary Exhibition* (Cardiff, 1987), p. 6, is inaccurate. Cleaver says that the exhibition was conceived at a meeting held at the Royal Institute of British Architects in May 1935, with Clough Williams-Ellis in the chair. While this meeting may have served to formalize the organizing group, it is clear that arrangements were already well advanced by then. Cedric Morris had started work at least as early as January 1935. See Cedric Morris Papers, 8317.1.4., item 99. The exhibition was presented to the press as the brainchild of Augustus John. Cf. *Western Mail*, 15 October 1935: 'In one sense the personality of Augustus John broods over the whole display – as much because the exhibition was conceived and very largely organized by him as because of the magnificent series of his paintings which it includes.' In fact, John was the figurehead, not the instigator or organizer. Morris makes plain in his correspondence that press interest in John was so intense that his involvement would guarantee success – and so it proved. The group transformed itself into the Contemporary Art Society for Wales in 1937, placing the emphasis on the purchase of works by living artists to be distributed among public collections throughout the country.

[56] *Cambrian News*, 19 July 1935.

[57] Cedric Morris Papers, 8317.1.4., item 91.

Two days later, Morris had put himself into a position where he could vicariously experience the privations of the unemployed:

> Am staying here in an out of work miner's cottage – all extremely uncomfortable and filthy food, but nice people and clean and it is the landscape I want – 30/- per week – I shall stay a week or so – have finished one picture and there are 3 or 4 more – I am getting on to something. I am edging towards Swansea and getting used to living with these people. It is really heartbreaking the way they have to live – I am not enjoying it ...[58]

By early August Morris was becoming embroiled in the wider movement to alleviate distress. The status of his family enabled him to gain the ear of influential local people, promoting the exhibition and seeking further ways in which he could be of use. At the same time, his family background left a huge gulf between him and the people whose conditions he sought to improve. He observed the community from close proximity and yet from afar, wondering at the humanity of the people, just as visiting artists and writers of the eighteenth and nineteenth centuries had done:

> I am having dinner at a holiday camp for out of work miners ... I went there on Sunday and met the men and I got on a chair and gave them a talking to about painting – how I did it I don't know, but I did and they were most interested and asked me intelligent questions afterwards which I found most difficult to answer, as the language of painting is not the same as that of the people – yesterday I walked across Gower to Oxwich – and it was most interesting – rather like Derby day – the Valleys pour themselves into Gower when there is a holiday in every known kind of conveyance – the discomfort and noise must be awful as all the children and babies are brought too and the dogs – but I have never seen people enjoy themselves so much – Southend is not in it – poor devils they look half starved most of them and such nice looking people I was amazed at their kindness and pretty manners. It is dreadful to think that S. Wales can never recover and that they and their children will all have to die in this disgraceful poverty – so much for industrialism ... I am going up the Swansea Valley today to have a look at it, but one has to keep one eye shut – the squalor is appalling ...[59]

Among the people he became acquainted with at this time was David Rees Grenfell, Labour MP for Glamorgan and Gower:

> I went to a lecture last night by the labour member for this district who said that things were by no means as bad in Glam. as they were going to be and that the people must face utter destitution ... that there was no hope of escape and that they must face it and try to save the children – that there was no solution from any party – they sang 'Land of My Fathers' afterwards! They were all unemployed ... Something is drawing me into the middle of this –

[58] Ibid., item 92.

[59] Ibid., item 93.

[60] Ibid., item 94.

[61] Ibid., item 95.

[62] Ibid., item 99.

[63] Ibid., item 86.

[64] Ibid., item 78.

[65] Richard Morphet, *Cedric Morris* (London, 1984), p. 110.

[66] 'Everything seems to be going quite well at Aberystwyth. 2000 visitors at the exhibition in one week – not bad – but of course all the staff are quite incompetent and the librarian impossible.' Cedric Morris Papers, 8317.1.4, item 91.

I want to go away but I can't – I feel there in a curious way, it is part of me, that I came out of it and in some way I must go back into it – Grenfell the MP said to me after his lecture do I realise that one of the worst spots in S. Wales bears your name and I said yes – I went there yesterday – then he said – I was born there and worked 23 years underground – then he said Morris of Swansea has gone and Morris of Swansea has come back – so I said Morris of Swansea is dead and he said I don't think so ...[60]

By the middle of August Morris was beginning to doubt the usefulness of his contribution in view of the enormity of the problem around him. 'A few pictures won't do it', he remarked to Lett-Haines and then 'plenty everywhere and the people have not enough to eat. Either I am going mad or the rest of the world is ...' In September, following the private view of the exhibition at the National Museum, opened by Augustus John, Morris finally collapsed under the strain, feeling 'that the whole business of being a painter is quite useless really'.[62]

It is not clear what precisely angered Cedric Morris at the opening in Cardiff, but it may well have been the contrast between his own belief that the exhibition might enrich the lives of people suffering the deprivations of unemployment and the less altruistic motives of some of his colleagues. Morris seems to have got on well with Augustus John, whom he described as 'a most charming person, half naughty boy and half wise man',[63] but he found others, such as the novelist Richard Hughes of Laugharne Castle, less easy to tolerate. Although he had visited Hughes in the period of the genesis of the exhibition, he had chosen not to stay: '[the] whole atmosphere too bogus, it oppresses me', he remarked.[64] Morris was an upper-class intellectual, but he seems to have been offended by the gulf he perceived between those like Frances Byng-Stamper and the common people with whose fate he was, at this time, concerned. His double portrait of Frances and her sister Caroline was privately known to him under the title 'The English Upper Classes'.[65] Nevertheless, despite Morris's own sense of the irrelevance of the venture, the 1935 exhibition was visited by large numbers of people – over two thousand in the first week at Aberystwyth, according to his own account.[66] More pertinent to

316. Unknown photographer, *Private View of the Contemporary Welsh Art Exhibition at the National Museum of Wales*, 1935, from left: Augustus John, D. Kingsley Baxandall, J. B. Manson, Frances Byng-Stamper, Major Trehearne James, Sir Cyril Fox, Richard Hughes, Lady Fox

317. Cedric Morris, *The Sisters*, 1935, Oil, 760 × 635

318. Unknown photographer,
Sir E. W. Cemlyn-Jones with Owen Bowen,
President of the Royal Cambrian Academy,
at a Children's Art Exhibition, c.1947–53

ABSORBED IN WELSH ART—The Glamorgan Elementary Schools visits to the Contemporary Art Exhibition at Swansea commenced yesterday, with visits by scholars from Gowerton Girls', Godre'rgraig Mixed, Gorseinon Boys', and Rhossili Mixed Schools, who had explanatory talks from Mr. Kenneth Hancock and Mr. Gwilym Thomas.
" Evening Post" Picture

319. Unknown photographer, *Glamorgan school children at the Contemporary Welsh Art Exhibition on tour in Swansea, 1936*

[67] *Report of the South Wales and Monmouthshire Council of Social Service*, p. 7, held at WEA archive.

[68] The exhibition was not simply an extension of that of the previous year. Most of the works shown were different, and the work of Alfred Janes was also included.

[69] The details are given in Cedric Morris Papers, 8317.1.2.406. This item is a précis of events leading to the foundation of the Welsh Federation of Music and Arts Clubs, probably written by Morris with Esther Grainger.

[70] NLW MS 22745D, f. 81, undated but clearly 1937 since it refers to the imprisonment of Saunders Lewis.

[71] Arthur Giardelli would interpret these pictures as overt social comment in his article on Cedric Morris in *Wales* (ed. Keidrych Rhys), no. 2 (1943), 71–6. However, he subsequently modified his views; see Chapter 5, note 17. The painter Glyn Morgan remarked of Morris's reaction to social and political problems that 'he wasn't a logical mind. I don't think he worked out these ideas; he was completely intuitive. His thoughts were his emotions and his emotions his thoughts'. NLW, Welsh Visual Culture Research Project Deposit, interview with Peter Lord, 30 May 1997.

[72] The pictures owned by Lloyd George and the National Museum respectively.

[73] Nor was Ceri Richards selected.

his particular concern were visits, arranged by the Council of Social Service, by members of clubs for the unemployed when the exhibition was at Swansea and Cardiff. They were given guided tours by Sir E. W. Cemlyn-Jones, a member of the organizing committee, and Augustus John 'inspected the work of a number of budding artists from the clubs at the Council's offices'.[67]

In 1936 a second contemporary art exhibition was shown at the Fishguard National Eisteddfod. Most of the artists from the previous exhibition were again selected, but Morris's contribution was greatly reduced and he does not seem to have been involved with its organization, which was done by Frances Byng-Stamper.[68] Morris was moving in a different direction, clearly feeling that direct intervention by teaching art was a more useful response to the social crisis. Despite his loss of faith in 1935, in the following year Cedric Morris lectured at a summer school for unemployed people, arranged by Mansel Grenfell, the local WEA organizer, where they discussed various schemes for art education, including summer painting schools and clubs in west Wales.[69] However, no money was available and little was done. Despite his privileged background, Morris was not rich, but an educational settlement at Gwernllwyn House, Dowlais, established by Mary Horsfall, an English philanthropist, eventually provided him with the outlet he needed. Probably in 1936, and certainly by 1937, Morris was in touch with Horsfall, and over the next decade he would make an important contribution to the development of visual art in Wales through his involvement with the settlement movement. Nevertheless, despite his concern and a passionate sense of his own Welshness, he made his contribution from England. He chose to open his own art school in Dedham, Essex, which became his life's work when it moved to Benton End in Cambridgeshire. In 1937 he wrote to Keidrych Rhys, editor of the new magazine *Wales*: 'No, I have not forgotten the unemployment – my country. I never forget it and all the misery that goes with it. I hear from Miss Horsfall from Dowlais at times – I want to go to Wales, but I can't get away – perhaps later ...'[70]

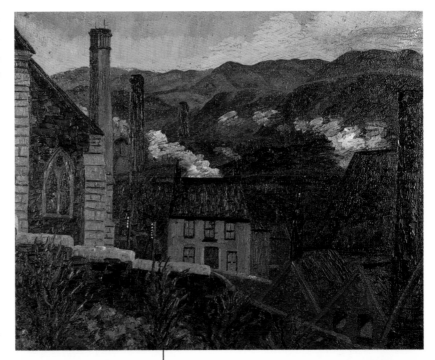

320. Cedric Morris,
The Tips, Dowlais,
c.1936–9, Oil,
585 x 710

Cedric Morris used his painting to communicate the outrage he felt about the condition of communities in the Valleys only in the most tentative manner. On visits to the settlement at Dowlais sometime between 1936 and 1939, he painted two of the most celebrated pictures of the period, *The Tips, Dowlais*, and *Caeharris Post Office*, which, although they were sombre in tone and portrayed a silent and apparently depopulated industrial landscape, cannot be seen as part of a sustained attempt to develop an iconography expressive of the trauma of the time.[71] Indeed, in their structure, these pictures were not essentially different from the lyrical landscapes of Solfach and the Gower painted by Morris on his first return to Wales in 1928. He does not seem to have painted portraits of working people or attempted subject pictures such as those he painted in the 1920s. Neither did Morris, in so far as he was responsible for the selection of the pictures, favour industrial or socially provocative subject matter in the 1935 exhibition. Evan Walters's contribution to the exhibition included *The Miner* and *The Welsh Collier*,[72] but these were the only images rooted in the life of the people to whom Morris hoped the exhibition would appeal. Works by Augustus John, Gwen John, David Jones, Morland Lewis and many other painters, sculptors and architects were shown, including those of J. D. Innes, who had died twenty-one years earlier. However, Vincent Evans and Archie Griffiths were not chosen, despite the fact that both men were well known to the selectors.[73] By comparison with contemporary writing such as that of Lewis Jones, the images of classless utopias, of labour and even of suffering produced by Evans and Griffiths seem, in retrospect, cautious and politically non-committal.

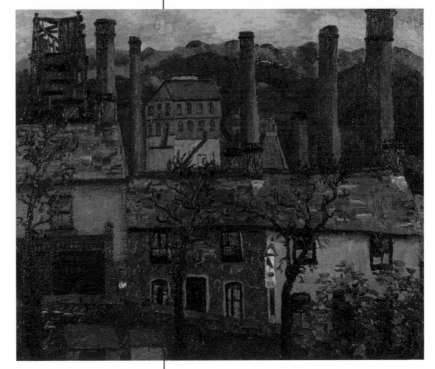

321. Cedric Morris,
Caeharris Post Office,
c.1936–9, Oil,
585 x 710

below: 322. Unknown photographer, *Archie Rhys Griffiths on the roof of the South Wales Evening Post building*, c.1932

below right: 323. Archie Rhys Griffiths, *Awaiting his meal*, c.1930, Etching, 137 × 115

324. Evan Walters, *Sir Cyril Fox*, 1937, Charcoal, 504 × 328

Nevertheless, it appears that Morris and John felt that they were strong enough to warrant exclusion on political, social and aesthetic grounds. However disagreeable Morris may have found the pretensions of some of his colleagues, the 1935 exhibition was the product of a self-appointed art establishment of which he was an essential part whereas Griffiths and Evans were not.[74] A letter written by Vincent Evans to the *South Wales Evening Post* in April 1935, proposing 'an annual art exhibition of a national character', strongly suggests a public attempt to pre-empt the other scheme. Morris's exhibition was permeated by attitudes that had been well expressed, a decade earlier, by R. E. Mortimer Wheeler, Director of the National Museum. In 1924 Wheeler had addressed the Cymmrodorion at the Pontypool National Eisteddfod on the subject of the teaching of art and architecture:

... art and architecture are vividly realised at the same time as social symptoms and as social re-agents. The coal-miner, in his damp upland valley imprisoned between sombre, mist-clad hills, is condemned to a daily alternation between shaft and slum. His eyes are filled with monotony of colour and devastating monotony of form; the glinting brasswork of his doorstep is polished with the same desperate impulse for variety as that which urges the proverbial prisoner to tend the prison mouse. He has left to him his voice, and that he uses with a good will. But that alone, without dwellings to which he can come with pleasure, and surroundings which can 'soothe and elevate' him, cannot be expected to provide a universal alternative to 'political agitation' and 'drinking'... Let us bring painting and sculpture intelligently within the reach of our industrial populations. Let there be adequate teaching of the *appreciation* of art and of architecture. Given the opportunity, it is perhaps not too optimistic to hope that the self-same causes which now drive a man to drink may sometimes be persuaded to drive him to art. It is worth trying. It is a political and an economic, no less than an aesthetic, problem; and its solution is becoming daily more urgent.[75]

By 1935 Mortimer Wheeler had been succeeded at the National Museum by Cyril Fox. Both Fox and Isaac Williams, Keeper of Art, believed that the aim of the exhibition was to elevate the minds of the people as well as to raise the profile of contemporary artists. The exhibition would help to bring the values and aspirations of working people into line with those of establishment intellectuals like themselves. Celebrating the industrial community by presenting the imagery of Evans and Griffiths would be to restate the problem, rather than to solve it. The following year Evans's *Repairing Main Roadway* and *Trimming after Charge*[76] were both shown at the Royal Academy and the artist wrote to the National Museum offering them for sale. At the head of an internal memo on the

[74] Goscombe John, however, continued to associate himself with Archie Griffiths, and attended the opening of his exhibition at the Young Wales Association in London in 1932 at the age of seventy-two. Thomas Jones was also associated with the organization of this exhibition, which was reported in the *South Wales Evening Post*, 2 April 1932.

[75] R. E. Mortimer Wheeler, 'The Teaching of Art and Architecture in Wales', *Transactions of the Honourable Society of Cymmrodorion* (1923–4), 108.

[76] *Trimming after Charge* is sometimes referred to as *After the Blast*.

325. Vincent Evans,
Repairing Main Roadway,
1936, Oil,
1005 × 1255

326. Vincent Evans,
Trimming after Charge,
1936, Oil, 506 × 720

Yesterday was sending-in day for oil paintings at the Royal Academy Exhibition, which opens on May 4. Here, a hopeful artist is seen carrying in his masterpiece, to wait the verdict.

327. Unknown
photographer,
*Vincent Evans with
'Repairing Main Roadway'
at sending-in day,
The Royal Academy,*
1936

328. Harold Tomlin,
Clough Williams-Ellis,
1934

[77] NMW, Vincent Evans file, memo dated 30 June 1936. Vincent Evans (who was forty at this time) had offered the pictures for sale since 'The subjects are essentially from Welsh inspiration and of Welsh life'. The class animus against Evans continued after the Second World War. The Keeper of Art, John Steegman, was offered *A Welsh Family Idyll* in 1948. He regarded it as 'thoroughly poor'.

[78] Patrick Abercrombie, 'Wales: A Study in the Contrast of Country and Town', *Transactions of the Honourable Society of Cymmrodorion* (1922–3), 185.

[79] Cedric Morris Papers, 8317.1.4, item 103.

[80] In a letter to Keidrych Rhys, written in 1938, Morris referred to Williams-Ellis as 'That old –' NLW MS 22783D, f. 82. For Clough Williams-Ellis, see Jonah Jones, *Clough Williams-Ellis, The Architect of Portmeirion* (Bridgend, 1997).

[81] NLW MS 22779E, f. 70.

[82] The Ashington painters were presented in a widely discussed essay in *The Listener* in May 1935.

[83] John Davies Williams (1878–1936) became editor of the *Cambria Daily Leader* in 1919, and of the *Herald of Wales* and the *South Wales Evening Post* in 1932.

subject, Fox added a handwritten note: 'A bombastic young man: turn him down politely – absurd!'[77] The Valleys, which had once been included among the beauties of Cambria, were now a prison of 'sombre, mist-clad hills', an archetype of ugliness, and their darkness was a metaphor for the spiritual deprivation and political threat presented by the people who lived there. Even from a liberal standpoint, Patrick Abercrombie described the 'grim horror of the mining villages of South Wales' in these terms in 1933:

> The Rhondda may stand as a type ... Quite apart from health and social aspects, the Rhondda may be considered as the aesthetic climax of what Professor Patrick Geddes has called the paleotechnic age of industrialism: it is Adam Smith's glorious vision of individualistic success absolutely realised: framed apart from the world by its hillsides; hung up on the fair wall of Wales as a complete picture for posterity.[78]

With unwitting yet prophetic irony, Abercrombie concluded: 'No one should attempt the improvement of the Rhondda – it should be kept, carefully sterilised of human life, as a museum specimen.' As we have seen, Cedric Morris observed that particular part of human life on holiday in the Gower with sympathetic fascination. In other circumstances, where his sense of family guilt did not colour his vision, he was less disposed to proletarian sympathies. Visiting St David's in August 1936 'was a madly depressing experience – the Cathedral sitting like an outraged hen in the middle of a howling mob and the Pilgrim's Way – well –! So we went to St. David's grave about 2 miles off over the head (the second holiest place in Europe) to find the cove literally packed with motor cars – hundreds of awful people in the cove, an ice cream van and about 30 people actually sitting *on* the grave having a picnic – I was filled with a kind of panic – half rage and half fear – as though thousands of ghosts were gibbering all round – and the menagerie was really appalling – so went away'.[79] Such views reflected the emerging conservation movement of the period. Though often expressed in terms of planning a better future for the common people by slum clearance and new housing in garden suburbs or even modernist cities, it was deeply conservative and patrician in its origins. Clough Williams-Ellis, its chief Welsh exponent, was a prominent member of the organizing group of the 1935 contemporary art exhibition. Morris's response to him as a person was distinctly mixed, but the critical framework of the exhibition and the underlying alienation of both men from working-class culture underlines how much they had in common.[80]

The status of Evan Walters in 1935 made it impossible to exclude him from the exhibition. Nevertheless, comments made later by Augustus John, when Walters's reputation had sunk low, revealed a contempt for his subject matter not apparent in public utterances made at the time. John believed that art was about beauty and,

329. Evan Walters,
The Welsh Collier,
1931, Oil,
770 × 639

like Clough Williams-Ellis, that the industrial communities of south Wales were a paradigm of ugliness. In 1951, writing to David Bell, he recalled adjudicating at an eisteddfod 'where I noticed a painting of a collier: At least, I took it to be a collier from the general blackness of the colour'. This was a picture by Evan Walters and, following his London exhibition in 1926, John 'wrote to Evan and advised him to go to paint in Provence and so develop a colour sense. He did not do so but always drifted back to S. Wales where colour is apparently taboo or non-existent. I don't think Evan Walters improved much in his short career ...'[81] Augustus John's only affirmative images of Wales were those which he had painted in the company of J. D. Innes before the war. Together, they had bathed the Arennig in imported Mediterranean light.

The exclusion of Vincent Evans and Archie Griffiths and the marginalization of the industrial imagery of Evan Walters in the 1935 exhibition did a huge disservice to Wales. Considered alongside the few works by Morris which approached the subject matter, it is clear that the material existed for the identification of a school of painting. The selection of works for the 1935 exhibition deliberately obscured that potential, in contrast to the contemporary celebration by English intellectuals of the paintings made by working miners at Ashington in Northumberland.[82] From 1911 onwards John Davies Williams had sought to construct a critical framework for the understanding of the work of the Swansea painters. He believed that their work should be considered as the basis of a national Welsh art with industrial imagery at its heart. However, his enthusiastic and informed writing was published mainly in the local newspapers with which he was professionally associated.[83] No national English-language press, appropriate for the discussion of such issues, existed in Wales. *The Welsh Outlook* had ceased publication in 1933, and *Wales* was yet to emerge. When it did, the work of

330. Unknown
photographer,
John Davies Williams,
1913

right:

332. Albert Houthuesen,

Jo Parry, a Welsh Collier,

1935, Oil,

1219 x 914

331. Mervyn Levy,

Dylan Thomas,

1948, Pencil,

306 x 236

84 The career of Archie Rhys Griffiths, in particular, suffered as a result of Williams's death. He remained in London but found it increasingly difficult to earn a living as a painter. He continued to work on mining subjects, depending on his wife, Edith Annie Rose Griffiths, a commercial artist, for support. In his later years he was described to the author by his doctor as 'depressed, crumpled and monosyllabic'. He died in London in 1971.

85 'It is extraordinary the interest there is in him among all classes – though they have never seen him. He is spoken about with the greatest awe.' Cedric Morris to Lett-Haines, Cedric Morris Papers, 8317.1.4, item 93.

86 *South Wales Evening Post,* 11 September 1935. Similarly, S. Morse Brown remarked in a BBC broadcast on 8 August 1938, '[Wales] must produce artists who will live in *Wales* and paint in *Welsh*.' NLW, BBC Archive, Box 8.

87 NLW, Welsh Visual Culture Research Project Deposit, interview with Peter Lord, September 1995.

88 For Houthuesen, see James Huntington Whitely, *Albert Houthuesen 1903–1979, An Artist in Wales* (Cardiff, 1997). The painter was a contemporary of Archie Griffiths as well as Ceri Richards at the Royal College of Art.

Cedric Morris secured substantial exposure as a consequence of the painter's friendship with the editor, Keidrych Rhys, but virtually nothing was published concerning the industrial imagery of Walters, Evans and Griffiths. When Williams died in 1936, even the limited degree of exposure that he had been able to afford them immediately ceased.[84] By contrast, and largely as a result of the widespread public interest in Augustus John, the 1935 exhibition, with its image of Wales rooted firmly in the tradition of the second half of the nineteenth century, was widely publicized.[85] Evan Walters pointed out that it was a display of work by contemporary Welsh painters, not a display of contemporary Welsh art. Furthermore, in his opinion, it was English art:

> What we have in Aberystwyth is English art by Welsh artists. Welsh art would express the ideals and soul of Wales – just as 'Bydd Myrdd o Ryfeddodau', 'Calon Lân', and 'Yn y Dyfroedd' are expressions of the very soul of Wales.[86]

Neither the general public nor the next generation of painters were encouraged to respond to the industrial imagery of Walters, Evans and Griffiths with either patronage or by emulation. Mervyn Levy and Alfred Janes were at the Swansea School of Art in the early 1930s. Unlike their predecessors, they left to study in London with aspirations only to escape. Levy remembered that 'What we wanted to do was to go to London and if possible go to Paris and somehow or other identify ourselves with the French or continental *avant-garde*'. They admired Augustus John but the work of Evan Walters stirred little in them: 'All we thought was here was a bloke who painted miners.' Astonishing as it may seem, having grown up among the shopocracy of Swansea with Dylan Thomas, Levy could look back on the social trauma of the Valleys in the inter-war years and say, 'It passed me by'.[87]

In the mid-thirties Mervyn Levy, Alfred Janes and Dylan Thomas indulged, rather self-consciously, in the Bohemian artist life for which the pattern had been set for the Welsh in London by Augustus John. At the same time a number of non-Welsh artists were turning their attention to Wales, including the Dutch-born painter Albert Houthuesen, who had known Ceri Richards at the Royal College of Art in London. From 1932 until 1948 Houthuesen made regular visits to Flintshire, staying at a farm near the Point of Ayr colliery, where he painted *Jo Parry, a Welsh Collier*.[88] However, Houthuesen was a particularly isolated individual, pursuing his own artistic agenda at a time when many artists on the political left had decided to come together in the Artists International.

[89] Interview with Hastings published by the *Daily Mirror*, quoted in Robert Radford, *Art for a Purpose: The Artists' International Association, 1933–1953* (Winchester, 1987), p. 76. After the first two years, the Artists International (subsequently the Artists' International Association) adopted a less specifically pro-Soviet, more generally anti-Fascist position. It then attracted a large number of members who encompassed a range of political views but who were united by their support for the republican side in the civil war in Spain. Even Augustus John felt able to exhibit with the group on this anti-Fascist platform and to support schemes for raising money in support of the republicans. John contributed work to the 'Artists Help Spain' exhibition in 1936 and was able to donate £500 as a result of his participation in the 'Portraits for Spain' scheme. He was not a member of the Artists' International Association.

For them, the trauma of the Valleys exercised a particular fascination. The Welsh miner became emblematic of the class struggle, a perception rooted not only in the activism of Tonypandy before the Great War, but more deeply in the mystique of the exotic which had attracted the documentary artists of the liberal-minded illustrated press in the 1870s. In 1935 Jack Hastings, an influential early member of the Artists International, used a Welsh miner as the central figure in his Social Realist mural painted for the library of the movement at its headquarters at Marx House in London. The miner bound the portraits of Robert Owen, William Morris and Marx on the left of the composition to that of Lenin on the right, symbolizing 'the worker of the future upsetting the economic chaos of the present'.[89] Among Hastings's colleagues in the early years of the Artists International was Edith Tudor Hart, an Austrian photographer who had moved to London in 1933. She was a Communist and showed her work under the banner of the Workers' Film and Photo League. In 1934 her husband, a doctor, was invited by the Miners' Federation to work in Llanelli, providing

333. Jack Hastings, *Mural at the Marx Memorial Library, London*, 1935, Fresco, 3024 × 6028

335. Albert Houthuesen, *Study of a Miner*, 1940, Charcoal, 760 × 547

334. Albert Houthuesen, *Study of a Miner*, 1935, Charcoal, 742 × 536

Edith with the opportunity to photograph mining communities, particularly in the Rhondda. As a political activist, Edith Tudor Hart recorded what she saw 'not for posterity but for the day'.[90] The critical thrust of her photographs was often achieved by understating material deprivation as a contrast to the intimate and affirming portrayal of individuals. The poor and the unemployed often smiled in her pictures. Despite being an outsider, she was able to achieve a remarkable rapport with her sitters, which contrasted starkly to the alienation of the studio portraits of miners taken in the 1860s. Edith Tudor Hart attempted to produce her images in book form under the title 'Rich Man Poor Man', in association with Pearl Binder and James Fitton, colleagues in the Artists International. Like the American photographer, Walker Evans, working in the United States at the same time and with closely comparable subject matter in the rural depression of the south, she failed to find a publisher.[91] Nevertheless, some of her images achieved wide circulation, beyond the exhibitions organized by the Artists International, in periodicals.

[90] Wolf Suschitzky, *Edith Tudor Hart, The Eye of Conscience* (London, 1987), p. 10. Suschitzky is the brother of Edith Tudor Hart. See also J. A. Ford, 'The Rediscovery and Recontextualisation of Photographic Work from the Edith Tudor Hart Archive' (Postgraduate Diploma, the London Institute, 1994). Edith Tudor Hart (1908–78), had attended the Bauhaus at Dessau in 1931 before moving to London. She worked for Soviet intelligence as a courier in the People's Commissariat of Internal Affairs (NKVD) and was probably responsible for the recruitment of Kim Philby to the KGB. See J. Costello and O. Tsarev, *Deadly Illusions* (London, 1933), pp. 133, 138–9. I am indebted to Douglas Gray of De Montfort University, Leicester, for his assistance with this and other photographic material.

[91] Walker Evans took the photographs for *Let us now praise famous men* in 1936, but was unable to find a publisher for the book until 1941. The text was written by James Agee.

336. Edith Tudor Hart, *Miners' Houses, South Wales,* c.1934

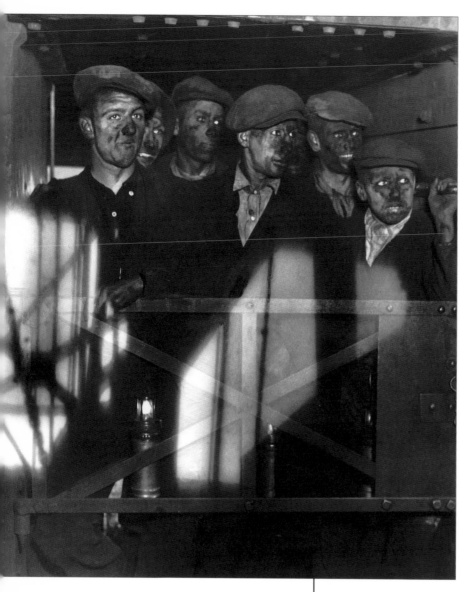

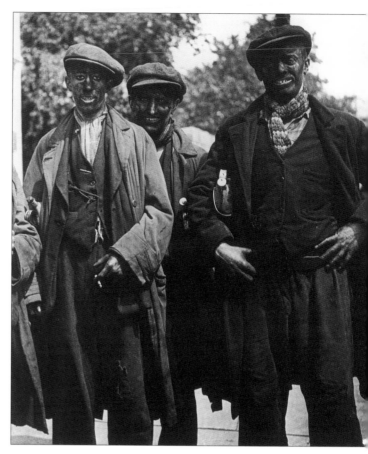

338. Edith Tudor Hart,
South Wales Miners,
1936

337. Bill Brandt,
*Miners returning to daylight,
South Wales*, c.1935

[92] *The Weekly Illustrated*, 6 October 1934, 4–5. The brief text was written by H. V. Morton, also in the nineteenth-century liberal tradition: 'The Welsh miner is a splendid man. His courage, his cheerfulness, his sense of humour, his love of beauty and his alert curiosity mark him out from many of his fellows.' H. V. Morton, *In Search of Wales* (London, 1932), included a photograph of Archie Rhys Griffiths's sepia drawing, *Standing a Post*. The use of underground photography in illustrated magazines of the period raises the question of its possible influence on painters. However, there is little evidence to suggest that Griffiths or Evans used photographic reference directly, even though they continued to paint detailed pictures of men at work for many years after they themselves had finished working underground.

In March 1936, the *Geographical Magazine* used her work to illustrate an article about the Rhondda written by Miles Davies of the Bryn-mawr settlement. Edith Tudor Hart's work was supplemented by that of an unknown photographer working for *The Weekly Illustrated*. As in the mid-nineteenth century, developments in popular publishing which emphasized the image rather than the word provided a new opportunity for documentary artists. Among the features commissioned by *The Weekly Illustrated* in 1934, its first year of publication, was 'Coal and the men who get it'. Its double-page spread of photographs both of work underground and community life closely echoed the engravings of *The Graphic* and *The London Illustrated News* of the 1870s.[92] However, in January 1936 the same magazine published the first of a series of more radical features, 'Underground Lives', which included one of the most remarkable images of Wales made in the period, *Miners off to work in the early morning at a mid-Rhondda colliery*. The magazine itself was clearly aware of the power of this image, interpreting it in detail in didactic terms:

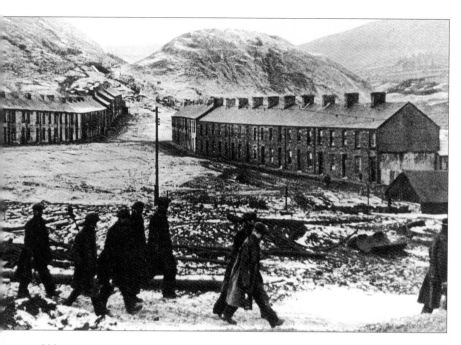

339. Unknown photographer,
*Miners off to work in the early morning
at a mid-Rhondda colliery*, 1936

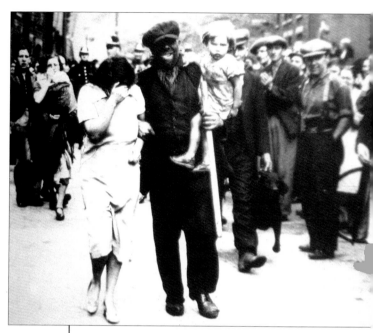

340. Unknown photographer,
Up after 292 hours underground,
1939

The rows of houses show his arduous and narrow life. The grey light stands
for work at all hours and in the pitch darkness underground. The group of
figures represents the comradeship of the miners, giving rise to acts of
heroism which thrill the country one day and are forgotten the next.[93]

The Weekly Illustrated's photographer was not named but was presumably one
of the many talented individuals, such as Bill Brandt, who visited Wales from
outside. *Western Mail* photographers, though insiders in the sense that they
were based in Wales, worked under an editorial policy generally hostile to
union activity. Nevertheless, they continued the tradition established before
the Great War, and produced a number of notable images of the period. Unlike
Edith Tudor Hart, the newspaper concentrated its attention on moments of crisis
such as the strike of 1921, captured in an image of picking coal from the tips. It
was the depths of the depression in the mid-thirties, however, which provided
staff photographers with their most powerful images as they recorded the stay-
down strikes devised by the men to combat the threat of a lockout by the owners.
One such image, taken by an unidentified photographer in 1935, subsequently
achieved widespread celebrity as a sympathetic symbol of the militant Socialism
of the period, a considerable irony in the light of the Conservative sympathies
of the newspaper.

[93] *The Weekly Illustrated*, 11 January 1936, 13.

341. Frame enlargement from Ralph Bond's *Today We Live*, 1936

[94] See Berry, *Wales and Cinema*, Chapter 7, 'The Miner's Cinema: an Alternative Circuit'.

The even greater potential of film as propaganda for the Socialist cause drew other members of the Workers' Film and Photo League to Wales. In 1934, film of the aftermath of the Gresford Colliery disaster, in which 265 miners had died, was included in the second *Workers' Newsreel* produced by the League and the Communist Party. The main problem for film-makers outside the commercial cinema was how to ensure that such films were seen by a large and appropriate audience. The Workers' Film Society had established a branch in Cardiff by 1930, but it was essentially a club for the converted among the intelligentsia. It was the large number of cinemas in working men's institutes in the coalfield which offered the greatest opportunity for left-wing film-makers to create an audience. The institutes continued to show commercial film as the mainstay of their programmes through the 1930s, but more overtly political material, including some Russian and German film, was also screened.[94] Among those involved in directing the *Workers' Newsreels* was Ralph Bond who, in 1936, was given the opportunity to film at Pentre in the Rhondda for the coal mining section of *Today We Live*. The film contrasted the industrial community with rural life in Gloucestershire and was funded with the aid of the National Council of Social Service. As we have seen, the Council had close links, forged by Thomas Jones, with the government and, as a result, Ralph Bond's position as a critic of the government policy of palliative measures in the coalfield was compromised from the outset. Nevertheless, *Today We Live* was remarkable for its attempt to present the Depression from the point of view of the communities most seriously afflicted. The film was scripted but used local people rather than actors to develop its narrative. Bond used unemployed miners to present his critique of voluntary work schemes and other aspects of relief.

342. Frame enlargement
from King Vidor's
The Citadel, 1938

The film included shots of idle railways and pit-head gear to great effect, images presented at the same time by Archie Griffiths. Of *The Disused Colliery*, the painter remarked with ironic detachment to a London journalist, 'There are far too many of these at home you know', but contemporary Welsh critics were more forthright, suggesting the potency of the image for both painters and film-makers in the period. The *South Wales Evening Post* remarked: 'The picture breathes the dank, gloomy hopelessness of the deserted mine, with its pit-head gear standing like gaunt sentinels at the grave of the lost.'[95] John Davies Williams, who saw the picture at the National Eisteddfod at Neath, was even more impressed:

> 'Disused Colliery'... may repel you at first; but if you go back to it you will get to see that this Gorseinon artist has painted the whole hopeless tragedy of the Welsh coalfield. Here is the artist indeed taking the role of prophet. Mr Griffiths has never done anything so big. It is sombre – but it is Wales in 1934.[96]

343. Frame enlargement from
Ralph Bond's *Today We Live*,
1936

Ralph Bond's *Today We Live* was notable, above all, for the powerful low-angle shots of silhouetted figures scrambling up tips to salvage small coal, scenes which had made an equally powerful impact on Herbert Johnson, illustrator for *The Graphic*, when he had visited the Valleys in 1875 to portray the consequences of the strike of that year. Bond remarked, in the very different context of mass unemployment in 1937: 'The only contacts miners have with coal are the slag-heaps where sometimes they are permitted at ever present risk to life and limb to scramble for enough to keep the fires burning in their own homes.'[97]

[95] *South Wales Evening Post*, 2 April 1932.

[96] *Herald of Wales*, 11 August 1934.

[97] *World Film News*, II, no. 6, September 1937, quoted in Berry, *Wales and Cinema*, p. 134.

344. Frame enlargement from Pen Tennyson's *Proud Valley*, 1940

The celebrated image of scrambling for coal on the tip had not been shot by Bond but by another film-maker, Donald Alexander, and inserted into *Today We Live* by the producer. It repeated scenes originally filmed by Alexander and a group of friends in 1935 for a short film called *Rhondda*. On the strength of that film, in 1937 Alexander was given a budget of about £1,500 to make *Eastern Valley*, in which the Bryn-mawr Experiment and related ventures played a central part. The film was partly funded by the Society of Friends and therefore closely reflected their philosophy of spiritual regeneration through craft and agricultural work, which was contrasted with the human and environmental degradation of the valley caused by industrialization. Both *Today We Live* and *Eastern Valley* sought to speak both for and through mining communities by using the scripted documentary format. Among film dramas, a number had their origins in the work of writers on the political left, but perhaps only *The Citadel* (1938) fulfilled some of its political aspirations. The film was based on a story by the Scottish author A. J. Cronin, who had worked as a doctor in Treherbert and Tredegar.[98] *The Citadel* presented a highly critical view of the health care available to ordinary people and brought the problem of silicosis to the attention of the public outside the coalfield. However, as a result of the attentions of the censors, the message was considerably diluted in the film version made by the American, King Vidor, for MGM.

Commercial cinema made increasing use of the Valleys as a source for film during the 1940s. Like *The Citadel*, *Proud Valley*, made in 1940, was based on a story written by an author on the political left, Herbert Marshall. Furthermore, it featured Paul Robeson, a figure held in great esteem by many working-class people in the Valleys. However, the script was watered down by the intervention of various other writers, including Jack Jones, who also played a small part in the film. The critics regarded it as cliché and evasive on the social and political issues it might have been expected to confront. According to the *New Statesman*, it 'shunned reality like a disease'.[99] Similarly, for the sake of melodrama, the Hollywood director John Ford's version of Richard Llewellyn's *How Green Was My Valley* largely avoided the violent political context of the story in the years immediately before the Great War which gave meaning to the attitudes of the main characters. The emphasis in these films on the softer mythology of Christian values, family loyalties, individual dignity in adverse circumstances, and heroism in the face of physical danger cannot, however, be construed entirely in terms of an outsider construct. As we have seen, both Archie Griffiths in the Camden Town mural and Vincent Evans in *A Welsh Family Idyll*, evoked a similar mythology, with political struggle present only by implication and intelligible only to an audience already familiar with the context from which these myths sprang.

[98] Published in 1937 by Gollancz, London.

[99] Quoted in Berry, *Wales and Cinema*, p. 169.

c h a p t e r

f i v e

THE

DEMOCRATIZATION

OF ART

345. Ivor Williams,
Thomas Jones,
1939, Oil,
604 x 504

If the 1935 Exhibition of Contemporary Welsh Art proved a personal disappointment to Cedric Morris, nevertheless it had important implications for visual culture. The organizing group would redirect their efforts into forming the Contemporary Art Society for Wales which began to provide limited but useful patronage for Welsh artists and to enrich public collections with its purchases.[1] Cedric Morris directed his efforts into teaching and found in the settlements a network through which he could both contribute personally to the communities they served and act as a catalyst for the deployment of a number of other important teachers and practitioners.

At the same time, Thomas Jones was provided by the Second World War with the opportunity to devise a new structure of public arts patronage. It developed, step by step, from the early interventions of the charitable trusts which he administered, through the British Institute of Adult Education [BIAE] and its successor, the Council for the Encouragement of Music and the Arts, into the Arts Council of Great Britain, launched exactly ten years after the Exhibition of Contemporary Welsh Art.[2] Since these institutional developments took place at a British level, they affected the whole of Wales. Nevertheless, it is clear that the arts activities of the

[1] The Contemporary Art Society for Wales was formed in 1937. An account of the work of the organization is given in *The Contemporary Art Society for Wales: 50th Anniversary*, op. cit. The introduction is inaccurate in its description of the founding of the organization: see Chapter 4, note 55.

[2] The role of Wales in the evolution of the post-war system of state patronage was acknowledged in the *CEMA Monthly Bulletin* in 1943: 'Wales is, in some ways, the cradle of CEMA.'

settlements in the industrial parts of the south provided the pattern which would lead to participation by more people in art and craft activities, and increased opportunities for the public to see exhibitions of both international and Welsh art. It led to the creation of a network of resident professional artists and teachers which extended considerably the existing but limited art world based on regional art societies with their mixture of amateur and professional practice. Furthermore, the imagery which emerged, in both amateur and professional practice, was heavily influenced by industrial and urban life.

The ideas which moved Cedric Morris to invest so heavily in the 1935 exhibition were manifested in similar ventures to bring art to a wider public in England and in the United States. In the same year as the Welsh exhibition, the BIAE organized a touring exhibition under the title 'Art for the People'. The instigator was a Welshman, W. E. Williams, secretary to the organization. It toured in England only but a second exhibition, the following year, was shown at Coleg Harlech. The venue was significant since the exhibition had been partly funded by the Treasury and the Carnegie Trust, administered by Thomas Jones. In June 1936, under the title 'Art and the People', Jones gave a talk, broadcast on radio in Wales, to introduce the idea:

> The College invited the exhibition to Harlech so that its students and the Merionethshire folk should have an opportunity of living on intimate terms for a month with a representative collection of modern art ranging from David Cox and Turner and Cotman to Augustus John, Picasso and Roger Fry.[3]

According to Jones, the students who would see the work at the college were 'drawn for the most part from working-class homes and very often from among the unemployed'.[4] Very soon, the BIAE began to send collections of reproductions to educational clubs and settlements, but no other exhibition of original paintings was sent to Wales until 1940, apparently because of the lack of local funding. The Institute regretted this situation since they felt that their exhibitions were 'likely to be a greater success there than anywhere'.[5] The 1940 exhibition, funded by the Treasury and the Pilgrim Trust, consisted of eighty paintings, including works by the accepted canon of modern Welsh artists, J. D. Innes, Augustus John, David Jones, Morland Lewis and Evan Walters. It toured to Bridgend, Neath and Aberdare, and was intended, like the 1936 exhibition, to visit the National Eisteddfod, though this was postponed because of the war. At the same time, an exhibition of work by artists in clubs and institutes for the unemployed, 'Art by the People', was shown at the Risca settlement. The high level of Treasury funding for the 1940 exhibition presaged the evolution of the BIAE into the Council for the Encouragement of Music and the Arts [CEMA], which was entirely financed from public funds. W. E. Williams became honorary Director for Art and the exhibition programme he developed toured extensively in south Wales at venues which included places of employment and educational settlements as well as galleries and other public buildings.[6]

[3] 'Art and the People' (1936), published in Jones, *Leeks and Daffodils*, p. 204.

[4] Ibid., p. 205. Jones did not, however, develop a democratizing argument in the broadcast, but turned his attention to the supposed visual failings of the nation as a whole. In his opinion, the Welsh had 'no eyes' and were in a 'blinded' condition.

[5] *Western Mail*, 1 May 1940.

[6] Public funding was doubled to £200,000 and the chair was given to John Maynard Keynes. Details of activities in this period are documented in the CEMA *Monthly Bulletin*, published by the organization. William Emrys Williams (1896–1977) was the son of a carpenter from Porthmadog and a farmer's daughter from Llandeilo, where he spent his early years. The family moved to Manchester, where W. E. Williams attended university. He followed a distinguished career in the development of adult education, working for the WEA and, during the Second World War, developing the army education programme. He was Secretary General of the Arts Council of Great Britain from 1951 to 1963, a trustee of the National Gallery, and the joint editor of Penguin and Pelican books.

above:

346. Heinz Koppel,
Mary Horsfall,
1948, Oil

above right:

347. Glyn Morgan, *Cedric Morris,*
c.1955, Pen and ink, 340 × 265

[7] In the summer of 1937, Morris wrote to Arthur
Lett-Haines: 'Would you mind leaving Wales and
everything to do with it out of our conversations
in future and treat it as one of the subjects which
are taboo. Whether I am Welsh or not does not
matter – it is at any rate my home and the home
of my people – therefore I have a special feeling
about it. I have perhaps inflicted this special feeling
on you and other people – I shall not do so again.'
Cedric Morris Papers, 8317.1.4, item 107.

[8] Mary Horsfall was prepared to give '£50 – £100
at a pinch'. Ibid., 8317.1.1, items 2116–38.

[9] Ibid., 8317.1.4, item 115.

[10] Ibid., 8317.1.1, items 977–81.

In parallel with the public funding of art exhibitions through the BIAE and CEMA, Cedric Morris used the privately-funded Dowlais settlement at Gwernllwyn House as a base from which to develop a network of activities in the Valleys. Despite the fact that his continued involvement with Wales created strains in his personal life,[7] Morris visited Gwernllwyn House on several occasions in the war years. He established classes in art and craft with the aid of Tom and Marion Davies as resident leaders. The Davieses, in turn, visited the Benton End school to work as students under Morris. Mary Horsfall, patron of the Dowlais Settlement, also gave financial help to the school in East Anglia and repeatedly emphasized in her letters to Morris her vision of the two establishments as a partnership.[8] In due course, teachers and students from Benton End, including Arthur Lett-Haines, would visit Dowlais to assist in the teaching and to pursue their own work. In a letter to Lett-Haines, written in 1939, Cedric Morris described the teaching at Dowlais:

> Several factories are being started ... but for the rest the means test has been much tightened since the war causing some riots and much distress but things are a bit better on the whole ... I am starting evening classes for various kinds of design and handicrafts – 2 nights a week and every afternoon. We have had a 'meeting' and my students so far are John – 2 Toms – 2 Dais – ap Owen, Olive, Doris and Marion and Latimer – Their surnames seem to be all either Davies or Williams. We start with – wall paper, some Woolworth colours, brushes, pencils and some very good clay off the mountain – They are all young or youngish – I shall stay on some weeks to get this going.[9]

In his correspondence, Morris often revealed the social gulf that separated him from the communities which he sought to serve. Mary Horsfall and even Marion Davies, a local woman, manifested similar attitudes. On a train journey from

Cardiff to Merthyr, Davies described the disagreeable personal characteristics of the working classes to Morris: 'Fortunately I had a bottle of Eau-de-Cologne in my bag so I saturated my hankey with it and held it to my nose else I should have died from the overpowering odours!' It reminded her of a Jack Jones story.[10] The contradiction implicit in Morris's identification with, but distance from, working-class people was reflected in the philosophical ambiguities of his teaching. Beneath the contemporary fashion for enriching the lives of working-class communities by self-expression in art lurked the nineteenth-century ambition to discover and improve hidden talent: 'Probably there is no talent, but perhaps there is – at the moment they are all speechless with shyness and enthusiasm', he remarked. Furthermore, his level of commitment was dependent on their talent: 'If there is nothing there I shall escape after a few weeks – If there is something I shall stay as long as possible.'[11] The Welsh working classes were 'ridiculous people – part baby, part crook and part mystic'.[12]

Cedric Morris's stay at Gwernllwyn House in August 1942 proved particularly important in developing the educational network. He had organized an exhibition of his paintings that was greeted in Dowlais with 'the most inspiring enthusiasm', which he compared to the 'complete indifference' which had greeted 'a rather dull CEMA show'.[13] The exhibition was sent on to the Pontypridd settlement and it was at this time that Morris met Esther Grainger, 'an art mistress ... quite nice looking but very shy and frightened'.[14] Esther Grainger was, by then, thirty years old, having trained at Cardiff School of Art and subsequently worked for the Council of Social Service as an art and handicraft teacher, touring the Valleys' settlements.[15] Morris invited her to Benton End and an intimate friendship developed which lasted until his death in 1982. Grainger lived in Pontypridd and had become involved with the development of art classes and exhibitions at the settlement from as early as 1938. She greatly admired Morris's work:

> Your paintings grow and grow steadily on me – if this sounds rather impertinent it isn't meant that way. On the contrary. And another thing, they are growing steadily on Pontypridd. These exhibitions are so important. It will take years but already there begins to stir a feeling for pictures where before all was dead.[16]

348. Glyn Morgan,
Esther Grainger,
1955, Pastel,
500 × 365

[11] Ibid., 8317.1.4, item 115.

[12] Ibid, item 180, undated but 1942. The remark was made in the context of what Morris regarded as the enthusiastic but naive reaction of working-class people to his pictures: 'I don't feel a bit embarrassed or aloof or angry – I don't mind them calling my pictures photos a bit whereas if the English did it – well!'

[13] Ibid. In the following year, 1943, CEMA organized a touring exhibition of Morris's work.

[14] Ibid.

[15] *Western Mail*, 25 November 1955.

[16] Cedric Morris Papers, 8317.1.1, item 1260, 13 June 1944.

Also on the staff was Arthur Giardelli, a Londoner of Italian descent, who had first come to rural Pembrokeshire during the Depression. He had become a teacher in Folkestone but his school was evacuated to Merthyr in 1940. He was dismissed because of his refusal to join the armed forces, but stayed on to teach art history and appreciation at Dowlais and other settlements. Giardelli had studied at art school, though he did not begin to work as a painter in oils until Morris encouraged him to do so in 1943. Like Grainger, Giardelli was much enamoured of Cedric Morris and wrote an essay about his CEMA exhibition for *Wales*, describing him as 'everyman's painter'. He saw some of Morris's landscapes as unequivocal social comment: 'Disused chimney stacks stand like night-mare fungi in his paintings of Dowlais made during the great depression. He paints as a Welshman enraged at the suffering of the unemployed miner and steel worker.'[17] Subsequently, Giardelli helped to develop the work of the students at Dowlais, which was sent by post to Morris for criticism. 'We of course don't expect remarks about every individual bit of work', he wrote to Morris in June 1944, but 'we thought a good number of paintings and drawings would enable you better to assess the general situation.'[18]

[17] Giardelli gave an account of these years in Meic Stephens (ed.), *Artists in Wales [1]* (Llandysul, 1971), p. 23, but did not mention the influence of Cedric Morris. However, his letters, kept in the Cedric Morris archive, 8317.1.1, items 1182–91, and the essay in *Wales* (ed. Keidrych Rhys), no. 2 (1943), 71–6, make it clear that Morris's influence was of fundamental importance.

[18] Cedric Morris Papers, 8317.1.1, item 1185.

349. Unknown photographer, *Arthur Giardelli on the beach at Pendine*, c.1965

350. Heinz Koppel,
Self-portrait,
1947, Oil,
619 × 566

It was also in 1944 that Esther Grainger and Arthur Giardelli met the German painter, Heinz Koppel. The Koppel family had left Berlin for Prague, finding their way to London in 1936. Heinz Koppel's studio was bombed and he came to stay with a cousin who lived near Pontypridd. Through Grainger and Giardelli, he was introduced to Cedric Morris and began work as art teacher at the Merthyr Art Society, an offshoot of the Dowlais settlement. Under the leadership of this group – Cedric Morris, Heinz Koppel, Esther Grainger and Arthur Giardelli – the Pontypridd and Dowlais settlements began a brief but intense period of creative activity in teaching practical and theoretical aspects of art. In discussion with Morris, Grainger and Giardelli coordinated their activities with those of others in the field, and the Federation of Welsh Music and Arts Clubs was founded, with Grainger as secretary. Initially, five clubs expressed an interest, but the number rapidly expanded to forty.[19] Nevertheless, the clubs at the Pontypridd and Dowlais settlements remained the most important centres. In 1945–6 Pontypridd showed three Arts Council of Great Britain exhibitions as well as the Federation's own travelling show, which had been selected by Morris in association with the Hungarian painter, George Mayer Marton, and Evan Charlton of the Cardiff School of Art. Lectures given at the settlement by Giardelli and others were supplemented by visits to the National Museum and by exchange visits to the Dowlais settlement. There were five painting groups for children and adults, and among the projects carried out was a series of cartoons for panels illustrating the myth of Branwen for the pavilion at the National Eisteddfod of Mountain Ash in 1946.[20] At Dowlais, Koppel was an idiosyncratic but inspiring teacher, believing that students should be encouraged quickly to find their own approach and subject matter, and subsequently to concentrate on the development of technical skills. He taught mainly by example. Koppel brought his friend, Helmut Ruhemann, head of picture restoration at the National Gallery in London, to lecture, along with George Mayer Marton and other notable speakers.

[19] Koppel initially dissented and did not take part in the establishment of the organization, but he later served as a member of the art committee. The Federation was launched at a meeting in Caerphilly in 1944. Details of the activities of the constituent groups in 1945–6 are given in the Cedric Morris Papers, 8317.1.2, item 406.

[20] This project was initiated in 1940, but the Eisteddfod was postponed because of the war. It was directed by Evan Walters and involved students from the south Wales art schools and Howell's School in Cardiff, as well as the Pontypridd settlement. An account was given by Paul Matt in the catalogue to the art and craft exhibition of the National Eisteddfod at Mountain Ash in 1946.

351. Esther Grainger,
Pontypridd at Night,
1953, Oil,
397 × 500

229

[21] Benjamin Ifor Evans (1899–1982) was the son of a Tregaron farmer who moved to London and played an active part in the life of the London-Welsh community. He became an educationalist and a specialist in English literature, working for the British Council from 1940 and subsequently becoming Provost of University College, London.

[22] Walter Dowding, 'The Music and Arts Clubs: What are they?', *Wales* (ed. Keidrych Rhys), no. 23 (1946), 42–4. Walter Dowding (d. 1961) was a Quaker and a nationalist. He lived at the Bryn-mawr settlement from 1934.

[23] Cedric Morris Papers, 8317.1.1, item 1263.

[24] *Western Mail*, 10 February 1956.

[25] For an analysis of these changes, see Nicholas Pearson, *The State and the Visual Arts* (Milton Keynes, 1982), p. 48.

[26] David Bell, introduction to the catalogue of the exhibition 'Some Pictures from a South Wales Town' (Cardiff, 1947). The exhibition had initially been proposed by Koppel in 1946, prior to Bell's arrival in Cardiff. Bell's views were not shared by the National Museum, who refused to show a similar exhibition when proposed some years later. As Keeper of Art, John Steegman wrote to the Museum Director in November 1950 that 'Heinz Koppel is an interesting artist, but in my opinion neither his work nor that of his pupils is sufficiently good for exhibition in this Museum'. NMW Artists' Files, Heinz Koppel.

[27] Ibid.

Art clubs which aimed at extending the practice of painting and other forms to a wide public grew rapidly all over Britain in the immediate post-war period. As we have seen, Thomas Jones and W. E. Williams had already made contributions of fundamental importance to the development of this new atmosphere of democratization. In 1951 Williams would become Secretary General of the Arts Council of Great Britain. A further, if rather more marginal contribution at this British level, was made by a London Welshman, B. Ifor Evans[21] and his co-author, Mary Glasgow, in their book, *The Arts in England*, published in 1946. From their standpoint within the newly formed Arts Council, they sought to review populist developments to date. However, their work revealed a divergence of philosophy between two concepts of populism, one of which emphasized the initiation of projects at a community level, and the other the dissemination to a wide audience of cultural models from a central bureaucracy, notably through exhibitions and associated education programmes. The art club movement in south Wales had grown out of the very particular circumstances of the settlements and in an article in *Wales*, published in 1946, Walter Dowding of the Bryn-mawr settlement took issue with what he considered to be the emerging centrist model of the Arts Council:

> There is a flooding of Wales with music, drama, art from outside. (The exhibition of South Wales artists, sponsored by the Federation last year, was a notable exception.) That sort of flooding spends itself in a measureable [*sic*] time, and very little is left when the tide ebbs back ... Too much dependence on the Arts Council of Great Britain – formed, be it ever remembered, for the propaganda of English, *not* British, culture – can be deadly too. And real initiative, hard work and independence on the part of the Clubs might conversely galvanise the Arts Council into an interest in the Celtic culture of these islands.[22]

In a discussion broadcast on radio in February 1947, Cedric Morris echoed these sentiments: 'The English point of view has been forced on Wales – that is why there is no art in the country ... One thing is certain – with all its merits, we in Wales don't want to rely on the Arts Council of Great Britain. Leadership for Wales in matters of Art can never come from Belgrave Square.' Morris praised the work of the music and arts clubs, naming Esther Grainger, 'that noble spirit', and the Pontypridd and Dowlais settlements in particular. Nevertheless, Grainger herself seems to have been less opposed to a reduced role for the Welsh Federation of Music and Arts Clubs. Despite its initial burst of creative activity, the Federation was compromised almost from its inception by the creation of the Arts Council, and particularly by the establishment of a Welsh office. In June 1946, Grainger wrote to Morris:

> One thing that has rather changed the situation is this appointment of David Bell – I expect that you've heard that the Arts Council has appointed more staff for Wales with David Bell as art officer. That's probably a good thing (I haven't met him yet). But if they are going to expand in Wales then there isn't so much room for the expansion we foresaw in the Federation work. They are the official people with the money and the staff to do the job, and it looks as if eventually they will do it.[23]

Davavid Bell worked for the Arts Council until 1951. Five years later, having moved to Swansea as Curator of the Glynn Vivian Art Gallery, he looked back on those years as 'his most satisfying achievement', especially in terms of 'planning and arranging the pattern of present-day painting in Wales from the then loose assortment of unattached art groups and societies'.[24] It was, undoubtedly, a period of great excitement in visual culture, centred on the industrial communities of south Wales. Bell was able to draw on the pioneer work of those involved with the Federation, and also on a wider circle of intellectuals and artists who were discussing the question of the Welshness of Welsh art and the establishment of a national school of painting with a passion not seen since before the Great War. Bell's attitude combined a negative perception of the history of visual culture in Wales with a radical zeal to develop a new practice by the creation of a wider market for art. To this end, he sought to develop art appreciation through exhibitions shown in venues attractive to ordinary people and through the encouragement of amateur artists. He contributed substantially to art criticism in the period by writing for periodicals and exhibition catalogues, and by broadcasting.

David Bell's philosophical position undoubtedly encompassed contradictions and inconsistencies. On the one hand, he developed the radical policies of CEMA at a time when the Arts Council of Great Britain as a whole was revising much of the wartime strategy by moving towards the dissemination of a model of metropolitan excellence.[25] In 1947 Bell organized a touring exhibition based on the work of Heinz Koppel and the amateur painters working at Dowlais, entitled 'Some Pictures from a South Wales Town'. Bell clearly intended its combination of amateur and professional practice, shown in small venues beyond the traditional art gallery, as a model. He believed that it presented the vision of people whose work had not previously been valued – 'The ploughman and the clerk, the miner and the child', who explored 'new fields of experience'.[26] In his introduction to the exhibition catalogue, he wrote of:

> The revolution in the entire scale of values by which we enjoy and assess a work of art, which has been in process of developing throughout the last fifty years. It is a change of outlook which reflects a similar revolution in the whole of our life and society, the gradual merging of the extremes of society, the disappearance of privilege, and the emergence of the 'common man' as the inheritor of the cultural tradition of the past.[27]

Nevertheless, Bell's understanding of art historical tradition, expressed in his books *The Language of Pictures* (1953) and *The Artist in Wales* (1957), reaffirmed the aesthetics and values of aristocratic art. Mervyn Levy savagely attacked *The Artist in Wales* for producing 'a thoroughly second rate and entirely provincial account':

> Bristling with *clichés* – 'Architecture is often called the "Mother of the Arts"' – and stiff with platitudes – his favourite method of introducing an artist ranging from 'One of the best known ...' to 'Another artist whose ...' – the author waxes priggish ..., patronising and sanctimonious as when he bleats at the end of the book about having 'devoted the last few years of my life, the years which are normally regarded as the best years of a man's life' to creating opportunities for the artist in Wales, as though Mr Bell were the only one ever to have cared or bothered about this problem; and ignorant, as one must infer from his astonishing omission of any reference to the late Mr Morland Lewis.[28]

In Levy's opinion, the book was 'written in pathetic journalese, pompous, self-satisfied, patronising, and partial'. Despite the generally high regard for Bell inside the establishment, Levy was not alone in his passionate rejection of the author's ideas. Bell's advocacy of the aristocratic tradition as an appropriate starting point for the development of Welsh visual culture had earlier brought him into conflict with Iorwerth C. Peate. Both had become involved with the art and craft exhibitions of the National Eisteddfod immediately after the war as an established popular platform on which they might present their different visions of a reinvigorated visual and material culture, with the common people at its heart. Peate not only believed that an important visual tradition already existed in Wales, but that it stood close to the very essence of the indigenous culture. He had expressed this idea lucidly in his book *Y Crefftwr yng Nghymru*, published in 1933. Peate believed that the craft tradition should therefore be given the highest status in Eisteddfod exhibitions and presented as the core material on which new developments in Welsh visual culture should be based. Bell's allegiance to the hierarchies of the European high art tradition prevented him from adopting such a radical position. The debate reached its climax at the National Eisteddfod of 1950 in Caerphilly, with victory for Bell and the establishing of a regime which would dominate art and craft in the Eisteddfod for a decade. The competitive principle was abandoned and a professional exhibition, selected by Cedric Morris, Ceri Richards and George Mayer Marton, was very well received. Peate, who had been chairperson of the Art and Craft Committee, or, as he pointedly referred to it, the Craft and Art Committee, retired from the fray with a warning that 'Welsh artists should not become too complacent about the establishment of a Welsh school of painting just because they have enjoyed a successful exhibition at Caerphilly. If we in Wales are to see a school of Welsh artists, the artist must familiarise himself with the whole background of Welsh material life'.[29] Peate's suspicions of the aristocratic art tradition in which Bell was rooted were, no doubt, reinforced both by the origins of the new movement in an urban and industrial proletariat which was increasingly English-speaking and by the

[28] *Wales* (ed. Keidrych Rhys), no. 2 (new series), (1958), 68.

[29] *Western Mail*, 8 August 1950, probably translated from an address given in Welsh. For a discussion of the debate between Bell and Peate, and the art exhibitions of the 1950s, see Lord, *Y Chwaer-Dduwies*, pp. 107–14.

354. Geoff Charles,
*Iorwerth Peate Opening the
Art and Craft Exhibition of
the National Eisteddfod,
Mountain Ash*, 1946

355. Unknown photographer,
Arthur Howell,
c.1935

emphasis in exhibitions on industrial imagery. 'Some Pictures from a South
Wales Town' had been followed in 1948 by an exhibition of the work of Josef
Herman, 'Miners at Ystradgynlais'. Like Heinz Koppel, Herman had fled to
England from Fascism in central Europe. Although he had worked in England
and Scotland, in 1944 an intense involvement with Wales began which changed
the course of his life and had a considerable impact on public perceptions of
Welsh art for some years.

Bell launched two other initiatives of importance from within the Arts Council
in his attempt to create a new art world in Wales. In 1948 he convened a
meeting of interested parties to discuss an idea mooted by Josef Herman in the
radio debate with Morris and others on 'Art in Wales', broadcast the previous
year. Herman had remarked that since his arrival in Wales he had not 'seen a
single collective exhibition of younger Welsh painters ... Why not have every
year a get-together exhibition?' he asked.[30] His comments touched a raw nerve
in Arthur Howell, a well-known figure in the London art world, who responded
with a letter to the *Western Mail* in which he painted a depressing picture of
the situation in Wales. In his experience there were 'no patrons; no buyers; no
institution for exhibiting, awakening interest in and for selling to the public; in
fact no encouragement of any kind from anywhere!'[31] By October 1947 Arthur
Howell had organized an exhibition under the title 'Sixty Years of Welsh Painting'
at the St George's Gallery in London. In the 'Art in Wales' broadcast, another
contributor, John Steegman, had proposed mounting an exhibition in a department
store along the lines of those organized in London at Heals and Peter Jones.

[30] Cedric Morris Papers, 8317.3.1, item 2, script
of the broadcast, 21 February 1947.

[31] *Western Mail*, 26 February 1947. Arthur
Rowland Howell (1881–1956) was the son
of James Howell, founder of the Cardiff store.
He had occasionally written about the situation
of art in Wales before the Second World
War, notably in 1931, when he proposed the
establishment of an artists' colony at Llantwit
Major. His book, *The Meaning and Purpose of Art*
(London, 1945), achieved considerable success.

356. Nan Youngman,
Self-portrait,
1948, Oil,
504 × 604

357. Unknown photographer,
*The Seventh Annual Exhibition of the South
Wales Group at the National Museum*,
from left: Rollo Charles, P. J. Barlow
(Honorary Secretary), Carel Weight,
and R. Czilinsky (Chairman), looking at
The Apple Tree by Ivor Davies, 1955

[32] However, James Howell's Cardiff store
mounted one such exhibition entitled 'Welsh
Vision'.

[33] David Bell, *The South Wales Group, First Annual
Exhibition, 1949* (Cardiff, 1949), Foreword.

By January 1948 Heals was showing an 'Exhibition of Welsh Art', for which
David Bell wrote the catalogue and which was subsequently sent to the David
Morgan store in Cardiff. However, such exhibitions did not become a frequent
occurrence.[32] The meeting called by Bell in response to the 1947 broadcast
proved more fruitful since it was agreed to form the South Wales Group, an
association of professional and amateur artists working in various existing
clubs and societies. The first group exhibition, selected by Ceri Richards,
Cedric Morris and D. Kingsley Baxandall (who had been involved with
Morris in the 1935 exhibition), was opened at the National Museum in
April 1949. In his catalogue, David Bell emphasized the democratic
philosophy at work from the point of view of both artist and patron:

> The purpose of this selection is to stimulate an interest in the practice
> of painting more generally in Wales, and to widen the reputation of the
> work of the Group. To many people the practice of painting is itself
> a new experience, and it is hoped that these pictures, painted under
> similar conditions to their own, may have a genuine relevance to
> people interesting themselves in art for the first time. Moreover, it
> is one purpose of the Group to serve to create a market for pictures
> in Wales, and these are all pictures of the kind which many could afford
> in their homes. Without being masterpieces, they suggest a way in which
> pictures could become, from being exhibits in a gallery or a hall, treasured
> possessions and a part of the home and our daily lives. Until we in Wales
> think of painting in that way, as something integrated into our homes,
> we shall never have a living tradition of the art.[33]

above:

359. Nan Youngman,
Steel Works, Ebbw Vale,
c.1951, Oil,
595 × 810

above left:

358. Nan Youngman,
Rhondda Saturday,
c.1953, Oil,
457 × 635

David Bell's final contribution from within the Arts Council of Great Britain to
the development of the art market was the establishment of the Pictures for Welsh
Schools scheme. Following the recommendations of a long line of official reports
and private exhortations, dating back to the middle of the nineteenth century, some
school boards and subsequently local authorities had established a tradition of
placing prints and original pictures in schools. Notable among them was Anglesey,
whose School Pictures Committee was responsible for placing original works in
schools on a regular basis from 1927 until 1941.[34] In England, the painter Nan
Youngman, an early member of the Artists International, had established a
series of exhibitions intended as a central market place from which education
authorities might buy on an annual basis. The scheme had caught the eye of
David Bell who asked Youngman to organize a similar scheme in Wales, which
proved a considerable success throughout the 1950s. It also brought Youngman
into contact with Esther Grainger and a relationship of deep personal and
professional importance to both women ensued. As a result, Nan Youngman
made frequent visits to Wales where she began to paint the industrial landscape
and communities of the Valleys.[35]

In the industrial areas of north-west Wales, Mary Elizabeth Thompson had
been recording the lives of quarry workers in Bethesda since about 1939.
M. E. Thompson was born in England but had been trained partly in Brussels,
where she was impressed by the work of Meunier, whom, she claimed, was
'competent in his craft, yet creating types rather than individual miners'. During
her first years in Wales she drew landscape but ultimately revealed herself to be
in sympathy with the ideas of Thomas Jones and John Williams Davies:

[34] In 1854, H. Longueville Jones had been
frustrated in an attempt to distribute engravings
to schools in Wales, see *Minutes of the Committee
of Council on Education, 1854–5* (London, 1855),
p. 591. The contributions of Fred Richards and
Thomas Matthews to the field are discussed in
Chapter 4, notes 1 and 14. The Anglesey School
Pictures Committee became 'Y Pwyllgor Arlunio'
in 1947 and began organizing exhibitions. Wynne
Cemlyn Jones was the chairperson until his death
in 1966 and the committee patronized a number
of notable Anglesey artists, including Mitford
Davies, Harry Hughes Williams and Kyffin Williams.

[35] Nan Youngman also painted in north Wales,
visiting her friend, the landscape painter Fred
Uhlman, at his house near Penrhyndeudraeth.
See Fred Uhlman, 'Why do I live here?
Penrhyndeudraeth', *House and Garden*,
August 1958, 34. See also *For Nan Youngman,
Tributes on her 80th birthday* (Cambridge, 1986)
and Julian Rea, *Nan Youngman 1906–1995*
(Morley Gallery, 1997).

360. Mary Elizabeth Thompson,
Trimming Slate by hand:
Penrhyn Slate Quarry,
1945, Pencil,
805 × 553

361. Mary Elizabeth Thompson,
Fifth bank: Trevor
Granite Quarry,
1951, Pencil,
704 × 504

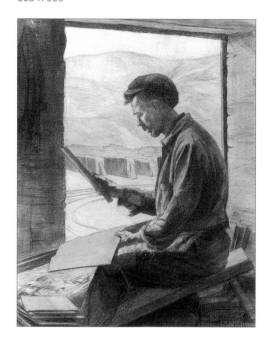

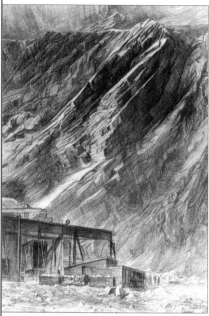

In our time, there is a world movement to depict 'labour', as epochs in the past have represented successively 'The pagan gods', 'religious pageantry', 'love of country and home', down to the present day when the effect of light and atmosphere on, and around objects, rather than objects themselves, is giving way to abstraction and abnormality which I personally feel to be a dead end.

What opportunities of artistic interpretation pass unobserved by artists! It is time to rid ourselves of the picturesque and accept the modern aspect of cities, and countryside, perceiving it with the aid of imagination and dream.[36]

Thompson suffered from a severe curvature of the spine which limited the scale on which she could work and, no doubt, influenced her choice of drawing with carbon pencils as her main creative medium. Within these limitations she recreated the world of workers at the Penrhyn slate quarries and the granite quarries of Trefor, imbuing the scenes with a mysterious quality of sympathetic detachment, reminiscent of the work of Vincent Evans. Her aesthetic conservatism was in contrast with the ideas of the German painter Martin Bloch, who also worked in Bethesda in the late 1940s and early 1950s. Like Koppel and Herman in the south, Bloch brought to industrial subject matter the expressionist tradition of central Europe. Indeed, Koppel had studied at the art school established by Bloch in London before the war. Bloch's *Down from Bethesda Quarry* was commissioned by the Arts Council of Great Britain for the Festival of Britain exhibition, 'Sixty Paintings for '51'.

[36] M. E. Thompson, 'An Artist in the Penrhyn Slate Quarry', *The Highway. The Journal of the Workers' Educational Association*, vol. 41 (May 1950), 161.

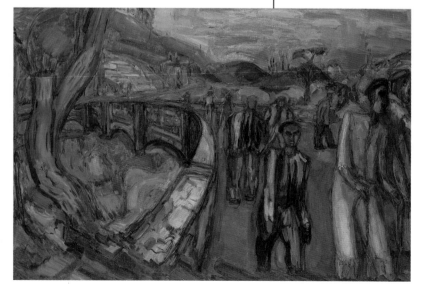

Among the most notable of a number of other visitors attracted to industrial Wales in the early 1950s were two photographers who would subsequently come to be regarded as masters of the form. Robert Frank was a native of Switzerland who had gone to New York in 1947 and worked for *Life Magazine, Harper's Bazaar, Fortune* and other picture magazines which were at the peak of their creativity at that time. William Eugene Smith was

362. Martin Bloch,
Down from Bethesda Quarry,
1951, Oil, 1224 × 1827

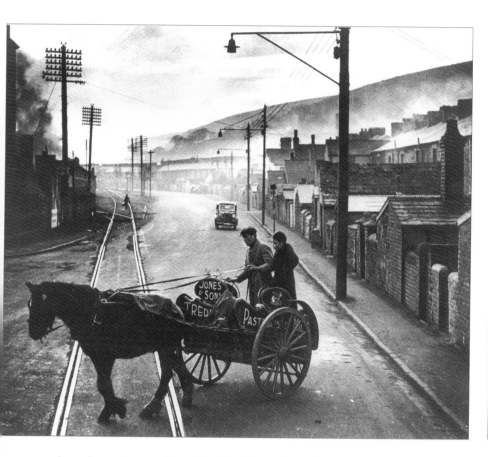

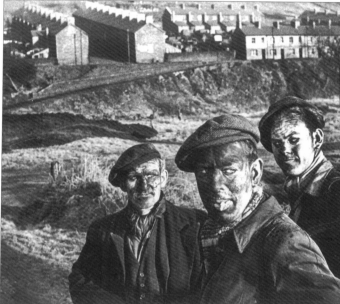

left: 363. William Eugene Smith,
*Horse pulling men in cart across
rail and road tracks,* 1950

364. William Eugene Smith,
Three generations of Welsh Miners,
1950

an American, also working for *Life Magazine* and a member of the Magnum Photos cooperative agency. Both came to the South Wales Coalfield in 1951, where Smith worked in the tradition of the photojournalist. Frank produced more experimental images which sometimes 'roughened up the medium with a blurry, blinding vision that left whole sections of the picture out of focus' to powerful dramatic effect, especially underground.[37] Nevertheless, more than any other single factor, it was the sustained critical interest in Josef Herman which raised the public profile of the artist's view of the life of Welsh industrial communities.

[37] Rafael Minkkinen, 'Robert Frank' in Colin Naylor (ed.), *Contemporary Photographers* (Chicago and London, 1988), p. 311.

The moment of vision on the bridge at Ystradgynlais which persuaded Herman of his mission to paint miners was described in an autobiographical passage which became as familiar as his paintings:

365. Robert Frank,
Miner Underground,
1951

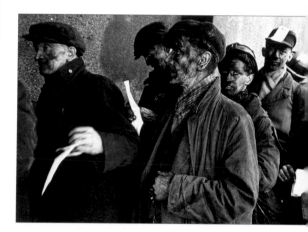

366. Robert Frank,
Waiting to be paid,
1951

367. Josef Herman,
Mike, 1954,
Charcoal and tint,
565 × 435

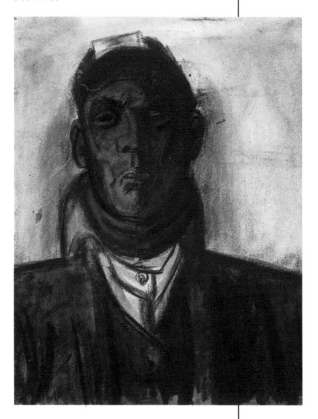

368. Josef Herman,
Miners Singing, c.1950–1,
Oil, 430 × 1220

Then unexpectedly, as though from nowhere, a group of miners stepped onto the bridge. For a split second their heads appeared gaunt against the full body of the sun ... With the light around them, the silhouettes of the miners were almost black ... The magnificence of the scene overwhelmed me ... it became the source of my work for years to come.[38]

Herman spent over a year drawing people and landscape in the town before he began to produce paintings. In describing a portrait of a miner called Mike, he summarized the way in which he used the very particular subject of the industrial community as a means of making more generalized statements:

I want my studies of miners to be more real than portraits. I am not trying to convey ... the abstraction of derelict pits and the wasted face of an industrialized landscape, but a synthesis of the pride of human labour and of the fortitude, the calm force, that promise to guard its dignity ... I like the miners and I like living among them. In their warm humanity and their expressive occupational poses, the way they squat, the way they walk and hold themselves, I find the embodiment of labour as a human rather than a merely industrial force, in fact the basic humanity that I have always sought and tried to express. The miner has thus become, for me, both incidental and symbolical.[39]

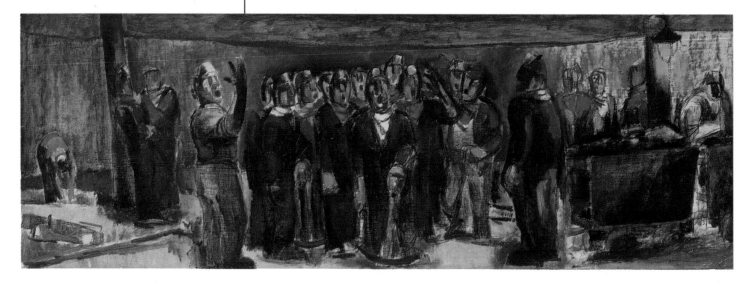

369. Evan Walters,
Winifred Coombe Tennant,
1950, Oil, 280 × 240

Herman's exploration of the idea of human dignity through the image of the Welsh miner divided critical opinion. David Bell and most of the new Welsh art establishment fêted his work. Bell believed that he had internationalized Welsh painting. In 1948 he wrote that Herman had brought to Wales 'as the invisible suitcase among his luggage, a profound knowledge of the great contemporary masters of European painting ... And when he has painted his neighbour in Ystradgynlais, the eye with which he has seen him has been sharpened by that familiarity'.[40] Winifred Coombe Tennant, writing to Augustus John, was less impressed. She clearly suspected that David Bell had been involved in the selection of Herman, along with Ceri Richards and Merlyn Evans,[41] to represent Wales at the Festival of Britain in 1951:

> The Festival of Britain has commissioned work – one picture – from three 'Welsh' artists out of a number whose names came before their selection committee. They have chosen 1) Ceri Richards! 2) Merlyn Evans (to me his pictures represent men and the visible world in terms of ironmongery!!) 3) A Pole now living at Ystradgynlais ... Herman or some such name! And these cranks are to go out into the world as representatives of art in Wales!!! What has David Bell got to say about this![42]

Herman painted two large murals for the Festival, *South Wales* and *Miners Crouching*, which exemplified the style for which he had become famous. Despite David Bell's populist philosophy, the celebrity afforded by him and other sophisticates to such pictures was often at variance with that of the gallery-going public. Reaction in the local newspapers to the 'Miners at Ystradgynlais' exhibition of 1948, for instance, included the comment that 'I have seen far better work in the lower standards of our elementary schools. The pictures are certainly ugly, debased, undefined and degenerate, an insult to other artists whose works always charm and delight me'. Another correspondent regarded them as 'monstrosities':

> The miners and the women look like blotted, misshapen, prehistoric beings emerging from the primaeval swamps of the Carboniferous age... ghastly travesties of the present-day miner and his womenfolk.[43]

[38] Moelwyn Merchant and Josef Herman, *The Early Years in Scotland and Wales, Joseph Herman* (Llandybïe, 1984), p. 21.

[39] Edouard Roditi, *Dialogues on Art* (London, 1960), p. 176.

[40] David Bell, 'The Art of Josef Herman', *The Welsh Review*, vol. VII, no. 2 (1948), 108.

[41] Merlyn Evans (1910–73) was born in Cardiff but moved as a young child to Scotland. Details of his career are given in Kirstine Brander Dunthorne, *Artists Exhibiting in Wales, 1945–74* (Cardiff, 1976), pp. 88–90.

[42] NLW MS 22786D, f. 70. The confirmation of the central place of Ceri Richards and Josef Herman in the new Welsh art establishment of the 1950s came in 1961 and 1962 when, at successive National Eisteddfodau, the two painters were awarded the Gold Medal for their services, rather than for individual pictures.

[43] Unidentified newspaper cuttings preserved in NLW, Welsh Arts Council Archive, Exhibition Files, A/E/11.

370. Josef Herman,
Miners Crouching,
1951, Oil, 2820 × 6240

371. Josef Herman,
The Pit Pony,
c.1959–60, Oil,
1211 × 1512

right:

372. Unknown photographer,
Josef Herman at the National
Eisteddfod at Llanelli,
1962

Arthur Giardelli, acting as a guide lecturer in the exhibition when it was shown at Tredegar, encountered similar criticism. Condemnation of Herman's alleged misrepresentation of the miner also came from the intellectual left outside Wales. John Berger alleged that Herman 'spent many years painting miners as if they were peasants instead of one of the most militant sections of the proletariat'.[44] The source of the divergent opinions of Herman's work was to be found in his transcendent use of the image of the Welsh miner as a universal token of human dignity, aggravated in the case of the more traditionally-minded public by expressionist style. The writer Glyn Jones remarked of the work, when he saw it on a television programme: 'The difference between the paintings and the human beings on which they were presumably based was so startling as to be funny.' However, Jones warned against proceeding on such grounds to the conclusion that Herman was 'to be regarded as a poor painter'.[45]

Herman's activity at Ystradgynlais was complemented by that of Will Roberts, with whom he shared a studio. Roberts had spent his early childhood at Ruabon in the North-East Coalfield, before his family moved to Neath. He was a year older than Herman and had trained, part-time, at Swansea School of Art from 1928 until 1932.[46] In 1945, at the end of his wartime service, he sought out Herman at Ystradgynlais:

> We met outside the local cinema. Joe was fond of films. We walked towards the Penybont, pausing on the 'Shakey Bridge'. We stood in wonder, looking downstream, the Cynlais sifting gently through the pebbly bed in the direction of the setting sun ... We arrived at the Penybont and made straightaway upstairs, where Herman and his wife lived and where he painted ... Facing me, as I walked into the large clubroom, which was his studio, pinned to the wall over the cast-iron fireplace, was a drawing of a man's head. 'Hello, you've got a Rouault', I said. 'You know Rouault?' asked the surprised Herman. Rouault in Ystradgynlais, how could it possibly be? Yes, I knew Rouault ...[47]

[44] John Berger, *Permanent Red* (London, 1960), pp. 90–4.

[45] Glyn Jones, *The Dragon Has Two Tongues* (London, 1968), p. 45.

[46] Alistair Crawford, *Will Roberts, A Retrospective, 1927–1992* (Llandudno, 1992), p. 4. In 'Will Roberts' in Meic Stephens (ed.), *Artists in Wales 3* (Llandysul, 1977), p. 104, Roberts himself gives 1930 as the date of his enrolment at Swansea.

[47] Roberts, ibid., p. 107. The drawing was by Herman who was 'still finding himself'.

374. Will Roberts,
The Old Tinplate Works,
c.1960, Oil,
885 × 1210

373. Will Roberts,
Self-portrait, c.1940,
Pencil, 289 × 201

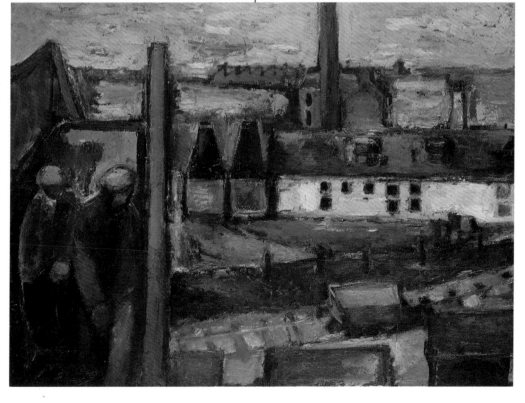

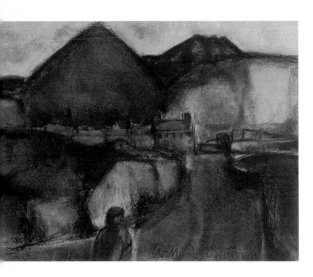

375. Will Roberts,
Onllwyn, Dulais Valley,
Unknown date, Pastel,
485 × 630

By the time he had moved to Ystradgynlais to work alongside Herman, Will Roberts was an experienced and competent draughtsman, well-informed about the European tradition. His subject matter, both portraiture and landscape, reflected the experience he shared with Herman of the mining community. He soon began to establish a reputation, and his work was shown at the 1950 exhibition at the Caerphilly Eisteddfod around which the debate between Bell and Peate had coalesced. Although Herman was not selected for that exhibition, Roberts's career was, to some extent, overshadowed in these years by the success of his friend, since both worked in a similar style. Herman was a more extrovert character than Roberts, and knew better how to present his work to the world.

[48] Ibid., p. 111.

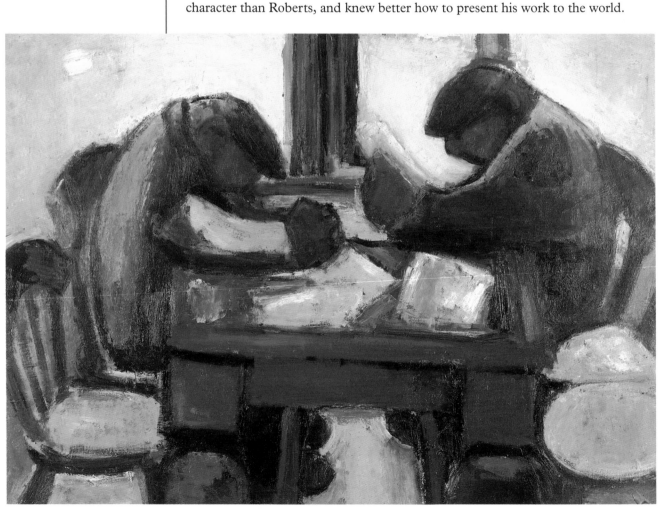

376. Will Roberts,
The Reading Room,
c.1964, Oil,
760 × 1020

Furthermore, as an émigré, he seemed more exotic, and therefore more interesting, to critics in the post-war period. Nevertheless, stylistic similarity masked an essential difference of emphasis in the work of the two men. Roberts did not iconize miners in the same way as Herman but rather painted them and his other sitters with concern for their individual lives and for the particular place. 'Will we ever cease to find what is new in the familiar, the commonplace?' he remarked.[48]

The 1950 exhibition at the Caerphilly Eisteddfod was organized by Esther Grainger and showed works by all the members of the group centred on Pontypridd and Merthyr. Herman's omission was surprising, but signified that, despite the fact that Herman had known Koppel in London before coming to Wales, there seems to have been little contact between the two circles. The art of Heinz Koppel was essentially different from that of Herman. As David Fraser Jenkins has remarked: 'The basis of all his work is the process of learning, learning to see, and to relate to the urban and domestic world ... But his work was never of a "subject" in the conventional sense, and it is possible to feel in the preparatory drawings his mind taking possession of what was in front of him, so that the final paintings become pledges of his existence.'[49] In a brief biography of Koppel, a friend confirmed the artist's internal transformation of the world around him:

There were a lot of pictures of the Welsh countryside. These were not academic records of his surroundings, but highly imaginative re-interpretations of what he saw. People had heard of Heinz and came to see him, quite a few fellow painters came to look, and also to learn from him.[50]

top left:

377. Unknown photographer,
Charles Burton,
1954

bottom left:

378. David Mainwaring,
Ernest Zobole,
c.1949, Charcoal, chalk
and watercolour, 280 × 217

[49] David Fraser Jenkins, introduction to the catalogue of the Heinz Koppel exhibition held at the Gillian Jason Gallery (London, 1988).

[50] Harry Weinberger, 'A Memoir of Heinz Koppel', unpublished essay, NLW, Welsh Arts Council Archive, Artists' Files.

379. Heinz Koppel,
Mare and Foal,
c.1953, Oil,
710 × 915

380. Unknown photographer,
Heinz Koppel in his studio at
Gwernllwyn House, c.1948

Among those who came was Charles Burton, a student in his early twenties at the School of Art in Cardiff. Later, he brought his fellow-student, Ernest Zobole. At the sight of the vast studio above the stables at Dowlais, Zobole was 'bowled over', as he was by Koppel himself, 'with his foreign sounding name, with a guttural German accent – it all added to the romance of it. I was very impressed by seeing all this and I remember describing somewhere along the line that [the pictures] were like Bonnard but there was a hardness in them – it was this combination – it was terrific'.[51]

Zobole visited Dowlais on several occasions subsequently with another student, Bill Austin, travelling up the valley by train to work and talk in the evenings. Zobole, Austin and Burton were part of a generation of students who attended Cardiff School of Art during the decade after the end of the Second World War and who would make a substantial contribution as artists and teachers to the Welsh art world. Their emergence from Cardiff marked a shift of emphasis away from the Swansea school, although it is difficult to attribute this to the teaching available there. In 1940 Ceri Richards had been appointed head of painting at the school and during his four-year stay he was given two major exhibitions in

381. Ceri Richards,
Tin-plate Worker,
1943, Pencil, chalk,
ink and gouache,
473 x 643

London galleries which helped to establish his international reputation. In 1943, as the result of a government commission, he made a series of drawings of tin plate workers, one of his few excursions into industrial subject matter which reflected the area in which he had grown up. However, Richards was not a dynamic teacher and his impact on the Cardiff school cannot be said to have carried over into the period after his departure in 1944. By 1946 the school was under the direction of James Tarr, who – like Richards – had been trained at the Royal College of Art shortly after Vincent Evans and Archie Griffiths.

[51] NLW, Welsh Visual Culture Research Project Deposit, Ernest Zobole, interview with John R. Wilson, 25 November 1995.

382. James Tarr,
Newport Road, Cardiff,
c.1954, Oil, 504 × 604

383. Tom Rathmell,
From Barrack Hill, Newport,
1950, Oil, 455 × 560

384. David Mainwaring,
Self-portrait,
1951, Pencil,
274 × 214

385. David Mainwaring,
Nigel Flower,
1950, Pencil and watercolour,
258 × 194

Tarr painted the urban landscape in which he lived but was conservative in his approach, leading Glyn Jones, a student at Cardiff from 1953 to 1957, to feel that the school 'encouraged a very bad Euston Road type of painting'.[52] As a leader, James Tarr lacked the vision of Grant Murray. In terms of teaching, by the time Jones was at Cardiff the creative emphasis had again shifted, this time to the Newport School of Art where Tom Rathmell was Principal and where the teachers included Hubert Dalwood and Trevor Bates. The creativity of Cardiff School of Art in the late 1940s and early 1950s was probably attributable simply to the common background from which a number of the students emerged, and to the immediate post-war atmosphere, described by Zobole:

It was a good time – there was an air of expectancy about. There was a Socialist government in and we had hope for all sorts of good things that were going to happen. It was a great time to be – you felt the vibrations of this throughout the whole country even though you were in one spot – you were part of this whole new thing that was setting off on something great.[53]

386. Ernest Zobole,
Ystrad Rhondda,
c.1951, Oil,
610 × 760

Several of the students travelled to Cardiff every day on the train from the
Rhondda Valley. The train journey became a legend. David Mainwaring from
Treherbert joined first, followed by Charles Burton and Nigel Flower at Treorci.
Gwyn Evans joined at Tonypandy and Zobole at Ystrad. They discussed and
criticized each other's work – Glyn Jones recalled that 'it was a pity when the
journey ended at Cardiff'.[54] They called themselves the Rhondda Artists' Group
and signed their canvasses RAG, although there was never any formal association
or manifesto. As older students left, younger ones, including Glyn Jones, began
their time at college and the tradition continued:

> The train would pick up people at almost every station down as far as Porth –
> people like Kerry Barclay, Peter Leyshon, Peter Wong, Geoff Salter, Islwyn
> Watkins – Charles Burton had gone by that time. There must have been eight
> or ten of us. It was the nearest thing, I think, to a café scene – we would all
> have the uniform – the beret and reefer jacket – and talk about art and politics
> and anything that occurred.[55]

The oldest of the Rhondda painters, Glyn Morgan from Pontypridd, provided
a direct link with the pre-war generation since, from 1946, he had visited Cedric
Morris regularly at the Benton End school. By 1951 he was in Paris, living the
bohemian life which he described in explicit detail in letters to Lett-Haines,
whom he referred to as 'Father'. He believed that Benton End had changed
his life: 'I owe you and Cedric more than can ever be calculated or repaid,
but I want you to know how grateful I am.'[56] Like Morris and Esther Grainger,
he painted dramatic and brooding landscapes overlooking Pontypridd, one of

[52] NLW, Welsh Visual Culture Research Project
Deposit, Glyn Jones, interview with John R.
Wilson, 30 October 1995. James Tarr (1905–95)
was born in Mumbles, Swansea, though he did
not attend Swansea School of Art. He trained
initially at Cheltenham but showed his work in
Wales from at least as early as 1930 when he
won the painting prize at the National Eisteddfod
in Llanelli. He was Principal at Cardiff School of
Art from 1946 to 1970.

[53] Zobole interview, op. cit.

[54] Jones interview, op. cit.

[55] Ibid.

[56] Cedric Morris Papers, 8317.1.1, item 2791.

387. Glyn Morgan,
Pontypridd,
1954, Oil,
600 × 1200

388. Unknown photographer,
*Cedric Morris, Glyn Morgan,
and Renate Koppel at
Benton End*, 1946

389. Cedric Morris,
Glyn Morgan,
c.1957, Oil, 604 × 453

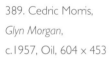

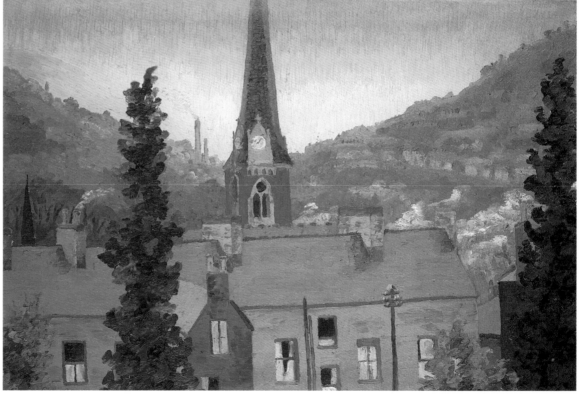

390. Cedric Morris,
Pontypridd,
1945, Oil,
510 × 762

391. Charles Burton,
Farmers on Horses,
c.1957, Oil,
620 × 745

392. Ernest Zobole,
Penrhys,
c.1951, Oil,
600 × 395

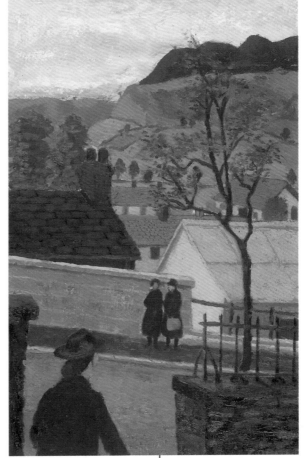

which drew favourable critical attention as early
as 1948 in the Exhibition of Welsh Art at Heals.[57]
Glyn Morgan's immediate successors at Cardiff,
Charles Burton and Ernest Zobole, were inspired
by Koppel rather than by Morris, and David
Mainwaring, at the School of Art between
1949 and 1954, also visited the German painter.
Mainwaring's influence on the younger members
of the Rhondda Group was strong both because
he formed a bridge between them and those who
had begun at Cardiff in the 1940s, and because he
was a natural teacher. Like all the members of the
group, he worked with local subject matter, producing both portraits
and landscapes, and he was a particularly fine draughtsman. Along with
his contemporaries Colin Jones and John Goddard,[58] David Mainwaring
chose to become a schoolteacher and worked through the 1950s, firstly
in the Rhondda and then in Neath. This commitment of many of the
Rhondda Group to the development of visual culture in their own
communities through teaching was also expressed in the organization
of small-scale exhibitions at public libraries and similar venues.

[57] See NLW, BBC Archive Deposit, Box 28,
George Tennant-Moon, BBC broadcast review,
22 January 1948, and also *Western Mail*, 30 March
and 31 May 1948.

[58] For an account of the reasons that persuaded
many young painters at the time to go straight
into school teaching, see NLW, Welsh Visual
Culture Research Project Deposit, John Goddard,
interview with John R. Wilson, 29 October 1995.
For other artists who contributed both as
painters and as teachers in this period, see
Dunthorne, *Artists Exhibiting in Wales*.

393. David Mainwaring,
Miners,
1959, Oil,
920 × 610

59 Jones interview, op. cit. The exhibition was entitled 'Rhondda Young Artists'.

At the library in Tonypandy, Glyn Jones remembered that, on their return from the art exhibition at the National Eisteddfod in Aberdare in 1956, 'many artists came and had a look ... and liked our exhibition better'.[59] Not having a commitment to a particular aesthetic, these shows often included work from invited artists such as Eric Malthouse and David Tinker, lecturers at the Cardiff School of Art.

394. Colin Jones,
Miners Resting,
c.1955, Oil,
714 × 915

Despite some negative comment in the press and on radio, the complex web of institutional developments and personal relationships developing in the post-war period created a stimulating intellectual environment and increased opportunities for artists to exhibit and the public to view pictures and sculpture. In the wider context of a general move to the political left in British society in the post-war decade, the imaging of industrial and urban society and of working-class communities in south Wales became not only acceptable but fashionable. In film, the romanticism which had emerged during the war, epitomized by *Proud Valley*, gave way to the work of writers and directors with a left-wing political agenda which attempted both to deal with social issues and appeal to the British mass market. Jill Craigie's *Blue Scar*, with music written by Grace Williams, was among the most notable examples.[60] As in the fields of painting and sculpture, in 1951 the Festival of Britain provided an opportunity for film-makers to develop subject matter that, in normal circumstances, might not have been commercially viable. The Welsh contribution was the remarkable semi-documentary *David*, directed by Paul Dickson of Cardiff. Dafydd Rhys, whose memories of his dead son provided the core of the film, was the poet D. R. Griffiths (Amanwy), brother of Jim Griffiths, the friend and patron of Vincent Evans.

[60] *Blue Scar* is discussed in detail by Berry, *Wales and Cinema*, pp. 172–8.

395. Frame enlargement
from Jill Craigie's *Blue Scar*,
1949

396. Frame enlargement
from Paul Dickson's *David*,
1951

397. Geoff Charles,
George Chapman (right) receiving
the Gold Medal for Fine Art at the
National Eisteddfod at Llangefni,
1957

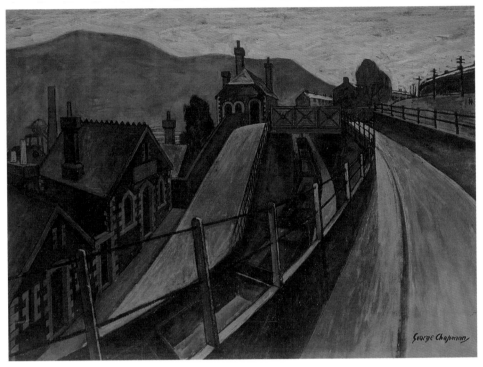

398. George Chapman,
View in Merthyr Tydfil,
1957, Oil,
790 × 1120

In painting, the industrial landscape – as if in reaction to two hundred years of marginalization – became such a common subject in the rapidly increasing number of exhibitions that, as early as 1955, the critic Goronwy Powell suggested it had become a cliché. Writing of the intention of the painter Michael Edmonds to paint miners at work, he remarked that 'relatively few skilled artists have depicted the miner underground, as a welcome change from pit-heads and slag-heaps'.[61] Such remarks made a dramatic contrast to the enthusiastic welcome accorded by John Davies Williams in 1911 to the pit-head in Evan Walters's painting of *Cefn Cyfelach Colliery*. Nevertheless, the pit-heads and slag-heaps, and especially the terraced housing of the Valleys' towns, continued to attract new devotees. George Chapman came to Cardiff in 1953 and, taking a detour on his way home to England, saw the Rhondda. Like Herman at Ystradgynlais, he instantly realized that he had found subject matter which would sustain him for many years. Unlike Herman, however, he painted the Rhondda from the outside, basing his finished pictures on preparatory material done on visits until he finally moved to Wales in 1960. He also found much of his audience in England through London exhibitions, but his work was recognized in Wales by the award of the Gold Medal at the National Eisteddfod of 1957 for his picture *View in Merthyr Tydfil*. This was the second occasion on which urban industrial subject matter had been awarded the main prize. Charles Burton's *Back from the Club* had won in 1954,

[61] *Western Mail*, 16 December 1955.

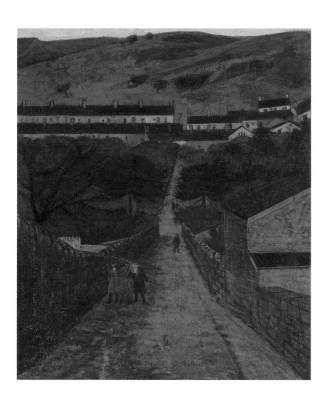

399. Charles Burton,
Back from the Club,
1954, Oil,
760 × 635

400. Geoff Charles,
Denys and Eirian Short (right) *with
'Terrace in Maesteg' at the National
Eisteddfod at Ebbw Vale*, 1958

401. Denys Short,
Porth, 1960, Oil,
1200 × 2580

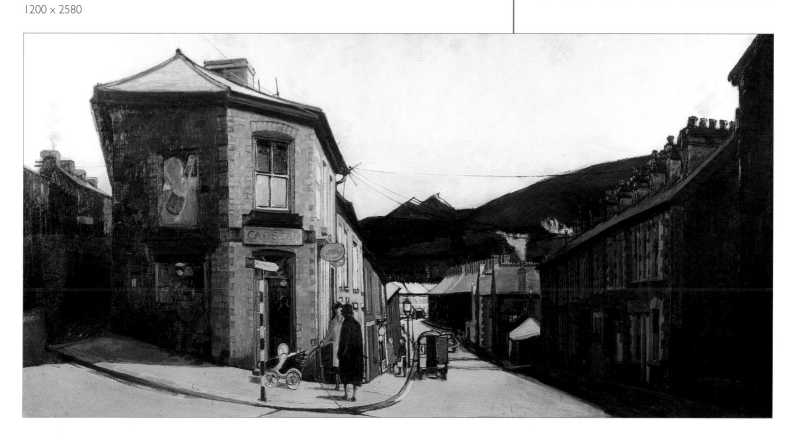

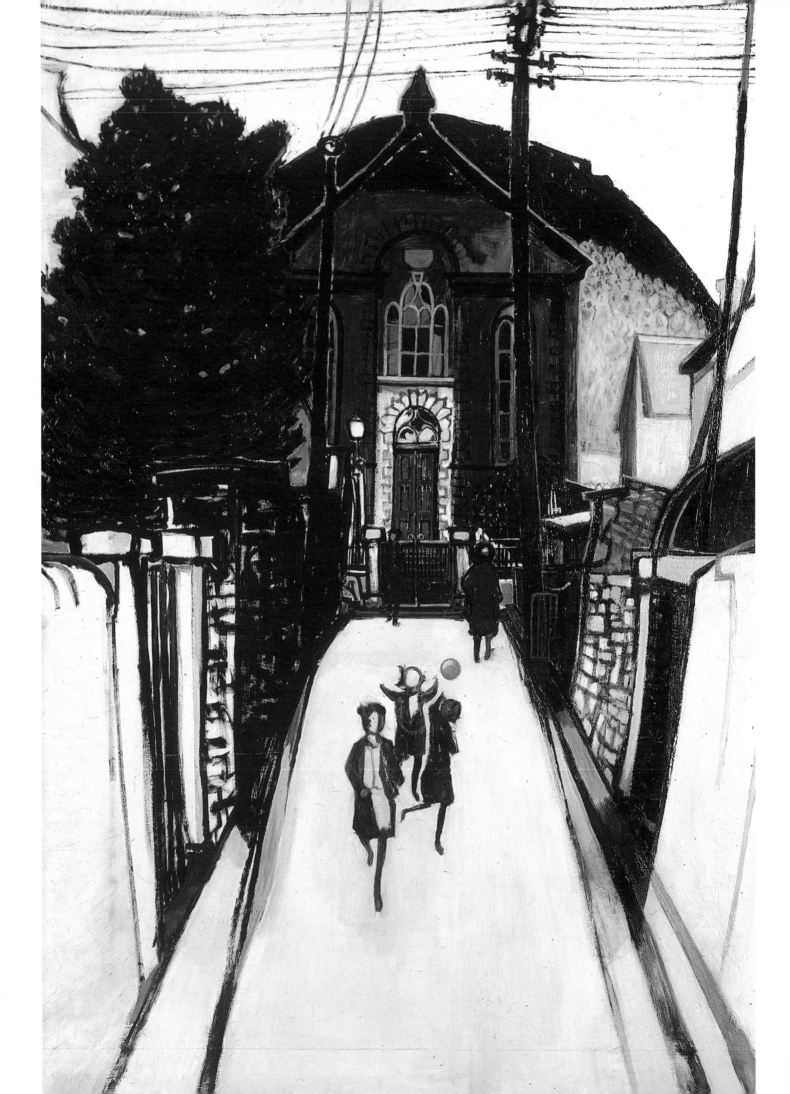

403. Denys Short,
Porth, Cymmer Hill,
c.1959, Pencil,
275 × 250

404. Denys Short,
Tŷ Mawr Colliery,
c.1959, Pencil,
275 × 372

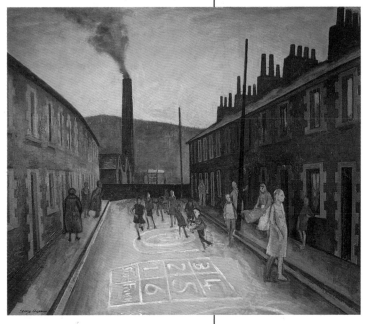

405. George Chapman,
Hopscotch,
1959, Oil,
1000 × 1205

and the year after Chapman's success,
his friend Denys Short was awarded the
Gold Medal for his *Terrace in Maesteg*.
For a number of years Short worked with similar images, which eventually
evolved into three-dimensional pieces based on the doorways and windows
of the Valleys' streets. Like Chapman, he worked in England and although
he had family connections in both west and south Wales through his wife,
the embroiderer, Eirian Short, he was essentially an outside observer.[62]
Neither painter extended his imagery into the domestic or social life of the
Valleys' communities, but nevertheless both developed a strong attachment
to the place to which they had come, expressed by George Chapman in 1960:

> It is all a rich and wonderful stream of life. A valley of strength and courage,
> sometimes sad with tragedy, but always intensely alive. I love it all, with a
> deep sense of gratitude, (including the seventy five inches of rain) from the
> top – Treherbert, to the bottom – Trehafod.[63]

opposite:

402. Denys Short,
Chapel and Tip (Cymmer Hill),
c.1959, Oil,
1800 × 1200

[62] NLW, Welsh Visual Culture Research Project
Deposit, Denys and Eirian Short, interview with
Peter Lord, 11 September 1995.

[63] *George Chapman – The Rhondda Suite*, catalogue
to the exhibition at St George's Gallery Prints
(London, 1960), p. 2.

406. Josef Herman,
*Cover for the Seventh
Exhibition of Contemporary
Welsh Painting, Drawing
and Sculpture 'Industrial
Wales',* 1960

408. Unknown photographer,
*John Petts and the painter
David Petts,* c.1952

407. John Petts,
Drawing for
*Thyssen Shaft
Sinking Company,*
c.1955, Pen and ink

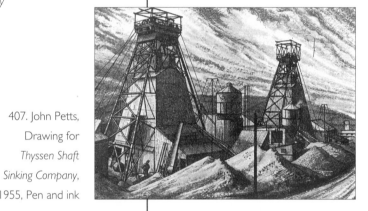

409. John Petts,
The Cage,
1949, Oil,
510 × 760

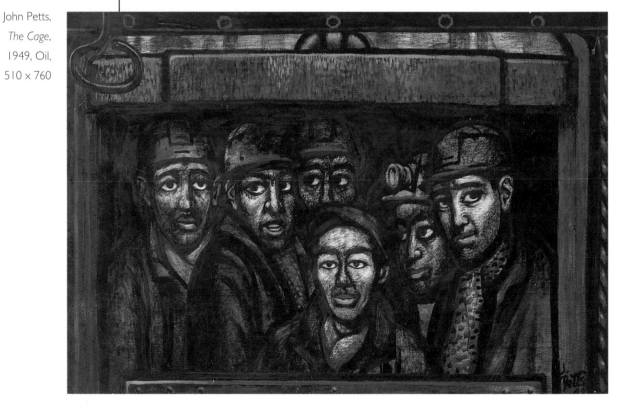

Both in the National Eisteddfod and in a series of Arts Council exhibitions which began in 1949 with '25 Pictures by Contemporary Welsh Artists' and continued throughout the 1950s, industrial imagery was placed side by side in visual counterpoint with the work of those painters who worked in the romantic tradition of rural and mountain imagery. In his foreword to the catalogue to the 'Contemporary Painting in Wales' exhibition of 1952, the painter John Petts, successor to David Bell at the Arts Council,[64] wrote of the variety of artists in Wales:

> One shows the sweat of steelworkers, the yellow belch of chimneys; one paints the pitprop strength of miners blue with coal; another paints the life of fields and the mood of sullen hills, slate chapels on bare hillsides, the leather cowman squatting in the inn. The artist watches, records, and selects: coaltips of the Rhondda, the piled fleeces of the upland clip, the pattern of Snowdon's screes, taut Bardsey fishermen, the chapel deacons grouped about the iron gate, jars on a table, the peeling paint of a deserted shop ...[65]

The chapel deacons to whom Petts referred had been painted by John Elwyn, one of the few artists who encompassed both industrial and rural imagery. In 1940 John Elwyn had been sent, as a conscientious objector, to Pont-rhyd-y-fen to work on Forestry schemes. There he observed the type of mining community on the western edge of the coalfield which Archie Griffiths and Vincent Evans had painted in the inter-war years. John Elwyn painted his pictures of this community several years after leaving the area, working from his recollections of the time.

[64] John Petts was Assistant Director for Wales (Art) from 1951 to 1956.

[65] Arts Council of Great Britain, Welsh Committee, *Contemporary Painting in Wales* (Cardiff, 1952).

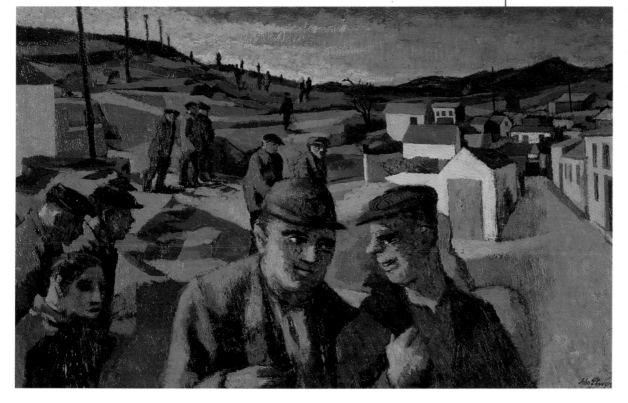

410. John Elwyn, *Miners Returning Home over Waste Ground*, 1953, Oil, 330 x 535

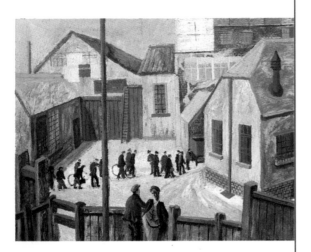

411. Leslie Moore,
Workmen Crossing a Yard,
1954, Oil,
540 × 670

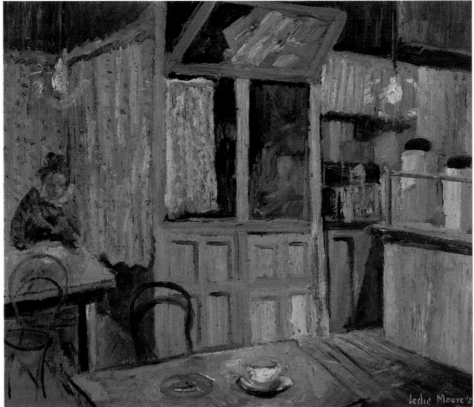

412. Leslie Moore,
Café,
1950, Oil,
490 × 600

In *Miners Returning Home over Waste Ground*, painted in 1953, he unknowingly repeated the scene depicted by Archie Griffiths in 1931, though he conceived it in the detached and picturesque terms of the visitor which might well have seemed inappropriate to his predecessor:

> To recall gazing into a sulphurous sunset and seeing the rows of small silhouetted figures of miners like insects with shadows and reflections scribbled on the wet roads making their way homewards to their tin baths in front of the kitchen fire, was a visual experience of the first order.[66]

Like John Elwyn, Leslie Moore belonged to that generation, older than the Rhondda Group painters, whose careers had been interrupted by the Second World War. He had been trained at Cardiff School of Art between 1932 and 1936, but did not work again in his home town until he was appointed Art Adviser to Glamorgan Education Authority in 1950. Once back in Cardiff he embraced the enthusiasm of the younger generation for imagery which reflected the everyday experience of the industrial south, and was able to combine successfully his role in education with that of a professional painter.

[66] John Elwyn, 'Notes towards an exhibition, 1994', quoted in Robert Meyrick, *John Elwyn* (Aberystwyth, 1996), p. 22, published to coincide with a retrospective exhibition of John Elwyn's work at the National Library of Wales.

Since they perceived it as a new subject, the industrial scene suited the mission of David Bell and John Petts to create a new art world in Wales. In 1953 Petts organized the first of a series of open exhibitions of contemporary Welsh painting and sculpture which provided a platform for the unprecedentedly large number of young artists who were working in Wales at the time. Furthermore, the exhibitions marked the beginning of a systematic policy of purchases by the Arts Council which provided an important incentive and resulted in the creation of a collection of considerable historical interest. The idea for the exhibition and the purchase policy had been presented to the Arts Council in a discussion document in 1951 by Evan Charlton and J. D. Powell, whose spirit of democratization and Welsh independence was wholly characteristic of its period:

> We want a profound and also a popular art which will give our painters a direction and will allow the public a chance to feel that they are being brought into the scheme and not excluded as has been the case in so much modern painting. Wales, with its eisteddfodic tradition, should be fertile ground for such a growth. In this way we shall be developing an Art of our own and helping to liberate our painters from the academic bondage of the RA.[67]

The selectors for the first open exhibition, John Piper, Carel Weight and David Bell, believed that 'the standard was in general higher than in other group shows in Britain'. They promoted urban and industrial imagery heavily, which was represented not only by the works of the Cardiff painters, such as Zobole's *Llwynypia, Rhondda*, Evan Charlton's *Britannia Dock*, and Colin Allen's *Street Scene, Cardiff*, but also by artists from Swansea and Newport. Notable among these was Maurice Barnes, who would play an important role over many years in developing the visual

[67] NLW, Welsh Arts Council Archive, Exhibition Files, A/E/10. The Arts Council had already begun to purchase pictures by the time the policy document was implemented in the first open exhibition in 1953, although only on an ad hoc basis. Evan Charlton (1904–84) was born in London and trained at the Slade. He was Principal at Cardiff School of Art from 1938 to 1945 and subsequently H. M. Inspector (Art) Wales. John David Powell was a former HMI, a literary critic and frequent adjudicator at National Eisteddfodau.

413. Evan Charlton,
Port Road East (Harbour, Cardiff),
c.1953, Oil, 890 × 1200

414. Ernest Zobole,
Llwynypia, Rhondda,
c.1951, Oil,
945 × 1525

415. Colin Allen,
Street Scene, Cardiff,
1953, Oil,
610 × 910

416. Evan Charlton,
Britannia Dock,
c.1953, Oil

417. Maurice Barnes,
The Disaster at Six Bells Colliery,
1960, Pen, ink and watercolour on paper,
443 × 583

arts in Newport.[68] From west Wales, Jenkyn Evans, brother of Vincent Evans, was represented among the sculptors by *Valley Toiler*. A selection of thirty works was made from the exhibition which not only toured in Wales but was also shown in London and Scotland, where it attracted considerable critical interest.[69] The catalogue introduction was written by Saunders Lewis:

> They tell us about Wales, about the disturbing dream-quality of a Cardiff dock, about the strange pressure of the sky mixing its colour with the colour of the streets, the amazing vision of Llwynypia, and about miners walking under the destiny-laden evening clouds. But one cannot translate from paint to language. One must stare meditatively and eagerly to receive what the picture says. Perhaps one can discover an akin-ness between M. Eldridge's Corris pen and the poetry of R. S. Thomas, but what is told the eye and what is told the ear are two different things ...[70]

Critical comment on the exhibitions of the 1950s, and in particular on the urban and industrial imagery they presented to the public, was often excited, but it remained sporadic. Mervyn Levy reviewed the second Open Art Exhibition in 1955 for radio:

> Anyone who missed this sparkling exhibition at Cardiff should take the next suitable train or bus to Newport, or they can walk or run – but go they must, if it is at all possible, or if they have the merest interest in painting or sculpture. And if you haven't bothered a great deal about the visual arts before, well this is just the sort of exhibition that will kindle an undying love. It has all the thrill, the dancing vitality, and exhilarating joy of a fine spring day at a bracing coastal resort.[71]

Mervyn Levy made a series of very short critical broadcasts at a time when his name was becoming familiar to millions throughout Britain on television. Stimulated by his wartime work in the Army Education Corps, Levy had found his niche not so much as a painter but by pioneering the teaching of painting and art appreciation through the new medium with a series of programmes called 'Painting for Housewives'.[72] A number of other artists of the period had contributed good writing to Welsh periodicals, but mainly in retrospect and in autobiographical rather than critical terms.[73] With the benefit of hindsight some artists modified their standpoint considerably to minimize or even deny the social and political content of the imagery of the 1940s and 1950s. In 1943 Arthur Giardelli had stated unambiguously that he regarded Cedric Morris's paintings as social comment, but he rejected this view when questioned about it in 1995. Similarly, when Charles Burton was asked about his motivation as a young man, he suggested that coal tips had offered 'nice black triangles' to paint.[74] Formal considerations in the works of many of the Rhondda Group were certainly of central importance. Zobole, for instance, remembered being excited by Koppel because his paintings were 'all to do with paint':

418. Stan Janus,
Mervyn Levy, c.1955

[68] Maurice Barnes was a founder member of the Newport Art and Crafts Society, and subsequently its Chairperson and President. He also served as Treasurer of the South Wales Group.

[69] The content of the show varied at different venues, notably in Bangor, where Frances Macdonald's *The Welsh Singer* (a picture of the Penrhyn slate quarry) was included. This was one of the works which had formed the Arts Council's Festival of Britain exhibition, '60 Paintings for '51'. Works by Nan Youngman and Esther Grainger were also shown at Bangor.

[70] NLW, Welsh Arts Council Archive, Exhibition Files, A/E/11. Saunders Lewis's introduction was printed in Welsh only (see Arts Council of Great Britain, Welsh Committee, *Thirty Welsh Paintings of Today* (Cardiff, 1954), pp. 5–6), although he prepared the English translation which is quoted here. The painter Mildred Eldridge (1909–91) was married to R. S. Thomas.

[71] Ibid., A/E/15. This exhibition marked the emergence of a number of painters, notably Ivor Davies, Roy Powell and Selwyn Jones, who continue to make important contributions to the visual culture of Wales.

[72] For Levy's contribution as an art educator, see Peter Lord, 'Mervyn Levy', *Planet*, 117 (1996), 126–8. Levy's interventions in the Welsh art world from his London base were often controversial. See, for instance, his pronouncements on what he regarded as the paucity of Arts Council support for artists reported in the *Western Mail*, 24 and 28 January 1956.

[73] Meic Stephens (ed.), *Artists in Wales [1]*, 2, 3 (3 vols., Llandysul, 1971, 1973, 1977).

[74] NLW, Welsh Visual Culture Research Project Deposit, Arthur Giardelli and Charles Burton, interviews with John R. Wilson, October 1995.

I didn't want to know what they were about, in terms of subject matter – but you could see they were figures – figurative – odd, strange things happening in them – and it was a paint language – I'd met a painter. I thought they were terrific and I can't enthuse enough over them.[75]

Zobole grew up, as did Glyn Jones a little later, 'with politics in the air all the time'.[76] The Rhondda Group and many of their contemporaries were distinguished from painters and photographers who came to this subject matter from the outside by the fact that they could take it for granted. They had not needed to search for it since, for them, it had always been there. The particular quality of the times allowed them, unlike most of their predecessors, to assume its inherent value and to use it as a firm base on which to explore ways of seeing. That assumption carried an implicit political statement similar to that made more explicitly in the contemporary spate of working-class literature. Furthermore, for many people outside the industrial community who admired the work of Zobole and his colleagues, such subject matter did not represent everyday life. The political connotations of works which seldom strayed beyond working-class communities for their subject matter cannot be dismissed as lightly as Burton facetiously dismissed them in retrospect. Nevertheless, the images functioned in an atmosphere in which the pre-war battles seemed to have been won. The pictures were not truly radical since they were affirming the new social order, rather than campaigning for change.

Unfortunately, no critic emerged in Wales to grasp the potential of this very large body of imagery for the construction of a working-class or socialist art theory linked to political traditions in Wales. There was, indeed, a critical discourse in Welsh art at the time which included this work, but rather than on questions of class, it centred on the question of whether or not the new work constituted a Welsh school of painting – and, beyond that, whether such a school was desirable or possible in the post-war world. In the absence of a specialist press, the discourse was conducted in a fragmentary way in exhibition catalogues, newspaper articles and correspondence, as well as on radio. In their introduction to the catalogue of the 1953 Open Exhibition, the selectors, Piper, Weight and Bell, had hinted at an emerging Welsh School and defined its characteristics:

A feeling is conveyed in many of the pictures of love and compassion for humanity and a consciousness of the relations of men and women to nature, buildings and everyday life in Wales. This concern with environment seems to augur well for the future of a Welsh School of Painting.[77]

Bell's agenda had been pursued consistently since his days at the Arts Council, but by 1956, his successor, John Petts, was beginning to express doubts, believing that Welsh artists 'persistently confine themselves to their own, often narrow, environments'.[78] The painter Gwyn Evans, born in Swansea but working in Denbighshire, expressed similar views, frowning upon 'post-war efforts to

[75] Zobole interview, op. cit.

[76] Ibid.

[77] NLW, Welsh Arts Council Archive, Exhibition Files, A/E/11.

[78] Western Mail, 2 March 1956.

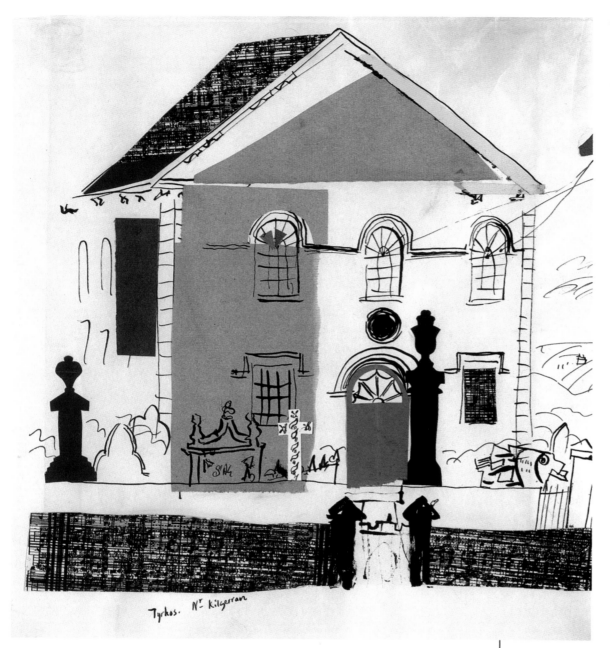

419. John Piper,
Tyrhos nr. Kilgerran,
1937, Collage,
300 × 288

develop an artificial Welsh tradition of painting'.[79] In their view, the new imagery was rapidly turning into a fashionable convention, which was satirized by Alun Richards in a short story, *The Former Miss Merthyr Tydfil*. The story concerned a young Welsh painter, Melville, who was making a career in London:

> The irony was that he'd completely changed his style since his exhibition. Now he painted Welsh industrial scenes exclusively and his little canvasses were all expressions of some aspect of valley life. Pit wheels, ravaged coal tips, cameos of gaunt chapels and back-to-back houses now made neat little patterns whose colours somehow formed an idealised picture of a way of life that had gone. There was something immensely nostalgic about his work.[80]

[79] Ibid., 9 March 1956.

[80] Alun Richards, *The Former Miss Merthyr Tydfil and Other Stories* (London, 1976), p. 210.

263

420. Unknown photographer,
John Petts, 1956

422. Unknown photographer,
Gwyn Evans, 1956

421. Unknown photographer,
Opening of a 56 Group Exhibition in Amsterdam,
c.1967

The image was becoming cosy. John Petts and Gwyn Evans had been provided with a platform to express their doubts about the new painting in a long series of articles about contemporary artists written by Goronwy Powell for the *Western Mail* in 1955 and 1956, which give a good flavour of the Welsh art world at a moment of change. Differences of opinion about the way forward were becoming heated, over both aesthetics and organization. David Bell was promoting a new Academy as the way forward, and the hostility aroused by the idea was noted by the journalist W. Anthony Davies in his diary for 21 May 1955:

> The attempt to establish an Academy in Wales is dividing artists. John Petts stated his grievances to me, sparing no one. The idea for an Academy originated in the brain of David Bell, and although I attempted to answer Petts's arguments factually and in a gentlemanly manner, I felt that Petts had proved his point.[81]

Among the younger artists interviewed for the *Western Mail* by Goronwy Powell was David Tinker:

> Tinker's gentle air of rebellion directs itself in fair measure against what he considers the prosaic, environment-ridden style of painting he sees done by Welsh artists, especially in the South.[82]

Like Petts, Tinker was not inclined to the idea of an Academy. With two other painters of similar persuasion, Eric Malthouse and Michael Edmonds, he established a radical group which took its name, the 56 Group, from the year of its formation. They were joined by other artists, including a number of those whose teaching and art works had contributed to the creation of the Welsh Environmentalism now under challenge – notably Koppel and Zobole. Consequently, the 56 Group could make no attempt at coherent aesthetics but rather provided an exhibition platform for those who wished to present themselves both to the Welsh public and to the wider world as familiar with progressive and international aesthetic trends. In the same year exhibition opportunities were further increased by the opening of the first private gallery in south Wales by the painter Howard Roberts and his wife Joan Prosser. Roberts used spare space in his studio in St Mary's Street in Cardiff to mount a mixed exhibition and was surprised by the amount of publicity and sales generated. Encouraged by this response, it was decided to proceed on a more planned basis and in 1957 the Howard Roberts Gallery mounted the first of many survey exhibitions of contemporary art under the title 'Wales through the Painter's Eye'. Later in the year the gallery instituted a picture loan scheme modelled on that operated by the Artists' International Association in London. The first one-person exhibition came in 1958, showing the work of Vera Bassett. For many years, the Howard Roberts Gallery remained the only private commercial gallery in the south and an important part of the developing art world.[83]

Among the pictures shown at the inaugural exhibition of the Howard Roberts Gallery were the abstract works of Eric Malthouse and Robert Hunter. Aesthetic fashions such as Abstract Expressionism, which were absorbing the metropolitan avant-garde in London, Paris and New York, began to have a much greater impact on practice in Wales and the art colleges became the centres for the dissemination of such ideas. Malthouse, whose abstraction developed out of earlier works in which characteristic aspects of Valleys' life, such as pigeon-keeping, were observed, was a lecturer at Cardiff School of Art, while Hunter was Head of Art at Trinity College, Carmarthen. Young Welsh artists in London, such as Glyn Jones, who had gone from his Cardiff background among the Rhondda Group to the Slade School in 1957, also became increasingly involved with the avant-garde. Jones exhibited between 1957 and 1960 at the Young Contemporaries exhibitions in London, widely perceived at the time as the pinnacle of achievement in England for those interested in the new aesthetics. The Welsh Environmentalism which had been evolving both in the practice of many painters and in the minds of theorists as a National School, was rapidly overturned in the rush to follow metropolitan trends. Many painters, such as David Mainwaring, abandoned their early styles, based on drawing and painterly technique, and only a few, notably Zobole, were able to develop their work in a more organic manner over a long period. The imaging of industrial landscape and industrial communities, which had taken so long to come to the fore, remained central to the work of Zobole, Chapman, and some others, but many more moved away, and in the 1960s it could no longer be promoted as a national mainstream.

423. Howard Roberts,
Steel Works, 1964, Oil,
700 × 1120

[81] Translated from J. Ellis Williams (ed.), *Berw Bywyd. Detholiad o Ddyddiadur W. Anthony Davies [Llygad Llwchwr]* (Llandysul, 1968), p. 176. Davies went on to state his admiration for Bell: 'For all that, it was the life and bravery of the lame David Bell that charmed me, and the story of his father and his family. David's grandmother was a Welsh woman from Llanfairfechan, and it is this which explains the love of Sir Idris and his son for the Welsh language.'

[82] *Western Mail*, 27 January 1956.

[83] See Howard Roberts, 'Howard Roberts Gallery', *The Anglo-Welsh Review* (ed. Roland Mathias), vol. 18, no. 41 (Summer 1969), 169–74. The same issue of the magazine (pp. 156–68) contains an article about the painting of Howard Roberts written by Bryn Richards. The Gallery moved from St Mary's Street to Westgate Street in Cardiff in 1966, and closed in 1970.

424. Eric Malthouse,
A Flurry of Pigeons,
1954, Oil,
1220 × 1525

Indeed, the very notion of an art related to a particular cultural experience became highly unfashionable, and was often derided by the widespread use of the word 'provincialism'. A new cultural imperialism, masquerading as internationalism, overwhelmed the minds of all but a small minority of stubborn individualists in Wales, as in many other parts of Europe. The metropolitan effect, dominated by London and New York, was magnified to an unprecedented extent in Wales by structural changes in the way visual art was manufactured and presented. From the middle of the 1960s a huge expansion of public funding, operating through a matrix of art colleges, the Arts Council,[84] and local authority exhibition spaces, rapidly increased both the amount of art being made and its exposure to the public. The turmoil caused by this combination of structural and aesthetic change in the art world persisted for over twenty years, and coincided with the collapse of industrial Wales in the form which had evolved over the previous two centuries. To what extent the image-makers of the period were able to respond to that collapse, either by reflecting its visual impact or by commenting upon its social implications, is for the next generation of historians to determine.

[84] The Welsh Committee of the Arts Council of Great Britain became the Welsh Arts Council in 1967, but remained directly funded by the ACGB until 1993, when that responsibility was transferred to the Welsh Office.

Acknowledgements

Every attempt has been made to secure the permission of copyright holders to reproduce images.

Reproductions by courtesy of the National Library of Wales, with the exception of the following illustrations:

Arts Council of Wales: 186 (© South Wales Police Headquarters), 353, 359, 374, 379, 386, 387, 391, 392, 398, 399, 410, 412, 414, 415
British Film Institute, Stills, Posters and Designs Collection: 341, 343 (© The National Council for Voluntary Organisations), 395, 396 (© British Film Institute)
British Library: [KTOP XL 11.51 (1)] 5
British Museum: 17 (© British Museum)
Carmarthen County Museum: 169
City and County of Cardiff, Cardiff Castle: 137, 138, 141, 144
City and County of Swansea
 Glynn Vivian Art Gallery, sponsored by Swansea Museum Service: 124, 289, 292, 296, 303, 306, 309, 315, 329, 331, 370, 390
 Swansea Maritime and Industrial Museum, sponsored by Swansea Museum Service: 195
 Swansea Museum Collection, sponsored by Swansea Museum Service: 11, 12, 123, 150
Contemporary Art Society for Wales: 325, 326
Cyfarthfa Castle Museum and Art Gallery: 10, 26, 71, 73, 80, 81, 83, 84, 85, 86, 89, 96, 105, 155, 156, 179, 194, 320, 321, 424
Deutsches Historisches Museum, Berlin: 242

East Glamorgan NHS Trust: 145, 146
Glamorgan Record Office, Cardiff: 106, 107
Gwynedd Archives Service, Caernarfon Record Office: 191
Hulton Getty Images: 202
Ironbridge Gorge Museum: 22, 67, 68
Leeds Museums and Galleries, City Art Gallery: 334, 335 (© Albert Houthuesen Trust)
Magnum Photos: 363, 364
Marx Memorial Library: 333
Master and Fellows of Trinity College Cambridge: 226
National Fairground Archive: 184
National Library of Wales: 337 (Bill Brandt, © Bill Brandt Archive Ltd)
National Museums and Galleries of Wales
 National Museum and Gallery Cardiff; Department of Art: 23, 29, 46, 50, 65, 66, 70, 77, 108, 117, 119, 122, 125, 142, 143, 147, 153, 154, 200, 208, 225, 235, 236, 238, 240, 241, 248, 249, 250, 253, 282, 284, 307, 308, 323, 324, 332 (© Albert Houthuesen Trust), 345, 360, 361, 362, 368, 381, 382, 394, 417, 419
 National Museum and Gallery Cardiff; Department of Archaeology and Numismatics: 8, 9
 Museum of Welsh Life: 60, 62, 167, 170, 190, 224, 311
 Welsh Industrial and Maritime Museum: 197, 198, 199, 201, 266, 267
National Museum of Labour History: 187 prior to restoration
National Museum of Photography, Film and Television/Science and Society Picture Library: 131, 328
National Museums and Galleries on Merseyside: Lady Lever Art Gallery, Port Sunlight: 166

National Trust Photographic Library: 109, 111, 112, 113, 114 (Ronald White)
National Trust, Knightshayes Court: 139
Newport Museum and Art Gallery, South Wales: 159, 203, 358, 376, 409
Oriel Mostyn: 373
Pace Wildenstein MacGill Gallery: 365, 366 (© Robert Frank)
Private Collections: 64, 79, 90, 91, 92, 93, 94, 95, 115, 120, 128, 129, 130, 285, 286, 317, 336, 338, 346, 347, 348, 349, 350, 356 (© Nan Youngman Collection: C. J. Rea), 367, 369, 389, 407, 421
Royal Commission on the Ancient and Historical Monuments of Wales: 103, 116
Sotheby's: 127
South Wales Coalfield Collection, University of Wales Swansea Library: 310
St Andrews University Library: 136
Swansea Institute of Engineers: 121
Tate Gallery London, 1998: 27, 371
University of London, Courtauld Institute of Art, Witt Picture Library: 19
University of Wales, Aberystwyth: 168, 171
University of Wales, Bangor, Bangor Collection, Bangor Museum: 47, 52, 61
West Glamorgan Archive Service: 100
Williamson Art Gallery and Museum: 21

Picture captions

Extant works:
Sizes are given in millimetres, height before width.
Main media only are given.
Photographic prints from negative/positive processes are not sized.

Destroyed or unlocated works:
Size and medium are not given unless known for certain.